1985 Carnegie International

Carnegie

International

John R. Lane and John Caldwell
Co-Curators

**Linda L. Cathcart, Rudi H. Fuchs, Kasper König,
Hilton Kramer, Nicholas Serota, Maurice Tuchman**
Advisory Committee

Saskia Bos and John R. Lane
Anthology Editors

Museum of Art, Carnegie Institute, Pittsburgh, 1985
Distributed by Prestel-Verlag

1985 Carnegie International November 9, 1985 — January 5, 1986

The 1985 Carnegie International is supported by grants from the United States Steel Foundation, the Howard Heinz Endowment, the National Endowment for the Arts, and the Pennsylvania Council on the Arts, and by income from The A. W. Mellon Educational and Charitable Trust Endowment for the Pittsburgh International exhibition.

Library of Congress Cataloging in Publication Data
Carnegie International (49th: 1985: Museum of Art, Carnegie Institute)
 1985 Carnegie International.

 Bibliography: p.
 1. Art, Modern—20th century—Exhibitions.
I. Lane, John R., 1944– . II. Bos, Saskia.
III. Caldwell, John, 1941– . IV. Title.
N6487.P57C373 1985 709'.04'8074 85-25870

ISBN 0-88039-011-5 (Museum of Art, Carnegie Institute)
ISBN 3-7913-0750-9 (Prestel-Verlag, Munich)
© Copyright 1985 Museum of Art, Carnegie Institute, Pittsburgh. All rights reserved.

Distributed by Prestel-Verlag, Munich
Distributed in the United States by te Neues Publishing Company, New York

Frontispiece: Andrew Carnegie

Lenders to the Exhibition

John Ahearn
Brooke Alexander Gallery, New York
Thomas Ammann Fine Art, Zurich
John Baldessari
Dara Birnbaum
Blum Helman Gallery, New York
Mary Boone Gallery, New York
Jonathan Borofsky
The British Council, London
The Edward R. Broida Trust, Los Angeles
Leo Castelli Gallery, New York
Paula Cooper Gallery, New York
Douglas S. Cramer
Crex Collection, Hallen für neue Kunst,
 Schaffhausen, Switzerland
Anthony d'Offay Gallery, London
Richard Deacon
Gerd de Vries
Jan Dibbets
Edward R. Downe, Jr.
Gerald S. Elliott
Luciano Fabro
Mr. and Mrs. Milton Fine
Konrad Fischer, Düsseldorf
Barry Flanagan
Xavier Fourcade, Inc., New York
Hugh Freund and Alan Flacks
Barbara Gladstone Gallery, New York
Arthur and Carol Goldberg
Mrs. Faith Golding
Marian Goodman Gallery, New York
Mr. and Mrs. Stanley R. Gumberg
Mr. and Mrs. Graham Gund
Mr. and Mrs. Richard C. Hedreen
Howard Hodgkin
Mr. and Mrs. Robert K. Hoffman
Jenny Holzer
Neil Jenney
Philip Johnson
Aron and Phyllis Katz
Anselm Kiefer
Mr. and Mrs. Gilbert H. Kinney
James Kirkman

M. Knoedler & Co., Inc., New York
Sol LeWitt
Lisson Gallery, London
Los Angeles County Museum of Art
Louisiana Museum, Humlebaek, Denmark
Linda and Harry Macklowe
Galerie Paul Maenz, Cologne
Lewis and Susan Manilow
Mellon Bank
Metro Pictures, New York
Milwaukee Art Museum
Mobay Chemical Corporation
Museum of Art, Carnegie Institute, Pittsburgh
Mr. and Mrs. Lewis E. Nerman
Tom and Charlotte Newby
Paul and Camille Oliver-Hoffman
The Pace Gallery, New York
PaineWebber Group Inc.
Ponova Gallery, Toronto
Private Collection (17)
Max Protetch Gallery, New York
Mr. and Mrs. James H. Rich
The Rivendell Collection
Saatchi Collection, London
Lenore and Herbert Schorr
Mr. and Mrs. J. Todd Simonds
Martin Sklar
The Smorgon Family Collection of
 Contemporary American Art
Martin and Toni Sosnoff
Sperone Westwater, New York
Emily and Jerry Spiegel
Stedelijk Museum, Amsterdam
Irving Tyndell
Waddington Galleries Ltd , London
Washburn Gallery, New York
Michael Werner
Galerie Michael Werner, Cologne
Whitney Museum of American Art, New York
Willard Gallery, New York
Bill Woodrow
Sue and David Workman

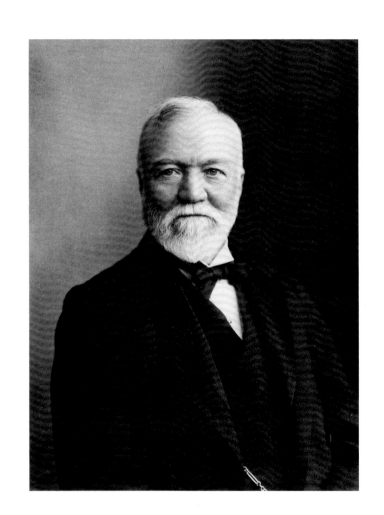

Contents

Foreword

In 1896, the year after Carnegie Institute was established, the first Carnegie International was mounted, initiating a succession of shows that became America's chief contribution to the regular round of international exhibitions of contemporary art. This venerable Pittsburgh tradition, whose forty-ninth edition is the occasion for this catalogue, is, after the Venice Biennale, the longest continuing series of its kind, and its presentation coincides with the one hundred fiftieth anniversary of the birth of Andrew Carnegie, founder of both the Institute and the International. This exhibition, along with several other important cultural events held during 1985 in America and Scotland, observes and celebrates Andrew Carnegie's sesquicentennial and honors his philanthropic leadership.

Cities on the periphery of the contemporary art world, such as Pittsburgh, Kassel, Venice, and São Paulo, seem well situated as the venues of large international exhibitions. Although they do not support the richness of artistic life that characterizes New York, Cologne, London, and other exciting hubs of creative activity, neither are they as subject to the art scene's quotidian diversions. At their best, therefore, they not only afford an environment conducive to the independent examination of artistic accomplishment, they also provide a nearly neutral ground on which the international art world can meet. This may explain why the International, Documenta, and the Venice and São Paulo biennials have traditionally enjoyed the cooperation of the entire contemporary art community. The 1985 Carnegie International is no exception, and it has benefited enormously from the advice, assistance, and support of a great number of individuals in Europe and the United States. We offer our sincere thanks to all these friends of the exhibition, whose many names are listed in a special acknowledgments section of this catalogue.

John Caldwell, the Museum of Art's curator of contemporary art, has served with me as the co-curator of the exhibition, sharing fully in the organizational responsibilities. It would be difficult to imagine a more thoughtful, dedicated, and amiable colleague with whom to undertake a demanding collaborative venture. He has richly earned both the museum's appreciation and my heartfelt personal thanks for his exceptional contributions to the project.

The bilateral advisory committee, made up of six leading figures in the European and American contemporary art communities, has been central and indispensable to the development of the exhibition, and we are deeply indebted to its members: Linda L. Cathcart, director of the Contemporary Arts Museum, Houston; Rudi H. Fuchs, director of the Stedelijk Van Abbemuseum, Eindhoven, The Netherlands; Kasper König, professor of art and media at the Staatliche Kunstakademie, Düsseldorf; Hilton Kramer, editor of *The New Criterion,* New York; Nicholas Serota, director of The Whitechapel Art Gallery, London; and Maurice Tuchman, curator of twentieth-century art at the Los Angeles County Museum of Art. The part the members of this group played in the International's organization is described in the introduction to this catalogue, but it

should be noted here that their role was extraordinary. These six individuals also served as the jury of award for the Carnegie Prize, along with co-chairmen H. John Heinz III and Adolph W. Schmidt, for which we are further beholden to them.

We are deeply grateful also to Saskia Bos, director of Stichting De Appel, Amsterdam, The Netherlands, for so acutely selecting and editing the European contributions to this catalogue's anthology and artists' statements. She was assisted by Arno Vriends in this work. John Caldwell edited the American artists' statements, with the collaboration of Annegreth T. Nill, the museum's assistant curator of contemporary art, and the artists' biographical and bibliographical section, with the aid of Elisabeth L. Roark, research specialist. We thank Hilton Kramer for his article "Internationalism in the Eighties," which was commissioned for this catalogue, and the artists who prepared new statements for publication. And we gratefully acknowledge the artists, authors, and publishers who permitted us to reprint previously published work.

This catalogue was designed by Michael Glass, an informed observer of the contemporary art scene and one of America's most prominent designers of museum publications. The book's graphic style has carried over to other printed materials associated with the exhibition, which were designed by Garrity Hughes and Company.

Sarah Buie designed the exhibition architecture and, consulting closely with the co-curators in an effort to regard both the objects being installed and the needs of the dozen artists who would be coming to make works in Pittsburgh, laid out the exhibition in the Heinz Galleries and the Scaife Gallery foyer and plaza. Her deep concern for the integrity of artworks in an exhibition setting, and her refined sense of space, were of enormous value.

Barbara L. Phillips, assistant director for administration and head of the museum's publications program, played a critical part in this undertaking, bestowing her rich resources of good sense on each juncture of the International's evolution and applying her considerable skills to the planning and implementation required by the uncommon complexity of the exhibition and catalogue. She was especially aided in these efforts by Marcia L. Thompson, publications and program coordinator; Kate Maloy, editor; Eleanor Vuilleumier, registrar; and John Vensak, workshop supervisor. Vicky A. Clark, curator of education, developed the extensive public programs surrounding the exhibition. We also acknowledge the significant contributions to the International of many other Museum of Art and Carnegie Institute staff members, among them Ann S. Blasier, William D. Judson, Cathy Kaiser, and Mary C. Poppenberg.

This exhibition would not have been possible without the generous participation of the many private collectors, museums, galleries, and artists who so kindly permitted their works to be included in the Carnegie International. Their names appear in the List of Lenders, and we are very grateful to each of them.

We asked forty-three artists to exhibit in the 1985 Carnegie International and interpreted it as a high compliment that forty-two

accepted our invitation. We warmly acknowledge the interest that the artists have expressed in the International and the friendly cooperation with which they and their representatives have favored us. The greatest satisfactions to be gained from organizing a large contemporary art exhibition such as the International emerge from interactions with remarkable artistic personalities, and we are much the richer for this privilege.

It is especially meaningful to the Museum of Art that the United States Steel Corporation, originally formed around the Carnegie Steel Company, provided a major grant for this exhibition in recognition of the one hundred fiftieth anniversary of the birth of our mutual founder. We particularly thank David M. Roderick, chairman of the board and chief executive officer of the corporation; Peter B. Mulloney, vice president and assistant to the chairman and president of the United States Steel Foundation; and Thomas C. Graham, vice chairman and chief operating officer and a trustee of Carnegie Institute. In 1975 the Howard Heinz Endowment funded the creation of the Museum of Art's twenty-thousand-square-foot Heinz Special Exhibition Galleries. These spaces are considerably larger than those which any other American museum can devote exclusively to temporary exhibitions, and they were planned especially to accommodate the scale of the Carnegie Internationals. The Howard Heinz Endowment, long the museum's most important source of annual funding for the exhibition program, also gave a generous supplementary grant for this year's Carnegie International. H. J. Heinz II, a Carnegie Institute trustee, chairman of the Howard Heinz Endowment, and influential Pittsburgh cultural leader, took a special interest in the development of the 1985 Carnegie International, and his ideas have been just as welcome and helpful as the generous support of the endowment. Additional funding for the International has been provided by the National Endowment for the Arts and the Pennsylvania Council on the Arts, federal and state agencies both celebrating their twentieth anniversaries in support of the arts. In 1980 The A. W. Mellon Educational and Charitable Trust, with the encouragement of Paul Mellon and Carnegie Institute Trustee Adolph W. Schmidt, made a terminal grant to the Museum of Art that created a major endowment for the Carnegie International, making it the only American exhibition with significant resources dedicated specifically to its perpetuation. The income from this endowment provides approximately half the funds required for the project's triennial realization, and the benefits of this magnificent gift to the long-term fortunes of the Museum of Art are increasingly evident.

The Women's Committee of the Museum of Art has earned an international reputation for the warm hospitality its members arrange for art world visitors to Pittsburgh and for the high standards of the special events the committee organizes to celebrate important museum occasions. For undertaking these responsibilities on behalf of the 1985 International, our sincere appreciation goes to Rita P. Coney, president; Alice R. Snyder and Lea Hillman Simonds, co-chairmen of the Carnegie International Events Committee; Jane Richards Lane; and the many other members of the Women's Committee who volunteered their efforts.

The International has been the main source of additions to the Museum of Art's contemporary fine arts collection, especially in years when the exhibition has been particularly strong. The current art market is characterized by exceptionally vigorous demand for new work by many recognized artists, which frequently limits the ability of either institutional or private collectors to extend their deliberations over a possible purchase. To the extent that our resources have permitted, the museum has responded to these conditions by committing to a number of acquisitions well in advance of the opening. Among the new works that recently have entered the collection and are included in the 1985 International are two paintings and a sculpture, each acquired in honor of an individual closely associated with the Carnegie Internationals. *Carnegie,* the towering sculpture by Richard Serra, has been erected through the extraordinary generosity of Jane H. Roesch in memory of her husband, William R. Roesch, a trustee of Carnegie Institute, president of the United States Steel Corporation, and the person with whom we initiated discussions regarding the sponsorship of this exhibition. The deaths of two previous organizers of Carnegie Internationals prompted memorial purchases: Howard Hodgkin's *The Cylinder, the Sphere, the Cone* in honor of Gene Baro, who curated the 1982 International; and Georg Baselitz's *Die Verspottung* for Gordon Bailey Washburn, who organized the 1952, 1955, 1958, and 1962 exhibitions.

Since its founding, the Carnegie International has had the goals of educating the public, inspiring artists, enriching the museum's collections, and, in Andrew Carnegie's words, "spread[ing] goodwill among nations through the international language of art." To these we have added the desire to restore to the exhibition, the museum, and the city of Pittsburgh their role of contributing substantially to international artistic culture. This can be accomplished only by once again earning the serious attention of the knowledgeable art community. The members of the Museum of Art Committee of Carnegie Institute's Board of Trustees have been a constant source of counsel and encouragement as together we have pursued these aims.

John R. Lane, *Director*

Introduction

by John R. Lane and John Caldwell

A Historical Perspective: Andrew Carnegie, Carnegie Institute, and the Carnegie International Exhibition

Andrew Carnegie was born in Dunfermline, near Edinburgh, in 1835. His father was a master weaver who, when his livelihood became threatened by mechanized textile manufacturing, took his family to Pittsburgh in 1848 to seek a better life. Young Andrew was hard-working, bright, and quick to seize the opportunities presented by the extraordinary industrial growth in his new home. As he grew up he demonstrated exceptional business acumen and an unerring ability to choose talented associates. From the 1860s to the 1890s he developed and directed the fortunes of several manufacturing enterprises, finally forming the phenomenally successful Carnegie Steel Company. Carnegie was certainly the foremost industrialist of his time, and in 1901, when he sold his enormous company (which became the core of the then brand-new United States Steel Corporation), J. P. Morgan said to him, "I want to congratulate you on being the richest man in the world."

In the years after he sold his steel firm, Andrew Carnegie dedicated himself to philanthropy, creating in the United States and Scotland institutions, endowments, and foundations that still contribute to his ideal of human betterment. This philanthropic impulse was an integral component of a utopian capitalist philosophy, the "gospel of wealth," that Carnegie was instrumental in formulating. Carnegie articulated this credo, with its background in Scottish thought and in principles of property rights, individualism, democracy, and Protestantism, in a text entitled "Wealth" that was published in the June 1889 edition of *North American Review*:

> This, then, is held to be the duty of the man of Wealth: First, to set an example of modest, unostentatious living, shunning display or extravagance; to provide moderately for the legitimate wants of those dependent upon him; and after doing so to consider all surplus revenues which come to him simply as trust funds, which he is . . . strictly bound as a matter of duty to administer in the manner which, in his judgment, is best calculated to produce the most beneficial results for the community. . . . [This is] the true antidote for the temporary unequal distribution of wealth, the reconciliation of the rich and the poor—a reign of harmony, another ideal, differing, indeed, from that of the Communist in requiring only the further evolution of existing conditions, not the total overthrow of our civilization.

The immensity of Andrew Carnegie's wealth presented a special challenge to philanthropy, since effective methods for giving on this scale were just beginning to be developed. Carnegie became as influential in the philanthropic sector as he had been in industry, and by the time of his death he had achieved his goal of responsibly giving away virtually his entire fortune, more than $300 million (in today's dollars a staggering three billion).

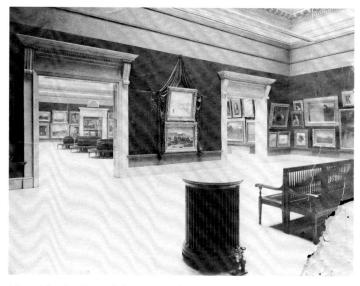

View of the first Carnegie International in 1896. *The Wreck* by Winslow Homer, Carnegie Prize winner and the first painting to be acquired for the Museum of Art's permanent collection, is the lower of the two pictures highlighted by swags and hung in a place of honor between the gallery doors.

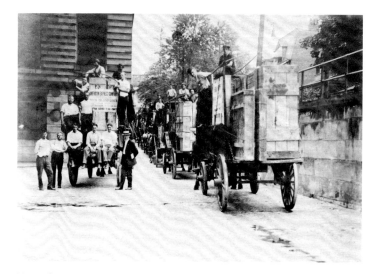

Horse-drawn wagons delivering crated paintings to Carnegie Institute for an early Carnegie International exhibition.

The cultural complex that forms Carnegie Institute and Carnegie Library of Pittsburgh was Andrew Carnegie's first major benefaction, the one in which he was most personally involved, and the one from which he derived the greatest personal satisfaction. Opened in 1895 and dedicated to art, music, literature, and natural science, this gift to the city where he made his fortune has become one of America's leading cultural institutions. It includes, in addition to the Museum of Art, a magnificent music hall, Pittsburgh's central public library, and a distinguished natural history museum.

Andrew Carnegie had a special vision for Pittsburgh's art museum, one that has informed its entire development and gives it a history, character, and role quite unlike those of the principal art museums in other major American cities. Most American museums founded around the turn of the century focused on collecting the works of Old Masters. But Carnegie said, "The field for which the gallery is designed begins with the year 1896," and he urged that it collect the "Old Masters of tomorrow." He called for the museum's program to be centered on a great annual (later a biennial and today a triennial) exhibition of international contemporary art. The Carnegie International series began in 1896 and has long been America's most important continuing forum for the presentation of new international art. Thus, although the Museum of Art has an active interest in the art of many cultures and historical periods, it has been, from the beginning, largely a museum of modern art, arguably America's first.

Although Andrew Carnegie was not personally interested in collecting art, he recognized that a permanent collection of consequence was central to the development of a museum, and he had an astute and farsighted acquisitions strategy. He viewed the Internationals not just as exhibitions but as the primary source of fine European and American works of art for the museum's permanent collection of modern masters. (Carnegie's strategy has certainly proved effective: about one-third of the museum's more than twelve hundred paintings and two hundred sculptures have come from the Internationals, among them a number of masterpieces.) The works purchased from each International were intended to be the best examples from the exhibition, and Carnegie proposed that they be hung chronologically to create a historical record of the continuing development and improvement of art. The early history of the Museum of Art accordingly reflects, in both process and product, Carnegie's positivist philosophy, which viewed in progressive terms all of Western—particularly American—social history and culture.

During the first decades of the exhibition's existence, the presence on the International juries of award of such leading American artists as Chase, Eakins, Hassam, Henri, and Homer was a measure of Carnegie Institute's ambition and of the respect and success that greeted the efforts of the first director, John W. Beatty (1896–1922). Both the exhibition and the institution played significant roles during these early years in defining the public perception of artistic

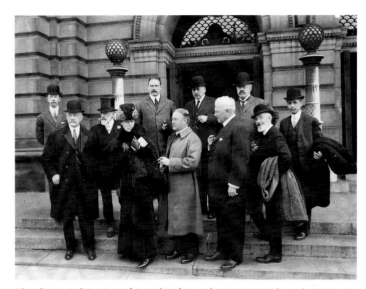

1911 Carnegie Prize Jury of Award. Left to right: Irving R. Wiles, John W. Beatty, William Merritt Chase, Cecilia Beaux, W. Elmer Schofield, Edmund C. Tarbell, Anders Zorn, J. Alden Weir, Frank Duveneck, Maurice Grieffenhagen, Charles H. Davis.

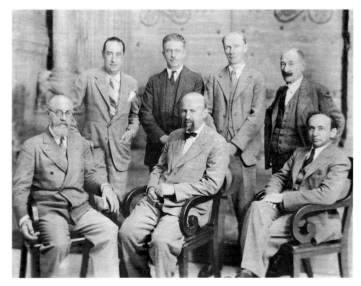

1930 Carnegie Prize Jury of Award. Left to right, seated: Henri Matisse, Karl Sterrer, Bernard Karfiol. Standing: Glyn Philpot, Homer Saint-Gaudens, Ross Moffett, Horatio Walker.

culture in America. Much of this early progress was motivated by Andrew Carnegie's forceful personality, however; for after his death in 1919 the part the museum played in the life of art did not change and grow with the times, and it was not until the 1950s that it regained the same level of aspiration.

The 1913 Armory Show in New York (the first major American exhibition to present the European modernists) and the early chapters of the modern art movement in the United States had small effect on the International. Due to the preferences of the museum's directors and trustees in the decades following Andrew Carnegie's death, the Carnegie International became more obviously conservative as modernism advanced its position as the significant artistic direction of the twentieth century. Relatively little avant-garde art was included in the exhibitions, and it was not until 1927, when Matisse won the Carnegie Prize, that a modernist was accorded high recognition. Although Bonnard and Matisse both sat on the International juries of award in the 1920s, they were the exception.

During these years, the International exhibition was conceived by Homer Saint-Gaudens, second director of the museum (1922–1950), as the "clearing house of the art world" and as an "understanding of the different pictorial desires of the social orders of many lands." Saint-Gaudens, in short, was more concerned with presenting a cross-section of art than with making statements about relative levels of artistic accomplishment or the significance of various artistic trends. John O'Connor, Jr., wrote in his suite of articles on the history of the International, published in *Carnegie Magazine* in 1952, "As Homer Saint-Gaudens liked to put it, the International was the news of the art world, and the visitors and critics were given, through the exhibition, the opportunity to write the editorial."

The philosophy of the exhibition was changed radically in the 1950s by Saint-Gaudens' successor, Gordon Bailey Washburn (1950–1962), who was much more inclined to make distinctions about issues of quality and direction. Under his leadership, the Carnegie International exhibitions re-emerged in the postwar era as important and influential shows of the new avant-garde style of Abstract Expressionism. Washburn's four exhibitions are still remembered vividly by those who saw them, and his enduring legacy to the Pittsburgh community is a receptivity to serious new work by both European and American artists.

During the late 1960s and the early 1970s the American art world questioned the value of extensive contemporary international survey exhibitions. The Internationals of 1964, 1967, and 1970, organized by directors Gustave von Groschwitz (1962–1968) and Leon A. Arkus (1968–1980), sustained the form but not the adventurous substance of the Washburn shows. In the 1970s Arkus tried a new format for the International, and in 1977 and 1979 major one- and two-artist exhibitions, accompanied by cash prizes of impressive magnitude, took the place of the usual large group exhibitions.

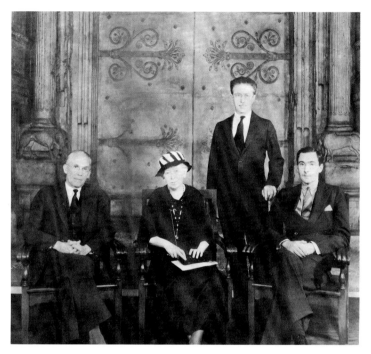

1934 Carnegie Prize Jury of Award. Left to right: Gifford Beal, Elisabeth Luther Carey, Homer Saint-Gaudens, Alfred H. Barr, Jr.

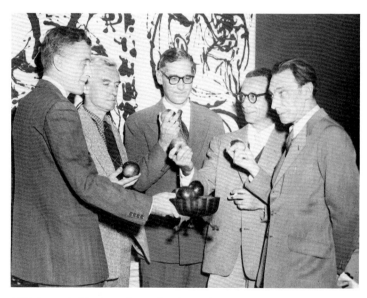

1952 Carnegie Prize Jury of Award. Left to right: Gordon Bailey Washburn, Jean Bazaine, James Thrall Soby, Rico Lebrun, Eric Newton, with *No. 27—1951* by Jackson Pollock in the background.

In 1980 The A. W. Mellon Educational and Charitable Trust made the Museum of Art a major grant of two million dollars, which provided an endowment whose income was intended to ensure the perpetuation of the Carnegie International. The timing of this grant coincided fortuitously with a general renewal of enthusiasm for great international exhibitions. In the late 1970s and early 1980s major shows like *Documenta 6* and *Documenta 7, A New Spirit in Painting,* and *Zeitgeist* were mounted in Europe, where they also commanded the attention of the American art community. In the expectation of presenting a comparable event in Pittsburgh, the late Gene Baro, curator of contemporary art (1980–1982), organized the 1982 International, the first since 1970 to follow customary form. Few projects could have produced such conflicting responses: on the one hand, exhilaration at the return of a beloved Pittsburgh tradition and the show's popularity with many of its local visitors; on the other, the negative response of a number of respected art critics and a general neglect of the exhibition among serious art circles.

The 1985 Carnegie International
In the spring of 1983, with the aim of restoring the Carnegie International to its historic place among the few ongoing series of international contemporary art exhibitions, we visited with more than fifty members of the contemporary art community in the United States and Europe, concentrating on individuals who were particularly experienced in exhibition organization and seeking advice on how we might best proceed with the show's forty-ninth edition, scheduled for 1985. Our travels were an invaluable source of information and encouragement; not only did our colleagues express warm interest in the upcoming project, but they also gave us the sense that, although the International had not been a significant force for twenty years, its distinguished tradition could still be invoked to revitalize the exhibition.

We began our researches with the hope that they would lead us to the right person to organize the 1985 International; what became clear to us instead was the breadth and complexity of the American and European contemporary art worlds and how daunting it would be for a single individual to attempt a full and balanced grasp of developments on both sides of the Atlantic. This convinced us that, although a project conceived by a small group might have its shortcomings (notably, the inevitability of compromise and the absence of a unique point of view), the advantages of the group approach— that is, checks and balances of internal criticism, the depth of information, and the scope of experience—would, for this edition of the International, substantially outweigh them. This judgment was further influenced by our recognition that, although European audiences had had several opportunities to see together the important accomplishments of artists from both sides of the Atlantic, no major exhibition in the United States for perhaps two decades had successfully represented the most interesting contemporary art of both

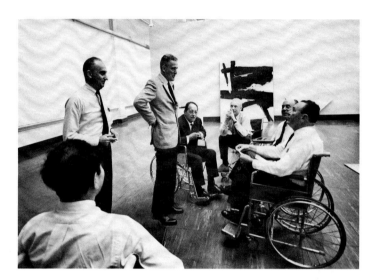

1961 Carnegie Prize Jury of Award. Left to right: Kenzo Okada (with back to camera), Leon Anthony Arkus, Gordon Bailey Washburn, Robert Giron, Lawrence Alloway, Seymour Knox, Daniel Catton Rich, with *Contrada* by Franz Kline in the background.

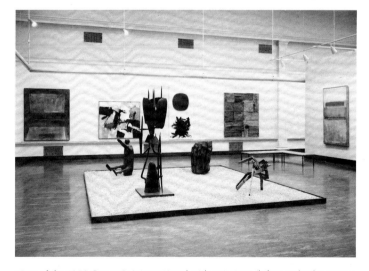

View of the 1958 Carnegie International with paintings (left to right) by Antoni Tapies (this work, *Painting,* won the Carnegie Prize and was acquired by the Museum of Art), Afro, Adolph Gottlieb, Alberto Burri, and Mark Rothko, and sculpture by Kenneth Armitage, Robert Muller, Etienne-Martin, and Eduardo Chillida.

America and Europe. For this reason we felt a special obligation to present a serious, broad, and noneccentric view.

We decided that the exhibition would be handled most effectively if the organizing curators were on the Carnegie Institute staff since a project of this scope and complexity required a full command of the museum's resources. At the same time, we recognized that our staff alone did not have sufficient experience and knowledge to conceptualize the exhibition and select the artists who would give it form. Our extensive series of discussions with American and European colleagues demonstrated to us how little communication there actually had been for many years between the two art worlds and—despite a shared tradition and a common set of issues that artists continued to address—how fascinatingly different these worlds were. Misunderstandings and hard feelings had grown up in the twenty years that Americans had largely neglected European art; and by the same token, while many Europeans seemed well informed about American art, they tended to view it from their own perspective, interpreting it in ways that frequently seemed very much off the mark to Americans.

We saw in these circumstances an opportunity for the Carnegie International to serve the purpose Andrew Carnegie had envisioned for it; that is, the advancement of international understanding. With this ideal in mind, along with our ambition to recruit the highest level of professional expertise, we approached three European and three American colleagues who represented diverse interests and positions, inviting them to serve as a working advisory committee and to share with us the responsibility for making the 1985 Carnegie International the first exhibition of its kind, in Europe or America, to be organized in recent years by a truly bilateral process.

What followed was a series of lively, pointed, cordial, informative, and productive deliberations that were extraordinary even beyond what might have been imagined. These experienced observers of the contemporary scene worked well together and with the curators, in part because of a common commitment to the idea of the exhibition and in part because—whatever other differences may have existed—we all shared an appreciation for both the visual and the conceptual aspects of art. This provided room to discuss a full range of issues, from matters of connoisseurship to philosophical positions on aesthetics and politics.

Working as a group, the committee and the curators began by defining the character of the exhibition; next the group discussed and settled on the artists to be invited; finally, we conceived the broad format that the catalogue would take. Although the curators are responsible for the choices of specific works shown, the group discussed the nature of artists' representations in advance, and in a number of instances a member of the advisory committee who had a special relationship with an artist participated in the actual selection process.

In our first meeting, held in Pittsburgh in November 1983, we discussed the differences in approach that, in general, have distinguished the American and European traditions for organizing large group exhibitions. In the broadest terms, American curators have tended historically to employ an empirical selection process that concentrates on the merits of individual artists and works of art without rigorous reference to a governing structure. European exhibition makers, on the other hand, have been more inclined to begin with a thesis that they then support in their choice of artists and art. In the extreme, the former method may be criticized for being mindless; the latter, for prepackaging artists and works of art for intellectual consumption. Although the advisory committee and curators resolved that the Carnegie International would not have a preconceived thesis, and that the artists would be invited to participate on the basis of rigorous standards of individual achievement, we also agreed it was critical to identify, in the exhibition catalogue, the significant positions in contemporary international art that these artists represented. This scheme would thus continue the tradition of the "empirical" American show but would also articulate, in the European manner, the issues and ideas that surround the work.

What followed this conceptualization was a most careful and exhaustive examination of the leading artists and tendencies in Europe and America, a discourse that continued in meetings of several days each in Eindhoven in March 1984 and Düsseldorf in October 1984. In most instances we worked by consensus, although one of the best aspects of our deliberations was the respect afforded, as it was most appropriate, to those most familiar with European or American artistic circumstances. In fact, in certain discussions we agreed that the strength of conviction of one contingent would be taken on faith by the other.

We decided early on that we would not attempt an exhibition that would include examples of every kind of work enjoying attention today. Instead we favored a concentration on those artists and tendencies we thought were most vital and resonant. We restricted the show to a relatively small number of artists (the original number was thirty, which grew inexorably to forty-two) so that we could show each one's work in some depth or scale, but this sometimes required difficult and unwelcome decisions. The focus of the exhibition is clearly upon the mature achievement of artists who, at midcareer, we believe to be among the major figures of our time. We virtually omitted the work of the artists who reached maturity in the 1940s and 1950s and, obversely, avoided a too-avid pursuit of the new, although a number of outstanding younger artists are represented. In our meetings we recognized that certain sensitive interests were either absent from or had limited representation on the list of invited artists. Hindsight has already suggested missed opportunities and inequities to all of us who were involved in the

selection process; but when we completed our work in October 1984, we felt, as a group, that our selection of artists was both credible and creditable.

In the process of selection we limited our consideration to artists whose work had received at least a certain amount of attention in America or Europe. Because of the relatively long time required to organize an exhibition of this sort, even those few artists who, at the time of our deliberation, were largely unknown on one side or the other of the Atlantic have since enjoyed acclaim for solo exhibitions or participation in important group shows. We suspect, as a result, that whatever astonishments the exhibition may hold will be found in the works of art themselves rather than in the presence of some heretofore unheralded figure. Likewise, the exhibition should not be expected to chart new directions. We made no effort in this regard, beginning instead with several principal convictions about the current state of affairs: that European art of the highest distinction, made over a considerable period, had been inadequately exhibited or understood in America; that new American and European art had not been seen together in conditions that endeavored to be sensitive to their cultural differences; that, following the turbulence of the late 1970s and the early 1980s, when new figurative and expressionist artistic modes vigorously sought and achieved acceptance in the eyes of the art world, the continuing vitality of minimal and conceptual art deserved to be recognized; and that an exhibition based on a rigorous assessment of contemporary artistic accomplishment would serve a useful, clarifying purpose.

The same criteria that led us to organize the 1985 International exhibition as a group effort also pertained to our plans for the associated publication. We wanted the catalogue to deal as broadly with artists, artistic tendencies, cultural situations, and issues of art criticism as we had in our meetings, but a powerful synthesis of this range of ideas seemed beyond a single individual's grasp. We agreed that the most positive alternative seemed to be to collect some of the most thoughtful and informative recent texts that bore on the art and artists represented in the exhibition and on the general state of the art world. The authors of the articles in this presentation did not have the exhibition in mind as they wrote (indeed, despite their generous permission to reprint their work, a number of the authors might not concur with the show's premises and contents), and so it was the assignment of the anthology's editors to select a group of texts that would, as a corpus, inform the exhibition.

The 1985 Carnegie International is dedicated above all to exploring the high ground of contemporary Western art and presenting a measured assessment of its complex circumstances. Yet the exhibition should also be seen as the forty-ninth edition in a long and continuing work-in-progress, a series whose future numbers will predictably reinforce our successes and correct our failures of judgment.

Anthology

Editors' Notes on Anthology Selections

Reading through articles by many European artists, critics, and exhibition organizers to make a selection for this catalogue of the Carnegie International, I realized once more that—on the level of information—the European art community, especially in Holland, is in a totally different situation from that of the Americans. Surrounded by Denmark, Germany, Belgium, France, and Italy, we have easy access to the many current developments in art and theory, for there is always an understandable language in which a given text is published. It is therefore important to Europeans that this catalogue is being published in the United States, for it will make some texts available to the American public that so far have been published only in German, Italian, Dutch, or Danish.

I have made a point of including critical articles that discuss the artists invited to participate in this show. Other artists' names will appear now and then because the movements which are discussed encompass a broader field than this show can cover. These selections are the ones that received the greatest attention or that offer a wide range of information about mainstream currents in the individual countries. More important, most of them were written by people who brought about these shifts in the art world by presenting or writing about new art. The dates of the essays' origins do not always coincide with the period in which the art was first shown, for in some cases an article written later gave a clearer view. Also, not all authors should be identified with the nations they seem to represent in these texts: some have also organized shows on American art; others seem now to have opted for a more Central European view.

As to the choice of the European artists' statements, most have been taken from catalogues and books, some are unknown, and a few were written for this occasion. Particular texts show how artists' thoughts can influence the writings of critics. In general I have selected the artists' statements either because they relate to the work those artists are now making or because they confront the critics' discussion about their work. The statements have been lifted out of their original context, but it is to be hoped that this has not rendered them less intelligible.

Saskia Bos

In reviewing the American critical literature for this anthology I tried to accomplish two things. First, I sought to illuminate the artistic directions most in evidence in the 1985 Carnegie International, selecting articles that dealt with narrative and expressionist figuration and with minimal and conceptual art. Although there is a large, growing body of writing on various aspects of new figurative art, this search reminded me that lively developments in minimal and conceptual art are currently receiving relatively little critical attention.

My second aim was to include writings that would characterize the general situation of art in a postmodern era, especially essays that would delineate the problem of defining postmodernism. One aspect of the problem, for example, is the attempt to forge a new critical approach that will inform the art of the eighties as formalist criticism informed the art of the forties and fifties. Thus far, the critical trend that has developed an internal dialogue and an identifiable body of writing has as its analytic foundation the aesthetic theories of the French structuralists and deconstructivists and the humanistic Marxism of the Frankfurt School. It would not be accurate, however, to imply any consensus in informed circles about the definition of postmodernism, the appropriate way for a critic to address today's art, or the relative significance of the various theoretical and stylistic directions now being pursued by artists.

John R. Lane

A Letter from Charkov

Rudi H. Fuchs

Charkov, January 26, 2017

Dear D:

Yesterday evening, around eight o'clock, I arrived here after a long train ride through the Ukraine in the snow. A cold, sharp wind blew over the frozen plain. In the compartment, even though it was first class with its comfortable armchairs (which still exist here), it was also cold. No technological progress seems to be able to prevent that. Shivering, I had to think about the warm, greasy cabbage soup which Chekhov ate on this stretch, traveling to the south, and what he wistfully and pleasurably spoke about. The wind blew from the east, and so, unbroken and frozen, it should just about hit at the Prinzen-dorf Castle, on the west side of this plain, where, as you'll remember, the old Nitsch lived, and which now houses a museum dedicated to his great O. M. Theater. I still remember that in the summer of 1993 he finally succeeded in realizing the six-day-extravaganza, a breathtaking and heartwarming, unusually peaceful gathering. Thousands of people came from all over the world. That many people only attended pop festivals, the way they were organized in the 70s of the last century, or went to the Wagner-Festspiele in Bayreuth—and that hasn't happened since the theater burned down twelve years ago.

I would love to have eaten cabbage soup at the station in Charkov, but the self-service restaurant, a thing made of aluminum and plexiglas, where it always (yes, still) smells like burned grease, was closed. The Odessa Hotel, where I'd booked in advance, was across from the station. Thank God it was warm there. I could only get some reheated special in the restaurant, as they were also clos-ing. The waiter muttered something about the unions. It seemed like England thirty years ago. But the old lady who managed my floor was still there, a real institution, like the shoe-shiners in Cairo, and she gave me a glass of tea. In bed, I read some more of Chekhov's letters, which accompany me on this trip.

The next morning, I took a taxi to my friend R.'s studio. Fresh snow had fallen during the night, but now the sun was shining, and the city, even the factories, were glittering. At the stately public university building which, by the way, is now a bit old-fashioned looking (it was designed in 1990 by the then world famous Italian architect, Rossi), people had already begun with the extensive deco-rations for the one hundred year anniversary of the Revolution fes-tivities, which will be celebrated later this year—among other things, so I read a few days ago in the Kiev *Daily Times,* with the perfor-mance on Red Square of a new Russian opera by Joseph Beuys, whose performances you'll still remember. Here, in Charkov, this opera will be broadcast live on TV, as well as in many other big cities throughout the world—New York, Amsterdam, Oslo, Nairobi, where not?

R. lives on the outskirts of the city in a low wooden house with a veranda, in a small park. He lives there alone, since his wife ran off a few years ago with a young poet from Sebastopol. Regardless of this,

I found him in radiant health. Although I hadn't seen him in a long time I'd read about him a lot, as he's had much success in the last years, and we toasted our reunion with a glass of vodka. He had the best kind in stock, Polish. Afterward, he invited me into his studio, a spacious and totally white room—the way studios were in the 80s (also yours, as I recall). It's remarkable that this style is coming back in style now in Russia; maybe it has to do with the fact that Malevich's paintings are now, since about the last fifteen years, allowed to be viewed. The great Moscow exhibition in 2004 was extremely impor-tant for Russian art. This can also clearly be seen in my friend R.'s work now. Not so very long ago he made elegant, wide landscape photographs which were then painted on, here and there. His new work is more abstract, white and light gray snow landscapes with, to put it one way, horizons which pass through each other. I don't really know if R. is a good artist—but I value his great seriousness. It must not be easy, in a city like Charkov. Naturally, real city-centers like there used to be (though, in our day there also weren't many left) don't exist anymore. The modern communications systems send out every new item to the whole world; even the Russian TV station is connected to the international system: actually, it's a miracle that books still exist. But in the midst of all this technology, which, by the way, I'm only slightly interested in, the artist has remained a crafts-man: an almost prehistoric figure, somehow comic and tragic, like the clowns from the former city circus in Moscow. The information flash-ing across the pulsing screen isn't enough for him; he needs the smell of things and the physical sensations. R. really suffers from this, just like me, by the way, and because of this we quickly succumbed to reminiscing. Over lunch in a nearby restaurant (hearty borscht fol-lowed by peppery black sausages, tomatoes and dark bread) R. told of a trip he took to Turin in 1984. He was thirty-seven then, and was permitted to work in a foreign country for three months; he was a good communist. (That's all different now.) He chose Italy because he had once seen paintings by Renato Guttuso and had admired their warmth. He lived in the Pensione Europa in Turin, on the corner of Piazza Reale and via Roma, where the elegant fashion stores made him feel restless, in his eastern European clothes. From his high, sparse room, he looked out over the former palace. Sometimes, in the evening, the chandeliers were burning behind the windows—a party that you saw from a distance (even though no king had lived there for a long time)—and then he had to think about the lights shining behind the windows in the foyer of the Bolshoi Theater; as a student in Moscow he'd been there many times, walking past with a vague longing. By the way, the old center of Turin was, in the eve-nings, totally an opera décor, with its majestic architecture, the gal-leries, and the old-fashioned spherical lanterns on their cast-iron poles—certainly when there was a thin mist hanging in the air, as was often the case in winter. After a couple of weeks, he met a few artists, Mario Merz and Giulio Paolini, who took him out to eat once in a while in cheery, boisterous restaurants. Exactly four weeks after his arrival (it was just before Christmas) he ate "risotto ai truffi"; to

this day, he said, he can still remember the taste. He learned from his Italian friends that art doesn't only have to do with commissioned work, but that it is also related to enjoyment and absolute quality and that, for an artist, the best foods and the best wines are still not good enough. Life in Turin, naturally, brought him in conflict with his Russian morals and he also didn't understand Guttuso's fat, robust women very well anymore. Much later, back in Charkov, he read something in a magazine about Edvard Munch in Paris, fresh from the barren northern province, and about his despair in the midst of the vulgarities of the big city, the cabarets and bordellos with mirrors and chandeliers, perhaps like in the foyer of the Bolshoi Theater: maybe he had felt this way in Turin. In any case, art changed for him in Turin, from rest and dedication to nervous restlessness. He could barely make anything, only drawings, in fact, of street lanterns in the night and once, a big one of a man with wild gray hair, singing in front of the lighted door of the Victoria Restaurant; that was, like a Falstaff in the mist, Mario Merz. He remembered that evening well. There was a large group of them and they'd had a lot to drink—the empty bottles stood on the middle of the table, like a monument. As always, the Italians spoke about the "situation"; by this they meant the restless and cynical retailing of young artists, which had become a wide-spread practice in those years. Because of this, the seriousness and the stability of art had been disturbed, and that was, they repeatedly swore to one another, "molto pericoloso." That evening a stranger was present, an artist from Rome, actually a Greek, whose name was Kounellis. He was accompanied by his thin French wife, who continuously was calming him down in his anger. He ran into them the next day, in a café near his pensione, where they were having breakfast. They got into a conversation, and he had the feeling that he'd met someone who was troubled by restlessness just as much as he was. Another Munch, displaced and somewhat lost in the set from one of Verdi's operas. Perhaps this was because Kounellis, like R. himself, not only was dealing with a historical break (in other words, between the old world now very far in the past and the new, in which the artist was, anyhow, a half-vagabond, an unfortunate minstrel), but also was dealing with a cultural break. From Orthodox Europe he landed in Catholicism, where everything has to do with the GLORIA. In contrast, we, with our historical background in culture and religion, contemplate suffering. Perhaps that was also the Russian problem, R. said; anyway, he'd thought about it like that. In Russia, communism had also introduced the GLORIA, and that continued to conflict with the nature of the people and landscape. For my generation in any case, he added. The GLORIA calls for boisterous movement—but Malevich himself had continued to paint icons, even if an angle was shifted once in a while, suggesting a bit of movement. That was also Kounellis's problem, he said. How do you paint an icon which nevertheless has the "Schwung" of the Baroque? In fact, it's impossible, because an icon, just like a painting by Malevich, is closed and without space. I also think, he said, that it

was because of this that Malevich had difficulties with the Revolution (or the Revolution with him)—not because he was too progressive or went too fast, but because in his being, in the soul of his work, he was old-fashioned. After the borscht and the sausage, we started in on the vodka. You know, he said, you from the north have never known this problem. That's why, back then and perhaps still today, you all dismissed such discussions as romantic. I understand that. In your art, the order has always been transparent. When I was in Turin those few months, I went to Amsterdam one time. I could get a ride in Kounellis's car; he had to be in a city in Holland, Eindhoven. In Amsterdam I met the artist Jan Dibbets (I don't know if you know him personally), and I stayed in his house for a few days and also looked at his work in his studio for a long time. You saw my work this morning, and you will have noticed that the memories of Dibbets's panoramas still play a role in them. But it isn't plagiarism; in fact, that's impossible after so many years. I still remember that Dibbets took me to a museum where paintings by Mondrian were hanging. At that time, in Russia, they were totally unknown; now they can also be exhibited here. Mondrian's paintings were a great shock for me. I saw that they were orderly, controlled, and firm—and, at the same time, completely different than those by our Malevich. Malevich's lacked the space which could breathe freely in Mondrian's paintings. In that space everything could move in every conceivable direction, like a cloud can float and turn in a tight blue sky while the sky remains firm. I had never seen anything like that, not even in Italy, because even the Baroque paintings there didn't have the spaciousness that Mondrian's had.

You can imagine that I was deeply moved by my visit with R. and by the conversation in the restaurant, and also later in the studio with apples and vodka (what a perfect old Russian combination). I hadn't seen him in a long time and I was happy that, in spite of the nostalgia (which I, anyway, can only value as positive because it sharpens the memory), it was going well with him. The next day we went to have a look in the small museum in Charkov: especially at the three rooms where R. will set up an exhibition of his work, three months from now. In a small room, dedicated to western art, there hung a drawing by Kounellis and a small piece by Dibbets—both donated by R. Afterward he took me to the train. I had to go on toward Odessa, from where I will write to you. On the platform, he pushed a well-thumbed book into my hand. "I got this during that time with Kounellis," he said, "I don't know if you know it." It was an Italian edition of Mandelstam's *Viaggio in Armenia*. I didn't say that I had already read it. "When I got it," he said, "it was forbidden in Russia. It is still forbidden today. It's about an artist who seeks his escape in the imagining of a journey. I don't need it now, because I believe, in the end, that I am at home in Charkov." I embraced him. Adieu.

"Een brief uit Charkov" by Rudi H. Fuchs. Reprinted from *FODOR* (March/April 1984): 33–35. Translated by Carol V. Bloom. Used by permission.

Homily

Jannis Kounellis

There is yellow in Malevič's white, because the memory of gold is behind it.

The dramatic quality that exists in our work (and yet, one sees the tension of the square)—exists, because Laochoon's memory is alive.

Malevič's lay orthodoxy.
Space as notion of the endless.
Dogma as composing order.
The hermit as antagonist.
Grief, as path to purity.
The absence of Purgatory in the concept of the square.

The conquest of freedom as research of reality and of the borders of a culture.
The limit of the metre.
The transgression of faith.
The prospects of ethics and the metre as justice.
Return of the People and formal invention.
Form as dignity and as meeting point.
Form as power and as opposition.
Pragmatism as oppression and as reality.
Centrality and the Wanderer.
The concept of heresy and intellectual dignity versus conformity.
The relationship between military power and formal credibility.
The centrality of a humanistic text in a society that caters to seriality.
The great philosophical legacy and the plain history of a drab colour.

The impassionate truth represented by a community.
Battle as history.
Advance as history.
People as history.
Why I, like a partisan of Enlightenment, defend the rights of the divine.
Melancholy as a proposal.
Melancholy as a historically recognized trend.
The ideology of perspective.
The point, where Gods and men have the same interests.
Knowledge (i.e.: ac-knowledge) multiplies contradictions: why, then, have many who recognize themselves in Enlightenment suppressed contradictions in their formal experience?
Let us talk straight: we are great, we just must formalize a proposal in a small space; but we know that it is historically almost impossible—whence, then, does credibility grow?
Credibility is born out of the mastering of the source; I can, then, be serene.
I am ideologically defined, *ergo*, I expect; who confers me this authority?

Crossing contradictions and passages leads to the consciousness of the limit, and from the knowledge of the limit, the concept of authority is born.
The concept of tyranny and the history of a calibrated point in space.
The imperative of tyranny as the last outpost of the just.
The apology of tyranny as unrenounceable ideal.
Totality as idea of the infinite, of the

sublime, and totality as unmistakable presence, is the minimal distance for a titanic dialogue.
The border between heresy and faith.
Heretic as progressive.
Heresy as discussion level.
Finally, one re-lives that time, when the heretic is not in line.

One must acknowledge the attraction of litanies.
One must grant pre-revolutionary Russian realities (including pilgrims and theophobiacs) a great cultural vitality. This vitality was a plausible prop for structuralism, and we miss it, today. The square, deprived of its basic idea, has lost its charm.

A stylistic coherence is not enough to confer credibility.

The concept of laity has nothing to do with the domain of pragmatism.

Centralism has a liberating, synthesizing meaning, when it amply embraces and yields.

Between one logic and another, there are hills, oceans, and abyss.

By and large, I defend my logic.

The only possible mediation is the linguistic concreteness of a work.

The extreme as ground for discussion.

And all this, in order to say that all which Donald Judd affirms in his essay—of course, we agree here and there—reveals the old fallacies of some American painters. Actually, if one does not understand the grass-root motivations and the historical authenticity of a given form, one looks at the works as at purely formal, metric data. This does not mean that a certain pictorial experience might not have had a dignified birth, a dignified re-emergence and a sudden fall.

Rome, December 1984

"Homily" by Jannis Kounellis. Reprinted from *AEIUO* (January 1985): 65–67. Translated by R.M. (The English translation of Kounellis's text is the result of a conversation between the artist and the translator and is not a literal translation of the original text.) Used by permission.

The Italian Experience

Germano Celant

Between 1952 and 1963 Italy experienced an industrial and economic prosperity of such magnitude that one refers to it as the "miracle." It was the decade of unrestrained development, and the aim of the Italian economic miracle was an American-style consumption. Italy's retarded development was revitalized through a boom in technology. In the cultural sphere this was expressed in a kind of "attitude of optimistic planning." The sources of the boom lay in planning and consumption, and its further development occurred through the interdisciplinary cooperation of political and intellectual forces. For a brief sequence of years, the sudden prosperity was maintained not only by international capitalism, but also by theories whose goals were the transformation of Italian society into a functioning part of the *world factory.* On this plane of glorification of industrial systems the most important theorists of art also moved (in this way art too experienced the "Sisyphus-effect" of technological expansion and industrial planning). Technological-industrial progress stimulated Italian postwar art to operate in a manner that excluded any subjective-personal action in favor of an alleged humanistic, admittedly illusory, consumption-oriented future (it was in the climate of de-stalinization and of postexistentialism, whose downfall coincided with the questioning of informal subjectivism). It was the age of *positivism* and the cooperation between intellect and industry (macro examples: the efforts of Olivetti and Italsider to give themselves a cultural image).

Design improved the value of all intellectual creations by stylizing each visual, publishable, political, or literary product into a luxury item. All production factors were tailored toward *appearances:* the language became mute, and art returned to its point of origin by reducing personal themes based on individual experience. Instead, the neutral, expressionless reality, which was influential within the applied language system, gained in importance. Attention was shifted to "minute units." A *tabula rasa* of signs and colors resulted that was bound up with a search for their primary meaning. Since the myths of the *other* (in East and West) had failed as a locus of social and political utopia, they no longer were prerequisites for intellectual action. Postulates were discussed anew, since all became uncertain and disobliging. The illusion of a real culture diminished to the degree to which it became clear that its purpose was merely to provide consolation for the inhumanity of society. One became increasingly conscious of the fact that the role of culture was one of glorifying the power structure. In this double play of progress and regress, of economic miracle and critical awareness, culture occupied the exact center: culture could not speak of liberation because it would strengthen the status quo, neither could it bring about a break, since the aesthetic reality was identical and synonymous with commercial products. This tension always became especially apparent when art confined itself to internal communication and hit upon an empirical solution. Artistic work did not at all reinforce the offer of hope and consolation, but "specified itself through that which separated it from the elements from which its development originated: its laws of motion were its formal laws" (Adorno). This

resulted in a process of recognition that concerned the basic realities of the artistic experience. Through these indiscriminate, reduced entities one perceived that dissonance which led not to personal solutions, but rather to a pluralistic coexistence. Extreme self-reliance, also in the area of speech, was clearly the highest degree of isolation and a rejection of any belief in the other. This action touched upon the bounds of the metaphysical. Nevertheless, in certain cases it lent to the instruments of logic the possibility of following dialectically opposed paths and of negating the compensatory, harmonizing moment of art in the face of tragedy, as represented by reality. The *negated* was thus used to examine the elements of speech. Thus the humanistic ideology, which supported the analysis and development of industrial positivism, was always then able to turn negative, when it proceeded from bourgeois uncertainty into the process of social practice, in which man sensed the need to objectify his instruments of action and his state of isolation. In opposition to the cognitive theoretical viewpoint thus stood situation related behavior. Both believed in a reconciliation between art and society and therefore hoped that individual talents could constructively form and critically correct the domain of "culture." One phenomenon strengthened the cognitive and research value of an art whose function lay in utopian, fantastic inquiry. The other phenomenon explicitly declared its alien character and renounced any fulfillment of duties so that it might constantly have the opportunity to present itself in contradictory harmony with the situation of the moment. In Italy these polarities were identified in literature with Calvino and Pasolini, in art with Lo Savio and Manzoni.

Pasolini and Manzoni developed a critical position vis à vis the cultural situation of the 50s. Both decided in favor of that which bourgeois propriety and order rejected and banned to the ghetto. Both tended toward psychological projections that occupied the space between the sadistic-anal and the primitive-wild and excluded any kind of humanity and prospect for salvation. Art and poetry expressed the *deviant,* as much so as possible, and the biological. Their locus of expression was *bodily passion* as refuge for the outcasts and the excluded. Thus there was no unequivocal basis (from zero to the anarchic infinite of art and poetry): communication was reduced to lower forms and matter, which belonged to the periphery of personal and social life.

In contrast to this *common* view stood the illusion of a constructive if not utopian practice that believed in a positive venture of the mind. One desired construction without destruction and an application of the insights offered by science and technology. In the climate of *reform,* objectivity became a neutral filter between literature/art and reality. This intellectual engagement served to establish connections between isolated areas rather than to expose repressive and reactionary structures. Calvino as well as Lo Savio operated under the illusion that logical action was harmonious with the artistic. Both acknowledged a utopia and morality and believed the intellect would bring forth constructions in the positive sense. They were interested in the philosophy of writing and seeing. The protagonist

was then no longer a physical being, but a "noble knight" who utilized the artificiality and neutrality of a fable or an architecture in order to create an abstract, immaterial context of crystalline, infinitely reproducible beings and spaces.

The "spiritual sensuality" of the transparent, faceted, reflective crystal signified a renunciation of the physical world of corporeal sensuality; that is, it separated knowledge from taste and common sense. With the introduction of pure, crystalline elements, art began to exclude everyday experiences (which it would only take up again at the end of the 60s). Art was transformed from an instrument that satisfied *needs* into a scientifically controlled instrument of knowledge. Consequently, logical mathematical statements and formulations grew in significance. They were typically purely visual and kinetic inquiries, as for example those by Castellani or Colombo, who put pictures and forms into a new order. The important themes of society and the individual, like political action and self-expression, became secondary. Instead one received insights, until now unknown, into the microcosm and into the totality of art. Art became *self-reflexive*. It no longer tended toward imitation but became a linguistic reference texture. The emphasis was on work dealing with inquiring into the "art" system, which found in Paolini a brilliant and consistent analyst. These artists took as their point of departure raw data with which they were occupied in order to free it from a large part of the content overload of previous cultural periods. The questions became basic: what do the size of the picture, color, canvas, wall, surrounding space, content, etc. mean. The answers were complex because the language of pictorial signs was a "goal directed system of expressive means" (Jakobson). But what place in the hierarchy of values do goal and system have? It would help to know (or rediscover) as did Paolini the coherent and organized totality of the aesthetic instruments and means of expression. These events, which ran parallel in Italy to the dissemination of linguistic-structural semiotic texts (one needs only to be reminded of De Mauro and Eco), were to articulate the reciprocal relationship (for Paolini the total equivalence) between signifier and signified or, in old Marxist terminology, between structure and superstructure. Closely examined, these investigations appropriated from the domain of art a philosophical area that represented a new position vis à vis the meaning of the object "art." Thus arose an *art of theory*, which in the form of pure conceptual art declared all forms of expressiveness to be inappropriate.

Of course expressiveness was not so easily eliminated, and thus also in the early 60s a few artists, Kounellis and Fabro among them, turned against the increasing superficiality and neutralization of the language. Kounellis sought a reference to his own history and to the classics. He did not, however, refer to rural archaism or to the subproletariat (the reigning climate still was that of Pasolini's and Fellini's Rome), but to the Greek high and folk cultures, which he considered the objective basis and foundation of Italian art. It was, therefore, an inquiry using different sources, which not only called to mind a bygone culture effectively displaced and buried under the power of the capitalistic technology of consumption, but which also conjured up a constant structural reference to events and pictures of *poetic* origin. It was daring, because it turned against conventions and against inquiries into anonymous, reduced signs. The study of the classical, at the historical moment of the development and inflation of the mass media, which attributed definitive meaning to information, represented an unequivocal, ideological, anti-institutional position. This process, also used by Fabro, tended to question integrative values, so that the work of art was converted into a constant *transformation* of the prevailing linguistic codes and constructions. The violation of the norm turned Fabro's work into an ever *present* art in the sense that it used a strategy that deviated from the homogeneous system of artistic communication. In doing so, it was important to recognize how each work diverged from the norm, so that it would not attain a fixed, unilateral definition.

This anarchistic aspect, which threatened to take the language apart, stood in decided opposition to positive, bourgeois ideology. The portents were of destruction, so that in literature Group '63 (to which belonged among others Sanguinetti, Porta, Belestrini, Eco, Pagliarani, Guglielmi, and Giuliani) made a "retreat into disorder" the basis for their own critical work.

Thus within the partiality of political, cultural, artistic, and literary institutions a locus of unrest arose which within a few years erupted in the entire system. The effects are still felt today, even in the assimilation of contradictory historical instances, as for example reaching back to the avant-garde of Dada and Futurism or the reference to the surrealist connection of Freud and Marx. In any event, this attack on the prevailing hierarchy took shape just at the time when the society could be characterized as a *cultural industry*, that is, as the social production of communication, determined by mass media.

Indeed we experienced at the beginning of the 60s the "world community of McLuhan," in which the media-created "community" was nothing other than human totality universalized by private and state capitalism. But contrary to McLuhan's assertions, this totality apparently was not positive. It arose from the relationship of production and consumption, so that a correspondence could arise between aesthetic value and merchandise, as was shown by the pop artists, among them Mario Schifano. In an apocalyptic but close to realistic view of things, the phenomena of imperialism became the subject of art—Coca-Cola, dollar, state controlled television, and electric chair. Art could only reproduce industrialized nature. At this point merchandise was triumphant, at this point the picture became mechanical. In this art, the human quality was no longer primary but secondary, so that any conception of a bourgeois humanism had to come to naught. Instead there arose not only a fugitive, but, as in the memoirs of Pistoletto, a reversed communication between human beings and the media. Our picture *revealed* itself when the technologically determined society was perceived as human and nature as artificial. Mechanics and biology became equal, as real picture and as enacted figure. In pop art the correspondence between human

and inhuman, natural and unnatural, served as a consistent critique of bourgeois enlightenment. The latter still tried to assert the priority of the individual over technological advances, while in the current capitalistic society the relationship was actually exactly the reverse. To that extent the humanistic point of view falsified reality, specifically in the direction of the rulers. Nothing was able to provide a guarantee against the industry of culture, not even art or poetry. Because in both the restoration manifested itself: it projected itself in its instruments and lived the myth of liberty and creativity, in which slavery and alienation have apparently been abolished. Out of this situation arose in 1966 the necessity of a critical stance. Its goal was to do away with the false alternatives between positive (art) and negative culture, between the elite and the masses, between the personal and the universal, between private and state capital, because such alternatives hid the actual ideologies (and the false consciousness) of power.

In 1966 Italy, like the rest of the world, experienced the (Maoist) *cultural revolution,* the revolt against the institutions which emanated from the underground student movement and the extra-parliamentary forces. To be sure this was only the year of the genesis of the revolt; it reached its peak two years later, but already a lasting revolutionary process was developing for which the system represented a strife-torn whole, which one constantly had to oppose with the revolutionary subject. Mao himself defined it thus: "In the great proletarian cultural revolution the masses can only free themselves, and one may in no case act in their place." Thus the invitation was issued to decide for oneself and therewith to *determine for oneself* action and theory. The universal, still hidden intolerance of imperialistic (i.e., in Algeria and Vietnam) or institutional oppression, as well as the rejection of pleasure and individual notions of desire, turned into an open protest against all "paper tigers." Dogmas and utopia failed: Marxist theory, the teachings of Freud, patriarchy, bureaucracy, and of course American as well as Soviet imperialism were questioned. The young of the "movement" overwhelmed the cities; the subject of world revolution was sociologically and historically determined *on the street.* One felt the need, in line with the anarchist principle of self-organization, to act en masse or in groups. "Potere Operaio" and "Lotta Continua" as well as the nonviolent revolt of the hippy culture strove for a liberation of the senses and the building up of political self-determination in accordance with the finding of the socially and aesthetically new. (Slogan: "Je prends mes désirs pour la réalité car je crois en la réalité de mes désirs: la culture est l'inversion de la vie" = "Ich sehe meine Wünsche als Realität an, denn ich glaube an die Realität der Wünsche: die Kultur ist die Umkehrung des Lebens" = "I see my desires as reality because I believe in the reality of my desires: culture is the inversion of life.") Here too the undertaking was negative, because the *negated subject* became the center (Lacan), that is, the social human being as consequence of the repressions to which it was subjected throughout its lifetime.

Archetypal needs of libidinous fantasies either liberated or submerged in crisis were again generated in art by the negated and by notions of desire. Likewise, the area of aesthetics comprised in its inclusiveness and in its illusion of linguistic coherence a kind of oppression and rejection of everything sensual. The determining factor lay in the reification of the subject. For the subject withdrew from itself, and thus began the mechanism which led to the terrible situation of negation. The new groups, among them "Arte Povera," therefore demanded the satisfaction of needs and desires. Productions, which would adapt to the totality of the negated, were replaced by the satisfaction of desires and impulses (the "Oggetti in meno" of Pistoletto) and the desire to experience and revive one's own body as a natural system according to a libidinous practice that included all threads of the basic elements (Pascali and Kounellis).

Empirical science again achieved importance. It attempted the integration of disparate practices without excluding certain methods or materials. The natural being, the activities of the senses, were valued again as the origin of symbols. A physical attitude arose that, according to Levi-Strauss, joined culture and nature.

Thus Mario Merz, Zorio, Penone, Anselmo, and Marisa Merz tried to make intelligible the sensuous nature of the liberating states of ecstasy and illusion of the industrialized nomads. They trusted in the dream and myth structures of Italian and European cultures, which proceeded independently from the technological and industrial exigencies. They rather propagated the nomadic style and work based on the situation: as well as self-determination in view of their own forms of expression—things that belong to the self-awareness of the poor (as for example Beuys who worked with students and others to liberate the meaning of truth, from whom the bourgeoisie kept and disallowed even the "poor" materials because they were sensuous, organic gestures). The unbroken totality was broken open, and *unlimited material* presented itself into which everyone was free to incorporate his own desires. Artistic discussion in Italy, on account of "Arte Povera," turned into a melting pot and was subjected to a dethroning to the extent that it became possible to use materials and symbols from any context whatsoever. That meant accessibility and extreme iconoclasm: thus inclusion of foreign elements and of images believed to be archaic, which had been taken from the everyday and from nature. Matter *turned into motion,* barriers were removed. A new area of expression began and its contours were indefinable.

Naturally one could object that advancing against fixed formulas by destroying or stretching of their elements and by emphasizing their independence (Fabro speaks of tautology) also changed the meaning of concept and theory. Perhaps the theoretical systems really did achieve, on the basis of literature and Louis Althusser, their own reality, making artistic practice appear to be the production of theory. The concept and its formulation thus became *observable.* Theory turned into practice, into the producer of reality. In Paolini, Boetti, De Dominicis, and Zaza the conceptual actualities were not only intellectual activities—and thus traceable to the humanistic license of the subject, to recreate and mirror reality—but were also practical exercises insofar as they were "theories" for pictures into which were assimilated social reality and verisimilitude of

the fundamental material of "art." Apparently these artists did not have the tendency, as did the American conceptual artists, to assume that all theoretical problems in the area of technology and politics were solvable with the help of the kind of logic that at the same time acts as the instrument of capitalist production. Rather they stuck to an anthropological view whose origins are found in the negated subject of a Southern European (Zaza) or a metaphysical culture (De Dominicis)—or in the alteration and expansion of consciousness, in which geography and sensuality again played a role (Boetti). In any case, the purely conceptual was felt to mask the anthropological context and was therefore rejected. What was valued instead was the search for a cultural, mind-body arrangement, where the interdisciplinary connections dealing with the *lived,* joined together.

One can say that the artists' generation of 1968 tended toward *antilogical* products/results with the intention of deconstructing the strict encodings of art. It believed in the lasting effect of the elements and caused a chain reaction: it attacked inorganically separated structures of the "art" context and even destroyed them, thus making it impossible to return to the condition of the old pattern. The intrusion of quite different and contrary forms of expression— for example, video, Polaroid, diagrams, sound tapes, photography— caused a *strangeness* in the pattern of thinking and exploration. At the same time this violent development forced the group of involved artists increasingly into a socially marginal group, into a group of uncertain social consequence. In Italy this phenomenon declared itself in the general defense of everything orthodox. It is understandable that the questioning of secure values and certainties led to a reaction of the traditional, conservative instruments; after 1969 these became increasingly evident. In the social-political arena the reactionary restoration provoked assassinations and strikes upon banks, trains, and institutions. At the same time private capital consolidated its position in order to reestablish its authority over the restless working class.

The sobered commercial world responded massively, not simply in the artistic, but also in the general cultural sphere, with all means available to the industry of culture. In this industry, the producers themselves formed a small minority, which represented a highly variable share of the total system of economic exchange. Instead of being supported, art was driven into an inflation: even the artists themselves did not succeed in maintaining their distance. The forces which supported this development were so effective that within a few years the market boom succeeded in leveling artistic expression by making all products similar and indistinguishable. This caused art to have, so to speak, a weak pulse and difficulty in breathing. A terminology derived from the economy and the market place was used in the critical evaluation of art. In 1972 dreams and actions entered a tragic situation with respect to their financial sources: crisis and flight of capital were responsible for the diminished interest in art as intellectual activity. Philosophy and poetry on the other hand experienced a flowering and also influenced the artistic production of the 70s. Texts by Deleuze and Guattari were being translated,

Foucault was being debated, and Barthes was shuffling the cards of Italian criticism and sociology. Under the anti-psychiatric influence and the critical engagements of the "Nouveaux Philosophes" even the charlatanism of the market softened: one returned to an antagonistic position doubtful of its social condition. Since the mechanics of the aggrandizement of the status quo ceased to function, intellectuals like Bartoli, Bonfiglioli, or Borini led a united fight for the negation of the existing situation, which corresponds to the actions of "Autonomia" and "Brigate Revoluzionarie (Rosse)" on the street. The aim no longer was reform. One desired to attack the religious (from God to "Democrazia Cristiana") and moderate forces (from the socialist to the communist party). As the social structures were unable to resolve the differences, this was done by those *excluded from society:* the extraparliamentary, feminist, or homosexual groups. They created *different* realities; that is, those demanded by a generation that felt the inadequacy of social promises and that longed for direct, existential experiences. They finally recognized the emptiness, the invalidity of the guarantees provided by the fathers and politicians; *they wanted everything.* Cities were conquered, the wealthy were dispossessed, never realized wishes were finally to be fulfilled.

The break with the ideological and social hierarchy was no longer hidden, neither was it embellished by religion or politics. The *autonomy* which declared everything to be inadequate and untenable was emphasized. They hurled themselves into chaos without misgivings. After the futile victory of the communists ("PCI") in June of 1976, the conflict finally ended "happily" in 1977 with the "city Indians" on the streets of Rome and Bologna and with the communications of "Radio Alice."

While the opposition against everything that *dominates*—from the head to the phallus—grew, what was sought as a remedy against this leveling effect was something common to all who are disenchanted: personal experience and autonomy of expression. As a consequence of people's preoccupation with themselves, they tended to free themselves of their inhibitions. In connection with this there evolved an art of *minorities,* which was new insofar as it made no universal and abstract statements; yet at the same time it was widely distributed because minorities exist everywhere. With this fundamental extension whereby the individual outsider represents the whole, they codified the prohibitions and repressions they had suffered, which now—externalized and made public—functioned as mechanisms of liberation and as an expression of the existential. There was no control through standardizations, no longer a tendency toward *exclusion.* On the contrary, everyone felt compelled to create an (art)work that would give him satisfaction without being committed to one particular formula. Togetherness would mean supervision. It would enable the institutions to co-opt the marginal groups and thus also the artists. For this reason, toward the end of the 70s the dissolution of the "group" in all areas of expression was accelerated. In its place came the existential readiness of the private, sexual *individual.* Culture could no longer be maintained by a com-

mon avant-garde ceremony; the opposite was true, and the concept of the "new avant-garde" dissolved. They went to the most extreme point of an intimate play; yes, one even went *back* to the autobiography of feelings, which seized on the moods of the soul and was supposed to make lyrical portraits manifest. No longer was the power of objects and concepts emphasized, which had been the determining factor in certain cases: land art, conceptual art, body art, etc. Rather one staged the breaking of fetters and *entanglements,* which in each one of us is the cause for the conflict between subject and object. The anti-hero replaced the hero and his arrogant, unbounded stage appearance.

The artist of the 70s, in fact, sensed the internal drama of the polyphonic ego and so no longer cared for the outward, public or political act. For him the world had already fallen, and the only salvation existed in the eccentric position of the inner self. The revolution was sought in a childlike language and in a *miniature space.* In this sense even artists like Bagnoli, Clemente, and De Maria seemed no longer interested in art as code and message to others, but rather solely in that which they themselves could gain from the art. Following a decade of exhaustion and consumption of materials and of forms of expression which simultaneously had excluded everything emotional, these artists were once again attracted to mysterious personal impulses. In their eyes dematerialization and the turning toward the poor represented the loss of the inner self. On the contrary there should be a process of *intensification,* aimed not at the exterior toward expansion, but rather at the interior. Without paying attention to the who and the where, the ego is understood by these artists as the sole audience; the works—as satisfaction of the ego—became autoerotic and in their way often so intimate that one could carry them in one's pocket. While art had again acknowledged pleasure, the number of "masturbatory figures" increased. The passion of the inner registers and the acknowledgment of one's personal history with reference to myths and legends burst forth anew. Everything took place on the threshold of the miraculous, and the works appeared to be settled at undecipherable crosspoints, but always at the center of the personal. This self-establishment in the whirlwind of the private made possible a multiplicity of directions, which strove to exclude all plans and predictions. The tendency was toward the unspeakable and unique, and therefore to an ambiguity within the work, which no longer pointed to a homogeneous goal-directed code. The works of Chia, Cucchi, Paladino, Rabito, and Bartolini thus appear as energetic pictures that filter the impulses between heart and hand. The exterior figure lies outside of every definition, for it neither has noun nor adjective. Even if it should prove to be a mirage, the ascertainable value lies alone in the intensity with which

is revived and reinvented just that which was destroyed in the 60s: the "sacred" element of creativity.

Pencil and watercolor thus return in order to produce drawings/symbols from the center of the ego, which are theatrical and metaphorical. It is the transition from the body into symbol, from person into figure, that creates out of a sheet (of paper) a second skin. The surface becomes a memory trace and the remains of it are the libidinous, sensuous forces of these artists. They *transfer* themselves onto paper, on which every personal fantastic event takes on the form of another sketch. The hand stands behind the symbol and executes it while attempting to forget conceptual metaphysics and bodily superphysics. Here is no longer the tactile formulation of the "Arte Povera" artists or the adroit verbal attack of the conceptual artists, but the intensive silence of charade and puzzle, whose meaning remains obscure and labyrinthian. Such a language of multiple meanings cannot be fixed; on the contrary it provokes exciting maneuvers of intellectual "perversions," similar to the machinery of the Baroque.

What is surprising is the decline of the materialistic and the devaluation of the bodily-sensual, that is the renunciation of the advances of the anti-society of 1968, in favor of a literary, clever, incomprehensible abstraction. Upon the explosion of the natural and bodily symbols of the 70s follows an *implosion,* which tends toward gathering minimal symbols: the creases in the skin of the paper, the traces of the finger. At the same time the phantom of technology, which the era of McLuhan had still glorified, no longer causes any kind of palpitation of the heart. Photography, video, and slides no longer appear as sensual records but become indifferent. Because they take up emotional states only with a delay in time, one keeps one's distance from them. As a result the traditional media, for example painting, appear more suitable. In Italy, artists like Salvo or Mariani appear to move toward a lyrical verism and a hermetic neo-realism. Stepping before the viewer is an art which is separated from the ego and from society. It is a kind of romanticism and dandyism, in which the coldness of the newly created painting becomes a yearning for the dream of the past and one's own culture. The artists oppose the global vision of 1968 with the appearance of an articulate fragment: the painterly marvelous and astonishing as apparently restorative mask. Forms and figures really do return to a common denominator of an unreceptive, statuesque pathos whose intensity aims toward order; a distance is not covered, it is the voyage that abides.

"Die italienische Erfahrung" by Germano Celant. Reprinted from *Kunstforum International* (March 1980): 125–133. Translated by Annegreth T. Nill. Used by permission.

Border Crossing

Per Kirkeby

I am always tidying up. But I never succeed in throwing anything away. Tidying-up is moving things around. A notion of bringing about clarity, of taking stock, of arranging oneself wisely, but the clarity is only glimpsed in the intention. It is never any particular place. It is like the idea of something "international," something that is the opposite of provincialism. That isn't anywhere either, rather it is a ghostlike intention floating between the places.

I am a Dane. Denmark lies in Europe. A little country north of Germany. There is a difference between writing about "Germanism" for Danes, as a Dane for Germans, and as a European for Americans. That last stage could occasion the release of floods of sentences. About the American "lack of history" versus the close historical texture of the European, about the incredible uniformity of the American style versus Europe's multiplicity. All geographical clichés but, of course, not without a core of truth. And if I add that American art-life at the moment appears to me to consist of a singular short-winded fragmentation, then this sounds like the most dreadful value judgment. It is not meant to completely. The point in time, dear friends. There are times when American qualities are indispensable and others where the European dead-weight is suddenly worth that weight in gold. There were the sixties, and there is now. There are great fluctuations, and there is your own biology. Remarkably enough the two things often go astonishingly well together. So, each thing to its own time. But in spite of the tolerance and all the circular tours, there are still a couple of things that I find difficult to understand—American formalism and the precipitously deep difference between Denmark and Germany.

"American formalism" is a decidedly development-oriented way of thinking. In the art world—that everything progresses and leaves something behind it, that one overcomes something. A method of getting a yardstick that is comfortable to talk about. That art can be good or bad in relation to that which it has "overcome," the "cubistic space." I incessantly come up against this way of thinking in America, in more or less sophisticated guises and editions, and I have never understood it. Just as little as I have understood a special "cubistic space."

In this context the precipitous cleft between Denmark and Germany is interesting. We will now approach the matter from the north.

Danes don't like Germans. That is history. Out of fear of Germans there exists this little people with their own language, with another perception of history. And after the last World War it is as if the understanding of the Central European, East-West connection has completely vanished from the Nordic repertoire. A Liszt, a Kafka, a Canetti are incomprehensible dimensions, seen from the North today. And that unbelievable division down through all Germans is also an experience of which Danes have not the faintest inkling. Then there is a mass of History that percolates by osmosis into the Northerner when he first crosses the abyss to the southern continent over *Teufelsbrücke*.

Throughout the years there have been a great many who have made this trip and perhaps these mongrels suggest something about "the German" precisely because they were both of it and outside it. Carstens, Runge, Thorvaldsen. To keep particularly to the Danish-German interchange. Jorn.

Carstens and Runge belonged to the North German-Nordic area, educated at the Academy in Copenhagen. Runge remained in North Germany, Carstens moved to Rome. As too did the Dane Thorvaldsen. He apparently leapt over Germany, but the Rome in which he arrived was Carsten's Rome; it was the Rome of German Classicism. All three of them were Classicists, early, romantic Classicists. And German by Type. Completely different from the French. Anyone can see that, but our three frontier-crossers were a particular sort of German. And because of this marginality, they perhaps illuminate some German possibilities.

What has always fascinated me about artists like Carstens, Runge, Thorvaldsen, is their striving after the "elevated," the "great, heroic, sublime." As a striving that far outreaches and bursts the external stylistic traits. And which thus, in the external, also evokes "unreasonable" dislocations in the stylistic norm, but on the other hand still operates within the common style, unlike Fuseli who, at the first glance, is already out on his own paths. It has perhaps been difficult to perceive these decided, but in a certain sense hardly visible, dislocations that, in most of them, are expressed in an undemonstrable unpleasantness, because all German Classicism is still a phenomenon of rediscovery.

Why is Runge's apparently so normal and idyllic depiction of children playing so disquieting? And why does Thorvaldsen, the most normal and mundane of his time, slip innocently out of this, why do his sculptures all the while contain this insistence on the ideal, and why did a work like the powerful Hercules spring from the ancient's hand?

Now comes my personal idea, the banalities which are a part of my working tools, because in their striving they blow up the motif even as they retain it. The motif is the start, the occasion, the entrance to the world. But The Great Striving reduces this starting-motif to a tool in the service of another "deeper" and indescribable motif. This motif can neither be described nor captured by the artist, and lives with the exterior motif like the good skin against its environment. The feeling that something other than what is shown is moving. That the skin is deceptive. This other one, the "deeper," could be called, for want of a better expression, the structures. There are some deeper motifs which are such little motifs in the picturesque sense that it is wiser to call them something else. Structures—that sounds so formalistically technical too. And also it is here that lesser spirits stop and the worst Frenchmen harmonize.

But with our artists, neither they nor the structures stop. They begin to slide. To slide incessantly and transform themselves deep down in the picture. The artist is driven far ahead (the metaphor is poor at this point but will have to do) but is also carried away. And

perhaps precisely because of this (without going into a discussion of conscious-unconscious) so violently works on the external motif: it is driven into caricature as a counter-reaction. As examples one could just mention Baldung Grien and Dürer from the popular German past. But the caricature need not, of course, always be banally caricaturing. With Thorvaldsen the caricature is an extreme stylistic norm. But it is important to differentiate between what I call caricature as a counter-reaction and the manneristic tricks. Naturally in Mannerism we again find much of the same mechanism. But the Mannerists are much colder people who just utilize painfulness in order to develop a usable pictorial machine. With our artists, Runge, Thorvaldsen, on the other hand, it is a question of endeavoring to maintain a normality in the exterior motif. In spite of the Sliding Structures. And the penalty for the maintenance of this exterior motif is the caricature-like traits.

"The German" is for me this bundle of disquiet, "unreliability," sliding structures and the exterior motif maintained by the caricature. And it is a very narrow path, only valid if the bundle is of a classicist nature, when it is dealing with a struggle for the valid picture in the classical sense, but is no use when it comes to effects (not used here as a value judgment) or merely noble Mannerism. It functions only when there is a striving for a normal picture and this, of course, is not an easy position in today's market.

All attempts to say something significant about pictures, and especially to make it into an assertion about "the German," are also doomed to end in civilized jargon or practically self-evident generalities. If one then as reader does not accept a certain understood something like a poetry reader, but allows the pictures' materiality and abundance to appear and be present in the memory. Then sometimes the trick will succeed: that, only in a quick flash, these banalities will take on the same truth-stamped existence as music, which cannot be discussed, which is, in the most profound sense, a choice.

In this piece the big metaphor, as stated, is The Sliding Structure. And "historically" I have maintained straight out that it is an important and distinct element in what is called "the German." But it is clear, of course, that it is one of that kind of obviousness that one could carry over to any art one found interesting, that it is just a disguised way of delivering a value judgment.

Therefore to finish I will throw out a couple of associations that one could, of course, reject as culture-historical chic, but as such should summarize the music: that the great Slide is a particularly German (Central European) possibility, or that only in German does it come into a field of special tensions, of latent existence and, at the same time, just as persistent imprisonment that, especially in the frontier regions, it is liberated now and then with great force. I have mentioned the Northern bridge. Just think of the pictures that were released when Munch got to Berlin. Another interesting combination: Schoenberg's *Gurrelieder* to poems by the Dane Jens Peter Jacobsen. Here a Dane, at any rate, can experience how a lurking insecurity, a dangerous mobility down in the apparently National Romantic poem-cycle is developed into a huge slide, the great transformation, in Schoenberg's music from down in the middle of the continent.

This sliding feeling contains—a lacking perception of finality, of a reasonable progression through the overcoming and putting behind of various stages (especially of a stylistic character). But the utmost exertion—and correspondingly increasing Sliding Feeling. Associations, both by themselves and in series: Liszt, Wagner, Nietzsche. It is also why "we" feel more attracted to an architect like Hans Scharoun than to Mies van der Rohe and the other regular types from The International Style. Because of Scharoun's iconoclastic buildings, which are, mark you, true iconoclasm and not the gratuitous moving about of historical wares as in the so-called Post-Modernist architecture.

Here it is again: The Big Slide is only interesting when the starting point, the motif, is great, "normal," classical. It is not accessible to ordinary decoration. It is not something one can go to directly. It is a product of The Great Striving.

"Grenzübertritt" by Per Kirkeby. Reprinted from Stedelijk Van Abbemuseum, Eindhoven, *uit het Noorden: Edvard Munch, Asger Jorn, Per Kirkeby* (1984), exh. cat., 67–68. Used by permission.

Painting in Germany 1981

Johannes Gachnang

"All national art is bad, all good art is national." (Christian Krogh, 1852–1925)

I

Berlin. In the early sixties, Lautréamont, Artaud and artists like Derain, Balthus, Gruber and Fautrier were at the center of debate. The retrospective exhibition *Jean Paulhan à travers ses peintres* (Paris, 1974) provided a fascinating picture of this climate, underscoring the extraordinary continuity and concentration which today represent the exemplary characteristics of this period—of our times. Discussion also revolved around the paintings of Stringberg and Schönberg, and the drawings by Hill and Josephson—works which my generation discovered along with Ensor's painting *Christ entering Brussels,* during the exhibition which the Council of Europe devoted to the *Sources du XX siècle* (Paris, Fall 1960). This remarkable exhibition revealed almost the full extent of the creative contribution of the period 1884–1914. In those years, Paris continued to play its traditional role as capital of the arts, fomenting artistic debate in Germany, and apparently meeting with specifically German interest. There can be no doubt, however, that the situation of the arts in Paris at the end of the fifties did not sufficiently satisfy our needs. With the exception of several fringe artists—such as Wols, Michaux, the members of the Cobra group, or Chaissac, Dubuffet and his Compagnie de l'art brut—the Ecole de Paris and the triumph of informal art (tachisme) meant little to us, and were not a source of decisive inspiration. This can partly be explained by the appearance in Europe at the end of the fifties of the radical paintings by Jackson Pollock and the American abstract expressionists. These were the "winners" in this contest, and they introduced new attitudes and ways of thinking to the intellectual sphere, creating a new order centered on New York.

At the end of the second world war, Germany and the whole of Europe were divided into the Eastern and Western blocs, representing the two rival zones where power was, and still is, exerted in both a political and cultural sense. This division obviously made it impossible for a city like Berlin to play the important integrating role which it had assumed during the first part of the century. This situation remained unaltered despite many attempts made in various directions. Progressive spokesmen, like the great architect Hans Scharoun (1893–1972), who built the Berlin Philharmonic and the National Library, and continued to sustain a European outlook, were soon denied the possibility of expressing their opinions. All these factors further widened the gap between East and West. The direct consequences have only begun to crystallize in the past few years but are now patently obvious. The effects of this East/West division have recently become the subject of discussion and efforts are being made not only to place them in their European context, but also to find some solution. For practical reasons, this initiative seems to present fewer problems from a political point of view—although the results obtained so far are not entirely convincing—than from a cultural and intellectual point of view, where existing structures are extremely fragile and complex.

After the trauma of national socialism, the cultural situation in Berlin and throughout Germany was extremely precarious, and was characterized by a feeling of isolation and lack of points of reference. The possibility of starting from scratch was discarded and remained a mere utopia. Reconstruction continued in each of the two new spheres of influence (USA-USSR) and no efforts were made to create any form of coordination: all contact seemed undesirable. In West Berlin and throughout the whole of West Germany, most artists yielded to the influence of the "winning side": first Paris, then New York and America. This massive foreign contribution was fatal for many talented young artists who rapidly became disorientated, lacking any direction, message or overall view of their own artistic practice. The impression is that in Europe, at the end of the fifties, it was considered necessary and sufficient to adopt informal art as a style and tachisme as a process in any new modern painting and, in fact, both found extensive application, despite differing mentalities.

This way of making art was further consolidated thanks to the contribution of abstract expressionism, and developed further under the influence of pop art. Amid this overwhelming flow of images, very few artists succeeded in finding and maintaining a personal point of view, in defending a personal position in their work: there were some exceptions—such rare artists as Asger Jorn, Constant, Emilio Vedova and Arnulf Rainer. There were also two other exemplary exceptions in West Germany: the painter Ernst Wilhelm Nay (1902–1968) and the sculptor Hans Ulmann (1900–1975). Both staunchly defended their artistic freedom and succeeded in revealing the source and origins of their being, in observing and visualizing them in their works. Little by little, we can finally see and appreciate the works of these artists, now that we have shaken off that unfortunate fifties mentality and the formalist way of looking at paintings, which we also took from the Americans. This attitude was responsible for occulting many works, by underestimating their importance, and draining them of their essence, which was confused with the painting's material, physical presence. The general rule was: "What you see is what you see" (Frank Stella).

"A good work of art is national, but a national work of art is ugly," is the paradox attributed to a Danish artist. We should think about it some day, because the artists we are dealing with thought about it very seriously. And this is how we come to what has been for many years, though never openly admitted, the source of several errors of interpretation by the critics. Even in the last few months, because of the subtle distinctions and differences in approach to the problem, this misunderstanding has given rise to fierce polemics. No one escaped attack, and some did not hesitate to slander several of our artists by questioning their artistic integrity, obviously after they had seen which way the wind was blowing.

Around 1960, New York was the center of artistic life and it was very common for artists to declare that international art was the best possible art and that, strangely enough, the most interesting artists worked in America. Although the artists and critics of this generation never failed to quote the Russian constructivists, their conception of

international art owed much to the good old Bauhaus, which they were intent on disputing, in an attempt to progress beyond it. Today these "prevailing" opinions are seriously compromised and cannot possibly be sustained, particularly as different attitudes and opinions have now made their appearance. If we consider the latest developments and tendencies in German art, it must be acknowledged that the international style formerly advocated is presently incapable of providing a decisive impetus, because it lacks any theory or overall view, not to mention all those elements which could have made a joint effort possible.

II

It was at the beginning of the sixties, in West Germany and particularly in Berlin and Düsseldorf, that a new generation of artists achieved a degree of self-assurance that was thought no longer possible, rediscovering some kind of identity by following a new course. They succeeded in holding out against influences and fashionable trends, because this was the only way that a new image of the world could be created. These artists certainly did not count on rapid success, or even on arousing any kind of esteem—many years of work were necessary before things began to take shape. One must also bear in mind certain fundamental aspects of these initial efforts. The problem here is to sketch a new framework of the recent evolution of German painting and to describe, given adequate premises, the course which this new painting gradually took, showing how these artists have since continued to measure themselves against an environment to which they remained essentially foreign. In Berlin, the first artists to move in this direction were Georg Baselitz and Eugen Schönebeck, closely observed by Antonius Höckelmann; they were followed by Markus Lüpertz and Ralf Winkler, alias A. R. Penck, who had already stirred up some curiosity in West Germany when he worked in Dresden and East Berlin. This circle can also be widened to include Michael Werner, an intermediary, keen interlocutor and close friend of these artists.

Just as the Berlin movement was getting to its feet, other forces were beginning to assert themselves at the fine arts academy in Düsseldorf, where Joseph Beuys had attracted an important following. The theme of the Berlin debate was thus extended even further. The methods and means adopted soon appeared to be much more modern and topical, and revealed a typically German way of interpreting the international style. Joseph Beuys was flanked by Gerhard Richter, Sigmar Polke, Jörg Immendorff, and Palermo, the youngest of the artists of this generation, and for this reason, always set slightly apart from the others. Per Kirkeby and Anselm Kiefer were also caught up in this new flow of energy, which characterized their artistic evolution—despite the fact that both artists started out from very different bases. In Düsseldorf, there was a greater tendency toward group work with Beuys at its center; the fine arts academy provided the right kind of atmosphere and countless opportunities for actions and events. There was no structure of this kind in Berlin, where artists worked individually, withdrawn and relying on themselves, only slowly coming to realize a mutual credo and common

vision. The first attempts to branch out and the initial appeals to the rest of the world met with little support.

The movement's first important début was with two exhibitions of works by Eugen Schönebeck and Georg Baselitz, *Pandämonium I* and *Pandämonium II*, which were both accompanied by the presentation of a manifesto (1961 and 1962). These manifestos represented the cry of youth, the revolt of artists who expressed the anguish of existence in that period, quoting both Lautréamont and Antonin Artaud. All points of reference had vanished, continuity had broken down in every sphere of activity, and nothing was left to sustain spiritual life after such a long period of cultural deprivation. What the new generation so passionately demanded was a culture. The search had begun and they had to be content with what they could find— the time for making choices would come later.

The fact is that the rigorous political and ideological schism divided Germany and the whole of Europe in two—above all this happened in the minds and hearts of the German people, leaving them stranded in the land of schizophrenia. After this rude awakening, the Germans, as well as all Europeans, had to question to what extent they still belonged to the Europe of the East, with its cultural traditions and its living past, or if they had already become Europeans of the West. Many German artists belonging to this generation originally came from the east of the country, and when they settled in the west, they by no means repudiated their origins, but remained indebted to their early cultural heritage. Twenty years ago to take such a position was not opportune, and these references caught one unprepared as they came as it were—in the context of the arts— from our friends. One sensed in this attitude and sustained effort not only strong spiritual forces but also a regained freedom, carefully and deliberately achieved, and it was only a small circle who understood it then. It seems that German painting has rediscovered in this freedom a sound and lasting basis, and this is borne out by recent results which are illustrated here.

The clearest, most direct painting from this period is Georg Baselitz's *Die Grossen Freunde (The Great Friends)* painted in 1965. About the same time, the Beatles were stepping onto the scene, along with the Rolling Stones, Flower Power and Cassius Clay alias Muhammed Ali, but the Chinese Cultural Revolution and May '68 had yet to come, and both these events were to inflict a new blow to our ways of thinking and acting, bewildering and disorienting the members of my generation, and forcing them to come to a decision for the future. In his painting/manifesto, Georg Baselitz was taking a clear stand against the Anglo-Saxon maxim, "the refining aesthetics of exploitation." Baselitz was trying to change the course of cultural debate in Germany and provide it with new bases. But his voice was drowned by the euphoric, deceptive uproar of the sixties—the "silly sixties," as they were later to be dubbed. A. R. Penck's *Weltbilder* and Markus Lüpertz's paintings met with the same fate. We could not stop at Lüpertz's declaration, "The charm of the twentieth century became perceptible through my invention of the dithyramb." No one had any time for these intellectual provocations. They have pre-

The End of the Avant-Garde? And So the End of Tradition. Notes on the Present "Kulturkampf" in West Germany

Bazon Brock

served something offensive and insulting about them, although this does not diminish their intentions or compromise their authenticity. The freedom that the innovatory artists fought so hard to win allowed them to go beyond declarations of principle and give a decisive contribution to contemporary painting after the sixties, without losing themselves in obscure questions of style. The battle of the styles *(Stilkrieg)* described in a painting by Immendorff (1980) has never actually taken place.

Thus, during the sixties, a movement began to take shape almost secretly, without attracting attention, in both Berlin and Düsseldorf; a movement whose visions and artistic production have now acquired very clear contours, and whose prolific nature is amply illustrated by the new developments that, over the past few years, have led German painting away from the old, well-trodden paths. Much remains to be discovered about these two artistic camps and the contexts in which they developed. A first attempt in this direction was made in the exhibition *Der gerkrummte Horizont (The Curved Horizon—Art in Berlin 1945/1967)* which I personally presented last year at the fine arts academy in Berlin. These few pages constitute a continuation of the ideas I defended on that occasion, and which neither critics nor historians were able to grasp. It was almost as if I had come to disturb a predetermined image, and I was hardly surprised by the reaction because today, in much of what one thinks and writes, there is a tendency to fall back on accepted genealogies, chronologies and didactic divisions, without questioning these gerarchies and frames of reference which invariably lead to reductive statements.

"New German Painting" by Johannes Gachnang. Reprinted from *Flash Art* (February/March 1982): 33–37. First published in French and Dutch in Société des Expositions du Palais des Beaux-Arts de Bruxelles, Brussels, *Peinture en Allemagne 1981 Schilderkunst in Duitsland* (1981) exh. cat., 11–18. Used by permission.

Some strange events are apt to make us ask questions.

1. While I was preparing this article, an excellent and significant artist tried to stop me from mentioning his colleague Anselm Kiefer. He then attempted to intimidate me so I would not give more emphasis to Kiefer's painting than to his own or that of his friends. What could explain this behavior, which unfortunately is not unique?

2. In 1980 the Georg Baselitz and Anselm Kiefer exhibits in the German Pavilion at the Venice Biennale were almost universally rejected by the German critics. The true reason for their disdain could be perceived behind the veneer of "artistic" criteria: they felt that Kiefer and Baselitz were using obsolete artistic methods to promote equally obsolete German mythology. This objection is untenable. What is behind such unanimous misconception?

3. Although there has been no shortage of intelligent criticism of Hans-Jürgen Syberberg's *Our Hitler,* 1977, in France, Britain and the U.S., in West Germany the film is put down because it is apparently paving the way for National-Socialist mythology.

4. When Richard Serra's large 1977 Documenta sculpture was installed on a public site in the city of Bochum, the public and officials reacted in a manner that was reminiscent of the Nazi campaigns against "degenerate art." Although this should no longer seem possible, such events are quite common in West Germany. There is a gradually increasing awareness that the campaigns against "degenerate art" did not cease with the end of the Third Reich, nor are they limited to obscure circles. From Henri Nannen's criticism of the 1958 Venice Biennale to Thilo Koch's mockery of the 1972 Documenta, this attitude about "degenerate art" has, in actual fact, been kept alive.

5. Eduard Beaucamp of the *Frankfurter Allgemeine Zeitung* recently stated that "the survival of art does not depend on its avant-garde qualities. In no way does the end of avant-garde amount to an end of art." Like many of his colleagues, Beaucamp is accepting all this talk about the end of the avant-garde, or even the end of modernism. What is it that created this curious agreement between the former champions of avant-garde and its longtime enemies?

Considering the current active, even aggressive, conflicts in West Germany, the recognition that this talk about avant-garde perpetuates the same peripheries that have existed for the past 70 years is useful, although unlikely on the part of those who are doing the talking. Do we have to accept that there have been no fundamental advances in the visual arts within the last 70 years? Since it is only now—now that the world's economic and political problems prove the usual explanation for the 12-year "mere accident" in German history to be insufficient—that a discussion of Germany's National-Socialist past is taking place, this debate about modernism could, in fact, be a good omen. But if it cannot be based on different and better arguments, we may soon be sharing the responsibility for

another cultural disaster. We need not necessarily become war criminals again. In certain respects, says Syberberg, peace criminals are just as bad.

In many ways a world experiment is taking place in Germany, with the side-by-side existence of socialist East Germany and capitalist West Germany. Both countries share the same cultural history, the same language and the same intense internalization of the fiction of a German national character. The existence of the two Germanys and their unique experience is of immense value for present cultural debates. Though conventional world opinion sees the Prussian mind (under scrutiny this year in numerous exhibitions and studies in both East and West Berlin) as industrious, self- sacrificing and productive, its true nature is radicalness leading, of necessity, to self-destruction. In a recent essay, Rudolf Augstein, editor of *Der Spiegel,* has shown German history—inasmuch as it was determined chiefly by Prussia in the last 240 years—to have been a series of crazy acts of brinkmanship. Frederick the Great, Bismarck, William II, and Hitler acted with a horrendous consistency that was by no means chance coincidence. Their attitude and that of their thousands of subordinate führers can be characterized by the statement that Hitler made in April 1945, in his last will and testament, concerning the disaster he had created: "If our political and military decisions should result in a catastrophe, the German people deserve no better."

What is the fascist element in this behavior, behavior that had prevailed long before fascism and National-Socialism were established as a political system? Heinrich Heine supplied an answer, describing the Germans as building their society and their state "in the realm of the airs," centuries after the French and the English had succeeded in creating actual states on earth. The Germans considered and continue to consider philosophical, literary and artistic world-constructs—purely intellectual designs—to be actual realities. They read philosophy and artistic works as if they were down-to-earth operating manuals for the translation of ideas and imaginary constructs into reality, instead of using them to justify criticism of the conditions actually prevailing in a given period. Examples of this can be found in the systematic liquidation of the Jews as a disciplined sacrifice supposedly made in the name of unpleasant duty, in the widespread acceptance of censorship of intellectual activity as being necessary to demonstrate the honor and purity of true Germanness, in the public destruction of "degenerate" art and the hounding of the creators of that art. Only in Germany was it possible for a competent Nobel prize-winning scientist in experimental physics, Professor Lenard, to accuse Professor Einstein and his colleagues of advancing "un-German" physics.

"What art is, [or is not,] I will decide."[2]

Even though Friedrich Schiller, whose teachings formed an indispensable part of German high-school education for a long time, held that the constructs of art were real only as "beautiful appearances," the Germans have always had difficulty understanding the English pragmatic approach to, or the French constructs of, beautiful appearances, since recognizing the idea of beautiful appearances was tantamount to denying the real and the true. The proverbial "German profoundness" results from an inability to accept beautiful appearances—figurative ideas or mythic narratives or scientific systems of thought—as just that: mere appearances. They have always seen the relation between surface and depth, appearances and inner nature, imagination and physical reality, in terms of plan and execution. Artistic statements were judged in terms of how they could be methodically translated into reality; an autonomous sphere of esthetic appearances could not be approved. Anglo-Saxon pragmatism selected artistic and philosophic systems based on how well they would fit into the reality of everyday life. The German idealists forced their philosophical and artistic system constructs onto everyday life. That is why it seemed natural to German leaders that they should decide which philosophical and artistic thoughts could or could not be admitted. To the majority of Germans, it was quite natural that William II or Hitler should act as the supreme arbiter of art and science.

Today we are still inclined to see the absurd Third Reich ideologies in art and science as products of the stupidity of political officials. Actually, the ideology of "un-German" physics, the supposedly empirical racial doctrine, the theory of the superiority of German culture, the assertion that medieval gothic was a German invention, and the legal application given to the ancient Germanic virtues—all were made up not by party big shots, but by ordinary academic professors. Hitler himself cracked jokes about this. Hitler was not forcing his own inventions on the people; he simply literally actualized a relationship between thought and act, plan and execution, art and reality, that had gained currency long before him. The German archaeologist Heinrich Schliemann had given a resounding and convincing demonstration of this when he succeeded in discovering historical Troy and Mycenae by taking the mythic fiction of Homer's epic as a practical guide. Like Schliemann and the majority of his colleagues in science and art, Hitler proceeded in the same manner. But instead of limiting himself to constructing a new history of our culture, he applied his literal interpretation of esthetic appearances and his literal understanding of artistic and scientific mythology to his present. The results are well-enough known even though the background is rarely understood. The first years of West Germany were openly—though perhaps unwittingly—called the reconstruction period. West German ideology was determined by the same forces, by the same scientists and artists who, without much evidence of pressure, had shown themselves willing to support National-Socialism and to integrate their professional organizations with the new regime as early as 1933, long before ordinary citizens allowed themselves to be drawn into the new order.

I am bringing all this up because this field of our intellectual history is being tilled again in the present cultural conflict. We are living through a permanent iconoclastic battle, and in this age of technological production and distribution of images this could in recent years have led to radical results, as radical as in the Third Reich

or the German Democratic Republic, if the constitutional courts had not been as strong as they were until now. It seems doubtful, however, that the constitutional guaranties can be maintained much longer.

The function of avant-garde.

The discussion about the end of the avant-garde has a special flavor in West Germany because the avant-garde came to an end in Germany before it ever began; the avant-garde has never been able to establish itself in Germany. Avant-garde works are those that compel us to see the seemingly familiar works within our traditions in a totally new way. The very creation of that which is new and incomprehensible is a necessary prerequisite to forming traditions. That is the function of avant-gardes. For traditions are not secure and unchanging things of the past that continue to affect the present; on the contrary, they have to be rebuilt every time from the present into the past. Traditions are the forms by which we appropriate history as an effective force in the present. All concepts of modernism and the avant-gardes insist on the creation of something new. But if something is really new, it certainly is unknown, unrecognized, not understood and not definable.

The majority of people wants to understand the new—avant-garde art—in its own terms, all by itself; and this, of course, is impossible. Artists who are prone to misrepresent their creation of the new as simply a break with the old and the preexisting, encourage such a simplistic view. But they cannot break with traditions unless they have a knowledge of unambiguous, constant and secure traditions. Panofsky, Warburg, Kubler and others have shown why this is so; why form and content can barely be communicated from one individual to another, let alone from one generation to another. The same form changes its content, the same content appears in a different form. All renaissances were de facto failures, even though the individuals involved, lacking historical knowledge, might have believed that they had succeeded in resurrecting traditions. Renaissances cannot aim at the resuscitation of traditions, but they can make sense as an attempt to create new traditions out of historical inventory.

What motivates this, what compels people again and again to create traditions anew? It is the pressure of the unknown, the incomprehensible, the unrecognized, that appears in avant-garde works. No one can remain indifferent to something new and unknown that suddenly comes into the environment. Most often it either will be destroyed or, by means of all sorts of projections, will be renamed in familiar terms. But sometimes an artist will proceed to exploit the new fact to induce a new attitude toward that which was, until then, the old and known. One can only learn about the known from the new, one can only experience the new with a new view of the old.

Thus the public for avant-gardes should trust its perception that these works are unknown, unrecognized, uncomprehended. For this implies that this public knows other works it has already recognized and understood. If someone considers a work by Joseph Beuys to be incomprehensible, he or she is bound to assert that there is a work by Rembrandt, Kaspar David Friedrich or some other artist that is known, recognized and familiar. This is of course a fallacy, since even with these artists there is no such thing as unchanging knowledge and permanent familiarity. The new avant-garde works prove themselves each time by forcing us to see and understand the same historical work once again in different terms, showing us the same Rembrandt as though we had never seen it before. Whereas the usual argument has it that the avant-garde is rejected for fear of having to reject old traditions, it seems more likely that people are afraid of the new because they are afraid to admit that they did not understand the seemingly old, known and traditional, either.

The making of a new past.

There is no point in classifying Georg Baselitz, Anselm Kiefer, Jörg Immendorff, A. R. Penck, Markus Lüpertz and any of the first-rate painters of the "Mülheimer Freiheit" as neo-Expressionists or neo-Fauves, for this would suggest that these artists are part of the modern movement but reflect a long obsolescent stage in it. Ideas about artists returning to traditions are meaningless. The opinions on the substance of traditions are themselves no more than contemporary constructs. Evidence of how difficult it is to understand this can often be seen in criticism of "post-modernism." As long as we label "post-modernism" (in the various fields) as an adversary of modernism, as long as we lump it with the perpetual enemies of all the avant-gardes, we are adding unnecessarily to the strength of these adversaries. In architecture, most critics do not even attempt to claim that "post-modernism" is related to modernism; instead, they treat it as a new eclecticism and historicism, that has turned the clock back to the days before Louis Sullivan and Adolf Loos. One of these critics, Uwe Schneede, director of the Hamburg Kunstverein, wrote in 1980:

> The present leaves the artists without hope, utopia is worn and decrepit. So they are looking for a link with something old to give them a new beginning, and imperceptibly this has changed the way 20th-century avant-garde sees itself. Since the end of the 19th century, art history has been a history of the avant-garde. Avant-garde—that was the vanguard advancing into unknown territory—anticipating an uncertain future—creating the new—not afraid of shocking confrontations.

1968 saw the rise of a fundamental critique of the cult of innovation, and this has since affected the practice of young artists. They are no longer totally committed to the new that the art dealers had been demanding from them (and profiting by) in the '60s. In those years the industrial trade fairs provided annual reassurance for the ideology of economic growth and the proliferating consumption approach to life, whereas the bustling art world found new strength in the innovation ideology at the annual art fairs. This obsessive forward pressure has waned. Today the avant-garde is no longer identical with the cult of

innovation. Today's avant-garde creates the new out of pensive retrospection.

This does not make much sense. First Schneede says that today's avant-garde is no longer aiming to create something new, then he concludes that today's avant-garde creates the new in pensive, searching retrospection, i.e., it does create something new. What Robert A. M. Stern has said for the current development in architecture should be repeated:

> One cannot emphasize enough that today's post-modernism is not a new style outside of modernism. Nor is post-modernism a revolutionary movement inside of and against modernism. It aims to correct the shortcomings of the earlier development, to restore the balance between tradition and innovation after the revolution of modernism that had been puritanical and limited to small circles.[3]

The critics were similarly in conflict about the latest Venice Biennale. On the one hand they said that the young artists had no new ideas; on the other hand they complained that the artists were constantly duping the public with a rapid succession of novelties that were nothing but new.

For a long time Picasso had a reputation with both laymen and experts as the epitome of the novelty-minded artist. But at the same time they were trying to prove that his novelties were not half so new. Stierlin wrote in his treatise on 11th-century Spanish book illuminations that "the treatment of an apocalyptic horse by the *facundas* master is already reminiscent of Picasso's horse in *Guernica*." The other way around it makes sense: it is Picasso's disturbingly new way of seeing things in *Guernica* that makes us see the *facundas* master differently. If contemporary artists cease to produce avant-garde works, they give up their ability even to perceive the seemingly old and known, the traditional. It is the impact of the new that makes us look back at historical inventory, so we can experience the energy of the actually new in the modified view of the old.

Baselitz, Kiefer, Immendorff, Penck, Lüpertz and their colleagues are not looking back; they are not neo-Expressionists, neo-Fauves or neo-anything. Their work makes us discover aspects in the Expressionists or the Fauves that could not have been perceived before their work began to exercise its effect on us.

Which past is the present of the arts?
The achievements of 20th-century avant-garde can be compared only with those of the 5th century B.C. in Attica and those of the 15th century in Northern Italy. The criterion for the level of achievement in this century is how earlier art was reviewed, thanks to the avant-garde pressure. Cézanne compelled the art historian von Rintelen to arrive at a wholly new discovery of Giotto's artistic achievements. Cubism proved itself to be an effective avant-garde by causing an entirely new view of the artistic manifestations of the so-called primitives (especially their sculpture). Expressionism amounted to an effective avant-garde because it did away with the prejudice of

the period against El Greco (until 1908 he had been considered a mere daubster) and many other Mannerists. Architectural thought from Loos to the Bauhaus resulted in an entirely new view and re-evaluation of Palladio and Brunelleschi. This series continues to the present time, where Bernhard Johannes Blume demands a new definition of art deco as a further formal canon in European art history. In the 1970s, conceptual art brought up 15th-century conceptionalism. Baselitz' upside-down paintings create a totally new Tintoretto for us. Seventeenth-century trompe l'oeil, which had been considered mere genre painting, was revealed as epistemological painting by Spoerri's *tableaux pièges*. With his materials and sculptural values Beuys compelled us to find a new attitude toward everyday waste materials that had been considered irredeemably amorphous. Penck's painting shows how the transition from the black-figure to the red-figure style at the turn of the 5th century B.C. can become a revolutionary reorientation in present-day painting. And so forth—the achievements of the avant-garde in this century are so numerous and dense that they prove all this talk about modernism losing historical dimension to be totally off the mark. The dense representation of history in our present (as an achievement of the avant-garde) simply cannot be rejected by calling it historicism or eclecticism.

What is the meaning of modernism?
If one wants to discuss modernism as a clearly defined and historically unique period, this is the conclusion: modernism is an attempt to understand artistic problems as exclusively immanent, i.e., as purely formal problems. This has in fact been going on for 100 years, the aim being to show progress in art as progress in the mastery of formal problems. But if one asks why the artists of a given period deal as they do with formal problems, one cannot help posing questions other than those about formal problems. Nobody has yet succeeded in seeing art works purely in terms of formal problems. This is why such a concept of modernism (as a history of solutions to formal problems) is not very useful.

There are no traditions without an avant-garde.
Thus we have to assume that the responsibilities of the modern avant-gardes are not historically unique, but that they occurred in all societies, in all cultures and periods as the task of preserving the connection between the contemporarily new with history. Societies that employed dictatorial measures to stifle the creation of new things in order to protect hallowed traditions were the first to lose their traditions. The more intense the battle against the new, the faster the loss of tradition. And this is what makes the avant-garde problem in Germany so explosive. Prussian radicalism arises from the lack of tradition and control that had to result from the rejection of the new.

I am not saying that the situation in West Germany today is the same as it was in the '30s, but I am saying that it is analogous. The diversity claimed in all artistic, scientific and political statements and

constructs to exist in West Germany has an anti-avant-garde and thus antihistorical drift even in the absence of totalitarian measures. That this should be so can be understood more readily by a comparison with Frederick the Great's Prussia. He, too, enjoyed a reputation as being tolerant and diversity-minded. Yet his account of the literature of his period mentions neither the names nor the works of Lessing, Goethe, Schiller or any of the other innovators of that time.

In Germany, any artistic, literary or scientific production immediately has a political dimension, and not only for the reasons outlined so far. The arts and sciences are greatly dependent—above all, financially—on state institutions. Though it may have been a good idea to make these fields independent of the tastes of private patrons (or of the "average public"), this has long since gone too far in the other direction. When major collectors can enlist government support to establish themselves as public institutions, this results in a cultural-political pact powerful enough to break up cultural communities and friendships between artists. And this is what is happening, as suggested in my introduction, at present in West Germany.

The avant-gardes on their way into the diaspora.
There is a popular strategy, invented in West Germany but since imployed in other countries, mainly in France, which is a like-minded attack on democracy by the radical left, the radical right, the dropouts and the copouts. Recently, an American, Noam Chomsky, wrote a preface for a radical right-wing polemical publication, and he justified his attitude with the definition of this strategy. He said that the Western democracies are not real democracies since they prevented radical right-wing opinions from being published. In Germany, young people in particular are once again succumbing to the sickness of taking system constructs literally. This time it is the West German constitution they are taking literally, and that, of course, makes it very easy to denounce actual conditions as not consistent with the constitution. This is fine as long as the constitution serves as a reference and inspiration for criticizing our political and social reality. But an insistence on literal compliance with the constitution would result in totalitarian conditions even if the constitution had been drafted by Jesus Christ and all the saints.

It has always turned out that the uncompromising identical application of a system construct is bound to have inhumane and destructive effects, since the very strength of thought is always rooted in the discrepancy between plan and execution, between idea and practice. Even the most ideal artworks and the most humane policies may only by construed as "ruins."

The radical hatred of the Jews in Germany arose principally from the permanent opposition of Jewish theology to any literal execution of a myth, a revelation, or a system of thought. This was the very substance of the German dream of the realization of the Holy German Empire. The present, increasingly explosive attempts to take scientific and artistic system constructs literally, and to enforce their exact execution, need to be watched carefully. This may explain why artists like Syberberg and Kiefer engender such widespread hostility in Germany, for their works imply an analysis of this cultural history and in the process they wreak havoc on the existing alliances.

1.
Kulturkampf or culture conflict refers to the roll-back of the influence of the Catholic Church attempted by Bismarck in 1872 and abandoned in 1887. It was largely a conflict between concept-minded Protestant idealists on the one hand, and Catholic supporters of an autonomy of esthetic appearances on the other.
2.
Declared by William II in a speech, 1901, and by Adolf Hitler as described by Joachim C. Fest, *Das Gesicht des Dritten Reiches*, in chapter "Professor NSDAP," Munich: R. Piper, 1963.
3.
Robert A. M. Stern, "Modernismus und Postmodernismus," *Design ist Unsichtbar*, Vienna: Löcher Verlag, 1981.

The Italian Trans-Avantgarde

Achille Bonito Oliva

Today the crisis in art in sensu stricto means the crisis in the evolution of the artistic language—the crisis in the avant-garde's Darwinistic and Evolutionary mentality. This critical moment is overturned in terms of new operability by the artistic generation of the 70s. They have unmasked the progressive valence of art, demonstrating how in the face of the unchangeability of the world, art is not for progress but rather *progressive* with respect to its consciousness of both its own and circumscribed internal evolution.

Now the scandal paradoxically consists in the lack of novelty, art's capacity to achieve a biological respiration of speedings-up and slowings-down. *Novelty* is always born of a market demand for the same merchandise, but in a transformed shape. In this sense many poetics and their relative sub-groups were burned in the 60s. Because through their poetics, the sub-groups permit the constitution of the notion of *taste* which, by reason of sheer quantity of artists working in the same direction, allows the social and economic consumption of art.

Finally the poetics have been thinned out, every artist working on an individual research that shatters social taste, and pursuing the finality of the work itself. The value of individuality, of working by oneself, is contrary to a social system crossed by superimposed totalitarian systems, political ideology, psychoanalysis and the sciences, all of which resolve the antinomies and swerves, produced in the forward movement of reality, inside their own viewpoints, their own projects. Inside a concentration camp which cuts down on its own expansion and tends to reduce all desire and material production off its own tortuous and impregnable routes, a culture of forecasts has to tighten its belt. The religious system of ideologies, of psychoanalytic and scientific hypotheses, tends to transform all that is different into something functional to the system, recycling and converting into terms of functional and productive all that is instead rooted in reality.

That which cannot be reduced to these terms is art, which cannot be confused with life. Art instead serves to push existence towards conditions of impossibility. In this case impossibility refers to the possibility of keeping artistic creativity anchored to the project of one's own production. The artist of the 70s is working on the threshold of a language which cannot be reduced to reality, under the impetus of a desire which never changes in the sense that it is never transformed except in its own appearance. In this sense art is biological activity, the applied activity of a desire which only lets itself be ratified according to its image and not its motivation. Art does not accept transactions, conjugated inside the artist's need to make the relative data of current production absolute and to create discontinuity of movement, while the austere immobility of the productive concept exists.

Today art is not the artist's insertion of remarks within the territory of language, never dual or specular with respect to reality. In this sense the production of art by the 70s generation moves along paths which require other disciplines and other concentrations. Here concentration becomes *deconcentration,* the need for catastrophe,

breaking with social needs. Artistic experience is a necessary lay experience that confirms the uneliminability of breaking-off, the incurability of every conflict and reconciliation with things. This type of art is born in the consciousness of the irreducibility of every fragment, of the impossibility of recreating unity and balance. The work becomes indispensable because it concretely re-establishes breakings-off and imbalances in the religious system of political, psychoanalytic and scientific ideologies, which tend instead to reconvert the fragment in terms of metaphysical totality.

Only art can be metaphysical because it succeeds in transferring its ends from outside to inside itself in its possibility of establishing a fragment of the work as a totality which recalls no other value outside of the fact of its own appearing.

Basically art finds inside itself the strength to decide the store from which to draw the energy necessary to construct its images, and the images themselves an extension of the individual "immaginario" that rises to an objective and ascertainable level through the *intensity* of the work. Because without intensity there is no art. Intensity is the work's ability to offer itself, or what Lacan calls the "look-tamer," its capacity to fascinate and capture the spectator inside the intense field of the work, inside the circular and self-sufficient space of art functioning according to internal laws regulated by the demiurgic grace of the artist, by an internal metaphysics which excludes any outside motivation.

The rule and motivation of art is the work itself, imposing the substance of its own appearing made up of material and shape, of thought directly embodied in painting, and the sign, unpronounceable without the help of the grammar of vision.

In this way art in the 70s appears deliberately shattered, disseminated in many works, each one carrying within itself the intense presence of its own existence, regulated by an impulse circumscribed to the singularity of the work created. Thus is delineated the concept of catastrophe, the production of discontinuity in a cultural fabric held up in the 60s by the principle of linguistic approval. The internationalistic utopia of art characterized the research of Italian "arte povera" bent on smashing national borders, thereby losing and alienating the deepest cultural and anthropological roots.

In opposition to the apparent nomadism of Italian "arte povera" and the experiences of the 60s, based on the recognition of methodological and technical affinities, the artists of the 70s respond with a nomadism both diverse and diversifying, playing on the sensitivity and the swerve between one work and another.

The unexpected landslides of the individual "immaginario" preside over the artistic creativity previously mortified by the impersonal, synchronic character and even by the political climate of the 60s, which preached depersonalization in the name of the supremacy of politics. Now instead art tries to repossess the artist's subjectivity, to express itself through the internal form of language. The personal acquires an anthropological valence because it participates in bringing the individual, in this case the artist, back to a state of renewal of a sentiment towards himself.

The work becomes a microcosm which grants and establishes the opulent capacity of art to repossess, to return to being a land-owner of a subjectivity fluid up to the point of entering the folds of the private as well, basing the values and the motivations of its working in every case on its own pulsion.

The ideology of Italian "poverismo" and the tautology of conceptual art are bypassed by a new attitude which preaches no pre-eminence outside of that already inside art and in the work's flagrantly rediscovering the pleasure of showing itself off of its own texture of the substance of the painting unencumbered by ideologies and purely intellectual worries. Art rediscovers the surprise of an activity infinitely creative, open even to the pleasure of its own pulsions and an existence characterized by thousands of possibilities, from the figure to the abstract image, from a flash of genius to the delicate texture of the medium which all simultaneously cross each other and drip in the instantaneity of the work assorted and suspended in its generously offering itself as a vision.

In its nomad creativity, art in the 70s has found its own movement par excellence, the possibility of unlimited free transit inside all territories with open references in all directions. Artists like Bagnoli, Chia, Clemente, Cucchi, De Maria, Paladino, and Salvadori work in the mobile field of the *trans-avantgarde,* meaning the crossing of every experimental notion of the avant-garde according to the idea that every work presumes an experimental *manuality,* the artist's surprise at a work no longer constructed according to the certainty expected of a project and of an idea but which forms itself before his eyes under the pulsion of a hand which dips inside the substance of art in an "immaginario" embodied somewhere between idea and sensitivity.

The notion of art as catastrophe, as unplanned accidentality making each work different from the rest, creates a transitability for young artists, even within the limits of the avant-garde and its traditions, no longer linear but made up of returns and projections ahead, according to a movement and a vicissitude which are never repetitive since they follow the sinuous geometry of the ellipse and the spiral.

The *trans-avantgarde* means taking a nomad position which respects no definitive engagement, which has no privileged ethic beyond that of obeying the dictates of a mental and material temperature synchronous to the instantaneity of the work.

Trans-avantgarde means opening up to the intentional chess-mating of Western culture's logocentrism, to a pragmatism which returns space to the work's instinct, not pre-scientific attitude but if anything the maturing of a post-scientific position which exceeds the fetishistic adjustment of contemporary art to modern science: the work becomes the moment of an energetic functioning which finds the strength to accelerate and to achieve inertia within itself.

Thus question and answer come to a draw in the image match, and art bypasses avant-garde production's feature of setting itself up as an inquiry, ignoring the spectator's expectations in order to arrive at the sociological causes provoking them. Avant-garde art always presumes discomfort and never the happiness of the public, obliged to move out of the field of the work to understand its complete value.

The artists of the 70s, whom I call the *trans-avantgarde,* have rediscovered the possibility of making the work clear through the presentation of an image which is simultaneously enigma and solution. In this way art loses its nocturnal and problematic side, its pure inquiry, in favor of a visual solarity which means the possibility of realizing works well-made, in which the work really functions as a *look-tamer,* in the sense that it tames the restless glance of the spectator, used to the avant-garde's open work, the planned incompleteness of an art which needs the spectator's intervention to be brought to perfection.

Art in the 70s tends to bring art back to a place of satisfying contemplation where the mythic distance, the far-away contemplation, is brimming over with eroticism and energy originating in the work's intensity and in its internal metaphysics.

The *trans-avantgarde* spins like a fan with a torsion of a sensitivity that allows art to move in all directions, including towards the past. "Zarathustra wants to *lose* nothing of mankind's past, he wants to throw everything into the crucible." (Nietzsche) This means not missing anything because everything is continually reachable, with no more temporal categories and hierarchies of present and past, typical of the avant-garde, having always lived the time to its back as archeology, and in any case as evidence to reanimate.

Excerpts from "The Italian Trans-Avantgarde" by Achille Bonito Oliva. Reprinted from *Flash Art* (October/November 1979): 17–20. Used by permission.

Transformations

Nicholas Serota

With notable exceptions, it is British sculpture rather than British painting which has commanded international attention since 1945. Perhaps we should not therefore be surprised that during a period in which the large international exhibitions have been dominated by German and Italian painting several younger British sculptors have steadily evolved not so much a new style, as a new manner of working. They have claimed, or reclaimed, for sculpture procedures and areas of enquiry that would have been regarded as out of bounds by their immediate predecessors.

The sculptors in this exhibition constitute neither a group, nor precisely a generation. They have been brought together to show some of the most vital strands in contemporary British sculpture and although the interests and means of two or more may at times coincide they remain distinct individuals.

Most were born in the late forties, only two or three years after Richard Long, Hamish Fulton, John Hillard and Bruce McLean (whose work was shown at São Paulo in 1971), but their work has emerged on to an international stage more than ten years later. For the seventies were a difficult decade, a period of formal study and later of isolation and self-investigation. At least two came to sculpture through other mediums, performance or photography; another trained originally in the discipline of anthropology. Initially several found themselves using the sculptural conventions of their immediate elders: stacking, classifying and using the materials of nature without modification, except in their arrangement in simple configurations on the ground. They continue to have a high regard for the work of the earlier generation (often still friends). In conversation the names of Long, McLean, Flanagan, Carl Plackman and William Tucker are mentioned not as bogeys, as is so often the case between successive generations, but as exemplars not to be matched.

Towards the end of the seventies a new sensibility began to emerge, not half-formed but already fiercely independent. Within two years, 1979 and 1980, sculpture quite suddenly acquired a new license.

The most obvious, and therefore the most widely noticed development, was the extension of the subject of sculpture into new cultural territory. In Britain, sculpture during the seventies, even some of the constructed sculpture which had developed in the wake of Caro, was distinguished by a return to natural forms and rural materials. Cragg's and Woodrow's sudden introduction of the detritus of an urban rather than rural society came as a profound shock. Seventy years earlier Léger, Delaunay and the Futurists had brought the modern age into painting through their depiction of the heroic phase of industrial and city life. No one had found the convincing way of doing the same in sculpture. Cragg and Woodrow scoured the urban environment, collecting evidence of the decidedly unheroic side of contemporary life. Of course the Surrealists has recognised and incorporated the found object into sculpture, Schwitters had used rubbish in his constructions and Chamberlain had presented a specific class of waste, the crumpled husks of American automobiles.

However, Cragg and Woodrow brought the detritus of conspicuous consumption into the gallery, rearranging, re-classifying and transforming it into emblems of the post-industrial age, in which information comes to us not through direct experience, but through the electronic media of the video and TV screen.

In the work of Tony Cragg tension is established between the reading of a single fragment and the reading of the whole image. The particles carry separate messages which confirm, compound, even contradict each other in the manner of a contemporary Babel. The whole reverberates with the chatter and noise of the urban environment, a metaphor made even more appropriate with the recent increase in the size of the elements and their graded arrangement. Woodrow, especially in the single objects, apparently transforms by touch. The metamorphosis seems to occur before our eyes, as the discarded utensils of contemporary life are recycled in the gallery. For each object the reading, and the corresponding social and cultural value, flickers back and forth between original function and present use.

The matter-of-fact procedure which distinguishes the making of sculpture by Cragg and Woodrow has parallels in the pragmatic approach of others. Deacon, for instance, describes himself simply as a "fabricator," and, like Wilding, he starts with a sense of what he wishes to achieve, without knowing all the steps that will take him to his destination. In such work the sculpture evolves slowly through a sequence of trial and correction. The physical and aesthetic properties of the material make a vital contribution to the process, though in contrast to the practice of the late sixties and early seventies material is no longer sovereign. The material is worked and its state and surface are usually changed by the physical acts of applying tension, polishing or treating with chemicals. Both Deacon and Wilding are fascinated by equilibrium, and their sculptures, always finely honed, frequently balanced and susceptible to the slightest interference by touch, recall the inherent instability of matter.

Where Cragg and Woodrow draw attention to the place of man in contemporary society, to clashes of culture and value, Gormley and Kapoor address themselves increasingly to the subject of man as "being." In a modern world their concerns are those of the artists of our most ancient cultures, the mystery and wonder of creation, the cycle of life itself and the dichotomy between the physical and the intellectual, so often regarded as separate and conflicting but essentially aspects of the whole. The sensuality, the latent sexuality, of Kapoor's forms owes nothing to the reading of classical Indian sculpture with which we are familiar in England through the work of earlier twentieth-century British sculptors such as Eric Gill and Jacob Epstein. Kapoor looks to his native India not for images of female abandon and fertility, but for an understanding of the reproductive cycle which embraces both male and female elements, both lingam and yoni. In Gormley's recent figure sculptures there is a corresponding interest in the pattern of existence. For Gormley the human body is but a temporary shell, a vehicle through which the most vital

Allegorical Procedures: Appropriation and Montage in Contemporary Art

Benjamin H. D. Buchloh

transmissions pass. His sculpture and drawings frequently deal with physical and psychic changes of state and the channels through which these occur, the passages within and orifices in the shell.

However, when Gormley presents a figure in stasis, poised and simply listening, he also moves close to the abstracted ears and trumpet-like forms of Deacon. In both the significance resides not only in the emphasis on the senses, but also in the transition from exterior to interior, from the space without to the space within. After more than two decades the biomorphic form has again become a central concern within British sculpture. In the early fifties this concern was characterised by an interest in structure, in the skeleton as the framework of the body. Today, variously in the work of Wilding, Deacon, Gormley, Kapoor, Woodrow, and even recently Cragg, we find a comparable fascination with surface, with the skin as an envelope of the form. The skin is the visible appearance, the surface which establishes the boundary, the defining edge, the volume within and the space without. For contemporary sculptors these different properties offer possibilities ranging, for example, from camouflage in Deacon's *Boys and Girls* to sheath in Gormley's *Three Bodies*, from penumbra in the forms of Kapoor to continuous membrane in the objects of Woodrow.

There is, in all their work, an underlying but pervasive sense of flux, of objects changing in form, shape of appearance. The skin becomes the visible manifestation of this process, a sign of transformations engineered with craft, elegance and wit.

"Transformations" by Nicholas Serota. Reprinted from The British Council, London, *Transformations: New Sculpture from Britain* (1983), exh. cat., 7 – 11. Used by permission.

From the very moment of its inception, it seems that the inventors of the strategy of montage[1] were aware of its inherently allegorical nature: "to speak publicly with hidden meaning," in response to the prohibition of public speech. George Grosz reminisces as follows:

> In 1916, when Johnny Heartfield and I invented photomontage . . . we had no idea of the immense possibilities or of the thorny but successful career that awaited the new invention. On a piece of cardboard, we pasted a mishmash of advertisements for hernia belts, student songbooks, and dogfood, labels from Schnaps and wine bottles and photographs from picture papers, cut up at will, in such a way as to say in pictures, what would have been banned by the censors if we had said it in words.[2]

In a highly condensed form, Grosz charts the terrain of montage as well as its allegorical methods of confiscation, superimposition, and fragmentation. He outlines its materials as much as he points to the dialectic of montage esthetics: to range from a meditative contemplation of reification to a powerful propaganda tool for mass agitation. Historically, this can be seen as being embodied in, for example, the opposition between the collage work of Kurt Schwitters and the montage work of John Heartfield.

The inventors of collage/montage techniques understood that they performed operations on the pictorial or poetical signifying practice that ranged from the most subtle and minute interference in linguistic and representational functions, to the most explicitly and powerfully programmatic propaganda activities. This is apparent, for example, in Raoul Hausmann's recollections of 1931 of the development from phonetic Dada poems to the political polemics of the Berlin Dada group:

> In the conflict of opinions people often argue that photomontage is only possible in two ways: one being the political, the other being the commercial. . . . The Dadaists, after having "invented" the static, the simultaneous and the purely phonetic poem, now applied the same principles with consequence to pictorial representation. In the medium of photography they were the first to create from structural elements of often very heterogeneous material or locales a new unity that tore a visually and cognitively new mirror image from the period of chaos in war and revolution; and they knew that their method had an inherent propagandistic power that contemporary life was not courageous enough to absorb and to develop.[3]

The dialectical potential of the montage technique that Hausmann refers to found its historical fulfillment in the contradiction that is exemplified on the one hand by the increasing psychological interiorization and estheticization of collage and montage techniques in Surrealism (and their subsequent, still continuing exploitation in advertising and product propaganda), and on the other hand by the historically simultaneous development of revolutionary montage and agitprop practices in the work of El Lissitzky, Alexander Rodchenko, and Heartfield, and the almost complete disappearance

of these practices' public social function from history, except for the isolated pursuits of the contemporary avant-garde.

Parallel with the emergence of montage techniques in literature, film, and the visual arts, we witness the development of a theory of montage in the writings of numerous authors since the late 1910s: Sergei Eisenstein, Lev Kuleshov, and Sergei Tretiakov in the Soviet Union; Bertolt Brecht, Heartfield, and Walter Benjamin in Weimar Germany; and later, Louis Aragon in France. It is the theory of montage as it is developed in the later writings of Walter Benjamin, in close association with his theories on allegorical procedures in Modernist art, that is of significance if one wants to arrive at a more adequate reading of the importance of certain aspects of contemporary montage, its historical models, and the meaning of their transformations in contemporary art.

In his analysis of the historical conditions that generated allegorical practices in European Baroque literature, Benjamin suggests that the rigid immanence of the Baroque—its worldly orientation—leads to the loss of an anticipatory, utopian sense of historical time and results in a static, almost spatially conceivable experience of time. The desire to act and produce, and the idea of political practice, recede behind a generally dominant attitude of melancholic contemplation. Similar to the general perception of the world's perishable nature during the Baroque, the world of material objects is perceived as being invalid with the transformation of objects into commodities, a transformation which occurred with the general introduction of the capitalist mode of production. This devaluation of objects, their split into use value and exchange value and the fact that they ultimately function exclusively as producers of exchange value, profoundly affects the experience of the individual.

It is in his later writings, especially in the "fragments" on Baudelaire, that Benjamin developed a theory of allegory and montage based on the structure of the commodity fetish as Marx discussed it. Benjamin planned to write a chapter in the Baudelaire study entitled "The Commodity as Poetical Object," and in one of the fragments there is an almost programmatic description of collage/montage esthetics: "The devaluation of objects in allegory is surpassed in the world of objects itself by the commodity. The emblems return as commodities."[4] By the time this was written the perception of commodities as emblems had already occurred in Marcel Duchamp's Ready-mades and in the main body of Schwitters' collage work, where language and image, taken into the service of the commodity by advertising, were allegorized by the montage techniques of juxtaposing and fragmenting depleted signifiers.[5]

The allegorical mind sides with the object and protests against its devaluation to the status of a commodity by devaluating it a second time in allegorical practice. In the splintering of signifier and signified, the allegorist subjects the sign to the same division of functions that the object has undergone in its transformation into a commodity. The repetition of the original act of depletion and the new attribution of meaning redeems the object. In the scriptural element of writing, where language is simultaneously incorporated into a spatial configuration, the allegorist perceives the essential site of his or her procedure: the Dadaist poet depletes words, syllables, and sounds of all traditional semantic functions and references until they become visual and concrete. Their dialectical complement is the liberated phonetic dimension of language in the Dada sound poem, where expression is freed from the spatial image of language and the usages of imposed meaning. The procedure of montage is one in which all allegorical principles are executed: appropriation and depletion of meaning, fragmentation and dialectical juxtaposition of fragments, and separation of signifier and signified. In fact, the following statement from Benjamin's Baudelaire fragments reads like an exact description of the montage/collage procedures:

> The allegorical mind arbitrarily selects from the vast and disordered material that its knowledge has to offer. It tries to match one piece with another to figure out whether they can be combined. This meaning with that image, or that image with this meaning. The result is never predictable since there is no organic mediation between the two.[6]

Benjamin's theory of montage ultimately outlines a historical critique of perception. The beginning of the Modernist avant-garde comes at the historical turning point where, under the impact of the rising participation of the masses in collective production, the traditional models that had served in the character formation of the bourgeois individual were rejected in favor of models that acknowledged the social facts of a historical situation where the sense of equality had increased to such a degree that equality was gained even from the unique, by means of reproduction. This perceptual change denied unique qualification and it dismantled by implication the hierarchical ordering system of the bourgeois character structure. This transformation of the individual psyche as well as that of larger social structures was anticipated in the new techniques and strategies of montage, in which a new tactility established a new physiology of perception.

The transformation of the commodity to emblem—a phenomenon Benjamin observed in the poetry of Baudelaire—came full circle in the Ready-mades of Duchamp, where the willful declaration of the unaltered object as meaningful and the act of its appropriation allegorized creation by bracketing it with the anonymous mass-produced object. With Duchamp's Ready-mades it seems that the traditional separation of the pictorial or sculptural construct into procedures and materials of construction, a pictorial signifier, and a signified does not occur—rather, all three coalesce in the allegorical gesture of appropriating the object and of negating the actual construction of the sign. At the same time, this emphasis on the manufactured signifier and its mute existence makes apparent the hidden factors determining the work and the conditions under which it is perceived. These range from presentational devices and the institutional framework to the conventions of meaning-assignment within art itself. It seems that what Yve-Alain Bois recently observed in regard to Robert Ryman's paintings is only half the truth in

Duchamp's work: ". . . the narrative of process establishes a primary meaning, an ultimate originating referent that cuts off the interpretive chain."[7]

Duchamp's *L.H.O.O.Q.*, 1919, must be recalled in order to discuss another dimension of the Dadaists' montage operations: the principle of appropriation. In his appropriation of a mass-reproduced icon of cultural history, Leonardo's *Mona Lisa,* Duchamp subjected the printed image to the essentially allegorical procedures of confiscation and inscribed it in a textual configuration that came alive as text only in its phonetic performance. The mechanically reproduced image of the once-unique auratic work functions as the ideological complement to the manufactured commodity that the Ready-made frames in its allegorical schema.

As is well known, beginning in the late '50s and throughout the development of Pop art, commodity images and objects were juxtaposed or run parallel with mechanically reproduced high-cultural icons in the work of Robert Rauschenberg, Andy Warhol, and Roy Lichtenstein. Duchamp's inverted Ready-made, *Rembrandt as Ironing Board,* 1919, which proposed the transformation of an actual cultural icon into an object of use value, found less of a following since it went beyond the culturally accepted limits of iconoclasm. Not since the '20s has the desire for use value in art resurfaced, most likely because it was submerged under pictorial exchange value.

In 1953 Rauschenberg obtained a drawing from Willem de Kooning after informing him of his intention to erase the drawing and make it the subject of a work of his own. After the careful execution of the erasure, which left vestiges of pencil and the imprint of the drawn lines visible as clues of visual recognizability, the drawing was framed in a gold frame. An engraved metal label attached to the frame identified the drawing as a work by Robert Rauschenberg entitled *Erased de Kooning Drawing* and dated 1953. At the climax of the Abstract Expressionist idiom and its reign in the art world this may have been perceived as a sublimated patricidal assault by the new generation's most advanced artist, but it now appears to have been one of the first examples of allegorization in post-New York School art. It can be recognized as such in its procedures of appropriation, the depletion of the confiscated image, the superimposition or doubling of a visual text by a second text, and the shift of attention and reading to the framing device. Rauschenberg's appropriation confronts two paradigms of drawing: that of de Kooning's denotative lines, and that of the indexical functions of the erasure. Production procedure (gesture), expression, and sign (representation) seem to have become materially and semantically congruent. Where perceptual data are withheld or removed from the traditional surface of display, the gesture of erasure shifts the focus of attention to the appropriated historical construct on the one hand, and to the devices of framing and presentation on the other.

A second, equally conspicuous example, Jasper Johns' *Flag,* 1955, not only indicated the beginning of Duchamp's reception in American art, and thus the beginning of Pop art, but more precisely the painting constituted the introduction of a pictorial method that had previously been unknown to New York School painting: the appropriation of an object/image whose structural, compositional, and chromatic aspects determined the decision-making process of the painter during the execution of the painting. The rigid iconic structure functions like a template or framing device which brackets two apparently exclusive discourses, high art and mass culture, yet the junction paradoxically reveals the gap between them all the more. In Duchamp's Ready-mades, the choice of the everyday object remains random and arbitrary. It could almost be argued that to the degree that the Ready-mades and the work emerging from them in American Pop art address mass culture and mechanically reproduced imagery as abstract universal conditions, to the same degree does this work fail to clarify the specific conditions of its own framing and the conditions of its reification as art within the institutional framework of the museum, the ideology of Modernism, and the distribution form of the commodity.

Well-balanced and well-tempered modes of appropriation, and the successful synthesis of relative radicality and relative conventionality, from the mid-'50s on, demarcate the position of American Pop art. This program has always been one of liberal reconciliation and successful mastery of the conflict between individual practice and collective production, between the mass-produced imagery of low culture and the icon of individuation that each painting constitutes.

Here lies the source of Pop art's social success, and the secret behind the present rediscovery and glorified institutionalization of painting under the auspices of a rediscovered and redefined Pop art legacy. If read against the historical moment which was dominated by Abstract Expressionist esthetics and ideology, Rauschenberg's *Factum I* and *Factum II,* both 1957, and Johns' first *Flag* might appear to be scandalous representations of rigidity in their denial of the validity of individual expression and creative authorship. They are, however, delicate constructs of compromise, refining gestural definition and juxtaposing individualized painterly craftsmanship with seemingly anonymous mechanicity, compared to the radical epistemological crudity and seemingly inexhaustible shock of the three-dimensional, unaltered Ready-made.

It could easily turn out to be one of the great ironies of history that a moment of radical truth was contained in Clement Greenberg's conservative formalism after all. He refrained from acknowledging the impact of Duchamp's work—and of the work of the Pop artists, for that matter—because it lacked, as he perceived it, the specific self-referentiality that could purify and verify itself in regard to all conditions of its making and position. This empirical/critical position at least did not fall for the premature delusion of an immediate reconciliation between high art and mass culture, as was implicit in the work of Duchamp's followers. It is not until two generations later, in the mid-'60s, that work emerges that, while taking both minimal and Pop strategies into account, integrates the historical ramifications of the Ready-made model and the consequences of a self-referential analysis of the pictorial construction itself. With this work we see

these conflicts develop a new level of historical significance. It is in the work of artists such as Michael Asher, Marcel Broodthaers, Daniel Buren, Dan Graham, Hans Haacke, and Lawrence Weiner that we see both the beginning of an examination of the framework that determines the pictorial sign and an analysis of the structuring principles of the sign itself.

A work such as Graham's 1966 "Homes for America,"[8] conceived as an art-magazine article, becomes now fully readable as an early example of allegorical deconstruction where the framework of distribution, materiality, and place of the work's ultimate existence determine the structure of the work from its very inception. Graham's "Homes for America" focused on the contemporary framework of esthetic information, the printed magazine page, and the photo reproduction, a sort of "disposable Ready-made." The work inscribed itself into the historical context of minimal sculpture's self-referentiality, and simultaneously denied it by introducing the "content" of serialized, standardized suburban prefabricated architecture.

Independently of each other Graham and Broodthaers had both become aware of the historical consequences of the works of Stéphane Mallarmé. The linguistic and semiotic interests of the early conceptual artists led to a renewed interest in Mallarmé's investigations of the spatialization of the linear, temporal dimension of reading and writing. In his essay "The Book as Object," written and published in 1967,[9] Graham discussed Mallarmé's 1866 project for "The Book," in which the poet conceived a book whose multidimensional geometry implied a complete restructuring of reading and writing as they had been known since the invention of the printed letter. In 1969 Broodthaers published his version of Mallarmé's *Un coup de dés jamais n'abolira le hasard*[10] which exercised literally all the principles of allegorical appropriation and montage as Benjamin developed them.

Broodthaers' *Coup de dés* appropriated the presentational details, format, design, and typography of the cover of Mallarmé's *Coup de dés* as it was published by Editions Gallimard in Paris in 1914; Mallarmé's name, however, was replaced by Broodthaers'. In a manner reminiscent of Rauschenberg's erasure of de Kooning's drawing, Broodthaers operated on the scriptural configurations of Mallarmé's poem: the actual text of the poem was substituted for the original preface. The visual and spatial dimension of the poem's configuration on the page was maintained, but depleted of its semantic and lexical information. Typographical modifications disappeared in favor of pure graphic/linear demarcations that correspond exactly to the position, placement, size, weight, and direction of Mallarmé's spatialized scripture. Since Broodthaers' book was printed on semi-transparent tracing paper, the pages could be "read" not only in the traditional linear, horizontal pattern that is structured on a vertical plane, but on an axis of superimposed planes as well as in verso.

Broodthaers' allegorical deconstruction of the prisonhouse of Modernism alternated between its institutionalized language and its objects: from his foundation of a fictitious museum in Brussels in

1968 where the icons of Modernism were presented as postcard images, to his large-scale installation *The Museum of Eagles,* presented in Düsseldorf in 1972, where 260 artifacts were once again submitted to the process of abstraction from history in the construction of a secondary mythical fiction.[11]

In 1972 Daniel Buren employed appropriation to transfer the viewer's attention from exhibited objects to the underlying framework which determines the conditions of their presentation. In *Exhibition of an Exhibition,* his installation that year for Documenta 5 in Kassel,[12] Buren divided the previously determined sections of the exhibition (painting, sculpture, advertising, propaganda posters, *art brut,* etc.) with elements (white stripes on white paper) that served to demarcate the framing institution and, in one case, actually constituted an autonomous painting. The most spectacular collision occurred when by coincidence Johns' *Flag,* 1955, was placed on one of the demarcated wall areas, revealing the historical distance between the two works and the specificity with which Buren had overcome the randomness of Johns' attempt to fuse high art and mass culture.

One of the first works that actually incorporated the commodity structure directly into the elements of presentation was Hans Haacke's contribution to the summer festival "L'art vivant americain" at the Maeght Foundation, St. Paul de Vence, France, in 1970. Haacke complied with the organizer's request to contribute to a "non profit avant-garde festival" by linking his contribution to the concealed promotion of salable objects at the nonprofit foundation. Haacke's "performance" consisted of a tape-recorded litany of prices and descriptions of Maeght Gallery prints on sale in the bookstore of the foundation. The recording was interrupted only by news agency teletype reports read over the phone from the office of the newspaper *Nice-Matin.*

It seems that only fear of audience protest deterred the organizers from banning Haacke's work. The history of attempts by museum authorities and exhibition organizers to censor Haacke's endeavors to reintroduce repressed elements in cultural production into the official face and functioning of cultural institutions proves the truly allegorical qualities of Haacke's art. In a number of works Haacke has chosen to write art history as commodity history—most prominently in the chronology of owners of the *Asparagus Still Life* by Manet (banned from an exhibition in Cologne in 1974), and of Seurat's *Les Poseuses.* More recently he has investigated the economic practices and maneuvers of Peter Ludwig, a major cultural benefactor and collector, uncovering the actual benefits and privileges that the apparently selfless generosity of the Maecenas implies (*Der Pralinenmeister* [*The Master Chocolate Maker*], 1981).[13]

In an American context, two works from the late '70s must also be mentioned as prefiguring contemporary allegorical investigations: Louise Lawler's untitled 1978 installation at Artists Space in New York,[14] which included a painting from 1824 by Henry Stullmann representing a racehorse (loaned by the New York Racing Association), and Michael Asher's contribution to the 73rd American Exhibi-

tion at the Art Institute of Chicago in 1979, which appropriated a bronze replica of Jean-Antoine Houdon's life-size marble sculpture of George Washington. Due to their enigmatic procedures these works have received little critical attention,[15] yet they both functioned as reverse historical mirrors, critically anticipating the antirational tendencies in esthetic production that are presently dominating us. Lawler's installation made the elements of an exhibition the subject of her production. As her contribution to the catalogue for the exhibition she designed a logo for Artists Space, and a poster with that logo was distributed outside of the exhibition. The actual exhibition consisted of the appropriated painting which, displaced and totally out of context, functioned as an allegorical shell, the negation of a historical tendency. Two stage lights illuminated the arrangement. One confronted the viewer's eyes from above the painting (interfering with perception of the painting itself) and the other was directed through the exhibition space, out the window and onto the street, connecting the isolated exhibition space with its outside environment and bringing the exhibition to the attention of the immediate neighborhood.

It was with the work of this group of artists that questions of material definition, site (physical, social, and linguistic), and ultimately questions of mode of address and audience became essential. Anyone taking the implications of the situational esthetics developed in the late '60s and '70s into account as an irreversible change in the cognitive conditions of art production would have to realize that any return to an unconditioned autonomy of art production would be mere pretense, lacking historical logic and consequence, just as any attempt to reinstitute the conventions of representation after Cubism is absurd. This does not imply that, for example, Lawrence Weiner's reduction of esthetic practice to its linguistic definition, Buren's and Asher's analysis of the historical place and function of esthetic constructs within institutions, or Haacke's and Broodthaers' operations revealing the material conditions of those institutions as ideological would embody positions that could not be logically continued and developed further. (The dialectical reply to these positions, of course, is not, as might currently be thought, a return to the obscurity of historically nonfunctional conventions and the commodity camouflage that they provide.)

The precision with which these artists analyzed the place and function of esthetic practice within the institutions of Modernism had to be inverted and attention paid to the ideological discourses outside of that framework, which conditioned daily reality. This paradigmatic shift occurs in the late '70s in the work of such artists as Dara Birnbaum, Jenny Holzer, Barbara Kruger, Louise Lawler, Sherrie Levine, and Martha Rosler, where the languages of television, advertising, and photography, and the ideology of "everyday" life, were subjected to formal and linguistic operations that essentially followed Roland Barthes' model of a secondary mythification that deconstructs ideology. Barthes' strategy of secondary mythification repeats the semiotic and linguistic devaluation of primary language by myth and structurally follows Benjamin's ideas on the allegorical pro-

cedure that reiterates the devaluation of the object by commodification. It seems justifiable therefore to transfer the notion of montage and allegory, as discussed above in the context of avant-garde practice of the first half of the century, and to extend its ramifications into a reading of recent and contemporary work.

The political spectrum within which these artists operate—inasmuch as it can be read in the work itself and inasmuch as it can be at all isolated from the current climate of desperation and cynicism—encompasses a variety of positions. They range from the apparently outright denial of productivity and dialectical construction in the work of Levine, to the agitprop position of Rosler's work. Holzer's anarcho-*situationniste* position trusts the strategy of an unmediated street activity in which anonymous posters generate a confrontation between language and its daily ideological performances, while Birnbaum's videotapes rely entirely upon and aim at mediation within both a high-art framework and corporate media production.

The risk of Levine's position is that it might function ultimately in secret alliance with the static conditions of social life as they are reflected in an art practice that is concerned only with the work's commodity structure and the innovation of its product language. Rosler's position runs the risk of ignoring the structural specificities of the work's circulation form and distribution system, and of failing to integrate her work efficiently into the reception of current art practice, when the work's actual claim is in fact radical political awareness and change. The dilemma underlying Holzer's work is that for the sake of direct action within language, it ignores the mediating framework of the institutions within which ideology is historically placed and has to support the radicality and apparent independence of that position with an increasing number of compromises to the framework that was originally dismissed. Finally, the risk for Birnbaum's work is that it could integrate itself so successfully into the advanced technology and linguistic perfection of governing television ideology that its original impulse of critical deconstruction could disappear in a perfect blending of a technocratic estheticization of art practice and the media's need to rejuvenate its looks and products by drawing from the esthetics of the avant-garde.

The inability of current art criticism to recognize the necessity and relevance of artists working within these parameters results partially from art history's almost total failure to develop an adequate reading of Dada and Productivist theory and practice, particularly of the activities of "factography" and documentary work and the range of agitprop production that emerged from it—for example, in the work of Osip Brik, Vladimir Mayakovsky, Liubov Popova, and Tretiakov, as much as the still essentially ignored key figure of montage practice, John Heartfield. Once these activities are admitted to the framework of legitimization that art history provides, their consequences for contemporary practice will become more readable.

It is furthermore not surprising that the impact of the work of the artists of the '60s and '70s on a contemporary understanding of art production and reception had hardly occurred before the need to

revitalize the art market brought about a reinstitution of obsolete production procedures in the guise of a new avant-garde of painting. Simultaneously, however, a different range of esthetic positions has been developed by this new generation of artists which continues and expands one of the essential features of Modernism—its impulse to criticize itself from within, to question its institutionalization, its reception, and its audience.

At a moment when the analysis of the institutional framework had become an issue that could safely be absorbed and integrated into the codex of institutional exhibition topics—a moment when the lasting supremacy of the functions of the museum had been widely reaffirmed and reinstituted by a general return to traditional artistic production procedures—Michael Asher abandoned the liberally delegated option to adorn the institution's repressive tolerance, by expanding the focus of the deconstruction. An untitled decentralized installation was his contribution to the exhibition "The Museum as Site" at the Los Angeles County Museum of Art. Asher's work integrated three fragments from heterogeneous discourses: 1) a wooden sign carrying the inscription "Dogs Must Be Kept On Leash Ord. 10309" was replaced in the park surrounding the museum at precisely the same spot from which it had been previously lifted by vandals. The sign was produced by the park authorities to match the rustic, handcrafted look of the other signs existing in the park. 2) A poster with a color reproduction and a black and white still photograph showing the same scene from the movie *The Kentuckian* was placed in the main entrance court of the museum on a brass placard which the museum normally announces its special events and lectures. Along with those two images (which show Burt Lancaster as "The Kentuckian" stepping out of a forest with a child, a woman, and a dog, facing two men with rifles) a map of the museum's park indicated the location of the replaced sign and identified it as Asher's contribution to the exhibition. 3) The viewer was furthermore informed that the museum's permanent collection housed a painting by Thomas Hart Benton entitled *The Kentuckian*, 1954, which had been commissioned on the occasion of the film's release. The painting, depicting Lancaster and a little boy, a dog, and a blossoming plant on the top of a mountain, was originally in Lancaster's collection, and was donated by him to the museum.

Inside the museum, the visitor could in fact find Benton's painting in its usual place in the permanent collection, without any additional information referring to Asher's temporary appropriation. Asher provided fewer clues or instructions here than in his previous works to enable the viewer to assemble and synthesize the various elements of his installation. The work's ephemeral existence and the dispersion of its elements made it likely that parts (or all) of the installation remained unseen by viewers who have recently become readapted to the traditional highly condensed and centralized esthetic constructions of visual regulation.

Benton's stridently anti-Modernist painting, inasmuch as it reveals his overtly sexist, racist, and chauvinist position dating from the McCarthy era, provided in the context of Asher's installation a dis-

comforting historical example of the political implications of those moments when a breakdown of Modernist thinking and a return to traditional models of representation occurs. Asher's work seemed to perceive itself as being a historically comparable situation, and it responded to the cultural symptoms of authoritarianism with a request to the viewer for an active commitment to reading and seeing an ephemeral, allegorical analysis. Appropriation functioned in Asher's work primarily in a designatory manner to establish a context and generate an awareness of the layers of ideological determination that condition the conception and construction of a work of art.

Ephemeral existence and marginal productivity in Asher's work do not imply a position of self-effacing complacency or melancholic contemplation. His work is almost totally constructed in the juxtaposition of various discourses of power and the subliminal gesture of arranging appropriated elements. In the same way that the reinstallation of the dog sign in the park of the museum denies the historical interest of an academicized notion of site-specificity in response to the topic of the exhibition, the reference to the movie and its star (as the donor of the painting) confronts the museum's function and activity with the comparison of high culture and mass culture, and the gradual transformation of high culture's institutions into appendices of corporate culture and the culture industry. The historical absurdity of an easel painting that was commissioned by a movie corporation from a master of representational painting, as a promotional gadget for the release of a film, and that was subsequently donated by a movie star to the collection of the museum, transcends any simple reflection of the local cultural conditions in Los Angeles. The iconic reference to the dog in fact functions as a pretext to the hidden dimension of authoritarianism in the representational painting.

Ultimately it is in the nature of the objects (i.e., their materiality and status) and their placement, as much as in their interrelationship, that the complex references of Asher's work become fully evident. Each element continues to exist within its own context as well as entering the superimposition of discourses that is Asher's work. By setting Benton's painting within its historical context (i.e., its place and function, its patron and original purpose), it acquires exemplary significance for contemporary painting and its conceits. As technically reproduced images, the poster and still photograph that were placed in the museum's showcase doubled their representation; they assumed temporarily and peripherally the status of art objects in the context of Asher's work, clarifying the unique, auratic object's dependence on technical reproduction and mass culture. The sign in the park, the only manufactured object produced for the purposes of this installation, was in fact the most functional object. In Asher's work the appropriated objects are not subjected to a finite status as art objects. To the degree that their historical authenticity and function are maintained and decentralized reading and viewing are necessitated by the absence of a unified, authorial presence, the work avoids the status of the fetish and resists commodification.

For the time being, at least, Sherrie Levine functions as the

strongest negation within the gallery framework of the re-emergent dominance of the art commodity. Her work, melancholic and complacent in defeat, threatens within its very structure, mode of operation, and status the current reaffirmation of individual expressive creativity and its implicit reaffirmation of private property and enterprise. At a historical moment when a reactionary middle class struggles to ensure and expand its privileges, including those of cultural hegemony and legitimization, and when hundreds of talents in painting obediently provide gestures of free expression with the cynical alibi of irony, Levine's work places itself consistently against the construction of the spectacle of individuality. Continuing and readjusting a position defined by Duchamp and updated by Warhol, her allegorical appropriations prove that Baudelaire was wrong when he argued that the poetical was necessarily alien to female nature since melancholy was outside the female emotional experience. Enter the female dandy, whose disdain has been sharpened by the experience of phallocratic oppression, and whose sense of resistance to domination is therefore more acute than that of her male colleagues, if they still exist.

In the current historical situation artists adopt the psychosexual standards of obsolete role models and provide products for the market, but fail to change esthetic practice. However, by transcending character formation, commodity form, and institutionalization through the redefinition of esthetic practice, they may fail to enter public awareness since they do not fulfill the public's expectations, and do not abide by the rules of culturally acceptable deviation. Contemporary male avant-garde models, in particular, seem to imply a return to obsolete notions of culture in order to ''. . . exemplify an attitude within which the bourgeois world can first and foremost find its identity, that of the enchanted consumer . . . By doing so the ideological condition of the *posthistoire* which late capitalism claims for itself, would equally be reaffirmed by art practice.''[16] No wonder, then, that strategies of allegory and montage which once dislocated and decentralized the hierarchical subject, generating participation in the tactility of the particularized fragment and rupturing the contemplative stance of the viewer, now return in painting, reconciled and thwarted, as abused gadgets of a decoration that offers empty codes and strategies for sale.

Strategies of fragmentation in contemporary painting seem to have sunk literally to the level of household goods. What was once, in the work of Antonio Gaudí and Simon Rodia, an index of the collective participation in everyday life of the oppressed and exploited, and which therefore rightfully entered the language of architecture as ornament in Gaudí's and Rodia's visionary constructions, has now been reduced to the level of gewgaws in paintings for a clientele whose vision is limited to the index of the commodity market.

By contrast, the contemporary montage work of Asher, Birnbaum, Levine, and Rosler uses methods of appropriation and montage conclusively and explicitly without estheticizing them in a historicist conceit that functions as an auratic disguise of the com-

modity. We can find strategies and procedures of quotation and appropriation in contemporary painting, but the very mode of painting provides an experience of reconciliation.

In contemporary paintings the ultimate subject is always a centralized author, whereas in contemporary montage procedures the subject is the reader/viewer. Even the ''conspicuous'' delegation of certain painterly tasks of figurative representation to anonymous commercial experts or professionals, who draw bunnies or bombers, does not resolve the historical limitations of this production procedure and its incapacity to develop an adequate viewer-text relationship.

It is in the critical analysis of the actual procedures and materials of production and reception that a work's historical legitimacy will be evident. In expanding the spacing of elements,[17] singularizing the elements of appropriation, and redirecting the viewing/reading to the frame, the new montage work decentralizes the place of the author and subject by remaining within the dialectic of the appropriated objects of discourse and the authorial subject, which negates and constitutes itself simultaneously in the act of quotation.

To the degree that the various sources and authors of quoted ''texts'' are left intact and fully identifiable in truly contemporary montage, the viewer encounters a decentralized text that completes itself through his or her reading and comparison of the original and subsequent layers of meaning that the text/image has acquired.

Levine's notion of fragmentation differs from the phallocratic tendency which associates fragmentation with broken saucers, burnt wood, and crumpled straw. In her seemingly random selection of imagery from the history of Modernism, representations are literally fragmented, torn from the hermetic totality of the ideological discourse within which they currently exist. Thus, just as Benjamin described the allegorical procedure, Levine devalues the object of representation for the second time. She depletes the current commodity status of photographs by Walker Evans, Edward Weston, Eliot Porter, and Andreas Feininger for the second time by her willful act of rephotography, by restating their essential status as multiplied, technically reproduced imagery.

Levine's apparently radical denial of authorship might fail to recognize the socially acceptable, if not desirable, features it implies: a reaffirmation of the dismantling of the individual, and a silent complacency in the face of the static conditions of reified existence. The faint historical spaces the work establishes between the original and the reproduction seduce the viewer into fatalistic acceptance, since these spaces do not open up a dimension of critical negativity that would imply practice and encounter rather than contemplation. This is one essential difference between Levine's position and that of Martha Rosler; it is evident in their differing attitudes toward the notion of historical authenticity and the material, i.e., social truth of their objects of appropriation. In true allegorical fashion Levine subjects historical objects to an act of confiscation where their innate authenticity, historical function, and meaning is robbed for the second time. Levine's attitude embodies the ambivalence of the artist

and intellectual who lacks class identity and political perspective, exerting a certain fascination over those contemporary critics, including myself, who are equally ambivalent toward their affiliations with the powers and privileges that the white middle class provides. This attitude is evidenced in the following statement by Levine:

> Instead of taking photographs of trees or nudes, I take photographs of photographs. I choose pictures that manifest the desire that nature and culture provide us with a sense of order and meaning. I appropriate these images to express my own simultaneous longing for the passion of engagement and the sublimity of aloofness. I hope that in my photographs of photographs an uneasy peace will be made between my attraction to the ideals these pictures exemplify and my desire to have no ideals or fetters whatsoever. It is my aspiration that my photographs, which contain their own contradiction, would represent the best of both worlds.[18]

Walter Benjamin, in spite of his devotion to the allegorical theory and its concrete implementation in the work of Baudelaire and the montage work of the '20s, was aware of the inherent danger of melancholic complacency and of the violence of the passive denial that the allegorical subject imposes upon itself as well as upon the objects of its choice. The contemplative stance of the melancholic subject, the "comfortable view of the past," he argued, must be exchanged for the political view of the present.[19] This view was developed in "The Author as Producer,"[20] a text in which all reflection upon allegorical procedures has been abandoned and in which he comes closest to the development of a factographic, Productivist position, as it was outlined in the writings of Brik and Tretiakov.

According to Benjamin the new author must first of all address the Modernist framework of isolated producers and try to change the artist's position from that of a caterer of esthetic goods to that of an active force in the transformation of the existing ideological and cultural apparatus. This essentially different position is evident in Martha Rosler's approach toward historical objects and the photographic conventions they embody. Two works that suggest a comparative reading with Levine's work are *The Bowery in two inadequate descriptive systems*, 1974–75, and the critical essay/piece "in, around, and afterthoughts (on documentary photography)," 1981.[21] In both works photographic conventions are addressed as a linguistic practice, whose historical position is evaluated in its varying affiliations with general social and political life, rather than with the criteria of neutrality that the program of photographic Modernism prescribes.

In *The Bowery in two inadequate descriptive systems*, a photo-text work which includes black and white photographs of Bowery store fronts and photographs of word-lists describing drunkenness, conventions of urban architectural photography are appropriated in restaged photographs that loosely seem to take the photographic stance of Walker Evans. However, these conventions are executed by

Rosler rather than simply confiscated, as is the case with Levine. Rosler's crude attempts to try her photographic hand at mimicking the great urban "documentarians'" style is of course as thoroughly disappointing to the cultivated photographic eye as Levine's photographs are to the collector's hand.

Rosler describes *The Bowery . . .* in explicitly allegorical terminology:

> In *The Bowery* the photographs are empty and the words are full of imagery and incident. . . . A lot of photographers made pictures of Bowery bums. That upset me because I thought it was a false endeavor, that it involved a pretense that such photos were about the people when they were really about the sensibility of the photographers and the viewers. It's an illicit exchange about compassion and feeling and the bums are victims of this exchange between the photographer and the viewer. They provide the raw materials for a confirmation of class and privilege. . . . I wanted to make a point about the inadequacy of that kind of documentary by contrasting it with verbal images. . . . I didn't want to use words to underline the truth value of the photographs, but rather words that undermined it. I felt that just as the images are expected to be poetic but aren't even "original"—they follow a tradition of street-photography and have more to do with commerce than with anything else, since they're shopfronts—the words would be a kind of unexpected poetry. Their ironic humor would cut against and be cut against by the deadpan photographs.[22]

It is not surprising that in the same interview Rosler introduces the question of a contemporary collage practice and its historical function and possibilities into the discussion of her work, and that the definitions she supplies coincide with the general outline of contemporary montage as I have tried to develop it in the course of this essay:

> I think it's even more valid to talk about contradiction than about collage, because much of the collaging consists of contradiction, putting things together that don't go together, but that are connected in some way. . . . Many of the contradictions I want to talk about in my work are not simple riddles of existence but things that arise from the system we live under which makes impossible and conflicting demands on us. I like to point to situations in which we can see the myths of ideology contradicted by our actual experience.

If Levine's position seems to originate from the cynical tradition of dandyism, then Rosler's seemingly naive attempt at recycling exhausted photographic conventions to clarify their historical meaning and their inadequacy for contemporary documentary production insists on maintaining an element of individual practice. In the futility of that naive attempt and in the revelation of its shortcomings she disqualifies the ahistoricity of abstracted photographic ambition all the more.

Rosler's critical writing such as "in, around, and afterthoughts (on documentary photography)," uses the format of criticism successfully to analyze the historical and political implications of contemporary photography. Here, instead of restaging photographic conventions, Rosler transforms the current interest of certain photographers (who have turned back to the history of their own discipline by rephotographing "in the manner of the masters . . . the subjects of the great tradition of Modernist photography") into actual confrontation with the material reality of the "subjects," i.e., the "victims" of photography. In so doing she takes away that veil of esthetic neutrality behind which photographic activity has hidden. If Levine's abstract and radical denial of production and authorship could place her ultimately on the side of the existing power structure against her wishes, then Rosler's attempt at constructing artwork outside of the existing level of esthetic reflection and formal procedures places her on the side of a political commitment which could fail precisely because of its lack of power within current art practice.

Dara Birnbaum's work does not merely employ rediscovered Pop art strategies, as is currently fashionable in the context of painting and still photography. Her work critically embodies all the concerns that originated in Pop art and were subsequently developed further in Minimal and post-Minimal art of the late '60s and early '70s. When she states that she "wants to define the language of video art in relation to the institution of television in the way Buren and Asher had defined the language of painting and sculpture in relation to the institution of the museum," it becomes clear that her work operates programmatically within both frameworks. It analyzes the overt ideological functions of the language of mass culture with the tools that the practice of high art provides. Simultaneously it looks upon the conditions of high culture—its isolation and privileged position, its commodity status and fetish existence—from the perspective of mass culture in its most advanced form: the television industry. Birnbaum's work integrates both perspectives in a dialectical exchange which has the potential to affect the languages of both art and television, though the work has not yet assumed a comfortable position in either institution. Seeing her work in a traditional gallery situation—for example, during her installation at P.S. 1 in New York in 1979—made the work's references (both implicit and explicit) to the past decade of sculptural thinking and transformation instantly readable. It emerges out of that historical moment in sculpture when artists such as Bruce Nauman and Dan Graham began to use video as a tool to implement a phenomenological understanding of viewer-object relationships as they had been introduced through Minimal sculpture. They gradually developed analytical video installations and performances that not only focused on the viewing process, but involved either author and audience, audience and object, or audience and architecture in an explicit and active interchange.

With the growing theatricalization of video and performance in the mid-'70s and its increasing tendency to narcissistic estheticization, it is understandable that the focus of the video activities of politically committed artists would return to television. At that time

such tapes as Richard Serra's *Television Delivers People,* 1973, emerged, differing substantially from the artists' tapes for television broadcast that had been previously produced but that had simply channelled artistic performance material on videotape through television, rather than addressing the language of television itself. The programmatic position of Fluxus ideas in Nam June Paik's pioneering video/television work of the mid to late '60s was that the visual culture of the future would be contained in and affected by the emergence of television as the primary social practice of visual meaning production, just as visual culture in the 19th century had been profoundly affected by the invention of photography. Birnbaum logically refers to Paik as one of the key figures to have influenced her thinking, along with Graham, with whom she collaborated in 1978 on a major project proposal entitled "Local Television New Program Analysis for Public Access Cable TV."[23]

Birnbaum's tapes using material taped off broadcast television focus first and foremost on the meaning of technique, the specific conventions and genres of television. In the formal analysis of these conventions and the mixing of genres their ideological functions and effects become transparent. It is crucial to understand to what extent Birnbaum's work is anchored in the structures that determine collective perceptual experience. Due to its revelatory deconstructive procedures, the work does not participate in the proliferation of artist-produced, innovative media strategies which in the end only function to bring television ideology esthetically up to date.

Birnbaum's videotapes appropriate television footage ranging from sitcoms and soap operas such as "Laverne and Shirley" and "General Hospital" to live broadcast material such as "Olympic Speedskating" and commercials for the Wang Corporation. They are ultimately destined for television broadcast, where they could most effectively clarify their functions in situ and in flagrante, but the contradictions within which the work exists place it, for the time being, exclusively within the framework of a high-art avant-garde discourse. Should it actually be shown on commerical television, its essentially esthetic nature might become all the more apparent, and its critical potential might decrease. The striving, necessary as it is, for a position of power within the media is therefore also the most vulnerable aspect of Birnbaum's work. This becomes most evident in *Remy/Grand Central: Trains and Boats and Planes,* 1980, where the attempt to embody the interests of a corporation's "support" for young artists in a simulacrum of an advertisement results in a construct that at best could be perceived as parody, and at worst could all too easily be misperceived as a new advertisement gimmick. It is not surprising that the work's potential for affirming a final, totalitarian synthesis of the culture industry and esthetic production would occur in an independent construct that mimics advertising conventions rather than addressing its critical acuity to found materials, which is the rule in almost all of Birnbaum's other tapes.

Technology/Transformation: Wonder Woman, 1978–79, unveils the puberty fantasy of Wonder Woman that has grown historically from a comic-book figure to a nationally broadcast television series.

This progression provides an image of crisis which, like the resurrection of Superman in film, feeds a collective regression toward icons that recall the monolithic powers that children perceive heroes, parents, and the state to be. The prime focus of this tape seems to be the inexhaustible special effects that corporate television and film producers draw upon when state power most urgently needs to be mystified. Iconographically this tape runs parallel to the comic-book-hero-turned-television-mirage in the same way that Lichtenstein's paintings placed themselves within and against the graphic techniques of comic-book reproduction in the '60s.

The formal procedures of fragmentation and serial repetition to which Birnbaum subjects the appropriated television material expand Warhol's pictorial strategy of serializing commodity imagery, and his and Bruce Conner's device of using film loops and serialized segments. They break the temporal continuity of the television narrative and split it into self-reflexive elements that make the minute and seemingly inextricable interaction of behavior and ideology an observable pattern. As a result of the precision with which Birnbaum employs these allegorical procedures we discover with unprecedented clarity to what degree the theater of professional facial expressions, performed by actors in close-ups on the television screen, has become the new historical site of the domination of human behavior by ideology. This becomes particularly evident in the ingenious juxtaposition of segments from a live broadcast of women speedskating at the Olympics and a segment from the "real-life" soap opera "General Hospital" in her tape *POP-POP-VIDEO: General Hospital/ Olympic Women Speed Skating*, 1980. The desperation of a female doctor, confessing in a series of reverse-angle shots to her paternal male colleague her failure in handling a communication breakdown with a man whose identity is not revealed, is tightly counterpointed by the spectacle of Olympic vigor and velocity. The splendor of a neo-futuristic imagery that celebrates the subjection of the female body to abstract instrumentalization does not become a sort of Leni Riefenstahl on color TV because of the image's constant paralleling with the spectacle of neurotic collapse in the features of the female doctor. Physiognomic detail and its meaning spark off even more in the tape *Kiss the Girls: Make Them Cry*, 1979, which extracts segments from the game show "Hollywood Squares."

Walter Benjamin's observation that neurosis has become the psychological equivalent of the commodity becomes obvious in the physiognomical detail of hyperactive television actors and actresses, a reading that is provided by Birnbaum's astute selection of details and the formal procedures to which she submits her material. The total apparatus of television technology and the machinations of its conventions become readable as instruments of ideology in visual language; the ideological instrumentalization of the individual is manifested in physiognomic spectacle. In Birnbaum's work the viewer is confronted with bare layers of ideology *mise en abyme*: the patterns of behavior on the screen anticipate and exemplify what television aims to achieve within the viewer—they are exercises in submission and adaptation.

Birnbaum's perspective on the technique of television does not seduce her into using those techniques as visual gadgetry employed for the sake of "pure pleasure" or "formal play," which always conceal estheticizing ideology. The visual pleasure that Birnbaum's tapes may generate in the viewer is balanced by cognitive shock. For example, in her Wonder Woman tape special effects appear as sexually disguised violence offering images of power and technological miracles as a diversion from the reality of social and political life; the shock resides in the recognition that such sexist representations of a female figure as a vehicle of male and state power are the cynical ideological complement to an actual historical situation in which radical political practice seems to have been restricted to feminist practice.

This becomes all the more transparent in the juxtaposition of sound and imagery that occurs in the second part of the tape. In the first part the staccato serializations and freeze-frame images of a spinning, running, fighting Wonder Woman are accompanied by original soundtrack fed through the same formal procedures as the images. The second part of the tape visually consists of the lyrics (in white letters on a blue background) of a disco song also called "Wonder Woman." Birnbaum happened to come across this relatively obscure disco song while she was editing the television footage. The graphic, scriptural representation of female sighs and of lyrics that we are normally supposed to hear, but not to read, inverts the split of the phonetic and graphic elements of language which we saw earlier in Duchamp's pun. Here, in the scriptural allegorization of the disco song, we become aware that even the most minute and discrete phonetic elements of such popular music (sighs, moans, etc.) are as soaked in sexist and reactionary political ideology as the larger syntactic and semantic structures of the lyrics.

The dimension of sound plays a very important role in Birnbaum's tapes in general—it does not perform the subservient role of phonetic illustration and emphatic massage to which music in film and television usually has been reduced. The restoration of sound to a separate discourse which runs parallel to the visual text makes the viewer aware of the hidden functions that sound normally fulfills.

In one of Birnbaum's recent works, *PM Magazine*, 1982, a four-channel video and sound installation at the Hudson River Museum,[24] she extrapolates the function of sound even further, just as she expands the material elements into the conditions of painting and sculpture, and of the museum framework which contains them. Two panels on opposing walls featured large black and white photostat images extracted from the television footage used in the installation, framing one and three monitors respectively. A wall surface was painted bright blue for the three-monitor panel and bright red for the one-monitor panel, both of which were graphically emphasized by Birnbaum. The panels possess the qualities of the kind of enlarged photographic imagery that might be encountered in trade-show displays. They are reminiscent of the grand-scale exhibition panels in the later Productivist work of El Lissitzky, such as his installation for

the Soviet Pavilion of the International Pressa Exhibition in Cologne in 1928 with Sergei Senkin, or the International Hygiene Exhibition in Dresden in 1930, in which photomontage techniques were expanded onto the level of agitprop architecture. Birnbaum's panels have lost their "agit" dimension for the sake of the museum "prop." As such they enter a dialectical relationship with the current return to large-scale figurative multi-panel painting which uses quotation as an end to legitimize historicism.

Quotation functions in Birnbaum's work as a means to disentangle this historicist collapse and to reinstate each element to its specific function and place. She transfers the procedure and syntactic structuring principle of spacing, which Rosalind Krauss has discussed in the context of Dada collage and Surrealist photography, from the level of material and iconic elements to that of perceptual modes—visual, tactile, and auditory—and their material correlatives—the iconic image, the planar sign, color, architectural space, and sound.

In this complex work the framework of the museum is bracketed with the commercial display, on the one hand, and the historic dimension of agitprop montage, on the other. In the *PM Magazine* trailer Birnbaum juxtaposes state-of-the-art editing techniques with electronically generated imagery of state-of-the-art animation techniques, recycling icons of the '50s American dream of leisure time and consumption. Television techniques and technology are made to refer to themselves and become transparent as the ultimate instance in which ideology is structured and contained. In the same way that the visual material is processed in four three-minute loops, the soundtrack of the trailer—or the key motifs of it—are run through four channels. Once again it is the auditory dimension that reveals most clearly the work's essential decentralization. The elements of the installation could only become congruent as text within the individual experience of an active viewer.

Birnbaum unfolds the historical potential of montage technique as it originated in Cubist and Constructivist relief constructions and as it was transformed and particularized in the work of the '60s and '70s ranging from Dan Flavin, Nauman, and Serra to Graham and Asher. Her installation, saturated with historical understanding and striving for contemporary specificity, provides an adequate definition and reading of the original implications of relief and montage techniques at a time when the market tries to assure us that their historical fate was to end up as Frank Stella's corporate brooches and Julian Schnabel's art-historical gingerbread.

While it is essential for the work of Birnbaum and Rosler to operate simultaneously inside and outside the framework of institutionalized art distribution, Levine's work functions exclusively within this framework. Only as a commodity can the work fulfill all its functions, and yet, paradoxically, for the time being it cannot be sold. Its ultimate triumph is to repeat and anticipate in a single gesture the abstraction and alienation from historical context to which work is subjected in the process of commodification and acculturation. In this respect Levine's and Birnbaum's work reveals an historical affinity with the position of Warhol, the first American dandy to systemati-

cally deny individual creation and productivity in favor of a blatant reaffirmation of the conditions of cultural reification. Warhol's curriculum ended in the institutions of fame and fashion, as de Sade ended in the Bastille. The fate of his work, which once subverted painting by precisely the same allegorical techniques of confiscating imagery, bracketing high-art and mass-cultural discourses, individual production and mechanical reproduction, was to produce the most singularized and rarefied icons of Pop art.

The artists under discussion here appropriate or "pirate" the material and imagery that they use for their investigation. Like the radical conceptual artists of the late '60s, they question the necessity of their work being relegated to the status of an individualized commodity. And they have been successful in their assault, if only temporarily so—until the general acculturation process finds ways to accommodate these works or their authors find ways to accommodate their production to the conditions of the acculturation apparatus. For ultimately it is the visual, rather than textual existence of a construct that imbues it with material reality, since that reality is the basis of its existence as commodity. In *Mythologies*, 1957, Roland Barthes deconstructed such contemporary myths as designed objects of consumption and advertising. In certain respects this can still be considered as the originary model for the deconstructive approach of the criticism of ideology as it has been developed in the work of the artists analyzed here. Unlike some of these artists, Barthes did not encounter problems of ownership and copyright. But the visual object/image has become the essential ideological correlate of private property.

1.

The introduction of this essay follows partially an argument that has been developed in Ansgar Hillach's attempt to define a notion of montage in the avant-garde of the '20s and its relationship to Walter Benjamin's concept of allegory. See: Ansgar Hillach, "Allegorie, Bildraum, Montage," in *Theorie der Avantgarde*, Frankfurt: Edition Suhrkamp, 1976, pp. 105-142. For a more specific analysis of the complexities and historical changes of Benjamin's allegory-model, I would refer to Harald Steinhagen, "Zu Walter Benjamin's Begriff der Allegorie," in *Form und Funktionen der Allegorie*, Stuttgart: Metzler, 1979, p. 666 ff, and Jürgen Naeher, *Walter Benjamin's Allegorie-Begriff als Modell*, Frankfurt: Klett-Cotta, 1975.

More recently, in regard to Benjamin's theory of allegory, see Bainard Cowan, "Walter Benjamin's Theory of Allegory," in *New German Critique*, No. 26, 1982, pp. 109-122. Cowan's assumption that Benjamin's theory of allegory ". . . has gone virtually without thorough explication," however, indicates, as does his text, that he is not familiar with the more recent literature.

2.

George Grosz, quoted in Hans Richter, *Dada: Kunst und Antikunst*, Cologne: Dumont, 1963. English translation from Dawn Ades, *Photomontage*, N.Y.: Phaidon, 1976, p. 10.

3.

Raoul Hausmann "Fotomontage," in: *A-Z*, No. 16, Cologne, May 1931. Reprinted in *Raoul Hausmann*, exhibition catalogue: Hannover: Kestnergesellschaft, 1981, p. 51 ff. (my translation).

4.

Walter Benjamin, "Zentralpark," in *Gesammelte Schriften*, Vol. 1, 2, Frankfurt: Suhrkamp, 1974, p. 660 (my translation).

5.

The spatialization of time and the adoption of a contemplative stance towards the world that Benjamin discussed in 1925 as the experiential conditions of allegory in the European Baroque were discussed in 1928 by Georg Lukacs as the essential features of the collective condition of reification: "Neither objectively nor in his relation to his work does man appear as the authentic master of the process; on the contrary, he is a mechanical part incorporated into a mechanical system. He finds it already pre-existing and self-sufficient, it functions independently of him and he has to conform to its laws whether he likes it or not. As labour is progressively rationalised and mechanised, his lack of will is reinforced by the way in which his activity becomes less and less active and more and more contemplative. The contemplative stance adopted towards a process mechanically conforming to fixed laws and enacted independently of man's consciousness and impervious to human intervention, i.e. a perfectly closed system, must likewise transform the basic categories of man's immediate attitude to the world: it reduces space and time to a common denominator and degrades time to a dimension of space." Georg Lukacs, "Reification and the Consciousness of the Proletariat," in *History and Class Consciousness*, Cambridge, Mass.: MIT Press, 1971, p. 89.

6.

Benjamin, "Zentralpark," p. 681. The famous anecdote in which Kurt Schwitters described the origin of the term "Merz" as a result of his encounter with an advertising for the *"Kommerzbank"* contains equally *in nuce* all the essential features of the allegorical procedure: fragmentation and depletion of conventional meaning are followed by acts of willful meaning-assignment which generate the poetical experience of primary linguistic processes.

7.

Yve-Alain Bois, "Ryman's Tact," *October*, No. 19 (Winter 1981), p. 94.

8.

Dan Graham, "Homes for America," *Arts Magazine*, December/January, 1966-67.

9.

Dan Graham, "The Book as Object," *Arts Magazine*, June 1967.

10.

Marcel Broodthaers, *Un coup de dés jamais n'abolira le hasard*, Antwerp: Wide White Space Gallery, 1969.

11.

Marcel Broodthaers, *Der Adler vom Oligozän bis heute (The Eagle from Oligocene to Today)*, exhibition catalogue, Vol. I and II, Kunsthalle Düsseldorf, Düsseldorf, 1972.

12.

Daniel Buren, "Exposition d'une Exposition," in *Catalogue Documenta*, Kassel, 1972. See also Daniel Buren, *Rebondissements/Reboundings*, Brussels: Daled-Gevaert, 1977.

13.

Haacke's work is documented in the following publications: Edward Fry, *Hans Haacke*, Cologne: Dumont, 1972; Hans Haacke, *Framing and Being Framed*, Halifax/New York: Nova Scotia College of Art and Design Press/New York University Press, 1975; Hans Haacke, *Der Pralinenmeister*, Cologne: Paul Maenz Gallery, 1981, English edition: Toronto: Art Metropole, 1982.

14.

See the exhibition catalogue: Christopher D'Arcangelo, Louise Lawler, Adrian Piper, Cindy Sherman, New York: Artists Space, 1978.

15.

For a notable exception, see Anne Rorimer, "Michael Asher: Recent Work," *Artforum*, April 1980.

16.

Annegret Jürgens-Kirchhoff, *Technik und Tendenz der Montage*, Giessen: Anabas Verlag, 1978, p. 191.

17.

The notion of "spacing" as a linguistic function has recently been introduced into the discussion of collage/montage esthetics of the '20s. See Rosalind Krauss, "The Photographic Conditions of Surrealism," *October* No. 19 (Winter 1981).

18.

Sherrie Levine, unpublished, undated statement, ca. 1980.

19.

Walter Benjamin, *Angelus Novus*, Frankfurt: Suhrkamp, 1966, p. 204.

20.

Walter Benjamin, "The Author as Producer," in *The Frankfurt School Reader*, New York: Urizen Press, 1978.

21.

Martha Rosler, *Three Works*, Halifax: Nova Scotia College of Art and Design Press, 1981.

22.

Martha Rosler, interviewed by Martha Gever in *Afterimage*, October 1981, p. 15.

23.

Dan Graham, *Video-Architecture-Television*, Halifax/New York: Nova Scotia College of Art and Design Press/New York University Press, 1979.

24.

Variations of the work have been subsequently installed at the Art Institute of Chicago's 74th American Exhibition and at Documenta 7 in Kassel.

The Problem of Pluralism

Hal Foster

The list is long: abstract, realist, performance, new image, new wave, site-specific, pattern and decoration . . . all these modes and more are open to artists now, each with its own factions and critics. Then, too, there is the new expressionism both here and abroad, and other art that is (as yet) nameless.

We exist, we say, in a state of pluralism: no style or even mode of art is dominant and no critical position is orthodox. Yet this state is also a position, and this position, it is now clear, is also an excuse—an excuse for art *and* criticism that are more indulgent than free.

As a general condition, pluralism tends to absorb argument—which is not to say that it does not promote antagonism of all sorts. One can only begin out of a discontent with the status quo: for in a pluralist state, art tends to be dispersed and so rendered impotent. Minor deviation is allowed only in order to resist radical change, and it is this subtle conformism that one must challenge.

What follows is not definitive. All I have done is sketch the conditions of pluralism in terms of the recent history and context of art. If I have stressed particular trends in art and architecture, it is only because they seem symptomatic. My motive is simple: to insist that pluralism is a problem, to specify that it is a conditioned one subject to change, and to point to the need for cogent criticism.

From Singular to Plural

Pluralism is not a recent condition. In 1955 Lionel Trilling could bemoan the "legitimation of the subversive"[1] in a pluralist university, and in 1964 Herbert Marcuse could even condemn pluralism as a "new totalitarianism."[2] Yet the visual arts are a special case: in the '50s Abstract Expressionism seemed monolithic, and in the '60s the visual arts had an order that culture otherwise lacked. In the '60s self-criticism centered these arts radically. In (schematic) retrospect, the major art and criticism of the period constitute a highly ethical, rigorously logical enterprise that set out to expunge impurity and contradiction . . . only to incite them as countertactics. For if late modernism was modernism's apogee, it was also its end and negation.

Late modernism was literally corrupted—broken up. The self-critical aspect was retained, but the ethical tone was rejected. This rejection led to an estheticism of the non- or anti-artistic. Such a reaction (much Conceptual art is representative) allowed many new modes. It also fostered an "institutional theory" of art—namely, that art is what institutional authority (e.g., the museum) says it is. Such a "theory" abetted philistinism of many sorts; it also pushed art into a paradoxical position. For if it was true that much art could be seen as art only *within* the museum, it was also true that much art (often the same) was *critical of* the museum—specifically, of the way the museum defined art in terms of its own history and contained art in its, the museum's, own space. But this impasse was only apparent: production hardly stopped and art continued to be made both against the institutional theory and in its name.

The problem of *context* was only part of a greater problem: the very nature of art. Late modernist critics (Clement Greenberg pre-eminent among them) held that each art had one nature and that the imperative of each was to reveal its essence. Such an esthetic was reflected in art that was both pure and centered (i.e., one was a painter *or* a sculptor, nothing else).

Against these norms, new imperatives soon arose: the "perverse" and the "marginal." (Apparent in early Happenings, such attitudes were crucial to early performance art.) At first extremely tactical, these imperatives in time became all but conventional. Thus, what was initiated as a displacement of specific art forms led to a dispersal of art in general—a dispersal that became the first condition of pluralism.

In practical terms pluralism is difficult to diagnose. Yet two factors are important indices. One is an art market confident in contemporary art as investment—a market that, recently starved by "ephemeral" modes (e.g., Conceptual, process, site-specific art), is again ravenous for "timeless" art (read: painting—especially, image painting—sculpture and photography). The other index is the profusion of art schools—schools so numerous and so isolate as to be unaware that they constitute a new academy.

For the market to be so open to many styles, the strict criteria of late modernism had to be dismissed. Similarly, for art schools to multiply so, the strict definition of art forms had to break down. In the '70s these conditions came to prevail, and it is no accident that a crisis in criticism, ensuant upon the breakdown of late modernism—or, more specifically, of formalism—occurred then too. In its wake we have had much advocacy but no theory with any collective consent. And strangely, few artists or even critics seem to feel the lack of cogent discourse—which is perhaps the signal of the concession to pluralism.

A State of Grace?

As a term, pluralism signifies no art specifically. Indeed, it grants a kind of equivalence, and art of many sorts is made to seem more or less equal—equally (un)important. Art becomes an arena of vested interests, of licensed sects: in lieu of culture we have cults. The result is an eccentricity that leads, in art as in politics, to a new conformity: pluralism as an institution.

Posed as "freedom to choose," the pluralist position is naive, for its freedom is largely false. To this position, a wide range of art is natural (what, it is thought, is more natural than freedom of expression?). But art is precisely *un*natural—indeed, both art *and* freedom consist entirely and only of conventions. To disregard this conventionality is dangerous: hypothetically, art seen as natural will also be seen as free of "unnatural" things (history and politics in particular). It will then be truly autonomous—i.e., merely irrelevant.

Indeed, the freedom of art today is announced by one critic as the "end of ideology" and the "end of dialectic" (an announcement that, however, naive, makes this ideology all the more devious).[3] In effect, the demise of one style (e.g., Minimalism[4]) or one type of criticism (e.g., formalist) or even one period (e.g., late modernism) tends to be mistaken for the death of *all* such absolutes. Such a death

is vital to pluralism: for with ideology and dialectic somehow slain, we enter a state that seems like grace, a state that allows, extraordinarily, for all styles—i.e., pluralism. Such innocence in the face of history is extremely dangerous: it implies both a retreat from the present problematic of art and a misconstrual of the historicity of style. It also implies a failure of criticism.

When formalism prevailed, art tended to be self-critical. Though it was seldom regarded in historical or political context, it was at least analytic in attitude. When formalism fell, even this attitude was largely lost. Free before of other discourses, art now seemed free of its own discourse. And soon it appeared that all criticism, once so crucial to art practice (think of Harold Rosenberg and Abstract Expressionism, Michael Fried and color-field painting, Rosalind Krauss and site-specific art), had lost its cogency.

Dilettante, Dunce or Dangling Man

Obviously a *critical* art—one that radically revises the conventions of a given art form—is not the imperative that it once was. We are free—of what, we think we know. But where are we left? The present has a strange form, at once full and empty, and a strange tense, a sort of neo-now moment of "arrière-avant-gardism." Many artists borrow promiscuously from both historical and modern art. But these references rarely engage the source—let alone the present—deeply. And the typical artist *is* often "foot-loose in time, culture and metaphor"[5]: a dilettante because he thinks that, as he entertains the past, he is beyond the exigency of the present; a dunce because he assumes a delusion; and a dangling man because historical moment— our present problematic—is lost.

Modern art *engaged* historical forms, often in order to deconstruct them. Our new art, however, tends to *assume* historical forms—out of context and reified. Parodic or straight, these quotes plead for the importance, even the traditional status, of the new art. In certain quarters this is seen as a "return to history"; but it is, in fact, a profoundly *a*historical enterprise, and the result is often "aesthetic pleasure as false consciousness, or vice versa."[6]

This "return to history" is ahistorical for two reasons: the context of history is disregarded, and the continuum of history is lost. That is, neither the specificity of the past nor the necessity of the present is heeded. Such a disregard makes the return *to* history also seem to be a liberation *from* history. And today many artists do feel that, free of history, they are able to use it as they wish.

Yet, almost self-evidently, a style is specific: its meaning is part and parcel of its period, and cannot be transposed innocently. To see other *periods* as mirrors of our own is to turn history into narcissism; to see other *styles* as open to our own style is to turn history into a dream. But such, really, is the dream of the pluralist: he seems to sleepwalk in the museum.

To be unaware of historical—or social—limits is not to be free of them; indeed, one is all the more subjected. Yet in much art today, the liberation from history *and* society is effected by a turn to the

self—as if the self were *not* informed by history, as if it were still opposed as a term to society.

This is an old plaint: the turn of the individual inward, the retreat from politics to psychology. As a strategy in modern art, extreme subjectivity *was* critical once: with Surrealists, say, or even the Abstract Expressionists. It is not so now. Repressively allowed, such subjectivity is the norm: it is not tactical; indeed, it may be worse than innocuous.

So it is that the freedom of art today is *forced* (both false and compelled): a willful naiveté that masquerades as *jouissance*, a promiscuity misconceived as pleasure. Marcuse noted how the old tactics of (sexual) liberation, so subversive in a society of production, have come to serve the status quo of our society of consumption: he termed this "repressive desublimation."[7] Similarly, pluralism in art signals a form of tolerance that does not threaten the status quo.

In Lieu of History

If pluralism seems to dismiss the need of a critical art, it also seems to dismiss old avatars like the original artist and the authentic masterwork.[8] But this is not so: as pluralism is without criteria of its own, old values are revived. But not any old values: the values revived are ones necessary to a market based on taste or connoisseurship (or, fashion and investment): values such as the "vision," "sensibility," the touch of the gifted hand. Photography and lithography tested these values, only (by and large) to submit to them (they are unique or auratic enough). But all these values depend on one supreme value, now revived with a vengeance: *style*. Style, at once absolute and subjective, is preeminent once again.

Early modernists sought to free style from tradition. A few (e.g., Malevich) went further, and sought to free art from style. Yet insofar as they did so, style (specifically, the "charisma" of the artist and the aura of the art work) became inflated, so much so that late modernists were again impelled to efface it. The '60s saw much art devoid of "personality," mute to individual or art history—in short, much art that renounced style and history as the grounds of meaning.[9] (Minimalist art is the obvious example.)

Ironically, just as '60s purity fostered '70s impurity, style and history were repressed, only to return. To forego historical references is often to forego references to given conventions too, the absence of which does not necessarily free meaning. Indeed, meaning only tends to return (by default, as it were) to the person of the artist and/ or to the material of the work (which then stands as "its own" truth).

This occurred often in '70s art, with the result that the self became art's primary "ground" once again. In the form of autobiography, the self provided content (e.g., diaristic art); and in the form of style, it became an institution of its own. *And thus its own agent of conformity*. This is important, for the modern reflex— namely, to violate or transgress conformity—still held, so that the self, perceived as style, was attacked even as it was embraced. Thus alienated from each new style, it only produced more styles. (Carter Ratcliff has noted in Robert Morris this antagonism of self perceived

as style.[10]) There seemed no way out of such (non)conformity: it became institutional too. Which is to say, art became skittishly stylish—everyone had to be different . . . in the same way.[11]

We tend to see art as the issue of a conflict: a conflict between the individual artist and the conventions of an art form. This notion is also a convention, one that persists even in the face of art that refuses it: not only '60s art that would efface "personality" (again, Minimalism), but also contemporary art that regards the individual (artist) as absorbed by conventions. (Thus Cindy Sherman assumes media roles in order to elucidate such conventionality.[12]) In work such as hers, the individual is seen as a myth, even a ruse of conventions, *and* as the only way to re-form these conventions.

In art today, the individual term (the artist) seems strong, the conventional term weak. And yet without any critique, the individual term is weakened too. This is not well understood, for throughout the art world the artist-as-individual is championed—even though, as Adorno remarked, "the official culture's pretense of individualism . . . necessarily increases in proportion to the liquidation of the individual."[13]

Rejection and Reaction: Pluralism Unbound
The conventions of art are not in decline; they are, rather, in extraordinary expansion. This occurs on many fronts: new forms, whose logic is not yet understood, are introduced, and old codes, with the "decorum" of distinct mediums broken, are mixed. Such art can pose provocative contradictions (Laurie Anderson's work, or Alice Aycock's, is an example). But more often, the mix is promiscuous and, in the end, homogenous (e.g., the many painting/sculpture amalgams).

Artistic conventions are also established precisely where they seem rejected—for example, with artists who assume subjects and processes alien to art, only to render them "esthetic." Such rejection of the artistic is rhetorical, i.e., it is understood *as* a rejection and so must be timely and tactical. Now it is not; indeed, it is all but conventional: we call it "Duchampian." (The case of Joseph Beuys suggests how this strategy now does not contest the conventional so much as turn the artist *into* a convention.)

Art that reverses Duchamp is no less subject to conventionality. Such art (characteristically, it dresses a modernist form in punk or pop-cultural clothes) is an art of "effect"; i.e., it wishes to be immediate. Yet what effect is *not* mediated, *not* rhetorical (e.g., not ironic, naive, etc.)? What effect *is* innocent (e.g., even bad painting becomes "Bad Painting")? Such work cannot escape its own condition, which is at once "politicized" and "futilized." It strains for effects, only to degenerate into postures, and these postures have no relief: they emerge even as flat and ephemeral.

Then, too, there is art that rejects Duchampian rejection, art that accepts a given conventionality. Alienated from the new mediums, these artists return to old forms (many simply dismiss '60s "politics" and claim the "legacy of Abstract Expressionism"). Yet

rarely are these old forms newly informative: painting in particular is the scene of an often vapid revivalism.

Moreover, such art cannot *project* its own contradictions; i.e., the future is not its dimension. This is troublesome, for though the habit of the historicist—to see the *old* in the new—remains with us, the imperative of the radical—to see the *new* in the old—is lost. Which is to say that we retain the historical (or "recuperative") aspect of art, even as we lose the revolutionary (or "redemptive") aspect.

Without such projection, one model of history falls, only to be replaced by another: history as a monument (or ruin)—a store of styles, symbols, etc., to plunder. Art that regards history so does not displace the given as much as re-place it.

Such a view of history is basic to much postmodern[14] art and architecture. The program of such work is often a pastiche, yet it is a pastiche that is oddly limited: it is *partial* in the sense of both incomplete and partisan. Thus many painters today cite Expressionism (with its now safe stress on the primitive), and many architects allude to (neo)classical monuments—i.e., to an *architecture parlante* that speaks mostly of an authoritarian tradition.

Even when an art-historical innocence is affected, it is pastiched (or at least conventional), for the innocence is seen as within the tradition of the naif. Indeed, our awareness of "art history" is such that any gesture, any allusion, appears already-known, always-given. Such sensitivity to style, however, hardly suffices for a critical art. Rather than explore this condition of clichéd styles and prescriptive codes (as critics like Barthes and Derrida have done), many artists today merely exploit it, and either produce images that are easy to consume, or indulge in stylistic references—often in such a way that the past is entertained precisely as publicity. Today's innocent, then, is a dilettante who, bound to modernist irony, flaunts alienation as if it were freedom.

An Arrière-Avant Garde?
Today one often hears that the avant garde is dead and how fortunate this is. Indeed, few observers draw any conclusions, and yet they are there to be read.

For one, art is no longer governed by the conflict of academy and avant garde. Rather, art now tends to be the issue of a collusion—of privileged forms mediated by public ones. More and more, art is directed by an historicism akin to that which governs fashion, and the result is an ever-stylish neo-Pop whose dimension is the popular past. An arrière-avant garde, such art functions in terms of returns and references rather than the ultimate ends and transcendence of the avant garde.

As a prophetic force, the old avant garde presented a critical edge; as a subversive force, it claimed a political idealism: one could not retreat to the certainties of past practices. Now, of course, such a stance does not hold, or at least not so strictly. Indeed, regressive art is openly entertained. (Note this remark of Francesco Clemente's: "I

don't have a progressive notion of art—one step after another. Thinking you can change history—that's not something minor artists can think about."[15]) This attitude may come as a shock; it may even be seen as critical (e.g.,"Bad Painting"). However, to use terms thus—in quotes—is not to qualify or transvalue them. At best, they are mystified and, at worst, emptied of meaning. Such is the fate of many critical terms in pluralism. As judgment is suspended, language is neutered, and critical orders fall in favor of easy equivalencies.

Pluralism as a Screen

Recently the Czech novelist Milan Kundera speculated that the radical postures of Western intellectuals are partly due to the fact that nothing radical, socially or politically, happens here: the status quo is assured.[16] So too, the many postures of pluralism reflect a stalemated status quo—they may even serve as a political screen. We believe (or did) that culture is somehow crucial to political hegemony; as such, we insist (or did) that the avant garde be adversarial. And yet how render art impotent but through dispersal, the franchised freedom of pluralism?

Pluralism may also serve as an economic screen. Again, culture is not merely superstructural: as Adorno stressed, it is an industry of its own, one that is crucial to our consumerist economy as a whole. With no strict standards, pluralism fosters art consumption. In such a state art is seldom adversarial, and so tends to be absorbed as another consumer good—an ultimate one. Undoubtedly, the prime agents of the art world (important galleries, auction-houses, magazines, museums) benefit from such consumerism. If they do not actively promote pluralism, they hardly campaign against it.

With the avant garde, it was said, the art world was assured a steady line of obsolescent products. Now however, in lieu of the historical sequence we confront the static array: a bazaar of the indiscriminate replaces the showroom of the new. As anything goes, nothing changes; and *that* (as Walter Benjamin wrote) is the catastrophe.

> Here the whole ideology of fashion is in question. The formal logic of fashion imposes an increased mobility on all the distinctive social signs. Does this formal mobility of signs correspond to a real mobility in social structures (professional, political, cultural)? Certainly not. Fashion—more broadly, consumption—masks a profound social inertia. It is itself a *factor* of social inertia, insofar as the demand for real social mobility frolics and loses itself in fashion, in the sudden and often cyclical changes of objects, clothes and ideas. And to the illusion of change is added the illusion of democracy . . . [17]

Fashion answers both the need to innovate and the need to change nothing: it recycles styles, and the result is often a composite—the stylish rather than style as such.

Such is the style of much art today: our new tradition of the eclectic-neo. (New Wave is the most eclectic of these "neos"—it is a virtual compendium of pop cultural sources. Neo-Abstract Expressionist painting is perhaps the most strict—it revives one source as *the* tradition.) Ten years ago Harold Rosenberg saw the advent of such art: he termed it *dejavunik,* by which he meant art that plays upon our desire to be mildly shocked, piqued really, by the already-assimilated dressed up as the new.[18] This was an early sign that modernism was dead: for how else could it be so *repeated?*

Such revivalism is profoundly unmodernist; it is akin, rather, to 19th-century revivalism. This revivalism and our own are different in origin (the 19th-century's fostered by a century-long pursuit *of* history, ours by a supposed century-long flight *from* history), and yet they may be alike in ideology—namely, the legitimation of a new patron class. 19th-century revivalism posed its patrons as the great *heirs* of history. Our revivalism is more retrospective: history is now regarded as an array of cultural treasure. 20th-century patrons are the great *collectors* of history—of history as objets d'art. The current revivalism in art and architecture, then, was almost to be expected.

Shock, Incorporated

Early modern art was adversarial: whether a dandy or a criminal (the two modern types as seen by Baudelaire), in pseudo-aristocratic withdrawal or plebeian transgression, the artist was posed against bourgeois culture. Yet this pose was largely assumed. Even initially, artists came from the bourgeoisie, and more and more after World War I, the bourgeoisie reclaimed avant-garde culture as its own.

One result was that the two anti-bourgeois types, the dandy and criminal, became bourgeois heroes. They are with us still, in various forms, often in the same artist. Recently, after years of the criminal (literal "outlaws" like Chris Burden and Vito Acconci as well as less literal ones like Robert Smithson), we are in a time of the dandy, of withdrawal from the political present. But with a difference: in a pluralist state such withdrawal is no transgression; the dandy is everyman's pose.

We have nearly come to the point where transgression is a given; indeed, marginality as such is almost institutional. Site-specific works do not automatically disrupt our notion of context, and alternative spaces seem nearly the norm. This latter case is instructive, for when the modern museum retreated from contemporary practice, it largely passed the function of accreditation onto alternative spaces—the very function *against* which these spaces were established.

Today, ephemeral shows are common, as are ad hoc groups and movements. All seek marginality even though it cannot be preserved (thus the pathos of the enterprise). Certainly, marginality is not now given as critical, for in effect the center has invaded the periphery. Here a strange double-bind occurs. For example, a once marginal institution like the New Museum proposes a show of a marginal group like Fashion Moda: the museum does so to (re)gain at least the aura of marginality, and the marginal group agrees . . . only to lose its marginality.[19]

The marginal absorbed, the heterogeneous rendered homogeneous: one term for this is "recuperation." In modern art recuperation often occurred when the non- or anti-artistic was made esthetic. Such recuperation is not now what it was for Duchamp, for the "space" of the esthetic has changed (indeed, the very category is in doubt). This is clear. So why has artistic strategy remained much the same? Shock, scandal, estrangement: these are no longer tactics against conventional thought—they *are* conventional thought. As such, they need to be rethought. Only, *that* process too is in many ways conventional: as Roland Barthes noted, such demystification is now the norm.[20] This is not to say that it is useless—only that such criticism is subject to the very "mythologizing" that it would expose. (Art, too, is subject to this conventionality of the critical, and may act in its name precisely when and where it least intends it. An index to such quasi-critical art is the degree to which it becomes a fashion of its own.)[21]

The problem of critical methods (like demystification) rendered conventional, like the problem of critical terms (like "bad") emptied of meaning, is a serious one, one fundamental to the problem of pluralism. For pluralism is a condition that obscures referents, with the effect that art practice becomes severed from art criticism—indeed, from cultural criticism in general.

Critical terms are not merely emptied or obscured in pluralism, they are also used anachronistically. A recent example is afforded by Achille Bonito Oliva in *The Italian Trans-avantgarde*. There he reclaims old terms, once privileged by Expressionism and Surrealism (e.g., art as "direct expression," art as "pure subjectivity"), as essential to art as such—which then allows him to valorize the new Italian painting as painting's "return to itself."[22] Such a use of archaic terms is not simply innocuous, for it tends to render contemporary art "like" old art and, by implication, "as important." A common form of false argument, it is part of the critical laxity that pluralism fosters.

Pop History

Like the avant garde, modernism seems to have few mourners, and this is not because its death is only rumored. Anti-modernism is rampant now: indeed, the consensus is that modernism was tyrannical, so "pure" as to be repressive. Such a sentiment is pronounced among post-modern architect/ideologues (Robert Stern and Charles Jencks chief among them). Alienated from modern "alienation," they would address the public; awakened from modern "amnesia," they would recall the past—all with a pop-historical imagery.

In postmodern architecture, references to historical examples (e.g., a particular Palladian villa) do not function formally so much as they serve as tokens of a specific architectural tradition. Architecture thus tends to a simulacrum of itself (often a "bad" or pop-ish copy), and culture is treated as so many readymade styles. Though parodic, post-modern architecture is instrumental—which is to say that it plays upon responses that are already "programmed." In effect, architectural signs become commodities to be consumed.[23]

Another kind of "consummativity" is often active in art that uses images from popular culture. The question here is: does such art seek to expose these clichés *or* to be made "popular" by them?

Art that is made popular by clichés *exploits* the collapse of art into the mass-media. This is the way the art-historical references in work such as Julian Schnabel's function. As clichés, they render the work historical to the naive (and campy to the hip). Which is to say that the cliché is used to codify response.

On the other hand, art that *exposes* clichés plays upon them critically. Such art stresses, even rehearses the collapse of art into the media in order to inscribe—against all odds—a critical discourse there. In such art the clichéd response is elicited, only to be confounded: here the cliché is used against itself.[24] Again, the stereotypical subjects that Cindy Sherman assumes and, to a lesser extent, the banal images that David Salle uses, serve to implode the cliché.

Such a tactic—the cliché used against itself—points to a specific problem in modern art. As is well known, images and styles of modern art were and are exploited commercially. Such exploitation has now become a pretext for much contemporary art—and not only art of a Marxist or Conceptual bent. Indeed, much art today not only reclaims degraded images from old low-cultural forms (e.g., '40s pulp fiction, '50s movies) but also steals popular images from present mass-cultural forms (e.g., TV, magazine ads). In the latter case, such art steals representations from the very culture which had heretofore stolen from it.[25]

But the use of such images remains problematic, for the line between the exploitative and the critical is fine indeed. This holds true for the use of art-historical images, many of which are so often reproduced as to be almost mass-cultural.

The problem of the art-historical as cliché is most acute in postmodern architecture: for there the use of such images is justified as "egalitarian," a rhetoric that is only implicit in postmodern art. Though subject to criticism on its own, such architecture serves as a useful analogue.

Here a question, similar to the one posed above to postmodern art, must be posed to postmodern architecture. Does this architecture use its historical references critically or "naturally"? That is, does it seek to renew its form through these references *or* to establish its form as "traditional" by means of them? (Even parodic references propose a tradition to debunk.)

Proponents of such architecture (like proponents of such art) tend to argue in two ways. They say that historical references are *given*, that they are so blank as to be merely ornamental and not ideological at all. Or, they say that it is precisely the confusion of such references that makes this usage both timely and tactical (i.e., that it is the interference of, say, a type of pediment, a vernacular aside, and an allusion to Ledoux or Schinkel, that renders such architecture serious and complex).[26]

But both arguments are too easy. Historical images, like mass-cultural ones, are hardly innocent of associations: indeed, it is be-

cause they are so laden that they are used. This is clear. What is not clear is that these images are not all equally associative, not all equally given or public. In short, they are not the "democratic signifiers" that they are claimed to be.

It is argued that postmodern architecture draws on so many styles and symbols that everyone is suited.[27] Precisely: *fixed*—by class, education and taste. The "confusion of references" is superficial: often the references encode a simple hierarchy of response. Such architecture, then, stratifies as it juxtaposes, and condescends as it panders (some will get this, it says, some that). In short, it plays upon social levels, past and present. Though it may wish to paper over social differences, it only pronounces them—along with the privileges that underlie them.

Today one often hears of a new freedom of reference in art and architecture. But this freedom is restricted: it is not truly eclectic (as noted above, usually only one tradition is quoted); no more is it truly egalitarian. And it certainly is not critical: often an old modern idiom is simply revived—or a rhetorical attitude that is modern-trite (e.g., the abstract/representational ambiguity in New Image painting). Rarely does this art or architecture expose the contradictions of the styles upon which it draws. Instead, it tends to dismiss these contradictions as trifling or to defuse them in the stylish or even to delight in them as historical vaudeville. (Examples of the last are Charles Moore in architecture, Ned Smyth in art.) Not a "new dialectical high,"[28] such confusion is an old static irony—and bad faith to a public that is not initiate, the very public that such art would entertain. The choice is dismal: in taste, either elitist order or a false vernacular, and in form, either modern amnesia or false consciousness.

Either/Ors?

There are other dismal either/ors that pluralism only seems to solve; the two most troublesome are the either/ors of international or national art and of high or low art. Here, pluralism becomes an overtly political issue, for the idea of pluralism in art is often conflated with the idea of pluralism in society. Somehow, to be an advocate of pluralism is to be democratic—is to resist the dominance of any one faction (nation, class or style). But this is no more true than the converse: that to be a critic of pluralism is to be authoritarian.

In art since World War II, the "dominance of any one faction" has seemed to mean American art, specifically New York art. We are, by now, sensitive to the chauvinism here. This dominance may even be seen as a hegemony—i.e., a form of political control of and through cultural representations.

Today American culture is often rejected as hegemonic. But the *basis* of this hegemony is not limited to any one country or culture: its basis is in a mode of production and information (often termed "late-capitalist" or "post-industrial") that is multinational.

This hegemony is to be resisted, for what is at stake is self-representation. And though hegemonic control is mostly a matter of low culture, it is sanctioned by high culture, by art—thus the importance of resistance. Such resistance does exist (the artists, international in number, are too diverse to list), but it is weakened by a false resistance: by a newly promoted art of local sentiments and archaic forms. This art (it is not specific to Italian or German or American art) is more reactionary than the art that it would displace; indeed, it is often more reactionary than the hegemonic representations that it would resist. Such art constitutes a disavowal—not only of radical art but also of radicality *through* art.

This is not to say that such art lacks a logic. For if the old myth of the artist-as-genius had to be restored, and with it old modes of artistic production, it was more than likely that old images of national identity would follow. This has indeed happened, and such a renascence of nationalisms as we presently see is surely symptomatic of a cultural retrenchment. For if the return to history is a retreat from the present, what is the return to local culture but a retreat from the given problematic of art in the West—a problematic that, again, is cultural *and* political, and multinational?

It is argued that the new national art uses archaic representations so as to cut across history and culture: such is the rhetoric of the "trans-avantgarde."[29] Yet how can we respond to these representations *except* as "historical" and "cultural"—i.e., except as new images privileged by art-historical ones? And what, then, is this "culture" but a nostalgia for exhausted forms? And what is this "history" but a random tour? Provincialism so exploited is only compounded, and art becomes one more curiosity: one "other" among others. Pluralism is precisely this state of "others among others."

If pluralism renders art relative and so, in a sense, provincial, it also seems to de-define high and low art. And yet it is on the line between high and low, between art and the media, that much new art is drawn. The best such art accepts this line as a front, a space of contested representations where conventions of many sorts may be questioned. But in most pluralist forms, this line is obscured, and art that would be critical (of both high and low culture) loses its edge. This is not part of any explicit agenda, but here, for example, the claim is clear: " . . . there is no more hierarchy of heaven and earth, no difference between high and low: the perverse and limited bastions of ideology and of every other dogma have fallen."[30]

Free of these "perverse bastions," the artist enters a (private?) state of grace. Yet what is this "grace" if not indiscrimination? One is left with this dismal sense: that just as our pluralist state of affairs may reduce criticism to the homogeneity of local advocacy, so too may it reduce art to a homogeneity—in which real differences are reclaimed as so many minor deviations and in which freedom is reduced to so many isolated gestures.

Postscript

A polemic against pluralism is not a plea for old truths. Rather, it is a plea to invent new truths, or, more precisely, to *reinvent* old truths radically. If this is not done, these old truths simply return, debased or disguised (as the general conservatism of present art makes clear).

Many modern premises are weak now. The impulse toward autonomy, the desire for pure presence in art, the concept of negative commitment (i.e., of criticism by withdrawal)—these and other tenets must be rethought or rejected. But the need for critical art, the desire for radical change—are these premises invalid too? Are we quite sure such avant-garde motives are obsolete? Granted, the logic of the avant garde often did seem foreclosed. But pluralism answers with a foreclosure—an indifference—of its own, one that absorbs radical art no less than it entertains regressive art. This, then, is the crucial issue that faces both art and criticism today: how to retain (or restore) a radicality to art without a new foreclosure or dogmatism. Such foreclosure, it is now clear, can come of a postmodern "return to history" no less than of a modern "reductionism."

1.

Lionel Trilling, "On the Teaching of Modern Literature," *Beyond Culture*, N.Y. and London, Harcourt Brace Jovanovich, 1965, p. 23.

2.

Herbert Marcuse, *One-Dimensional Man*, Boston, Beacon Press, 1964, p. 61.

3.

Achille Bonito Oliva, *The Italian Trans-avantgarde*, Milan, Giancarlo Politi Editore, 1980, trans. Gwen Jones and Michael Moore, pp. 28, 32 and passim.

4.

Though it is evident that much contemporary art dialectically revises Minimalism and so in some sense derives from it.

5.

Edit deAk, "A Chameleon in a State of Grace,"*Artforum* (February 1981), p. 40.

6.

Benjamin H. D. Buchloh, "Figures of Authority, Ciphers of Regression: Notes on the Return of Representation in European Painting," *October 16* (Spring 1981), p. 54.

7.

Marcuse, pp. 72–79.

8.

See Douglas Crimp, "The Photographic Activity of Postmodernism," *October 15* (Winter 1980), pp. 91–101.

9.

See Rosalind Krauss, "Sense and Sensibility: Reflections on post-'60s Sculpture," *Artforum* (November 1973), pp. 43–53.

10.

Carter Ratcliff, "Robert Morris: Prisoner of Modernism," *Art in America* (October 1979), pp. 96–109.

11.

See Donald Kuspit, "Stops and Starts in Seventies Art and Criticism," *Arts* (March 1981), p. 96, and "The Unhappy Consciousness of Modernism," *Artforum* (January 1981), p. 57.

12.

Craig Owens, "The Allegorical Impulse: Toward a Theory of Postmodernism (Part 2)," *October 13* (Summer l980), pp. 65–67 and 77–79.

13.

Theodor W. Adorno, "On the Fetish-Character in Music and the Regression of Listening," repr. in Andrew Arato and Eike Gebhardt, eds., *The Essential Frankfurt School Reader*, New York, Urizen Books, 1978, p. 280.

14.

Much art todays plays with literal and pastiched references to art history and pop culture alike. On the analogy with architecture, it may be termed postmodern. Such art, however, must be distinguished from postmodern*ist* art which is posed theoretically against modernist paradigms. Whereas postmodern art refers so as to elicit a given response and regards the reference as natural, the return to history as certain, post-modern*ist* art refers "to problematize the activity of reference" (Owens, p. 79).

15.

Quoted in deAk, p. 40.

16.

Quoted in an interview with Philip Roth, *The New York Times Book Review* (November 30, 1980), p. 78.

17.

Jean Baudrillard, *For a Critique of the Political Economy of the Sign* (1972), trans. Charles Levin, St. Louis, Telos Press, 1981, p. 50.

18.

Harold Rosenberg, *Discovering the Present*, Chicago, The Univ. of Chicago Press, 1973, xi.

19.

See Thomas Lawson, "Reviews," *Artforum* (March 1981), pp. 81–82.

20.

See Roland Barthes, "Change the Object Itself," *Image-Music-Text*, trans. Stephen Heath, N.Y., Hill & Wang, 1977, pp. 166–67.

21.

For a virtual portfolio of such quasi-critical painting, see Thomas Lawson, "Last Exit: Painting," *Artforum* (October 1981), pp. 46–47.

22.

Oliva, pp. 27, 29, 30, and passim. Oliva's next installment, *The International Trans-avantgarde* (see *Flash Art*, October/November 1981, pp. 36–43), promises to be another assay in such argument.

23.

See Kenneth Frampton, "Intimations of Tactility," *Artforum* (March 1981), pp. 52–58.

24.

See Fredric Jameson, *Fables of Aggression: Wyndham Lewis, the Modernist as Fascist*, Berkeley, University of California Press, 1979, pp. 62–80.

25.

Owens, "Allegorical Impulse," passim.

26.

Robert Venturi provided the basis for such an argument vis-à-vis postmodern architecture, and Donald Kuspit has argued such a line vis-à-vis recent art (specifically New Image); for the latter, see Kuspit, *Arts*, p. 98.

27.

See Charles Jencks, *The Language of Post-Modern Architecture*, London, Architectural Design, 1977.

28.

Kuspit, p. 98.

29.

Oliva, p. 11.

30.

Oliva, p. 28.

"The Problem of Pluralism" by Hal Foster. Reprinted from *Art in America* (January 1982): 9–15. Used by permission. A revised version of this essay appears in Hal Foster, *Recodings: Art, Spectacle, Cultural Politics* (Port Townsend, Washington: Bay Press, 1985).

The Rhetoric of Rawness

Donald B. Kuspit

Julian Schnabel is a brilliant synthesizer of styles, almost to the point of summarizing major aspects of the postwar American tradition. (This is partly responsible for his success; he stands on so many shoulders.) He unites the famous painterly "muddiness," as Clement Greenberg called it, of Jackson Pollock's more "archaic" paintings with Robert Rauschenberg's vision of "combine painting," an extension of collage which encourages the use of a seemingly infinite variety of materials, including three-dimensional objects.

Schnabel's most notorious additions are velvet and crockery. Like the newspaper many of the original Cubist collages incorporated, velvet and crockery are mass-produced "domestic" materials. Velvet is a romantic material, epitomizing the everyday idea of luxury. It satisfies the conventional taste for easily consumable illicit sensuality; it is the populist version of erotic, thrilling touch. It seems to afford deep sensuous experience without any effort on one's part. Velvet conveys facile voluptuousness. Also, as the middle-class version of high-class material, enjoyment of it satisfies the desire for "possession" not simply on the sexual level—velvet concentrates all erogenous zones in one dense material—but to the very depths of the bourgeois soul, which experiences velvet as priceless property par excellence. A cheap thrill from a royal material: what more could a romantically inclined bourgeois spectator want from art? Crockery is primitive substance given civilized shape and put to personal use. Shards of crockery are typically the first elements of a find in an archaeological dig; they are often the only remains of a lost civilization. To piece together ancient crockery is to reconstruct a dead world in its most commonplace aspect—in its seemingly most intimate detail. Velvet and crockery—these materials are at once the bedrock of Schnabel's most interesting pictures and the quicksand in which their images inevitably dissolve. Bourgeois sensuality and ancient death—it is from their very material auras that Schnabel's images spring, like Myrmidons from the earth, and to which they return, after their Pyrrhic victory over time.

Breaking modern crockery, as Schnabel does, is metaphorically to break the back of modernity—to provocatively deny contemporaneity. Schnabel's fierce antimodernism is the heart of his art, signaling the way he attempts to recover timeless truths from the modern experience. The broken crockery makes whatever image is embedded in it resonant with "ancient" meaning, rich with a patina of time. The velvet deepens the image in a timeless way; the velvet is a soft salver that serves the image up as if it was the fragile gift of a possible feeling. The materials cushion the images the unconscious creates, that they not be crushed by the everyday light of consciousness. Time and the artifacts that survive it, instantly sacred by reason of their survival—instantly catalytic of our deepest consciousness, our unconscious belief that every shred of the past makes profound sense as the particular trace of a general immortality—are Schnabel's "subject matter." On face value, if we were to stay only with its materials, Schnabel's art is about the destruction of the modern to reconstruct the primitive, in an at once populist and extreme form; everyday surface is turned into a mediator of sensual depth by

breaking it up into raw dead matter. Schnabel destructively hammers—a painter's version of Nietzsche's philosophizing with a hammer?—familiar surfaces into raw "flesh" that is erotically profound but also signifies a state of deep woundedness. His surface agonizingly mixes pleasure and pain until neither can be distinguished.

His painterliness masticates not only modern materials but traditional images: they also help make the belly of his pictures hang out in pseudocyesis. His pictures have the look of Roman vomitoriums; they are bloated with the regurgitated remains of many meals of surfaces and images. Schnabel has an enormous appetite, a stomach for the most horrific objects and scenes. But he does not so much consume as suck the juice of life from them. Painting for him means chewing up and spitting out known surfaces and images in the hope of evoking a hitherto unknown depth of meaning. Painting for him is a decadent act of quasi-sadistic violence on helpless victims—figures from the historical and mythical past who can do nothing about the way the world will use them after their deaths—for the sake of a rare experience of forbidden depths. The figures, who signify these magical depths, may even be grateful for being brought back from them—from the Hades where they were merely shadows—to be whipping boys for a romantic new "depth art." Schnabel brilliantly reactivates a statically conceived depth, showing that there is still life in the old shadows and unexpected profundity in everyday surfaces. Profundity is a dynamic state he participates in through his painterliness, rather than a passive state of innocent contemplation. Schnabel stands inside his figures, rather than outside looking in. He brilliantly synthesizes Symbolism and primitivism narcissistically searching for a new afflatus. Schnabel's best pictures are like whales in which a prophetic Jonah-like figure or object endures the corrosive action of a wrathful, turbulent god. His pictures are stormy excursions to sound an unfathomable depth. They are masterpieces of decadent mentality, "the pursuit," in Arthur Symons' words, "of some new expressiveness or beauty, deliberately abnormal," deliberately pursuing rare experience through "perverse" manipulation of existing stylistic languages. Schnabel is the leader of the new romantic decadents—a term I use with approbation, for decadence is the most advanced state of civilization.

Crockery is as necessary for everyday life as velvet is unnecessary, yet both are peculiarly intimate in import, even if it is a vulgar idea of intimacy—intimacy turned inside out into conspicuous material, that is, intimacy made demonstrative. In the directness with which they publicize intimate sensation, these materials convey a philistine coziness. To use them is one way of restoring vigor to modern art—which is always quickly spilling its seed, always romantically desperate for new materials to generate fresh potency and novel effect, to save it from the deterioration of its ideas—while being rhetorical in the postmodern way. (It is as though each new material was not only a freshly invented sexual position, but announced a general new permissiveness.) To use such materials, especially in the destructive way Schnabel does—paint on velvet

forces, even brutally overstates voluptuousness or luxurious surface the way chalk screeching on a blackboard pushes sound to a new absolute of rawness—is one way of raising to a feverish new pitch the rhetoric of rawness which has been an important ideal of art at least since Gauguin and Munch. It was not without effect on Cézanne—modern art's pursuit of raw surface, which is one of the major strategies of its primitivism, can be derived from Impressionism's "vibrating" surface—and for many artists and critics it is the gist of modernist painting. That is, raw surface is a major way of making the medium of painting manifest—ideally, self-evident to the point of a blasphemous immediacy. Archaic surface on a sophisticated flatness—that is one important version of modernist painting.

The transformation of vibrating surface into agitated (anxious) surface—that is the formula of primitivism "civilized" or used for modern purposes, namely, to register and reveal through an estranging visual babel the disturbed self underneath and disruptive of the social surface, the horrendous feelings underneath and distorting the correct social form, especially the feelings of disintegration corroding the integrating, "socializing" shapes. In other words, primitivism in its modern use is a mode of liberation from repression. It claims to offer concentrated expression—which makes it seem to speak in an unknown tongue—to repressed feelings. The most primitive of all means for effecting a generalized sense of the lifting of the censorship of repression is the exaggeratedly raw surface, destructive of whatever representations rest on it. Raw surface becomes suggestive of the inherent ambivalence of feeling disrupting all object relations—as though when one experiences ambivalence one knows one is really feeling. The rawness of the surface communicates the questionableness of all representations of objects by reason of the ambivalence of the relationship to them. The rawness embodies the ambivalence in all its trechancy—embodies the unstability of all representation, the unreliability and subjectivity of all perception.

Schnabel's raw or primitive surface is simultaneously repulsive and attractive. It is repulsive because of the emotional turmoil and terror it suggests, and attractive because its tumultuous character implies the release of strong emotions—the return to a state of primitive, direct feeling. This is exactly what modern primitivism intends to effect. The hyperraw surface carries with it the complex social response we have to primitive feeling, as well as the ambivalence that signals that feeling is indeed primitive.

In Schnabel's pictures, the figure is no longer an integrating shape, but almost completely shattered, ruined—rendered "incomplete," hurt, distressed, a mutant of gross body and twisted spirit, inadequately body or spirit—a sort of Caliban of shape. Indeed, it can be argued that the often weird bodiliness of Schnabel's figures suggests a mad—tortured, self-tormented—state of being. In any case, the figure, traditionally a stronghold of complexly integrated shape—a shape which, because of its immediate narcissistic impact, because of the narcissistic satisfaction it affords through its simplest presence, is unconsciously as well as consciously "impressive"—is shipwrecked in a Schnabel painting, the victim of the

rough ocean of raw surface. Depending on the painting, the figure is broken on the rack of that surface or dissolved in it as in acid—is incorporated into the cruel surface, by whatever means. It is sometimes ground down almost to the point where it is completely voided, stripped of substance—perhaps not to the same extent as in later de Kooning, but Schnabel always seems to be pulling the figure back from the brink of an abyss into which it is about to vanish. The figure is always threatened by the irrational surface which mediates it. Schnabel's figure is an irrational image growing out of an irrational surface, incompletely differentiated from it, and thereby incompletely individuated. If it did not have its literary associations to pull it back from the maw of the surface's raw flux, it would forfeit its identity altogether. As it is, it is permanently in crisis, which sometimes seems to spiritualize the figure more, for it has to resist the brutally raw surface—partially its own flesh—to survive. Such "self-conflict" is one form of spirit.

How much does this reconstituted rawness affect the traditional—predetermined—meanings associated with the figures? How much does it generate an extraordinary meaning of its own, overwhelming all other (ordinary) meanings? These are two ways of asking the same basic question that focuses the issue Schnabel's paintings raise. Sometimes it seems as if Gert Schiff discusses their traditional iconographic meanings as if they were the major point of the pictures—which is to underplay the point of their expressionism. Their ostensible message tends to be religious, whether harping back to Christianity, as in *Veronica's Veil* (1984), or to classical beliefs, as in *King of the Wood* (1984), alluding to Frazer's story, in *The Golden Bough*, of the killer priest-king sacred to the goddess Diana. In either case, the religion is primitive and mythological—legendary. Yet it is a mistake to assume that the message passes through the fiery painterliness unscathed—remains straightforward and narrative, if "enhanced." The mediation of the legendary message through the raw surface, which seems to have a violent will or at least temperament of its own, violates the message as much as it restores primitive force to it. The irrational surface is responsible for the sense that the legendary figure does not mean what it customarily should mean, as well as for the sense that it truly represents and speaks from the depths of feeling. What Schiff does not sufficiently attend to is the fact that the strong surface disrupts the narrative figures and initiates a subliminal "narrative" of its own. It seems to "represent" something other than the figures, to have some obscure meaning of its own rather than to serve to reinstate the official meanings of the figures. The raw surface is unwillingly pressed into service as a reinforcer of traditional meanings (however as "mystical" as itself they may be); the more it serves these meanings, the less its autonomous meaning seems communicable. This is why Schnabel's raw surface finally seems to function more destructively than constructively—why Schnabel seems to renew, with unusual vigor, Picasso's idea of the picture as a sum of destructions, or to pay, as Mondrian said the artist should, special attention to the destructive element in art. Schnabel's uniquely raw, chaotic surface—in and of itself a triumph

of art in its seeming artlessness—reduces the figures it mediates to inchoateness. They become such unstructured gestures that they seem like manifestations of libidinous effluvium. This is even the case when, as in *T.T.*, *Red Sky*, and *Cookie's Doll* (all 1984), their contours are more rather than less intact, and their faces starkly clear, as if implying the integral being that the body belies.

What we have in a typical Schnabel picture is a perverse contrast between consciously created figural illusions and unconsciously meaningful "real" physical substance. Traditional figures become subtly meaningless except as manifestations—however major—of elemental force embodied by the raw physical surface. All meaning is carried by the surface, which is in violent conflict with the tentatively meaningful figures—wants to pull them back into its quicksand. The figures are momentary emanations of the forceful surface, which is the truly "mythological," primitive, "durable" element in the paintings. The figures have a purely academic meaning, which is far from obscure or indecipherable, but it is Schnabel's raw surface that really has cabalistic import. It is, as it were, a timeless duration.

One of the lessons of modernism is that only the most immediate surfaces communicate intentionality in the modern world, in whatever way the effect of immediacy is generated. Only the fiction of immediacy, carried out on literal surfaces, catalyzes meaning and feeling. It is surface alone that we cathect with today, surface seductive in itself, with no promise of profundity—but the moment we fall for the bait of surface, become hooked on it, we experience unexpected depth of meaning and feeling. That is, through the intense sensation of a particular surface we experience a general rush of elemental power. We only cathect with surface today—surface is character and power in the modern world. And the extremes of chaotic, raw surface and super slick surface—in Schnabel represented by broken crockery and velvet respectively—excite the greatest sense of power. Thus, Schnabel's figures are nothing unless they are all surface; the meanings associated with them throw the surface into greater mental relief—make it more ecstatically visible—rather than subsume it. The tension between surface and associational meanings reinforces the "fabulous" character of Schnabel's surface. The sublime fable of shattered infinite space which Schnabel's surface is matters more than anything else in his paintings.

We might call this modern emphasis on surface the Hollywood aspect of modern life. It can be summarized by saying that in the modern world only surfaces are respected—are sacred—for there is no coherent sense of significant depth. (Generally speaking, high art resembles popular art in the acceptance of surface as an end in itself as well as a realm of aimless implications—implications unanchored to any sense of depth, with no tie to any logic of depth, for modernity claims to have shown that there is none. The cinematic model [of rapidly moving but directionless, and so seemingly raw, surface—of "moving" surface as an end in itself] Arnold Hauser spoke of as basic to Cubism has become a general model for the mediation of meaning as well as for form.) Schnabel reduces the historical and mythological ("transcendent") meaning of his figures to pure surface meaning; it is

what gives them their intensity. But Schnabel is incompletely Hollywood. He accepts the modern absence of depth, yet by making surface so brutally raw, intensifying it to an excruciating extreme, he creates the illusion of depth of feeling—of a logic of transcendent depth responsible for the surface, erupting onto and through it. This is why complete allegiance and attention to Schnabel's surface rewards the spectator with a strong sense of lasting power—the real prize of existence, which seems to emerge from the unconscious depths but is in fact a matter of scintillating surface sensation. The unconscious is knowable only as intense, difficult, "different" surface. This "depth experience" of primordial power has nothing to do with any belief in "deep meaning," such as the figures traditionally have. It is rather the result of serious engagement, to the point of obsession, with unusual, fascinating surface. And no artist today has created more fascinating, dynamic surfaces than Schnabel, the exemplary "Hollywood" artist.

The more strictly one remains on Schnabel's surface, the profounder one's sense of "depth," partly because of the extraordinarily restless "creative flux" (Whitehead) of the surface. The "mystical" experience of depth also occurs when no representation seems to stay secure on the surface—when a surface is created on which nothing makes coherent sense. One might say that in a Schnabel painting inchoate "depth"—the unrepresentable—is invoked in inverse proportion to the decay of representational meanings on the surface. Clearly, the sense of irreducible depth depends on the "deadness" of the figures. Depth and death correlate for Schnabel; death is the only depth left, the only source of the experience of depth, the only meaning left to "depth."

Schnabel's enormous hunger for "deep" meaning is short-circuited by the fact that all his meanings exist either in surface ("superficial") images of figures or in profound energy that is permanently discontented with any imagistic/figural form it might take. The strange mix of discontent and power that animates Schnabel's surface is what counts; it signifies both the discontent that unconsciously embodies our civilization's death wish and the erotic drive inherent in its will to power. Schnabel's surface implies an enormous discontent with the cultural images he advocates as meaningful—images that tradition says are deeply meaningful, but that hardly move us. They exist only as rhetorical devices unless they are fueled by primitive power. Indeed, Schnabel's uneasy use of once profound images reminds me of Faust's discontent with ordinary human experience. He runs through experiences—including the "mythical" one of living with the long dead Helen of Troy—the way Schnabel runs through culturally representative fictions in which profound human experience is supposedly sedimented. Both are in search of the power that informs the "fictional" experience. Faust wears experiences and Schnabel wears fictions as though they were fancy dress costumes; but the costume, once put on, makes the hero, as the hero well knows. Heroic adaptation within a fiction one knows is one (may indeed be the only) way left—the modern way—to feel genuinely vital, truly powerful, and indeed, to be authentic. Both are heroic in

their restlessness—Faust perhaps the first, and Schnabel perhaps the last, of the modern heroes, that is, of those who are heroic by reason of their dissatisfaction, which puts them in a position to articulate primitive power.

Schnabel's expressionism makes explicit the underlying dynamic of modern expressionism since its beginning: the failure of traditional cultural symbols to move us, the need to recharge them by investing heroic energy in them, the paradox that the result is purely surface in appeal, and the realization that nothing but intense surfaces can deeply move us in a situation of failed symbols. All significance comes to exist in the powerfully immediate surface. Art becomes the production of "extreme" surfaces, whose strong atmosphere one breathes the way one breathes oxygen in a vacuum. Works of art like Schnabel's become oxygen tanks to be used in the spiritual emergency brought about by the collapse of faith that is registered in the reduction of traditional cultural symbols to linguistic status. Schnabel's dynamic surface lends the dead language of culturally symbolic figures its power to make the perverse point that it is only in surfaces that we can have faith these days—only in surfaces that we can find depth.

Again, let us remember that this is very much a Hollywood situation, where the surface flow of the movie is more meaningful and moving than any particular scene or figure in it. The flow seems to reflect the unconscious libidinal flow, which relates transiently to objects that seem to "represent" it. It may be that this situation is not particularly modern, that unconscious libidinous energy has always used objects rhetorically. Yet it is in the modern period that this has become explicit—that the rhetoric of it all, especially from the point of view of the unconscious feeling of omnipotence, has become manifest. (Ambivalence towards objects—their reduction to sinister representations—serves the feeling of omnipotence by keeping one subtly disengaged. Of course, ambivalence is itself a form of engagement, even of profound relationship.) Certainly that is what Schnabel is about: the unconscious feeling of omnipotence revealing itself energetically in purely rhetorical imagery. And certainly that is partly what religion is about, which is why it seems safe to call Schnabel a religious painter: the inadequacy of the images of divine power to that omnipotent power, and so the need both to manifest the power more directly and to churn out more image/symbols/fictions in which it can be rhetorically invested. All one needs to do is to look at eternal Rome to realize that religion is pure Hollywood, in the very best sense—its fantastic architectural rhetoric seems at once to generate and embody the feeling of omnipotence, the energy of absolute power.

Schnabel, religious painter that he is, is interested in generating the feeling of faith—of the momentary sense of omnipotence and invincibility that comes from breaking through repression—which occurs with the general "conversion" to feeling. With that explosive release from repression, feeling fastens on—"believes in"—the image that catalyzed its release. Schnabel's raw surface embodies the energy of absolute instinct at the moment of its release from repres-

sion, when it at once embodies itself in "straw" objects and knows its own invulnerability and irreducibility. That is, when feeling is finally expressed, it discovers its own ambivalence and omnipotence. Schnabel is a very "Freudian" artist, in that for him absolute instinctive energy comes before the objects it is invested in, yet only fresh objects can restore our sense of the power of instinctive energy. For Schnabel, as for Hollywood, the freshest, most modern objects are, paradoxically, those that belong to dead traditions of meaning, for they are ready to be reinvigorated by energetic surface treatment. Schnabel's energy is indeed miraculously powerful, for it has raised so many Lazaruses from the dead. One cannot help but regard Schnabel as the master of what the psychoanalyst John Gedo calls "metaphysical magic." It is this that makes him such an unbourgeois, decadent painter. If, as Charles Peguy said, the "bourgeois mind . . . prefers the visible to the invisible," then Schnabel prefers the invisible within the visible.

This issue, which to me is the fundamental one in Schnabel's paintings, comes to a kind of overt climax in *Resurrection: Albert Finney Meets Malcolm Lowry* (1984), referring to John Houston's filming of Malcolm Lowrey's *Under The Volcano,* about an alcoholic British Consul drinking himself to death in Mexico. Schnabel has long been interested in Mexico, where he has vacationed, and he has used Mexican crockery as collage material. The actor Albert Finney plays the role to perfection, becoming the British Consul—who in the novel seems to be performing an elaborately rhetorical act that produces a quite real death. The Finney/Lowry figure blends with that of a Mexican peasant saint, at once angel of death and angel of mercy. It might be an angel from the heavenly chorus that saved Goethe's Faust despite his pact with the devil (which alcohol can be said to be, since it gives one mythical devilish powers, or the illusion of having them: it is the Mephistopheles that makes the ordinary person into a Faust). The Schnabel painting is a "supernatural" performance depicting a "supernatural" performance which reflects a supernatural tension, which is exactly correlate with the "performance" of the tension between figural/object representation and raw surface power in Schnabel's work in general. (It is worth noting in this context that for Gauguin the pursuit of "supernatural sensation" was central to his definition of Symbolism.)

The Finney/Lowry performance is a brilliant act of art—all art, the postmodernist position seems to say, is a rhetorical act of grandiose display which, by transforming all ordinary sensuous surfaces into gratifying sensual or erogenous zones, attempts to take one in, to convince one to have faith in it, to emotionally invest in it by willingly suspending one's disbelief in it. And then one is to discover, once one's feeling is strongly committed, that it exists in and for itself, isolated and free from the fiction it invested itself in. Schnabel's pictures are brilliant propaganda for the modern faith in feeling as the last court of resort for understanding. One invests one's feelings in Schnabel's paintings, as in Caravaggio's, because of their ambiguous dramatic effect—which is what we come to believe in, since it correlates with our self-protective ambivalence and delusions of

grandeur (omnipotence). We believe in the performance of Cara-vaggio's "supernatural" tenebrism, just as we believe in the "super-natural" performance of Schnabel's surface—both generate extraordinary delusions of grandeur and ambivalence simul-taneously—not in the figures or myths involved. To believe in the power of stylistic performance as such is true and pure religion.

In sum, the real source of the archaic effect of Schnabel's paint-ings is their "indeterminacy"—the sense of libidinous energy dissat-isfied with the objects it is invested in, yet having no choice but to experience them as "moving." And then to realize that the only end is to be moved, and that only stylistic performance can move. This archaic search for the moving goes hand in hand with the archae-ological aspect of Schnabel's works, which is conveyed emblem-atically be the broken plates. As noted, they function like shards in an excavation site, signaling a dead and buried world of meaning, but giving us only glimpses of it—tantalizing us with fragments of infor-mation about it. The shards bring it in reach, seem to give us a quite concrete grasp of it—are indeed literally pieces of it—but, even if they were reconstructed into the crockery from which they came, hardly do more than offer a very limited understanding of the primi-tive "underworld," which reeks of death.

The fragmentation plays a crucial role in generating the aura of indeterminacy of meaning. The one suggests actual, the other immi-nent death. Schnabel's art is about the immanence of death—the way it informs the fictions we live by. Death is as immanent in his raw surface as divine power is. His art in general is about death and perverse rebirth—the representation is killed by the raw surface yet, phoenix-like, rises again from its flames—as in the legend of the "renewal" of the *King of the Wood* through his replacement by a more powerful figure who kills him, and who comes to symbolize eternally young divine power. An artist of power like Schnabel must always worry about the next most powerful artist who might kill and replace him. Are his pictures allegories of the art world? Whether or

no, Schnabel need not worry, for at the moment his power is supreme. And yet he clearly worries, for in his works power and death fuse. He is clearly today's king of the wood—having killed off his many ancestors by subsuming their art in his own—but not so clearly tomorrow's. His works are the perfect mix of artist's rage and depression.

Schiff has remarked about Schnabel's figures: "Voodoo doll, golem, mummy—a typical example of this painter's kaleidoscopic shuffling of the most disparate pages in mankind's Book of the Dead." Not simply the figure but the whole canvas can be under-stood as a lurid objectification of the power of death, an abstract allegory of it. Indeed, the weirdly fluorescent cast Schnabel's color often has can be understood as the glow of advanced decay, and the figures so many corpses from the tomb of time. The unconscious is, of course, the land of the dead; one reason Schnabel's pictures are so moving is that the significant fictional others or suffering heroes (and heroines) they depict belong to the land of the mythically dead. Our deepest emotion is invested in the dead beings who have cultural significance for us. *Sexy Jane* (a take on Yeats' "Crazy Jane"?) and *Pope Music* (both 1984) say it all: powerfully moving figures literally looking like death; raw representations of death ripe with yet disap-pearing into the instinctive energy of the crude surface. One has an instinct for death—a death wish—the greatest (deepest) power of all, Schnabel seems to be saying. All public revelry—ever popular sex and the populist Dionysianism of pop music—unconsciously cele-brates it, reflects it. Schnabel's paintings are dances of death. He has apotheosized Baldung-Grien's figure of death in powerful abstract form. Schnabel's various mythopoetic figures and objects—his his-toricism—show, in their different ways, that all ages unwittingly celebrate death, acknowledging it most just when they seem most full of raw, passionate life, and raw will to art.

"The Rhetoric of Rawness" by Donald B. Kuspit. Reprinted from *Arts* (March 1985): 126–130. Used by permission.

The Ascendance of Subject Matter and a 1960s Sensibility

Mark Rosenthal

One characteristic of the rejection of formalism in the last twelve to fifteen years has been the reappearance of recognizable subject matter. Painting is the most obvious area in which this development can be perceived, although the turn to an emphatically stated subject has been realized in nearly every kind of work.[1] Two of the most prominent and influential figures in the evolution have been Jon Borofsky and Neil Jenney. Their emphasis on a content-centered art has been extreme.

Jenney's paintings of 1969–70 are in some ways paradigmatic, and certainly among the earliest to influence subsequent events. Vividly portrayed themes are the core of his art. On crudely painted, brushy fields of either blue, brown, or green acrylic paint, he depicts elemental themes. In contrast to many narrativists, Jenney creates powerful compositional effects, giving his subjects forceful, emblematic portrayals. Beneath the paintings, he boldly states the titles in block letters on the frame. This gesture is a crucial reinforcement of the seriousness with which the subjects are to be taken, as if an antidote to the potential irony of Pop and the inherent banality of Photo Realism. Jenney wants no confusion about what is being represented or whether the subject is incidental. His insistence is archetypal for art of the 1970s and early 1980s.

Borofsky's first exhibition in New York in 1975 consisted of a welter of material, including scraps of paper showing quickly described, child-like dream images, the same enlarged as wall drawings, and bits of figurative sculpture. Because the work was installed randomly and densely, and each image had a direct, ingenuous quality, the exhibition suggested that the basic tenets of Surrealism might have finally been achieved. Borofsky had revealed his interior world without once seeming to modify the effect for the sake of style or art.

The aspirations of these artists are contained by the themes that are shown. Borofsky revels in the content of his dreams whereas Jenney seeks "an imagery that is universal."[2] Representing these themes requires means which enhance the stark vision of what is being communicated. Hence, the artists eschew technical virtuosity in favor of primitiveness and apparent oversimplification which, nevertheless, results in powerful, riveting images.

The presence of subject matter is not in itself a fundamental challenge to the continued dominance of modernist aesthetics. For many artists, a subject is simply a bland motif either subservient to the objectness of the painting or a stimulus for an exercise in realism. But the introduction of crudely rendered themes by Borofsky and Jenney represents a divergent approach in which content becomes paramount. In so doing, they diminish the modernist emphasis on the art work as a physical entity. While various Expressionist and Surrealist forebears are echoed in this approach, the two artists may be said to theoretically reflect the entire history of art previous to the modern period. Subject matter has nearly always been a central concern of artists. A context beyond the boundaries of aesthetic history should also be considered, however.

Although Borofsky and Jenney do not know each other and are barely familiar with one another's work, they share certain attitudes which parallel and possibly originate in the spirit of the 1960s and early 1970s. It was then that many twentieth-century values were questioned and modernism/formalism became an oppressive academy for young artists. The model provided by Romano Guardini's *The End of the Modern World* is useful to recap the *Weltanschauung* of the era.[3] Although his insights were published over a decade earlier, they epitomize the views of 1960s youth. For Guardini, modern life held no "veneration of nature."[4] Instead, nature was to be tamed by technology which would, as well, solve many of the ills of the world.[5] While sacking nature, the modern period carelessly and irresponsibly failed to make certain of the regeneration of the natural world.[6] Modern life produced what Guardini called "mass man," a regimented person who not only has no regard for nature but disdains individuality and creativity, and has a "moral insensitivity in using force."[7]

Memories of the 1960s should prove adequate to confirm Guardini's model. Youth attacked these patterns by stressing nature and spiritual values, and condemning American political policy as being that of "policeman" to the world, employing enormous force against minimal opposition. The dominant public sensibility of youthful people of the 1960s—Borofsky was born in 1942 and Jenney in 1945—concerned political and social ideals and commitment to the world situation. Remarkably, this tumultuous period did not immediately find equivalent expression in the visual arts, although the views were everpresent in the music of Bob Dylan and the Beatles, among others. Rather, young artists had the example of an older generation making art from mass-produced materials; that is, minimalism itself expressed a kind of "mass man" aesthetic. Furthermore, abstraction had by the 1960s become devoid of the spiritual values and idealism of its pioneers and Abstract Expressionist heirs.

Borofsky and Jenney thoroughly express the 1960s sensibility. An exhaustion with the technological finish of the modern world is first shown by the rebellious crudity of their technique. Second, they dismiss modernist art's corollary to technology: the emphasis on the cool, rational, objectively perceived art object. Borofsky's and Jenney's art assert that they and the viewer are most concerned with *what* is being represented. Reinforcing the near denial of modern ideals, Borofsky dreams he is "taller than Picasso," quoting a visual passage from Michelangelo in an installation,[8] and Jenney states that his heroes are the Greeks.[9] Jenney especially has portrayed nature as a sacred presence threatened by civilization. Whether Borofsky would agree is moot, but a clue is in the generally grim view of contemporary society that is always shown in his works. Individuality is a central aspect of the two artists, for they constantly express their philosophy, personality, and convictions. Indeed, the very boldness of their art is itself symbolic of the potential of the human being. In sum, Borofsky and Jenney reject modernism and equivocal attitudes with

regard to subject matter in favor of the hot, committed position that characterized the 1960s.

The art of Borofsky and Jenney has evolved considerably since their initial exhibitions; for instance, both now emphasize execution to a greater extent. Borofsky is allowing a natural, linear virtuosity to emerge, and Jenney is using illusionistic devices to make his subject matter more accessible. At the same time, the two are becoming yet more political.

There was considerable evidence of a political stance from early on, as befitting their 1960s outlook. Borofsky's counting and use of numbers in place of signatures was not only a conceptual device but was meant to recall Nazi numbering of the Jews. And Jenney's *Them and Us* (1969) is one example of a political awareness and preoccupation in his art. The recent work of the two, however, makes political concerns more central. In Jenney's earlier pictures he valued technology as a means to be joined with nature so that humanity might perfect itself. But *Melt Down Morning* (1975) represents a disenchantment with technology; here, humanity's tool becomes a weapon. In the last few years Borofsky has become less patient about recognition of his metaphors (for example, placing numbers on his own face in a 1980 photograph to make the Nazi association more evident). Similarly, after showing a ping-pong table and the figure of a hammering man in a number of exhibitions, he began to attach messages to each. These state that the first is a symbol of the nuclear arms race between the United States and Soviet Union, and the second embodies the concept of a workers' strike. It should be understood, then, that the two artists do not simply stress personal individuality in a hollow affirmation of the "me generation." As Guardini would proscribe,[10] they affirm the individual by showing the human problems that exist within the mass. Yet, unlike other political artists, Borofsky and Jenney refuse to make art reflective of one political system. Implicit is that all current ideologies are generally bellicose and corrupt, and are the cause of the problems.

Guardini wrote that near the end of the modern world a "single fact . . . will stamp the new culture: danger."[11] The danger would result from the use of violence "to solve the flood of human problems which threaten to engulf humanity."[12] He imagined the approach of a "second wilderness," the first being Eden. The second would follow a period of "chaos" and "horrors."[13] Guardini's vision develops beyond the 1960s period of optimistic and idealistic revolt to what is perhaps the mood of the present and immediate future for some individuals, including Borofsky and Jenney. Borofsky's *Hammering Man* evokes both subjugation and violence, as if the *denouement* to a tragic story has arrived. Jenney's *Melt Down Morning* suggests the final nightmare of the modern world. His *North America Abstracted* (1980) shows a subsequent metamorphized period, after the nuclear holocaust or, as it were, "after the Flood"; it is a "second wilderness."

The title of Guardini's book, *The End of the Modern World*, provides an appropriate analogy for the artistic position taken by Borofsky and Jenney. For them, modern life is an exception to the history of human behavior because of its rejection of nature and individuality. Furthermore, modernist art is an accomplice, taking exception to the historical imperative that artists reflect the cultural-religious values of their period. Gestated in the period of the 1960s, Borofsky and Jenney require significant themes as the basis of serious art.

1.

Certain object makers, such as Scott Burton, employ familiar forms from daily existence and thereby give to their pieces a contextual reference in life. Site-specific artists, for example Daniel Buren and Robert Irwin, emphasize the qualities of a locale, making a particular place the major theme of a work. Various explorers in what might be called the second wave of earth art, including Alan Sonfist and Hamish Fulton, rather than stressing their gesture in the landscape, have made the landscape—indeed the theme of nature—central. Narrative artists, employing multiframe drawn or photographed images, illustrate anecdotes. Performance, too, by virtue of its theatrical, plot-like concerns, often announces an overt subject, as does photography.

2.

Mark Rosenthal, *Neil Jenney: Painting and Sculpture 1967–1980*, Berkeley, University Art Museum, 1981, p. 49.

3.

Romano Guardini, *The End of the Modern World*, trans. Joseph Theman and Herbert Burke, ed. Frederick D. Wilhelmsen, Chicago, 1956.

4.

Ibid., p. 80.

5.

Ibid., pp. 74–75.

6.

Ibid., p. 106.

7.

Ibid., pp. 76–80.

8.

Basel Kunsthalle, 1981.

9.

Conversations with the author from 1977–1981.

10.

Guardini, p. 83.

11.

Ibid., p. 108.

12.

Ibid., p. 111.

13.

Ibid.

"The Ascendance of Subject Matter and a 1960s Sensibility" by Mark Rosenthal. Reprinted from *Arts* (June 1982): 92–94. Used by permission.

Minimalism

Peter Schjeldahl

As a naive newcomer to New York and also to art in the middle 1960s, I was a pushover for the shocks and delights, the puzzlements and sensations, of that liveliest of eras. Among cognoscenti, with whom I yearned and despaired of being numbered, Andy Warhol and Frank Stella were already established masters, Jasper Johns and Robert Rauschenberg were old masters, and Jackson Pollock and Willem de Kooning occupied the farthest, mistiest reaches of the classical past. The one earlier modernist with a dispensation of awe was Marcel Duchamp, because no way had been found to outsmart or outflank his scepticism. In those days, scepticism was rapture.

The lightning of the movement called Minimalism—in retrospect, the dominant aesthetic of the last two decades and one of the most important renovations of the art idea in modern history—struck me in March 1966, when I entered the Tibor de Nagy Gallery and saw some bricks on the floor: eight neat, low-lying arrangements of them. Construction in progress, I thought, and I turned to leave. Then another thought halted me: What if it's art? Scarcely daring to hope for anything so wonderful (I may have held my breath), I asked a person in the gallery and was assured that, yes, this was a show of sculpture by Carl Andre. I was ecstatic. I perused the bricks with a feeling of triumph.

Why?

I could not have explained at the time. It seems to me now that my response to Andre's bricks, like the appearance of the work itself, had been long and well prepared, partaking in one of those moments of Zeitgeist when unruly threads of history are suddenly, tightly knotted. What elates then is the illumination, in a flash, of much that has been inchoate and strange in the world and, most of all, in one's own sensibility. An instinct for the radical, a hunger for irreducible fact, a disgust with cultural piety, an aesthetic alertness to the commonplace—all these predispositions were galvanised for me, in a form that embodied and extended them. At the root of such an epiphany is the youthful need to be acknowledged, to know that one is not utterly negligible or crazy; and here was an art (was it art?) which existed in relation to me and which, in a sense, I created.

The main art-historical precedent for Andre's bricks, I was immediately aware, had been Duchamp, with his readymades and his theory that the art work is a collaboration of artist and viewer. But the difference was enormous—the difference between the idea of something and the thing itself. Duchamp's readymades gestured. The brick works *were*. With them at my feet as I walked around the gallery, accumulating views, I felt my awkward self-consciousness, physical and psychological, being valorised, being made the focus and even the point of an experience. I had had intimations of this from artists other than Duchamp, mainly Johns and Warhol. By contrast, though, Johns's moody emblems seemed "too personal" and Warhol's iconisations of mass culture "too social." Here, at last, was the purely and cleanly existing heart of the matter.

For a long time, this innocent revelation of the bricks remained the high-water mark in my appreciation of Minimal art. Like many

another mere art lover then, I was dismayed by the arcane criticism that swarmed, rather comically, around the mute simplicities of the work—much of it written by the Minimalists themselves, whose often overbearing and scornful personalities daunted and antagonised me. As time passed, I was particularly appalled by the celerity with which Minimal art was embraced by art-world institutions, to the point where its meaning became practically indistinguishable from the certifying authority of those institutions. This seemed a betrayal of the feeling of liberation I had gotten from Andre's bricks, though, thinking back, there was one ominous sign that afternoon in 1966: Before enjoying the bricks as art, *I had to ask.*

Today Minimalism is deeply lodged in the blind spot of an art culture bedazzled by a revival of paint and images. There is a tendency to regard it, if at all, as a defunct episode of sensibility, even a period style—which in several ways it is. But it is also the legacy—the living legacy, in the continuing productions of some major artists—of an aesthetic high adventure roughly comparable to that of Cubism. Like Cubism, it may less have ended than to have so thoroughly insinuated itself as a philosophical model that it governs even the reactions of styles hostile to it (Neo-Expressionism being today's aesthetically conservative, psychologically rebellious equivalent of Surrealism in the 1920s). To sort out the ideas and contradictions, successes and failures, of Minimalism seems both newly possible and imperative in this moment. For me, there is the added motive of recovering the mystery of another moment, eighteen years ago, when the future was on the floor.

Where did Minimalism come from? As attentive a critic as Lucy Lippard, writing in 1967 (of what she then proposed to call "post-geometric structure"), despairingly pronounced the movement "a virgin birth," and the art-historical record still offers scant rebuttal of that improbable judgment. Minimalism at heart was less a style than a critique of styles, less a new look than the imposition, on art, of modes of thought and feeling previously marginal or downright alien to it. Russian Constructivism—particularly its early-1920s phase, when artists including Tatlin and Rodchenko strove to merge art with industrial production—presents certain analogies, striking but almost certainly adventitious. As for earlier geometric abstraction, even the most astringent of it—from Malevich and Mondrian to Ad Reinhardt—appears almost hopelessly fussy from a Minimalist viewpoint.

Even Duchamp, the godfather of all anti-art, seems a bit beside the point of Minimalism, in a way that is instructive. Duchamp was a wit, a gadfly within the philosophical structures of Western art. He required them for his fun, which was the production of little pun-shaped double binds revealing the rational incoherence of cultural conventions. His was an innocent sort of fun, finally, since he advanced no vision of an alternative, superior convention (except maybe chess). He aimed to sting, not destroy, and to pique rather than demoralise (though to think too long on the implications of Duchamp's work is to have an abyss yawn at one's feet). Committed

not to tease but to revolutionise convention, the Minimalists were far deadlier. Their works often had the thought-structures of Duchampian jokes, but, except now and then, they weren't kidding.

Minimalism was a fiesta of subversion, what with Andre's literal flattening of sculpture (internal space "squeezed out," in Rosalind Krauss's phrase), Robert Morris's gaily cynical manipulation of styles, Sol LeWitt's subordination of the visual to arbitrary mathematical logics, Richard Serra's pitiless physicality, and Bruce Nauman's methodical unpacking of the idea of the artist. (For reasons I will explore, Donald Judd must be kept to one side in such generalising.) All these activities had the effect of bracketing and freezing— reifying—certain structures and expectations formerly enveloped in the golden haze of the word "art." In the resulting petrified forest of tropes, the one traditional element that remained alive was artistic *intention:* not the Mephistophelean intention of a Duchamp, but a Faustian intention like that of the Abstract Expressionists.

Abstract Expressionism was the real sire of Minimalism, though in ways that will not register in an art historian's slide lecture. To appreciate the connection visually, one must determinedly—and perversely—view Pollock and Barnett Newman, say, through a filter that will admit the paint-as-paint literalism of the former and the reductive formats of the latter while blocking out their content. Actually, such perversity is something of a modern habit, as when we dutifully inspect the eccentric surfaces of late Cézanne through the scientific eyes of Picasso and Braque; but never before Minimalism was creative "misreading" so radically pursued. The explication of Minimalist sensibility—the Minimalist filter—must ultimately be sought outside of art, I believe, though it has a major anticipator within art: Jasper Johns.

One of several pedagogical coups in the recent rehanging of The Museum of Modern Art's permanent collection comes right after the singing grandeurs of Pollock and Rothko. Entering the next space, one is confronted—with a sensation like that of being hit in the face with a bucket of ice—by one of Johns's "Flags" of the late 1950s. The conjunction is incredibly rich and, in terms of a sea change in American culture at that time, dead accurate. What we notice right off about Johns's elegant icon, in context, is what it *leaves out:* self. Subjectivity is reduced to a wandering, empty signature: sensitive, waxen brushstrokes which, like the bleats of lambs without a shepherd, call feebly after the missing figure of the artist. At MOMA, this painting acts as a kind of *Ur*-form, and common denominator, of the American Pop and Minimal works that shortly follow it.

Tentatively in Johns and decisively in Minimalism (as also in Warhol), there was a reversal in the polarity of artistic intention: from the expressed, expressive self of the artist to the effected, effective entity of the art work. Rosalind Krauss traces directly to Johns the "rejection of an ideal space that exists prior to experience, waiting to be filled." Anything *a priori* was out. The production of a work was to be the beginning, not the fulfilment, of its meaning. These reflections help me to understand my feelings about Andre's bricks in

1966: Precisely a sense of beginning—a new world, a *tabula rasa*— fuelled my afflatus. As with many revolutions, what was confidently begun would end in confusion. Today Minimalism is more obviously the finish of modernist idealism than the commencement of a new era. But without some imaginative recuperation of its initial thrust, we will not comprehend the conviction of the best works in its canon.

The destructive threat posed to the modernist tradition by Minimalism was not lost on Clement Greenberg and his formalist followers—Kantian idealists all—in the 1960s. Greenberg's own waspish sniping at the movement, like the bland abstract painting he upheld as the legitimate art of the day, was ineffectual, but one Greenbergian, Michael Fried, got off a memorable blast: "Art and Objecthood" (1967). Sometimes hatred can sharpen perception. In his detestation of what he termed "literalist" art—as a species of "theatre," the "negation" of all self-sufficing, modernist arts—Fried gave an account of Minimalist aesthetics that, with adjustments of tone, could serve as a signal appreciation. As it is, his counter-attack on what he saw as a barbarian onslaught is a classic text of conservative criticism.

By "theatre," Fried meant the essential quality of *"a situation"* which *"includes the beholder,"* who is confronted by Minimal works "placed not just in his space but in his *way."* (All italics Fried's.) The viewer "knows himself to stand in an indeterminate, open-ended— and unexacting—relationship *as subject* to the impassive object on the wall or floor. In fact, being distanced by such objects is not, I suggest, entirely unlike being distanced, or crowded, by the silent presence of another *person*; the experience of coming upon literalist objects unexpectedly—for example, in somewhat darkened rooms—can be strongly, if momentarily, disquieting in just this way." Fried then pushed this simile too far, asserting that the hollowness of much Minimal sculpture, its "quality of having an *inside*," made it "almost blatantly anthropomorphic"—forgetting that people are not hollow. But his basic sense of the way Minimal art addresses its viewers is definitive.

As a modernist, Fried wants art to leave him alone, and to do so *explicitly.* In his view, art should emphasise and reinforce—celebrate—autonomy. His is an aristocratic cast of mind, of the sort that cherishes quiet cultivation and loathes crowds. One can sense in his denunciation of Minimalism a tacit protest against the militantly democratic culture of the 1960s, a culture of liberating candour and humane values, on the one hand, and of narcissism and spectacle, on the other. Had he acknowledged this subtext of his theme, Fried might have dropped the "anthropomorphic" red herring and seen Minimalism in its full historical lineaments, as the paradigm of a cultural reality in which self-conscious spectatorship—like being "crowded"—is a universal fact of life. He wouldn't have liked it any better, but his sense of what made Minimalism "strongly disquieting" would have been illuminated.

Minimalism was substantially determined by American social changes that were felt with special drama within the formerly her-

metic precincts of art, where in the years around 1960 there occurred an unprecedented explosion of the audience for avant-garde work. Owing in part to what might be called the de-Europeanisation of the avant garde by Abstract Expressionism, the arrival of this new audience (upwardly mobile professionals, mostly) was given a gala welcome by the Pop art boom, then registered in more complex and equivocal ways by Minimalism. (The apparent sequence of Pop and Minimal—the former going public around 1962, the latter around 1965—was a happenstance of exhibition; actual first production of definitively Pop and Minimal work had been nearly simultaneous.) On the simplest level, Minimalism was art created with the absolute certainty that it would be exhibited and seen—"stuff you wouldn't make unless you had a place to show it," as Nauman once remarked.

But nothing was simple about Minimalist responses to the changed estate of art in the world. If, in one way, Minimal works were virtual symbols of the new order—aggressively outer-directed presences, spraying their surroundings with aesthetic vibrations (inducing in viewers a kind of delirious sensitivity that invested nearby elevator buttons and fire-alarm boxes with vicarious sublimity)— Minimal works were also chastisements of too-ready and complacent enjoyment. Inevitable attention being discomfiting—threatening the professional integrity and rectitude of the artist—measures were taken to frustrate, attenuate, or otherwise challenge it. Always obdurate, Minimalism in its later stages became overtly hostile to an audience that appeared willing to tolerate any degree at all of enigma, boredom, and even cruelty. Ultimately, limits were reached.

The death of Minimalism as a movement was as ineluctable as its birth had been, a process of murder by institutional smothering and suicide by what Greenberg accurately enough termed "hypertrophy." Having keenly resisted the commodity culture of publicity and commerce, Minimalism failed to gain a comparable critical edge on the burgeoning new culture of "support structures"—often publicly-funded museums, universities, "site-specific" outdoor shows, sculptural commissions, and "alternative spaces"—which in a sense bureaucratised the movement's principles. And no one who was paying attention to New York in the late 1960s will ever forget the fantastic pace of "dialectical" proliferation, the nightmarish speed with which minimalistic styles (or, really, styloids) succeeded one another, in a torrent of two-noun designations: process art, earth art, body art, performance art, on and on. Conceptualism, the terminal stage, was less the last development in a series than a receiving bin for aesthetic entities too frail to stand on their own.

The disintegration of the American avant garde in the early 1970s, abetted by political traumas of the day, had long-range consequences which have included gravitation of young talent to traditional mediums, revived interest in ideas of "expression," recommercialisation of the art world, and a shift of artistic initiative to Europe. American Minimalism itself was more or less expatriated to Europe, where curators and collectors remained hospitable and where native artists have never ceased to extrapolate and to play variations on Minimalist themes. (We badly need a full account of

Minimalism from a European perspective.) In America, meanwhile, Minimalist critical consciousness has proved itself quite capable of surviving with only slight nurturance from actual art. It persists in the robust "anti-aesthetic" stance of numerous post-structuralist, Marxist writers, allied with a few minor conceptualistic artists.

Yet Minimalism is still the essential backdrop of all important art since the middle 1960s. What is called "post-modernism" in culture might as well, within the art culture, be termed the Age of Minimalism. Cardinal features of Minimalist thinking—phenomenology, a sense of contexts, criticality—remain aesthetic common-sense on both sides of the Atlantic, exerting pressure on and through all but the most determinedly backward-looking new art. Artists may have retreated from the confrontation with non-art that Minimalism enacted, but what was learned from the confrontation continues to inform and even haunt. Minimalism lives on in the collective mind as a region of austere rigour and sceptical probity—a troubled, troubling conscience. Its history cannot yet be written, because it is not over.

As I write—bringing the introductory section of this essay to a close—I have before me Carl Andre's *Equivalent VI*. It is one of the arrangements of bricks from the show I saw in 1966. (Does it matter whether these are the same or different bricks? No.) The work comprises a hundred and twenty bricks—firebricks, the colour of dirty sugar—in a two-tiered rectangle, five bricks wide by twelve long. (In the 1960s, geometry was poetry.) My mind recognises it as "an Andre," but the work still fails to awaken an automatic "art" response. If I didn't know, I would still have to ask. I find this oddly reassuring, as perhaps anything permanently intransigent can be in our world of change: in this case, a dour emblem of change itself, an ineffaceable provocation. Though far upstream, now, from the present, those bricks continue to baffle the current.

An art collection is a work of criticism. The occasion for this essay being the presentation of this remarkable collection of Minimal and minimalistic art, I am engaged in adding a text of words to a text of objects, and I am obliged to start with a clear sense of the latter. Though extraordinarily comprehensive, this part of the Saatchi collection has the peculiarity of embodying a connoisseuring approach to a highly theoretical movement. It seizes on intrinsically significant, excellent sculptural objects and paintings instead of trying to document the sorts of environmental and conceptual work that, from other points of view (and in other collections), might appear to be fulfillments of the Minimalist enterprise. It offers and invites judgments of the traditional kind: good, better, best. Ironically, this conservative cast, with its effect of questioning the relation of Minimalism to the traditions of Western painting and sculpture, highlights the radicalism of the movement, the jagged edge of its break with the past.

As a topographical map of Minimalism, the collection emphasises, by its relative proportions, four of the six major sculptors of the movement's middle-1960s heyday: Andre, Flavin, Judd, and LeWitt. Morris, a supple didact and magician of styles, whose sculpture of

the period was a sort of course in three-dimensional art criticism, is properly less represented, given the collection's character. The late Robert Smithson, whose major contribution (two or three earth-works aside) was literally his brilliant critical writing, is not represented at all. Around this core, the collection includes some variants of Minimal sculpture in the work of Larry Bell, John McCracken, and Fred Sandback. It forms another core around four major figures of what Robert Pincus-Witten has dubbed Post-Minimalism: Eva Hesse, Nauman, Serra, and Richard Tuttle.

The paintings of Jo Baer, Robert Mangold, Brice Marden, Agnes Martin, and Robert Ryman are both a special strength of the collection and a separate category within it. Strictly construed, Minimalism was a sculptural movement, and it is misleading to speak of "Minimal painting" except within the broad terms of a sensibility which had effects in all areas of culture (notably music and dance). These painters (Ryman perhaps excepted) did not so much advance Minimalism as register, and even strategically resist, its impact on their medium. The real-space, real-time phenomenology of Minimalist aesthetics, with its anti-illusion, anti-pictorial bias, tended to question the validity of painting altogether. There was little likelihood that any painting, no matter how simplified, would fail to be perceived as art, and it was the interest and the honour of mainstream Minimalism (Judd, as usual, excluded) to risk not only the look but the felt possibility of non-art.

I will offer no definition of Minimalism. In a way, mere use of the word "Minimalism" constitutes more definition than is warranted for a movement which relentlessly undermined previous definitions of art. But all style-names are no more than gross conveniences ("Cubism," if you please), and I will continue to employ this one, which usage has sanctified. I trust that its arbitrariness will be perceived as we proceed to deal with the particular achievements of individual artists.

Donald Judd

If Andre is the *echt* Minimalist, Donald Judd—the first name most people associate with the movement and widely deemed its best artist—may scarcely be a Minimalist at all. An obstreperous enemy of generalisation, he has always renounced the label. At one time, he even eschewed the designation "sculptor," preferring to speak of himself as a maker of "specific objects." Whatever his work may be, there is no mistaking it for anything besides art. It is unfailingly elegant—even lapidary, in a grandiose sort of way. To the extent that it is Minimalist, Judd's work is definitive of Minimalism not as a set of ideas but as a *style*, the typical expression of a particular visual sensibility—a sensibility itself typical of America in the 1960s and shared by all the artists under consideration here, the painters included.

It seems rather a pity for the strength of Michael Fried's case, in "Art and Objecthood," that he could not see his way clear to claim Judd for the modernist side in his war on Minimalism; he had already commandeered Stella, much to Greenberg's disapproval. (The art politics of the 1960s might inspire a nice musical comedy.) Judd and Stella have marked similarities, for example in their uses of materials. Judd's various sheet metals and industrial finishes, like Stella's shaped supports and unconventional paints, are palpably extensions, not disruptions, of the conventional aesthetic field: They are things of beauty. Both artists are essentially formalists, aiming to refresh rather than revolutionise modern art—heirs of Matisse rather than Duchamp. Their initial rationalisations of form were radical, but in ways purely in the service of their common, quite traditional intent to produce objects at once powerfully engaging and decoratively satisfying.

Already in the earliest and most severe Judd here, the wall-mounted, galvanised-iron box of 1965, one senses not a philosophical gesture but the straightforward operations of an acute and imperious eye. The effect of the piece may be analysed in terms of opposed qualities: aggressive projection/light-softening material, geometric regularity/arbitrary proportions, relief configuration ("pictorialness")/truculent shape ("thingness"). The extreme economy of the piece works to discipline, but not to deny, the pleasure of the viewer, who is simply discouraged from indulging in any partial or tangential thoughts or feelings. The box will be looked at in its own way—for what it *is*—or not at all. It is tough, bracing, and, without being in the least sensuous, quite lovely.

Loveliness, often of a racy, rather expensive-looking kind, has been a recurrent tone of Judd's work, as it was not of more doctrinaire Minimalism. Judd has been criticised on this score for producing elitist, corporate-style decor, a charge to which his only defence is the autonomous value of his determinedly uningratiating rigour. At the least, this rigour distinguishes Judd's objects from the mass of similarly bright and shiny art of the 1960s—art that complacently reflected the bluff pragmatism, faith in technology, and can-do arrogance of pre-Vietnam America. If Judd's style is inconceivable without the background of those values, it is also independent of their survival.

The rigour of Judd's objects is both cause and effect of the emphasis given each decision in their making. Often the decisions are of a systemic, instrumental kind, like the use of mathematical progressions to determine unit-intervals. It is unimportant for viewers to know Judd's systems. (From time to time, I have taken pains to learn them, only to have them slip my memory almost immediately.) They are there to stabilise one's experience by foreclosing the normal "expressive" associations of composition. Judd's work provides satisfactions analogous to those of machinery, architecture, decoration, and the purely structural aspects of poetry and music. It does so by functioning in time with the viewer's movements. This is especially the case with Judd's huge, magnificent plywood piece of 1981. Walking along its eighty-foot length is like physically traversing—and, by one's speed, determining the tempo of—a great fugue.

In the nether realm between painting and sculpture that characterises Minimalist sensibility, Judd is the master orchestrator of visual/physical tensions. A fine example is the open copper box, with red

lacquered bottom, of 1973. Three feet high, it has the obtrusiveness and the proportions of a thoroughly impractical piece of furniture; it is, indeed, "in one's way." As one approaches, however, all awkwardness dissolves in sheer optical ravishment, the glow of some spectral substance at once molten and cold. There is no way of reconciling, in an orderly Gestalt, one's impressions of the piece from near and far, outside and inside. Rational in conception, the work is irrational in effect, an endlessly and agreeably exacerbating presence.

Dan Flavin

In scale of achievement, Dan Flavin's work might seem in peril of being classed with lesser variants of Minimalism, as the limited extension of a single, schematic idea. However, he belongs by biographical right with the first generation of the movement, and he is important as a ridge between the Minimalist sensibility of Judd and the more conceptual or ideological Minimalism of LeWitt, Morris, and Andre. At one extreme the most coldly geometrical and technological of these artists, at the other extreme Flavin is the most romantic, even sentimental; and the contradictory nature of his position, though never fully resolved in his art, makes him an intriguing test case of contradictions that beset the movement as a whole.

If Judd's work is Minimalism as style, Flavin's is Minimalism as period "look" and period romance, a spectacular and poetic apostrophe of the movement's decorative taste and spiritual cast. All the main points are present, amazingly, in the earliest and simplest work represented here, the *Diagonal of May 25, 1963*, a lone fluorescent tube: the non-art look of the readymade commercial fixture; the obvious, clean beauty of the light; the art-historical nostalgia of the diagonal (definitive trope of Constructivism); and the urbane, diaristic glamour of the title. Flavin has always let tender and exalted feelings, squeezed by the impersonality of his style, leak out in titles and allusive configurations—as in the *"Monument" for V. Tatlin*. Recently he has become quite shameless, for instance in a large work of 1984 (not in the collection) dedicated to his pet dog: a sloping series of green and blue tubes evoking the line of a grassy hillside against a summer sky.

In narrowly aesthetic terms, meanwhile, Flavin's work belongs with the purest Minimalism, meaning the most explicitly phenomenological: He creates "not so much an art object as the phenomenon of the piece's existence in a particular location, at a particular moment in time," as Grégoire Muller neatly put it. His pieces are art only when installed and electrified; betweentimes, they are just hardware. By being literally illuminated (almost, one may feel, looked at) by the work, the viewer is made even more sharply self-conscious than in the case of Andre's bricks. On a theoretical checklist, then, Flavin emerges as a crack Minimalist, the peccadillo of his poetic enthusiasms aside. But such perfection has its costs.

Flavin's art is a hothouse flower, abjectly reliant for its basic meanings on an institutional setting—a place where its non-art qualities can have piquancy and bite, as tacit assaults on conventions by which, for instance, lights on the ceiling illuminate art on the walls rather than the other way around. Outside such a setting, a Flavin is merely bizarre and merely beautiful, far too ingratiating to generate much aesthetic or critical friction. We do not despise hothouse flowers, of course. We like them for their poignancy as signs of nature unnaturally itensified, and for their dependence on us. By being imprisoned, they are glorified. This being so of Flavin's work, his rhetorical gestures and lurking metaphors are not simply idiosyncratic frills, but—by referring to life and history beyond the hothouse—the one level on which he escapes the fate of theory realised not wisely but too well.

Sol LeWitt

If Sol LeWitt, my own favourite Minimalist, had never created anything but his wall-drawing ideas—sets of written instructions capable of being executed by anyone almost anywhere—his eminence would be assured. When performed, these exercises in draughtsmanship by proxy are works of grace and of a peculiar mystery: the mystery of art (or, really, of anything at all) as something that people *do*. In one way, the drawings are no less period pieces than Flavin's light works. Distant relatives of Happenings—the party-like performances of the early 1960s—they belong to a moment when getting people involved in gratuitous toil seemed an answer to the problem of an expanded, largely naive audience. (With his monumental swaddlings, engaging hordes of volunteer helpers, Christo is the road-show Barnum of this idea.) However, LeWitt's wall drawings differ in that they issue in experiences superior both aesthetically and philosophically. Their executions are as entrancing to the eye as their concept is elegant in the mind.

The equivocal relation between art in the eye and art in the mind is LeWitt's playground. He is the most elusive major figure—the Ariel—of Minimalism, with a way of making any perception of him seem almost but never quite the right one. This baffling quality is physically palpable in LeWitt's many sculptures of cubic and laticelike forms, works which, like the wall drawings, are relentlessly faithful renderings of arbitrary mathematical formulations. ("Irrational thoughts should be followed absolutely and logically," he has said.) Clear and shapely as prior ideas, the sculptures have been more or less abandoned into actuality. There is a delicate awkwardness, an excruciatingly "off" quality, about them that seems symbolic of the fate of all well-laid plans when they encounter the happenstance of realisation. The difference between LeWitt and other planners is that he makes no adjustments to contingency in the fabricating process, because a mismatch of thing and idea is of the essence for him.

There is, besides Ariel, a bit of the social-democratic Pied Piper about LeWitt, who in the high-anxiety art world of the late 1960's was a memorably encouraging and reassuring influence on younger artists—none of the standard swagger and snarl for him. His strangely denatured friendliness, coming across in works of the utmost austerity, is surely one of the unique artistic flavours of modern times, and fascinating for its redolence of a social vision. Minimalism

abounded with fragmentary schemes and yearnings for community, for a creative, anti-capitalist phalanx similar to that of the revolutionary-era Russian avant garde. Most versions of this aspiration appear foolish or tyrannical in retrospect, but LeWitt's retains appeal because it is a matter less of fantasy or ideology than of tone: a hint of what a better world would *feel like*. It would feel, in a word, better.

The symbolic genius of LeWitt's wall drawings, in the broadest terms of our civilisation's discontents, is their reconciliation of "scientific" mentality and the frailty of the human machine. They engineer an enjoyment of our waywardness. As Kenneth Baker has written, LeWitt's work "lets us approach and contemplate without anxiety the aspect of aimless energy that belongs to our own spontaneity, and the meaninglessness that characterises human activity." Given the vagaries of various hands, the drawings will never turn out the same in different executions. No particular execution—one in The Museum of Modern Art, say, when compared with one in somebody's apartment—has more authenticity as art than any other, and no number of executions of a drawing can begin to exhaust its potential—because the drawing, in common with human nature, is a mental inscription of *potential* pure and simple.

LeWitt's understanding of art as activity, as an unreasonable course of action reasonably pursued, is the very soul, as opposed to the theory, of mainstream Minimalism. Like a soul, it is invisible and only provisionally inhabits material form—as the principle of the form's animation and the idea of its transcendence. If this sounds objectionably theological, there's no remedy for it: Minimalism always carried religious as well as political charges, though the positivist sensibility of the 1960s held them in check. (Minimalism's mystical side gained wide expression during the 1970s in much pantheistic and otherwise primitivist art, well documented in Lucy Lippard's recent book *Overlay*.) In LeWitt's case, positivist scepticism is reinforced by a kind of sunlit civic virtue, a determinedly secular, sociable timbre. His is a practical Platonism, a supernaturalism free of spooks.

Robert Morris

Having dubbed Sol LeWitt Minimalism's Ariel, I am tempted to call Robert Morris its Caliban—but this would become complicated since it would entail a Caliban in masquerade as Prospero, philosopher king of art's enchanted isle. Morris's presence in the 1960s art world, as artist and theorist, was prodigious. He anticipated, invented, or quickly put his stamp on every twist and turn of Minimalist dialectics from geometric structures to earthworks, not disdaining to lift an idea from any younger artist who nipped in ahead of him. Like no one else, he had mastered subtleties of Duchamp and Johns, and he was sure-footed in the dizzying spirals of irony that, for a while, were art's sport and passion. There has never been a consistent look to Morris's art, only a consistent cleverness—the distinctive tattoo of an idea faired, trued, and hammered home. That was literally the noise of an early work (not in the collection) which Carter Ratcliff has

pointed to as the touchstone of Morris's art: *Box with Sound of Its Own Making*, 1961, a wooden box containing a live tape recorder.

Caliban, it will be remembered, is the "natural man" considered as a creature of brute necessity. At a time when step-by-step, tactical reductivism seemed the nature of art, Morris, for all his nimbleness, was exactly that. In contrast to Duchamp and Johns—and LeWitt—there is no fume of liberation about any of his ironies, but rather the opposite. As Ratcliff has also suggested, "In the Realm of the Carceral"—a series of drawings of imaginary prisons done in the late 1970s—might serve as an apt summary of Morris's entire career (nowadays involved in one-upping the expressionist trend with icons of death and apocalypse). A perverse enjoyment of deprivation and a savouring of entropy (the latter shared by Minimalism's greatest critic-artist, Robert Smithson) make Morris a *poète maudit* far more powerfully interesting than can be guessed from his sculptural works alone. He must be sought, if at all, on the mazy island of esoteric discourse he long ruled and terrorised.

Carl Andre

Having made extravagant use of my first encounter with Carl Andre's art, I ought to acknowledge that never again have I had an experience with any Andre of even remotely comparable intensity. Though far from being a one-note artist, Andre definitely packs only one big surprise, which, having once been registered, does not recur. In a sense, all his works are simply reminders and confirmations of a state of affairs: the world according to Minimalism. Though awfully monotonous at times, Andre's endlessly repeating formats, all of them making essentially the same point, indicate a faith in the overarching importance of his initial insight. Monotony may even be a matter of honour in such faith: the monotony of ritual observance or (as Andre has said in punning reference to his metal-plate pieces) of a "great bass," the harmonic drone of a scale's lowest perceptible chord. (Also, of course, a "great base" on which to stand.) And one thinks of Albert Einstein's mild remark that, after all, in his whole life he had had only one or two ideas.

Every now and then I do get a little jolt from an Andre, as I realise something I had forgotten: that his work is, by and large, quite beautiful. Almost sacrificially, Andre brings to the draconian discipline of his style some fine sculptural gifts, most apparently a sense of the poetry of materials and an acute feeling for scale. These qualities become lyrical in his deployments of wooden blocks or beams, and I daresay that art lovers of the last two decades have, on account of Andre, a relatively vast sensitivity to the colour and texture of industrially rolled metals. Not that Andre's work has aesthetic appeal sufficient to justify its importunity: That importunity—insistent, dumb, impassively challenging—still comes first, as the ongoing fanfare of Minimalist revolution.

As I have suggested repeatedly, the Minimalist revolution turned out to be a palace coup, confined to art's certifying institutions. However, it demands credit for being a real and consequential coup—like Cubism, now a fundamental element of aesthetic literacy.

The cliché that radical impulses are defeated by acceptance does not always hold true. Andre's work has changed our sense of the museum a lot more than the museum has changed our sense of his work, and anyone who fails to grasp this is doomed to being bewildered by new art today and to the end of time.

John McCracken, Larry Bell, Fred Sandback

My history with Andre repeated itself (as farce) when, in 1967 or so, I first saw one of Los Angeles artist John McCracken's lacquered planks—a staggeringly *correct* painting/sculpture hybrid whose combination of sleek geometry and vernacular disposition (it leaned!) was ineffably racy. Thus was I introduced to the "L.A. Look": feel-good Minimalism, Minimalism without tears. The L.A. Look favoured plastics and dreamy colour and was attuned to the intense radiance of the Southern California sun. (It tended to look a bit off-key in New York's weaker and moister Atlantic light.) Besides McCracken's planks, its most iconic expressions were Larry Bell's ubiquitous coated-glass boxes on plexiglass bases: ultrasubtle inflectors of space and light and, with their stainless-steel fittings, muted paeans to the high-tech sublime.

Regional variants of Minimalism were few in America—in Europe they were legion—and this gives the L.A. Look, short-lived as its heyday was, a lasting curiosity. It had something of a counterpart in New York, actually: an unnamed but virtual "N.Y. Look" which emerged in last-ditch opposition to the art object's vanishing in Conceptualism. Such art soberly exploited Minimalist aesthetic discoveries in an unironic spirit of Less-Is-More. Much as the L.A. Look celebrated Southern California beach weather, the N.Y. Look indexed a phenomenon peculiarly congenial to Manhattan: the immaculate "white cube" of the contemporary gallery. Fred Sandback's spare elastic-cord geometries are perfect examples—dependent on a proper setting to the point of being its mascots, but agreeable as environmental grace notes and as tokens of urban refinement.

Bruce Nauman, Richard Serra, Eva Hesse, Richard Tuttle

In a way perhaps unprecedented in any other art movement, much of the best of Minimalism was saved for last: a "second generation" which includes two artists, Bruce Nauman and Richard Serra, every bit as important as any of the pioneers—plus a third, Eva Hesse, who might well be on their level but for her tragic death in 1970 at the age of 34. Along with Richard Tuttle (a maverick who is a case unto himself), these artists not only realised a host of possibilities latent in earlier Minimal art but retroactively deepened and clarified the movement's premises. They did not do it by theorising. On the contrary, they created works which, though difficult, were self-explanatory, and in so doing they acted to close the disturbing gap between tight-lipped object and teeming verbiage that at times gave the 1960s art world an air of Alice's Wonderland. The gap had been produced by an all too successful strategy of suppressing artistic personality.

There was always something out of whack about the Minimalist first generation's cult of impersonality: a shiftiness on an issue—artistic ego—that forms a subterranean, competitive link between the Minimalists and their forebears, the Abstract Expressionists. Deflating myths of "self" was all very well, but denial of art's subjective dimension reached absurd extremes. Minimal works were made by *somebody*, after all—somebody with motives and attitudes livelier than that shrivelled theoretical residue, "intention." (Judd, in his more conventional ambition as a stylist, escapes this objection.) The work of Andre, Morris, Flavin, and even LeWitt often had an eerie, remote-control quality—as of the Wizard of Oz enjoining Dorothy through a fiery apparition, "Pay no attention to that man behind the curtain!"

While no less chary of the "expressive" fallacy, Nauman, Serra, and Hesse found ways of being psychologically present in their art, thereby entitling viewers to a fuller range of response. (Rather than be similarly forthcoming, Tuttle turned the tables in works practically symbolic of evasion: disappearing acts of the artist.) Which is not to say that they cosied up to the public. As often as not, the tones of their work varied between creepy and threatening—and probably contributed to the flight of general viewers from the new art, an exodus well underway by the late 1960s. But to those still paying attention they brought a new dispensation of seriousness (mingled with extraordinary wit, in Nauman's case). Their achievements of the time remain exemplary, and the last has not been heard of their influence.

In January 1968, at the Leo Castelli Gallery, Nauman had one of the most phenomenal of first one-man shows, not the least of its astonishments being that it occasioned the artist's first visit to New York. Seemingly from nowhere (from San Francisco, as it happened), he had arrived with an enormous variety of sculptural objects strange in form and material and bristling with intelligence. Some were loaf-shaped fibreglass casts which produced standard effects of Minimalist "presence" with disquieting overtones of organic life. Others involved body casts, neon signs, and such wild congeries of stuffs as aluminum foil, plastic sheet, foam rubber, felt, and grease. Many made sly reference to the idea of the artist, perhaps as someone who makes an impression (knee prints in wax) or "helps the world by revealing mystic truths" (as a spiral neon sign surmised). In such works as *Henry Moore Bound to Fail* [1967–70, Saatchi Collection, London] many-levelled facetiousness attained heights of poetry.

Nauman reversed a valence of previous Minimalism, replacing stark certainty with a process of endlessly ramifying questions about the sources and uses of art. Like the hero-scientist who tests a new serum on himself, Nauman used self-reference to explore notions of what an artist is and does. What kept this innately disintegrative project integral was—beneath the anxious, fencing humour—a conscientious bet that, whatever its contradictions, art somehow truly matters. In myriad forms since 1968, Nauman's conflict of belief and scepticism has remained constant. Lately, it has taken on an

added weight of moral implication—playfully, in neon amplifications of judgmentally loaded words and earnestly, in haunted sculptures for meditating on political torture, such as *South America Triangle* [1981, Saatchi Collection, London]: a suspended, eye-level (masking) triangle of I-beams framing the mute catastrophe of an upended cast-iron chair.

Without a whisper of irony, Serra observes none of Nauman's equivocating distance from the idea of the artist. *Being* his own idea of the artist, Serra has dramatically forced certain essential issues of art's role in the world—as assertion of creative will, as purposeful manipulation of viewers, and as a thing distinct from other things. Serra's feat has been to clarify all these relations *physically*, by sheerly sculptural means. His ambition far surpasses the creation of imposing objects. Part of his work's scale is social, involving a keen sense of art's capacity to affect an unprepared audience. (This part of Serra's enterprise has encountered the withering contradictions of all "public art" today, but his approach is at least cogent.) In cynical times, the purity and absoluteness of Serra's conviction are exotic.

Serra derived his style through experiments with the fundamental properties of materials, such as the weight of metal. *House of Cards (One Ton Prop)*, [1968–69, Saatchi Collection, London], was the definitive statement of Serra's decision to let gravity determine the structure of his work. He thereby eliminated the last remnant of illusionism in Minimalist aesthetics and came to psychological close quarters with the viewer. The piece's perceived element of danger gives it a cobra-like fascination, even as its self-evident logic and blunt beauty satisfy mind and sense. We see exactly what the artist has done and, consulting our own response, why: We are to have a violently heightened sense of the reality of matter, which includes our bodies. Since *House of Cards*, Serra has cautiously expanded his repertoire to include uses for pictorial means and effects and for less clear-cut compositional procedures; but the jolting directness of his prop pieces remains the gesture central to his art.

Hesse's way of restoring psychological content to sculpture was similar to that of Nauman's loaf-shaped pieces, but she was even less reticent about exploiting the metaphorical charge of organic-looking materials. Self-conscious sexuality, explicit in the ovarian imagery of *Ingeminate* [1965, Saatchi Collection, London] was progressively suppressed in her later work (such as *Sans II* [1968, Saatchi Collection, London]), but even her most abstract pieces awaken an excruciatingly intimate, under-the-skin sensation. What lends her work authority, and makes her an important figure in the later development of Minimalism, is her foregrounding of *process*. By making perceptible the decisions and manual operations involved in fashioning her work, Hesse realised a deft and theatrical lyricism of the studio.

Tuttle's is an anti-lyricism of the exhibition space, a series of understated, passive-aggressive responses to the demand that an artist *do something*. After making some remarkably prescient odd-shaped wall pieces in the early 1960s—acknowledged by Nauman as an important influence—Tuttle pursued courses of work parsimonious to the verge of negligibility. The lovely and witty *Tan Octagon* [1967, Saatchi Collection, London], proposes a species of painting that can be (and looks as if it had been) transported by being stuffed in a pocket. With his recent "Monkey's Recovery" series [1981–83], Tuttle has made what is, for him, a large concession to traditional practice.

The Painters

The 1960s played some dirty tricks on abstract painting. After the Golden Age of Pollock and de Kooning, there had come the Brazen Age of Johns and Rauschenberg, and abstract painting thus began the 1960s with a sense of having fallen from a great height and been kicked in the teeth en route. (Intimidating Fathers, mocking Pops.) Then things got worse. The possibility of serious abstraction became bounded by the Scylla of Greenbergian colour-field painting—a sterile formula, but championed by a mighty array of critics, curators, and dealers—and the truly disheartening Charybdis of Minimalism, which held all painting in contempt. Frank Stella won through, but only by purging the subjective dimension—the symbolisation of consciousness—that is a *raison d'être* of Western painting. Stella left in his wake less a new path than scorched earth.

The Minimalists rejected the "illusion" of painting for what seemed more than enough reasons: its signification of a "self," its ineradicable fiction of visual depth (even a blank canvas has this), its finicky dependence on "composition," its tacit acceptance of art's economic status as a portable commodity, and, in general, its entanglement in archaic, bourgeois, "humanist," individualistic, and "elitist" patterns of conventionality. (I can still feel, in the pit of my stomach, the terrorising authority such polemics once carried—before Minimalism was humbled by its own contradictions.) To roll with all those punches and come up with brush in hand took a special breed of artist, and the few who did so with force and conviction—notably Agnes Martin, Robert Ryman, and Brice Marden, among those represented here—are a tough, heroic lot.

Martin and Ryman had head starts on Minimalist sensibility. Already a veteran painter by 1960, the year of *Stone* [1960, Saatchi Collection, London], Martin had been obeying a simplifying and essentialising impulse for many years without satisfactory result. Her perfect solution of a symmetrical grid on a monochrome ground is one of those conjunctions of personal development and Zeitgeist that seem at once implausible and as inevitable as water running downhill. With it, she had a rational and sturdy form—disarming to the most positivist eye—which liberated a rich vein of feeling. It wasn't a matter of "less" being "more," but of "just enough" being the basis for a sustained spiritual adventure. Her abnegations bespeak not denial but tact: the kind of tact one would display by refraining to make noise around a sleepwalker on a precipice.

In Martin's words, "My paintings have neither objects, nor space, nor time, not anything—no forms. They are light, lightness,

about merging, about formlessness, breaking down forms." It is a lovely thing to see how Martin's "formlessness" is achieved by exact formal means. First come her grids, which iron out all possible figure/ground relations and forbid any part of a picture more emphasis than another. Then there is her decision, while employing square canvases, to make the grid units rectangular: If the grids were of squares, too, the work would be a unitary, semaphoric object, not a picture. The result of these nice calculations is like a visual equivalent of silence, in which the least inflection—a pale hue or the bump of a pencilled line over the tooth of the canvas—sings. Far from formless, the work is indeed "about formlessness": the oceanic feeling it stirs in us.

If Martin is reductivism's mystic, Ryman is its philosopher. (And Marden its poet.) Ryman tests what an analytical inquiry can do to that category of our perceptions called painting. In a way, his art is about *activity* no less than Sol LeWitt's is: painting as a set of behaviours involving the manipulation of certain conventions, the most basic of which is the spreading of paint on a delimited surface. His approach is anti-"expressive" in the extreme, and yet, mysteriously, in his work something does get expressed. It can only be painting's deeply rooted hold on us, its concordance with the grammar of our imaginations.

The two aesthetically "hot" zones of any painting are its surface and its edge. In most of his work throughout the 1960's, Ryman gave primary attention to the surface, really a coefficient of two surfaces: paint and support. More recently, his interest has shifted to the edge, painting's at once physical and metaphysical frontier. He dramatises it by highlighting the canvas's attachment to the wall, employing aluminum brackets to make visible this commonly invisible protocol. With a sober, oddly sweet playfulness, Ryman makes all necessary decisions for a painting in advance, methodically carries them out, and then, in effect, stands back to see what has happened. Something rather compelling always has.

Mangold and Baer differently reflect a variation of Minimalist sensibility which, with reference to Fred Sandback, I called the "N.Y. Look." Celebrating the contemporary gallery's virtual erotics of austerity, their paintings do not so much satisfy sensibility as *signify* its satisfaction. Mangold's designs that both suggest and distort geometric regularity can be very pleasurable in this way, delicately stimulating opposed responses (and flavouring them with the dry lyricism of his colour). Baer's bordered blanknesses hint at astringency but actually use reductivism to realise a special beauty: whiteness, so to speak, for whiteness's sake. (Contrarily, Ryman uses white—the all-colour colour—as a control element, to allow undistracted registration of texture, transparency, viscosity, and other features of the paint medium.) The works of Baer and Mangold are engines of taste.

I have saved Brice Marden for last because I believe he is the most important abstract painter to emerge during the Minimalist era and also because, of all the artists represented in [*Art of Our Time: The Saatchi Collection*], he is the one who most effectively bridges that era—keeping alive, under severe pressure, artistic traditions that today are flourishing anew. In one way, he is the last of the Abstract Expressionists, maker of lyrical paint fields that hint at elevated subjective states. In another way, Marden was the first American to anticipate a "return to the figure," not in the form of a drawn image but through recognising painting itself—its scale and its *skin*—as a metaphor of the human body.

Marden hardly invented monochrome—like the grid, an anti-compositional tactic very much in the air for painters in the 1960s. He owed the idea for his fleshy oil-wax medium to Jasper Johns; and his way of using diptych and triptych formats, to get lateral extension without losing straight-on address, was precedented by Ellsworth Kelly. But his miraculous scale and colour are his own, as is his device of hanging his paintings low on the wall, so that they will confront the viewer body-to-body—with their own subliminal version of the "anthropomorphic" dynamic that Michael Fried deplored in Minimal sculpture. Of course, all of this would be only a bag of tricks were it not in the service of a reason for painting, which in Marden's case seems an almost Keatsian ache for erotic connection. Moodily seductive and hypersensitive, his paintings have a vulnerable beauty and a quality of keen *wanting*. Their formal reductions come to seem symbolic not of what one can do without but precisely of what one cannot do without, though one lacks it all the same.

Minimalism was a world event, in a special sense. It was an experiment, a great reality-testing *what if*, by which artists—riding the crest of unprecedented public interest in art for its own sake—attempted to locate art's significance in a world beyond art, in *the* world of things and people and ideas. The experiment had a way of blowing up—for instance, by tending to make the practice of art more hermetic than ever—but that, too, was a datum, and an important contribution to knowledge. Never again will informed people be as naively idealistic about art as in what now seem the innocent, prelapsarian days before Minimalism. If you doubt it, spend some time in the company of the works I have been discussing. They are waiting for you, in permanent ambush.

"Minimalism" by Peter Schjeldahl. Reprinted from *Art of Our Time: The Saatchi Collection* (London, 1984 and New York, 1985): 11–17. Used by permission.

I Think Therefore I Art

Thomas McEvilley

Conceptual art had a burning hot moment in about 1968 when it developed at blinding speed and, passing beyond the limits of a narrow definition which was quickly closing in on it, entered into dance, music, and literature as a new indwelling spirit. This spirit seemed bent against the practice of painting, whose demise its practitioners declared to be imminent. But the demise of painting had been declared imminent by Alexander Rodchenko in 1921. Such predictions are notoriously inaccurate. D. W. Griffith, in 1915, predicted the obsolescence of the book within ten years; Marshall McLuhan reiterated the prediction in the '50s. Now we have more books than ever, and, in the last five years or so, more painting than ever also. Ten years or so after its hottest moment, in around 1978, conceptual art itself seemed swamped by the exciting onrush of the various "New Paintings." Now the tables were turned; one heard that conceptual art was dead, as ten years earlier one had heard somewhat breathless death notices of painting. But again the death notice was premature.

The resurgence of painting marks not the demise of conceptual art, but a new phase in its history. Many of the new painters had formerly practiced conceptual art, and have not forgotten its lessons. Most of them grew up in the '60s and '70s, and at the least imbibed the attitudes of conceptual art from the air around them. Granted this background, it has not been possible for many of these artists simply to revert to the solemn feeling-tone and quasi-religious belief-system of the formalist heyday. The influences of conceptualist wit and criticism have left a mark too deep to be ignored. Things have gone too far to really go back. What has happened is not an end, but a shift. Marcel Duchamp, with his outspoken rejection of painting, was the overpowering role model for conceptual artists of the '60s and '70s. In the early '80s the role model changed—by way of René Magritte—to Francis Picabia, who was engaged in the '20s in conceptual modes of painting which stand in the background of much work of the last five years or so.

The idea that conceptual art more or less died in the late '70s was made possible by certain types of statements made in its behalf during the '60s and early '70s. The claim, for example, that conceptual art marked a radical break with past art placed it in a limbo of separation from art history where it could hardly be expected to survive. In fact it was not a radical new beginning, but grew by observable stages and for understandable reasons out of the past. The claim of its radicality was useful in its day because its practitioners wanted to push their project so far that it would be impossible for art to really go back to where it had been before. This effort was successful, but created new problems in its turn. To enforce a sense of the reality and presence of conceptual art, a pantheon of artist heroes was fixed and a history was written and rigidified in place. This was like planting flags in conquered territory to insist that the territory that had been won would now be held. The theory that underlay this pantheon and history was fiercely antagonistic to the art commodity, and for this reason it was inevitable that elements in the art system would be happy to shake it off once its threat could no longer be ignored. Hence the myth of the demise of painting was turned back against its promulgators as a myth of the demise of conceptual art. The old doubt that had overhung conceptual art at its beginning—whether it was a legitimate art medium—has returned, and seems today to hang over both its present activity and its past history. The narrow definition assumed by that history for polemical purposes twenty years ago now facilitates the counterproject of brushing it all away.

When an impasse arises between theory and practice it is often because the theory is outmoded and no longer serves the needs of its time. Then a new theoretical model is required to allow emergent forms to enter discussion. The history of conceptual art involves a series of such impasses. Prior to the 1960s, conceptual art had already existed in a variety of forms which were not yet regarded as comprising a separate genre. Magritte and Picabia, for example, practiced conceptual painting in the '20s; Duchamp and Man Ray practiced conceptual sculpture. It was the impasse of formalist hegemony in the early '60s, which had become virtually tyrannical in its exclusion of conceptual elements and of social reference, that caused conceptual art to be specified as a separate genre; this impasse also gave conceptual art its somewhat puritanical early form, which attempted to reject sensory elements as fiercely as formalism had attempted to reject conceptual elements. In an essay published in 1963 Henry Flynt defined "conceptual art" as an art whose materials would be concepts, just as the materials of painting were pigments and surfaces to receive them.

In the following years many conceptual artists, eager to state emphatically the break they felt they were making with the traditional practice of painting and sculpture, attempted to reject material elements from their work altogether. By doing so they became involved in a kind of mirror image of the impasse that formalism had led to. As the formalists had rejected conceptual elements in favor of physical ones, the conceptualists rejected physical elements in favor of conceptual ones. By about 1974 the new impasse was solidly in effect. Conceptual art seemed dominated by an exclusively linguistic form. Terry Atkinson, Michael Baldwin, and others offered theoretical essays on art as works of conceptual art. In moving to reclaim the intellect, artists seemed to have incorporated the role of the critic. The critics of conceptual art found themselves writing about critical and theoretical essays. The two aspects had collapsed into one, not as a synthesis so much as by a new type of solipsism. Faced with this impasse of a puritanical theoretical conceptualism and circular criticisms of criticism, much of the art public lost interest, as did the next generation of artists, who mostly turned to more inviting modes involving the fusion of conceptual structure and intent with objecthood or performance. Conceptual art in the narrow sense—as constituted exclusively by concepts, without any fusion with other formal modes—though it continued to be practiced, seemed virtually to disappear from the public eye. Meanwhile a proper understanding of the fusion forms—conceptual painting, sculpture, and performance—had been obstructed either by purist denunciations

or by confusion as to whether they were conceptual art, art in the old sense, or something else.

The lack of recognition of conceptual art in its new clothing is the third impasse in its history, and the one that is in effect today. In a somewhat confused way a tendency is in place to regard the various new trends in painting, say, as trends back to painting pure and simple, that is, to the making of optical works in the old sense. In fact much more than that is going on. Quotational painting, for example, is not all of one cloth. In the work of Sherrie Levine it expresses critical insights into art history and objecthood. In Mike Bidlo's combinations of parody and visceral appropriative acts there is a more performative element, Pat Steir—whose work was conceptual in thrust long before it became quotational—recently produced, in "The Breughel Series," 1983–84, a complex mega-icon of analysis, homage, and criticism of and to the tradition of Western painting. In work where media imagery is a constant reference also there is at least as much claim to be conceptual art as to be optical painting. In these types of work theory is present at a constitutive level in a self-conscious way, but without obstructing the interplay of different modes of perception, both sensual and cognitive.

The belief system that underlay the first impasse, that of formalist hegemony, also determined the second impasse as a reaction against formalist hegemony; and in the third and present impasse the old formalist habit is hiding in a confused and casual way which is omnipresent though seldom openly acknowledged. The formalist idea that conceptual or cognitive elements have no place in art is based on Immanuel Kant's theory that human nature is composed of three separate faculties, the cognitive, the ethical, and the esthetic, which have separate realms that do not overlap. The cognitive faculty, then, is eternally and by its very essence separate from the esthetic faculty. The esthetic faculty supposedly makes its judgments on the basis of inborn knowledge, and these judgments are not susceptible to correction or alteration by either the ethical or the cognitive faculties. The idea that sense data and mental operations take place on discretely different metaphysical levels derives from Plato's mind-body dualism as retained by René Descartes under the misimpression that he was jettisoning all previous philosophical baggage. In this view, which has become the basis of Western common sense, the mind is held to function purely as an organizing faculty synthesizing sense data into a rounded impression of a world. Descartes divided all that exists into two categories, the material (res extensa), that is, the body, including the five senses and the objects that they sense; and the immaterial, which was specified as the mind (res cogitans). A consequence of Descartes' thought which is still present among us is the idea that mind, being immaterial, can have no intimate connection with the arts that, like painting, work through the senses. (One flaw in this scheme is that, since he offers no overlap between these categories, there is no way of accounting for the communication between them that was implied by the famous cogito ergo sum, "I think therefore I am.") The radical division of the human faculties into material and immaterial components was

of central importance to Plato because on it rested the idea of the soul, a nonextended or nonmaterial component of the human self, not subject to the changes of matter and hence inherently eternal. Plato, influenced by Egyptian masters, regarded the soul and its adventures in the afterlife as a central subject of metaphysics. This lineage is the pedigree of formalist art theory, which is constituted primarily out of concealed references to Platonic idealism and, ultimately, to the Egyptian vision of a human society beyond change. Plato, an aristocrat who saw that a changeless society was in the interests of his class, imported this doctrine into Western thought.

Mind-body dualism, in other words, is not the only way of looking at the constitution of the human self; it is a hidden theology with certain social interests, as is the formalist esthetic theory based on it. The phenomenalist view rejects mind-body dualism; since sensations are known only as mental impressions, there is no way to distinguish sense events from mind events. As Maurice Merleau-Ponty wrote in the Phenomenology of Perception (1945), "There are no senses, only consciousness." The Abhidharma psychology, of Indian Buddhist origin, recognizes two different aspects of mind. On the one hand it is regarded as an organizing faculty presiding over the synthesizing of sense data; on the other, as a sixth sense whose sense objects are concepts in precisely the way that the eye's sense objects are sights. It is the mind's function as a sense that accounts for its pleasures, such as the pleasure of appreciating mathematical formulas, the pleasure of of playing chess, the pleasure of wit. At the moment when one "gets" a joke, one set of relationships is unpredictably revealed to be another, and the mind delights in the unexpectedness of the relation between the new emergent meaning and the old retiring meaning. Scientists and mathematicians have declared that the pleasure they take in their work is essentially an esthetic pleasure. Certain modern philosophers, such as Friedrich Nietzsche, Bertrand Russell, and Rudolf Carnap, have suggested that philosophical arguments exercise a subjective esthetic appeal. This view eliminates the distinction between the cognitive and esthetic categories, which now appear to have extensive, perhaps complete overlap.

In terms of conceptual art it should be noted that this adjustment in our thinking about the human faculties eliminates the traditional critiques, such as Max Kozloff's complaint in this context that "conceptual art's questioning has no form" (Artforum, September 1972). The idea that cognition lacks form is based on the old mind-body dualism which separates the mind from the senses, the channels through which form is sensed. Yet the formal nature of thought can be demonstrated merely by thinking of logic or mathematics. James Collins' distinction between "things and theories" (Artforum, May 1973) is equally a disguised form of mind-body dualism. Theories, of course, are things; they are what Edmund Husserl called noematic objects, that is, mental objects. Every thought or concept is an object, and every object has form and esthetic presence. (What does a centaur look like? An angel?) There is, in other words, an esthetics of thought with its own styles and its own formalism.

Those who insist on certainty of knowledge resist recognition of

the esthetics of thought since it casts doubt on the distinction between truth and beauty (again a disguised form of mind-body dualism) and especially on the category of truth in and by itself. It implies that one adopts an opinion on the basis of an esthetic decision as well as a truth-related one, and that one's beliefs about reality are in part projections of esthetic preferences. The difference, for example, between a mind that prefers simple accounts of things and a mind that prefers complex accounts may be analogous to different preferences in visual composition. Seen in this way the history of philosophy becomes a branch of the history of art, with different ages or trends featuring different styles of intellectual formalism. Greek philosophers recognized this aspect of thought much more openly than have Christian-influenced European thinkers, with their special commitment to the concept of truth as the foundation of dogma. A Greek genre of philosophical literature was called the *paignion,* or "game"; it was a special place for the construction of paradoxes, infinite regresses, circular arguments, both-and-neither arguments, yes-and-no arguments, and other delicacies of an art that isolated the effects of different types of thought for essentially esthetic appreciation. No less a work than Plato's *Parmenides* is sometimes put in this class, as is Gorgias' *On Truth or On What Is Not.* The Megarian school specialized in conceptual art objects of this type, and Sextus Empiricus compiled an encyclopedia of them which still exists. (It is one of the most interesting and least-read of ancient Greek books.)

The esthetic of the infinite, though not prominent in the tradition of mind-body dualism from which our modern visual brand of formalism arose, is an example of a particular formalist moment in the history of the esthetics of thought. It demonstrates an intellectual esthetic of the sublime rather than the beautiful—for these distinctions apply to thought as much as to painting or music. The beautiful is dependent on explicit self-identity, on the preeminence of the figure over the ground, and hence on implications of the solidity of selfhood; the sublime on the other hand is based on dissolving the figure into the ground, on a claim of the primacy of the ground over the figure, and of the universal surround of nature over the individual self. In representational painting one thinks of the sublime as a tiny human figure lost in the awesome ruggedness of mountains, electrical storms, or oceans. In the esthetics of thought the sublime is experienced, among other places, in the way the infinity concept interposes enormous abysses of nonidentity into the world of other concepts, abysses that threaten constantly to spread and absorb every identity into them. In language, for example, a word derives its meaning from the differences between it and all the other words in its language; if that language system were infinite the word would never establish its meaning, since the chain of differences contributing to that meaning would unfold forever. The abysses of the infinite appear inside language as the infinite regress of signifiers that prevents the signified from ever being directly confronted. If one attempts to define a word *A* by saying it means *B,* when *B* is also a word or a group of words, then one has slipped from one signifier to

another, without really touching the signified. One is involved in an infinite regress and will never directly confront the signified, slipping from signifier to signifier forever. Thus the infinity concept opens abysses in thought like those vastnesses of nature which Edmund Burke called the sublime. Thinkers who have featured the infinity concept as a working tool, from Zeno of Elea to Jacques Derrida, bring the mind to a confrontation with the unknown and the unknowable that threatens individual selfhood with dissolution—that is to say, to a confrontation with the sublime. The esthetic of the finite, on the other hand, emphasizes definition, categorization, and clarity of outline as in the constructivist thought of Aristotle or Leibnitz, and relates to the experience of the beautiful rather than the sublime. Useful parallels may be drawn between preferences in the esthetics of thought and in visual esthetics. Philosophers who construct highly articulated models of the universe might be compared to painters of complex land- or cityscapes, or to abstractionists like Mondrian whose works feature order and hierarchy; philosophers who occupy themselves with deconstructing these models of the universe show an esthetic range that extends from the sublime to the minimal, like American painting in the '60s. Conceptual art involves both the constructing and the deconstructing aspects of the esthetics of thought, in a mode distinctively its own.

The prominence of language in conceptual art has led to a confused belief that it may be a kind of philosophy or literature. It should be remembered that such questions are questions of linguistic usage, not of essence. What is commonly called philosophy is the activity either of stringing concepts together in the hope they will lead to a conclusion, or taking them apart in the hope that false conclusions will be removed. On the other hand, while conceptual art does in some cases have actual purposes of a social or political type, it does not usually exhibit these philosophical purposes. It more often holds concepts up as objects to be beheld with an appreciative regard that has the same claim to disinterestedness (and no more) that has traditionally been posited for the act of regarding, say, paintings. What has been called literature, in turn, tends to feature narrative structure or its significant absence, and often demonstrates a concern for the sound of language; conceptual art for the most part relates to neither of these values so much as to the values of wit and critical insight, which, though they are not absent from literature, are generally embedded in the complex of literary qualities rather than foregrounded and independently focused.

In any case, the presence of language within the frame of the visual artwork does not need justification; it is not a radical break with established art practice but reflects a tendency that has been present for centuries and which it has been the special genius of our century to confront and force into the open. Before around 1920 the role of the linguistic element in the visual piece was somewhat hidden. An image, of course, appeared with a title, but the title was usually outside the frame of the image, like the proclamation of a transcendent god who stands outside his creation and issues statements of metaphysical definition to it. The idea that language, as a

cognitive element, stands over and above the perceptions of the senses was thus reflected in the structure of the artwork. In Western art in general, when words appeared within the frame they did not exercise the function of wit and criticism, as in conceptual art, but either the function of naming, as in Greek vases, or in the names "Mater" and "Magadalena" shining in the halos of the women in the *Avignon Pietà*, 1455; or the function of a stage prop, as in the letters "INRI" above the figure of the crucified Christ, the inscription on the pedestal on which the Madonna stands in Andrea del Sarto's *Madonna of the Harpies*, 1517, or the newspaper being read in a painting by Cézanne. Gauguin placed titles inside the frame, though usually in a corner out of the way of the figures; Van Gogh, Lautrec, and others of the late 19th century sometimes did the same.

Around 1908 Picasso and Braque began to include fragments of language or even whole passages of newsprint in their paintings as primarily plastic elements, not there to be read but to remind one, as it were, in a gestural way, of the whole presence of the cognitive realm in the texture. This trend picked up momentum in Futurism. Gino Severini, for example, included in his paintings words like *valse* and *polka* as comments on the movement of the image, in 1912; in 1914 Carlo Carrà made "free word paintings" of collaged bits of newspaper, music, and advertising. It was in Dada-related contexts that this trend really came to self-awareness. Kurt Schwitters, like the Cubists, used language fragments primarily as plastic elements, to be seen rather than read. But John Heartfield, Duchamp, Magritte, Raoul Hausmann, and others, began, in the 1920s, to use language-with-image in specifically conceptual ways. Duchamp's combination, in *L.H.O.O.Q.*, 1919, of an altered found photographic reproduction with a mysterious but essential linguistic message foreshadowed the structure of countless conceptual artworks to come. Magritte focused on a critique of the relation between linguistic and visual representation. In *La Clef des songes (The Key of Dreams*, 1930), he shows objects with captions that do not apply to them in any ordinary way. Common-sense attitudes like linguistic reification and image reification are deconstructed in such works. Linguistic reification means the naive assumption that one's own language, that is, one's conditioned mind-set, is an accurate map of the real; image reification, the belief that one's culture's conventions of plastic representation accurately portray the outside universe. In Magritte's critical paintings, as the verbal representation is declared to have nothing to do with the visual, or the visual with the verbal, so neither connects with a thing being referred to. Human beings are left alone with their experiences, the grids with which to control them being cancelled by mutual contradiction. Magritte's *The Treachery of Images*, 1928–29, makes this even more explicit. The project of relentlessly focusing attention on the language-image relationship, and the related project of critiquing naive acceptance of modes of representation as equivalents of the real, became fundamental and lasting themes of conceptual art.

The impetus begun with Dada and lost somewhat in the resurgent formalism of the '30s, '40s, and early '50s regained momentum with the works of Jasper Johns and others of his generation. Johns' famous *Flag*, 1955, in which the image extends all the way to the edge of the support, conflates the realms of real object (painted flag) and representation (painting of flag). A similar splitting of the meaning occurs in such other works of his as *Grey Alphabets*, 1956, and *Numbers in Color*, 1958–59. These letters and numbers seem meant not to be read, as in Magritte, but to be looked at, as in Schwitters; yet one cannot help but read them to an extent, as mental focus shifts between the symbolic and plastic orders of meaning. The symbolic order began to assert a claim to primacy in the '60s with works like Arakawa's *Look At It*, 1965, where names of objects are offered in place of images. In 1963 Gene Beery showed word paintings heralding the transition they were involved in, with such messages as "Sorry This Painting Temporarily Out of Style Closed for Updating Watch for Aesthetic Reopening." In that same year Flynt published his essay defining "concept art." The genre had been crystallized in part by the 20th century's long and intense analysis of language. Ferdinand de Saussure's *Course in General Linguistics* was roughly contemporaneous with Duchamp's early Readymades. This aspect of conceptual art has led to a series of events, from Duchamp's puns to Michael Snow's later anagrammatic respellings of his own name. The fact that conceptual art was born in part from the tradition of language analysis is one reason why artists' books became an important conceptual genre. The book expresses the desire to reinstate the mind in artistic activity, to focus on the relationship between word and image, and to eliminate the traditional art object. Finally the project of constructing such an inexpensive and transportable means of communicating concepts visually made these books truly international and translinguistic.

In the 1950s and early 1960s a kind of proto-generation of conceptual artists extended the boundaries of the art category not by stylistic change but by alteration of the art discourse directly; they forced the usage of the word "art" to expand to include things formerly outside its scope, through the process that Atkinson and Baldwin would later call "declaration." This procedure goes back to the example of Duchamp, and finds its strongest justification in the thought of Ludwig Wittgenstein, who demonstrated that a word's meaning is a matter of usage, not of essence. Understood in this way, the question, is something or other art?, is meaningless because it appeals not to the authority of usage but to the metaphysical and extra-linguistic idea of an art essence that informs both the word and the activity. A corrected version of the question asks whether something or other is *called* art—for there is ultimately no other way to determine whether it *is* art. If Duchamp calls a store-bought snow shovel art, and gets a significant number of others who supposedly know how to use the word to do so also, then it is art, because it is called art. Designating something as art is related to the procedure of contextualizing something as art. When in 1917 Duchamp submitted a store-bought urinal to the exhibition of the Society of Independent Artists, he hoped to express the fact that when we see something in a context which directs us to regard it as art, then we shift mental

focus and regard it as art—which is the same as saying it is art.

In the late '50s and early '60s the procedures of designation and contextualization were foregrounded in the works of Yves Klein, Piero Manzoni, Ben Vautier, George Brecht, Dennis Oppenheim, and others. Duchamp had physically signed Readymades; Klein instituted a looser fashion of designation by "signing" the sky in fantasy—a technique which Marinus Boezem realized literally with a skywriting airplane in 1969. Manzoni signed human beings and exhibited people on a sculpture stand. Vautier explicitly universalized the procedure, designating everything an artwork. These acts of designation are themselves works of conceptual art; their material is the mind-stuff of the art beholder, specifically the shift between ordinary focus and art focus that takes place within the mind. Klein extended Duchamp's rudimentary insights into contextualization by exhibiting an empty gallery in 1959; this gesture implied that if it is the context that makes an object art, rather than any qualities of the object itself, then it is the context that should be exhibited. Analysis of the relationship between an object and the environment in which it is seen became a continuing theme of conceptual art. Daniel Buren's early stripe works, for example, combined the idea of painting-as-Readymade with a relentless focusing of different art contexts—the gallery, the museum, the street.

Designation and contextualization were the early tools of conceptual art. Once the category of art had been opened up to receive whatever an artist might put into it, formalism's aspirations to universality and objectivity were replaced by a forced focus on relativism and the critique of meaning. Formalism's belief in the autonomy of the artwork was answered by the Frankfurt School's emphasis on social conditioning; formalism's belief in essence was answered by linguistic analysis and the Saussurean awareness that meaning derives strictly from differences within a bounded system. To clear the air of the archaic forms of thought embodied in formalism, conceptual art was rigorously 20th century, which is to say rigorously critical. Octavio Paz has remarked that in the 20th century there is no thought, only criticism; critical and analytic modes have been characteristic of movements as diverse as Freudianism, linguistic philosophy, Marxism, semiotics, and others. Jean-François Lyotard characterizes this critical-analytical trend of our time as a symptom of the Freudian death wish, which is to be understood not as a self-destructive impulse but as a tendency to dissolve patterns of meaning and personal identity which balances out the tendency to rigidify those things—a tendency that was dominant in the 19th century.

In a classic article from 1967 in which the term "conceptual art" is said to have first appeared in precisely this form, Sol LeWitt stressed the goal of "avoiding subjectivity." Conceptual art in general has focused on eliminating certain kinds of self-expressiveness. This project was of the first importance not because self-expressiveness is the enemy but because Western art had come to be locked into certain shades and clichés of self-expression—those of the romantic transcendentalist—as if they were the necessary essence of art. But artists like LeWitt, Dan Graham, and Carl Andre were in touch with the critical currents of modern culture and wished to exercise responsibility and intelligence in the mode of art. For this reason conceptual art adopted an expressive stance more like that of science and technology. It veered away from the mood of religion, which Clive Bell had said was art's essential zone, to that of science, where Bell had said it could not survive. As art had recently used analogues of the procedures of religion, now it would use analogues of the procedures of science. This reorientation arose in part from the influence of Minimalism, with its focusing of materials as themselves and of systems of presenting and thinking about them. The investigation of the expressive potential of technological means has brought with it a steadily advancing technological look derived from the camera, which is everywhere; the photocopying machine, as in the famous *Xerox Book* put together as an exhibition in 1968 by Seth Siegelaub and John Wendler; the audiotape and videotape, as in the works of Graham, Nam June Paik, Dara Birnbaum and others; and more recently the digital light sign, as in the works of Jenny Holzer, and so on.

Along with the reorientation of art toward science and technology came a new emphasis on analytic and critical methods. The Duchampian-Magrittean tradition had already focused on the question of representation and established a position antagonistic to the processes of linguistic reification and image reification. The question of photography's relationship to convention and reality became a third strand of this project of transcending or at least focusing subjectivity and point of view. These relations were the subject of Joseph Kosuth's formulaic "Protoinvestigations," first exhibited in 1972, though dated by the artist to 1965. *One and Three Chairs,* 1965, for example, presented a chair, a life-sized photograph of the chair on its site, and the dictionary definition of the word "chair." Kosuth's subsequent use of the dictionary and thesaurus as materials extended his focus on the naive assumption that one's language has the same shape as reality. Donald Burgy's *Name Idea #1,* 1969, directs attention to the fact that things and words change in different ways and at different rates. Robert Morris' exhibition of a card file, *The Card File,* 1962, pointed to the fact that our systems of arranging knowledge are also arbitrary attempts to project patterns of order and meaning onto the world. Something similar is conveyed in Bernar Venet's work of the late '60s and early '70s, in which he exhibited a series of technical books on subjects including astrophysics and mathematical logic as objects of nonspecialist regard. In a variety of ways Agnes Denes' works using symbolic logic as a material, Hanne Darboven's permutation drawings, and Lee Lozano's *I Ching Charts,* 1969, belong in this company. This area of conceptual work presents conventions of vision, language, and knowledge as objects for neutral regard, removing the sense of inevitability from them and ambiguously hinting at an attitude of freedom beyond. This project has been one of undermining the conventions with which our culture orders experience and projects special meanings onto it.

The central subject of such analysis is the question of whether artistic canons are objective or relative. Formalism implicitly assumes

that esthetic values are at some root level universal and objective, and would be similarly perceived by all developed faculties of taste. This view ignores 20th-century studies of language and behavior, which suggest that cultural and individual conditioning are factors in all judgments of taste, not just those of the supposedly uncultivated; the claim to an unconditioned exercise of judgment is virtually contradictory, since judgment necessarily involves canons and these, as Saussure's study of language demonstrated, can only define themselves in relation to a finite surrounding system. Duchamp's Readymades were an attempt to break open this sanctum sanctorum by forcing realization of the relativity of esthetic feelings. The raw unassimilability of these works in their day involved a confrontation with the unknown so far beyond accustomed tastes as to be an intellectual experience of the sublime. The still-repeated cliché that Duchamp's intention in the Readymades was to demonstrate that esthetic beauty can be found anywhere seems plainly incorrect. He was attempting, as he said in various interviews, to find objects that would be neutral or meaningless in terms of taste. This project was both a critique of formalist theory, with its privileged faculty of taste, and an attempt to transcend the limits of subjectivity in the form of personal habit. Taste, he felt, was not an independent faculty with inborn knowledge but a conditioned habit arising from cultural surroundings. What one is trained to enjoy as art one will enjoy as art. The same force that made Pavlov's dogs salivate at the sound of a bell makes the art beholder shiver with ecstasy before a painted cloth. An art tradition, then—like, say, European painting—is an arbitrary communal habit based on hidden social and economic forces as much as on esthetic inertia. Tradition exists when a whole culture has acquired a communal habit and rewards the indulging of it. Habits arise as ways to tame the unknowability of experience, but to tame unknowability is to flee the sublime—which Burke described as dark, formless, isolate, unapproachable without loss of self-definition.

Duchamp evidently felt there were three things that one could do about the fact that one was at the mercy of a habit. First, one could go on reinforcing that habit and indulge the pleasure of satisfying it until it came to seem like a given or natural or inevitable part of life. That is how he saw the practice of traditionally esthetic visual art. Secondly, one could break the old habit and start a new one which in time would run the same course from acquired habit to apparent absolute truth; this is what he thought the Cubists among others were doing. Third—and this is what the Readymades were about—one could attempt to find ways to a stance beyond esthetic habit. This was a genuinely new conception of the art object, which was now to be regarded as an instrument to pry apart the structures of habit without leaving anything newly enchanting in their place. The Readymades were objects designed to be unaccountable in terms of our culture's esthetic habits. They offered a pocket of freedom from art based on habit and from a life of believing that one was beholding transcendent forms when in fact one was mechanically acting out a habit one had not even chosen to acquire. This general intention—of deconditioning, destructuring, creating things

unaccountable by any easily available model—permeates the practice of conceptual art, at least that of the first generation.

Unaccountability is important because it stymies attempts to tame and control the rawness of things by corralling them into manageable categories. It is an openness to freedom and mystery, involving as it does a submission to givenness, a relinquishing of the belief in the effectiveness of one's categories and the fullness of the map of one's language. Recognition of it is a necessary part of the analytic adventure of modern culture. The *objets provocateurs* which the Futurists and Dadaists featured were transitional devices opening the way to unaccountable objects; they were themselves accountable by their consistent function of provocation. Countless conceptual art objects of later date have striven for pure unaccountability. Both Joseph Beuys and Marcel Broodthaers have been engaged, in much of their object-making, in the attempt to arrive at truly unaccountable objects that can find no place in the habit-systems of viewers, including the habit of shock. Broodthaers' mussel-shell works, like *Panneau de moules (Panel of Mussels,* 1965), and *Moules sauce blanche (Mussels in White Sauce,* 1966), and his eggshell works, his suitcase full of bricks, and many others, are unaccountable objects that resist esthetic appreciation from any habituated stance and render foolish most attempts at discursive interpretation. These objects, one feels somewhat eerily, might be meaningful to some unknown esthetic from some unheard of species or culture. The point is to see reflected there the arbitrariness of our own object preferences. Beuys' fat works, sausage works, and such function to separate his work from the vestiges of esthetic habit and suspend it in a zone of unknowability and unaccountability. So convincing are the works in this respect that the artist's autobiographical accounts and explanations seem both unconvincing and irrelevant. The range of conceptual objects that belong in the category of deliberate unaccountability is large, comprehending also, for example, James Lee Byars' work of 1968 in which a mile of gold thread was sent into outer space on helium balloons; the characteristic Byars-esque invocation of the angelic sphere and attempt to reconnect heaven and earth are recognizable, but after the accounts are given there is something left over that they do not account for. Many of the Flux-Boxes by Brecht and others are designed either to be unaccountable in terms of our usual categories or to imply new half-defined categories whose intentionality we can barely grasp. Unaccountability is found in forms as various as Gordon Matta-Clark's vertically sliced house and Wolf Vostell's *Berlin Fever,* 1973, in which cars clustered in groups of ten drove as slowly as physically possible alongside the Berlin wall for half an hour.

The assault on the premises of linguistic and visual representation, conjoined with the presentation of unaccountable conceptual objects, comprised a sweeping program of focusing on the idea that meanings are projected onto the world of raw information, not inherent in it. The other side of this coin is the recognition of the neutrality of information, which has only those meanings that we project upon it. In Christine Kozlov's *Information: No Theory,* vari-

ously dated 1969 to 1970, a tape recorder placed in an otherwise empty gallery recorded the ambient sounds on a two-minute loop; at any moment it preserved the sounds made within the last two minutes. In making no selection by form or content but treating all information as equal, she eliminated the meaning projections by which we ordinarily distinguish one piece of information from another as more meaningful, relevant, or useful. On Kawara, in *I Got Up,* 1970, mailed postcards that reported the time he got up every day for a year to a select group of recipients. There was no implication that the knowledge might be useful or even interesting to them; information was purveyed for its own sake, with no particular application of it in mind, parodying the declining tradition of art for art's sake. In Kawara's *Today,* 1966, the artist made a painting of the day's date each day for a year, parodying the tradition of painterly expressiveness and of the arbitrary perfection of the art elements in the work. Countless other conceptual pieces have involved expressions of the neutrality of information, including esthetic information. Vito Acconci, in *Step Piece,* 1970, stepped onto and off of a stool as many times as he could each morning for a month at a time, recording and later publishing the numbers. Christopher Cook's *A Book of Instants,* 1970, is filled with a list of apparently unrelated or arbitrary times, such as "November 21, 1844, 9:40 A.M." Jan Dibbets' *Robin Redbreast's Territory Sculpture,* 1969, presents information designated by the movements of a wild bird. Robert Smithson's guided tour of "the monuments of Passaic," 1967, confronted the art audience with the idea that Passaic, New Jersey, had replaced Rome as the Eternal City, and with information about certain monuments there. The presentation of raw or unordered materials is not, as Kozloff has argued, a meaningless activity; it is the useful promulgation of a view of meaning as imposed arbitrarily on materials from without, for reasons not inherent in the materials themselves but in our plans and ambitions for them.

One formalist projection of special meaning that came under special attack was the idea that the artwork was autonomous in the sense of being outside social and economic causes and conditions. This view was countered in the '60s and '70s by the widespread dissemination of the so-called Frankfurt criticism in the works of Walter Benjamin, Theodor Adorno, and others. These critics felt that the artwork had been co-opted by the processes of the market, which created the myth of autonomy to conceal this fact. The impression of autonomy was maintained as a pious fiction by the use of a special aurifying environment and by the apotropaic utterances of formalist critics; the outside world was identified as secular and the inner temple as sacred, along the lines of Bell's insistence that art belonged in the area of culture with religion, not with science. One strategy for presenting the artwork as embedded in rather than autonomous of the ordinary causal networks of human life has been the introduction of chance procedures which leave the work vulnerable to forces outside the artist's intentions. Chance procedures in the art-making process can produce artistic forms that are freed from the tyranny of conditioned habit. As the tradition of introducing chance

elements grew it developed a certain formalism of its own, based on the increasing elegance or expressiveness with which chance was introduced. To incorporate chance into the *Three Standard Stoppages,* 1913–14, Duchamp created a quasi-scientific procedure like that of an experimenter, dropping a meter-long piece of string three times from a height of one meter, and recording the three curves that it made upon landing; these curves were then incorporated as elements uncontaminated by hand and taste into a variety of later works by Duchamp, including the *Large Glass.* The quasi-scientific air of the procedure accords with what Duchamp called the precision of the random, and with the fact that here it is not a desire to control that is being acted out but a desire to invite the world to state its own projects, in the manner of a scientific experiment. In Klein's rain paintings, powdered pigment flung into the air was applied to a canvas on the ground by raindrops. In Smithson's *Asphalt Rundown,* 1969, a dump truck released a load of hot asphalt down a slope, where it cooled and hardened naturally. In Richard Serra's *Splashing,* 1968, molten lead was splashed along the base of a wall in a gallery.

The experiment-like procedure of the *Three Standard Stoppages* is echoed in the quasi-scientific instructions, as if to a laboratory assistant, in one of Duchamp's texts:

> "Theory":
> 10 words found by opening the dictionary at random by A
> 10 words found by opening the dictionary at random by B
> These 2 sets of 10 words have the same difference of "personality" as if the 10 words have been written by A and B with an intention. Or else, it matters little, there would be cases where this "personality" may disappear in A and B. That is the best case and most difficult.

Duchamp seems not to be instructing the reader to carry out this work, but the tone is the same. Such laboratory-type instruction becomes a basic element of conceptual art in its studied displacement from the realm of pseudo-religion to that of pseudo-science, and in its deliberate shift to a more impersonal mode of expressiveness. It relates to the procedural rules by which John Baldessari made his conceptual photographs of balls thrown into the air, to Mel Bochner's measurement pieces, to the technological look of many conceptual installations, and so on. LeWitt, in the essay of 1967, had prescribed execution according to a completely predetermined plan, with no impulsive alteration in process, as an antidote to the romantic myth of self-expressiveness. The principle still holds, for example, in quotational painting.

Another way of underlining the fact that the artwork is not autonomous but involved in ordinary causality is to site it directly in the flux of the changing world. Buren had his stripe paintings carried around the city like advertising signs, and sited them as flags flying over Paris. Maura Sheehan, in her "Urban Alterations" of the late '70s and early '80s, designated public parts of American cities as art, usually by adding monochrome paint to them; these works were meant to deteriorate in observable time with the normal activity of

the city. Time, in other words, was used as a material. Her recent paintings of guns and Greek vases on broken windshields retain the connection with change and the street. Robert Janz has sited works in the middle of a flowing stream and at the waves' edge by the ocean. The incorporation of time and change into the work, like sitedness in the world, reveals its contingency. Euan Burnet-Smith has made sculptures held together in a matrix of ice, which deconstruct themselves in about three hours. Bochner structured a piece around the growth rate of a tree, Wolfgang Laib around the seasonal production of pollen. These works feature acceptance of natural scales of time, like the rate of ice melting or of urban decay; time is also used as a material to be shaped or manipulated. Dibbets preannounced a moment when he would appear on a certain balcony in Amsterdam and make a gesture of greeting. Douglas Huebler offered a reward for the capture of a wanted criminal, presumably accelerating the process. Jean Tinguely made exploding artworks like *Study for an End of the World*, 1961, and *Study for an End of the World, No. 2*, 1962. Graham's *Yesterday/Today*, 1975, presented a video monitor showing activity in a nearby room while an audiotape recorded in the same room exactly 24 hours earlier was played.

Ephemeral works are in part an attempt to avoid the processes of commodification and fetishism in which artworks favored by the formalist ideology seemed so deeply implicated. Many sited works also avoid the system of commercial galleries and collectors, as does the use of the public mail as distribution system, a practice pioneered by Klein, Dick Higgins, and others in the late '50s and still much in use today. The frequent involvement of conceptual with performance art is a related means of enmeshing it in the real time of embodied human activities while simultaneously avoiding the commodifiable object. Richard Long's and Hamish Fulton's photo-documented cross-country walks hover at the interface between concept, performance sculpture, and photography. Oppenheim contrasted experiential and conceptual time in *Time Line*, 1968, in which he walked through the snow along the boundary between two time zones, in the gap between two times yet leaving a trail as proof of passage. Linda Montano has posited a performance of seven years' duration, in which she will immerse herself constantly for one year in the symbolism of each of the centers recognized by Indian occult neurology, listening to its tone, dressing in and visualizing its color, and speaking each year in a different accent intended to embody the sense of the center then in effect. The scale of this piece raises real questions about the relation between art and life. By the time it is over every cell of her body will have regenerated; nothing will be left of her.

Traditional gallery and museum settings are of course designed to eliminate the sense of embeddedness in a socioeconomic world and create in its place a sense of ethereal-eternal presence like that valued in religious buildings. Yet even within the gallery or museum setting ways have been found to breach, if sometimes only gesturally, the traditional separation between art and life. In 1969 Hans Haacke installed a UPI news tickertape in the Museum of Modern Art, bringing the entire world, or a manifestation of the entire world in all its political and social problematic, inside. Bochner, in *Compass: Orientation*, 1968, drew the four cardinal directions on the gallery floor, emphasizing that the gallery was located in a surrounding world and that the work seen in it could not be autonomous and transcendent. In Lawrence Weiner's *A Wall Stained with Water*, 1969, the gallery was shown as found but, as the title indicates, with a focus on the inadvertent sign of its vulnerability to external forces that involve it in change and decay. In 1968 Smithson began exhibiting heaps of natural gravel. The material was conceived as, to a degree, bringing its outdoor site with it into the gallery. Mary Kelly located her work *Post-Partum Document*, 1973–79, in the net of causality by rooting its content in autobiography, specifically in the development of her child.

Under the influence of both of the Frankfurt critics and Louis Althusser, the impulse arose to make artworks that would not only avoid the traditional channels of commodification and fetishism but reveal them as well—artworks that would pry apart the unidirectionality of the culture industry and turn its elements and strategies against itself. The critique of the culture industry has prominently featured a critique of photography and an appropriation of advertising styles. Les Levine has placed socially oriented works composed of photographs and verbal messages in the advertising spaces of subways. Victor Burgin has made photographs designed to look like advertising, adding texts intended to criticize the culture industry through its own look. Haacke has altered texts on advertising photographs in ways designed to reveal the tacit cooperation of the system of art commodification with the institutions of government and industry. Barbara Kruger's works of the '80s are a looser and somewhat more expressive variant of this mode. Birnbaum, Richard Prince, and others have variously incorporated the semiotics of advertising into their work.

Photography in this context is not of course art photography as such; sometimes it is its antithesis. Chris Burden, Vito Acconci, and others have kept their photo-documentation amateurish in style and quality to avoid estheticizing and commodifying effects. The use of instant photography has been favored for its emphasis on ephemerality, and the use of self-photography for its relation to images of solipsism and self-consciousness. The camera has had a kind of role as epistemological model; the once widespread belief in its objectivity has been discredited in part by the efforts of artists like Haacke and Burgin to reveal its uses as an instrument of propaganda and mystification. The wry critical composites of photographs and texts by Gilbert & George, Bill Beckley, and others tend also to reflect photography's involvement in the culture industry and its proliferation of illusions.

Conceptual art's deconstruction of formalist art theory and practice culminated in what was called "the dematerialization of the art object." To a degree this was an unrealizable ideal; since the brain is a material thing and its operations have a chemical aspect, even mind-objects or language pieces are kinds of material objects. Nev-

ertheless there was a real meaning to the project, which was another expression of the fundamental idea of self-consciousness: if consciousness is of itself, then subjectivity is the object—the object, as an other, is eliminated. Klein, who first applied the term "dematerialization" to art, exhibited empty space several times, beginning in 1959; but he did so only after convincing himself that he had projected mental vibrations into it that were actually material, though of a material too fine for ordinary senses to perceive. He conceived of these works in traditional genre terms, calling them invisible paintings and sculptures. In 1967 Buren and others exhibited visible paintings, but in a locked room where no one could see them. In 1969 Robert Barry stood in front of an audience and attempted to communicate to them telepathically the appearance of a work which they never physically saw. Weiner and William Anastasi removed parts of gallery walls rather than adding something to the space. As the other side of dematerialization, conceptual art has analyzed the context in which the art object had once been contained, focusing on the system of market-related processes that surrounded it like a net. Michael Asher removed the partition wall dividing the gallery's exhibition space from its sales space, revealing, through subtractive means, the market system which surrounds the artwork while concealing itself from it. Haacke exhibited the market histories of paintings by artists like Edouard Manet and Georges Seurat. Louise Lawler rearranged objects in the Wadsworth Atheneum, in Hartford, Connecticut, and has otherwise focused attention on the system in which the works are manipulated. Broodthaers, Anastasi, Asher, Buren, and others have made works in which the wall label identifying the piece as art was the material of the piece itself.

Related to immateriality and subtraction is the empty or hidden piece, which goes back to Duchamp's *With Hidden Noise*, 1916, and Picabia's painting presented to a Dada evening audience in its wrappings in 1916. Manzoni produced a line thousands of meters long, rolled it up, canned it, and buried it in the ground. Robin Winters, in 1984, installed his drawings under the bricks of the gallery floor. Douglas Davis, in 1974, buried a functioning video camera that recorded its own burial. A work of Bruce Nauman's was a concrete cubical chamber, with no entrance, buried in the ground, with a video camera operating inside it so the empty and buried interior could be seen in an aboveground monitor. The idea for this piece goes back through several stages to Klein's exhibition of the empty gallery, and forms part of a subgenre including Barry's exhibition of a closed gallery, Byars' *Imaginary Museum*, and various other pieces by Barry, Ian Wilson, and Tom Marioni in which the invitation to the show was in fact the artwork.

The theme of immateriality, hiddenness, and emptiness implied as its corollary the positing of mind-stuff or consciousness as the true art material. Artworks had always been thrown onto the screen of consciousness to be perceived; now the screen itself, and its various processes, were to be made both the subject matter and the material of art attention. The theme of consciousness, and of its reflexive activity as self-consciousness, has been basic to conceptual art from the beginning—it has almost been its emblem or logo. Self-consciousness is a concept next door to solipsism, which is the idea that consciousness is *only* consciousness of one's self, and solipsism in turn is next door to tautology, which is the statement of self-sameness or identity. Conceptual art has taken the rendering of these concepts as its special province. In 1966, Anastasi exhibited *Microphone,* a tape recorder that played back an audiotape on which the sound of its own operations had been recorded. In 1967 he exhibited photographs of gallery walls hung on the walls they represented, filmed a wall and projected the film onto the same wall, and so on. In 1968 Ian Burn Xeroxed a blank sheet of paper, then Xeroxed the copy, and so on through a hundred generations, presenting the results as a book; the page's moments of awareness of itself developed into a form and a content. A performative icon of elementary self-consciousness is found in reports of Allan Kaprow's private works of minimal human gesture performed without audience, documentation, or reportage, existing only in the medium of immediate self-awareness. In more detailed investigations it was possible to focus and isolate specific emotions, thoughts, or thought processes, such as imagining, relating, comparing, visualizing, or perceiving. When one turns a Huebler dot or line over 45 degrees in one's mind, then 90 degrees, and so on, it is the operations of consciousness that one is made aware of, and the fact that these operations may create realities that are in no way present in the material ambience. One watches one's mind perform these simple turning movements as if watching a child learning to perform such movements with its hands. The unfamiliarity of one's own mental processes becomes apparent—how uninspected they are, and yet how susceptible to or available for inspection. The turning of one's own mind-stuff is focused, isolated, and presented to one's attention as an object. Something similar, though with added inner tensions, is produced by Dibbets' *Perspective Corrections* in 1967–69, in which objects are presented in ways that seem to deny perspectival foreshortening while in fact they are being seen perspectively but their shape is other than one had thought. One corrects the corrected perspective and then recorrects it again. Here mental processes are the material or medium. There is a certain formalism to this type of work, of course. Weiner's early word pieces often involved the isolation of specific mental operations triggered by linguistic directions, such as *to the sea, on the sea, from the sea,* and *bordering the sea,* all 1970. Such work investigates parts of speech, in this case prepositions, concentrating on the single mental operation that differs from one prepositional formulation to another. Like turning one of Huebler's imaginary lines around in one's head, one similarly turns Weiner's tiny word pieces, or turns that part of the conceptual stuff which registers distinctions such as those between prepositions. Noematic or imaginary objects become artworks by deliberate impetus of the mind-stuff in a certain direction, the bestowing of the impetus being the art act. Weiner's piece entitled *Floatable Objects Thrown into Inland Waterways One Each Month for 7 Years,* 1969, is not a performance to be acted out, but a complex image to be constructed and beheld in the mind. Byars has

presented the receiver's imagination with less specific suggestive phrases like *The Perfect Book,* 1981, or *The Exhibition of Perfect,* 1983; from such hints the viewer obtains a kind of transfer of mental atmosphere. Somewhere between the hidden and the imaginary falls Barry's piece *Psychic Series,* 1969: "Everything in the unconscious/ perceived by the senses but not/noted by the conscious mind/during trips to Baltimore,/during the summer of l967." Such encapsulations of indefinite millions of data encompass whole shelf-loads of unwritten novels in their brief suggestiveness. They have something of evocativeness associated with the fragments of pre-Socratic philosophy or of early Greek lyric poetry.

To a considerable degree the complex of strategies forming conceptual art was first defined negatively, by the complex of strategies it was attempting to destroy, those of formalist painting and sculpture. Its early form was to a degree determined, or controlled, by the form of what it was criticizing. This aspect has been acted out in a series of pieces in which the artist claims to retire from the practice of art (that is, from formalist commodity-making) again, as a demonstration of his or her real seriousness about art in a broader sense. Again, of course, Duchamp has been the great prototype—or anyway the myth that he quit art for chess-playing, which seems moderately if not rigorously true. In the period of first-generation conceptualism such gestures were a common motif; a material, really. In 1970 Baldessari gave an exhibition that consisted of the ashes of his paintings. Venet predicted in 1967 that he would quit artmaking four years thence; that is, the instructions for his projected series of pieces ended that way. The myth of Duchamp indicated that by switching from art to chess he laid claim to a superior cultural and intellectual position. Beuys' piece *The Silence of Marcel Duchamp is Overrated,* 1964, is a kind of reverse example of this genre, expressing his frustration at Duchamp for a confused dichotomy that he left for later artists: if nonart has been declared art, then quitting art is not really quitting. What can be the distinction between practicing art by practicing it and practicing art by not practicing it?

It was this kind of dichotomized thinking that caused conceptual art to be called "anti-art." But the term "anti-art" was never right. Conceptual art is not innately inimical to formal object art—it may be used that way, but it is not innately so; it is itself a formal means with its own characteristic range of objecthood. The fierceness of this dichotomy was a result of the history of the theory of art more than of the history of art. It was a kind of Manichaean split forced by the repressive practice of formalist theoreticians and critics who artificially attempted to ban language and concept, and with them thought and discourse and in fact culture, from the visual arts. The puritanical excesses once performed in the service of Soul were paralleled by the formalistic excesses in the service of esthetic feeling. The conflict between faith and reason was replayed in the realm of

art, and reason lost. Reason became the old antagonist again, now called not Anti-Christ but Anti-Art.

In a sense the polarization of art over the form-content, or senses-mind, issue was fortunate, because in trying to back away from conceptual aspects of the art experience several things were achieved. Abstract types of representation not formerly prominent in the Western tradition were to an extent worked out—and such advocates as Clement Greenberg developed a vocabulary and discourse to describe them with impressive clarity; indeed, with the almost spooky clarity of a discourse that does not see beyond itself. Even more important, a new sensory genre—or rather one that had always existed but had not before been made explicit in discourse— was forced out into the open. Born in the heat of combat, and with the brand of the Anti-Art upon it, the new medium—conceptual art—seemed to promise a new future.

The pseudo-scientific mood in which classical conceptualism sometimes presented itself was not an absence of self-expression but a critical shift in the idea of self-expression, one that depended less on questionable claims about originality and pure creativity, and attempted not only to acknowledge the conditioned nature of artistic activity but also to investigate and analyze its conditioning. There is courage in investigating the realm of not-self, and this project, so characteristic of 20th-century culture in general, brings with it new modes and channels of expressiveness which in turn revalidate the aspect of self in a saner spirit. Creative feeling and intensity of artistic involvement open in unexpected new directions where twenty years ago they would have been regarded as impossible. Several quotational painters have remarked in the last year or so that copying the same work again and again deepens the expressiveness of the act. The radical antithesis that such activity offers to formalism is almost a parable.

Today at least two other generations of conceptual artists are active alongside the members of the first generation who have wrought such heroic changes in our perception of art. Mike Osterhout, echoing in 1984 Duchamp's invention of a female self with whose name to sign his works, created a fictitious artist, "Kristán Kohl," made abstract paintings for Kohl, and gave her a gallery show with advertisements in the art magazines. Other works confront the new moment with new styles. Kiki Smith, in 1984, exhibited 12 pints of human blood on a shelf as a person. Anastasi in 1985 has drawn hundreds of "blind" self-portraits, made with his eyes closed—a kind of parable for the whole art world today. Buren has transformed the stripe works into complex architectural performances involving a decision-making process that both parodies and incorporates elements of action painting. Performance painting is being practiced in a variety of forms, as media and genres once puritanically separate mix and fuse. Whether there is a puristically

separate genre of conceptual art no longer matters as much as it did twenty or thirty years ago, when art was nearly suffocating for want of it. The purpose of it all was to restore the mind to art. Once mind is back, every medium that truly exercises it becomes in part a form of conceptual art. But this does not mean that one can let it go now, like a thing whose purpose is past. It has its own destiny, as an increasingly complex and syntactical formal means, still before it. And the various forces and conditions that once attempted, so nearly successfully, to remove art from critical self-consciousness are still alive and active; we still require the vigilance of mind with all its attentiveness and critical ingenuity.

Internationalism in the Eighties

Hilton Kramer

Of the many things to be noted about the American art world in the 1980s, surely one of the most striking is the fact that it is far more international in its day-to-day outlook on the contemporary scene than it has been at any time since the 1950s. So much is this the case that for several years now there has been talk, on this side of the Atlantic, about a virtual "rediscovery" of Europe—a development that we see reflected in the increasing quantity of new art from (among other places) Germany, Italy, and Britain which has come to claim a more and more conspicuous place in the exhibitions to be seen in New York (and elsewhere in this country) and in our thinking about the new art that we see. Not since the first post-World War II exhibitions devoted to the work of Dubuffet, Giacometti, Miró, and Picasso, perhaps, has New York been quite as captivated and provoked by the new art of Europe as it is today. When we speak about the "re-internationalization" of the American art world that has occurred in the 1980s, we are therefore speaking of a genuinely new development—a historic shift which signifies an altered perspective on the life of art in the Western world.

Yet in taking note of this historic shift, it is important for us to distinguish what is significantly new about it and what is not so new, for there is an element of cultural continuity underlying this shift that is an essential component of its history. Nothing in cultural history occurs *ex nihilo*, and this re-internationalization phenomenon is no exception to the rule. A true understanding of it thus requires us to see this phenomenon as part of a larger historical development—which is to say, as a chapter in the history of the modern movement in America. From the very beginning of its history, of course, the modern movement in America has been eagerly and unashamedly internationalist in its outlook on art. If we have now entered upon a new phase of this history—and there is ample reason to believe that we have—then the very terms of this internationalist outlook will be found to have undergone some significant modifications. These inevitably involve an alteration, at once subtle and profound, in the relation that obtains between the creative life of art in America and its contemporary counterpart on the European continent. For both have been deeply affected by the new cultural and historical situation in which we find ourselves in this penultimate decade of the twentieth century.

In attempting to explore this subject, it is well to be reminded at the outset that there has never been a time in American history when Europe did not play an important role in the life of art in the United States. That role may be taken as the basic *donnée* in any discussion of the history of art in the United States. It is mainly European art, after all, that fills the great American museum collections, both those devoted to the Old Masters and those devoted to the modernists. It is from Europe that we have inherited our conception of the aesthetic and our understanding of the traditions which have governed its development. It was to the academies of London, Rome, Paris, Munich, and Düsseldorf that aspiring American artists long felt obliged to travel for their training, and it was in the art capitals of Europe, too, that generations of American aesthetes and amateurs of the arts gathered their impressions and developed their taste. For artists and amateurs alike, and certainly for critics and historians and connoisseurs, it is in their experience of European art that Americans have tended to acquire their sense of artistic *quality*. On the occasion of the present exhibition, moreover, it is appropriate to recall the fact that the Carnegie International has been governed from its beginning, nearly a century ago, by a steadfast commitment to this idea of a shared tradition which unites the art of Europe and America in a common fate.

Given this history, it was surely inevitable that Europe would come to exert a powerful, indeed definitive, influence on the American artistic mind in the early decades of the twentieth century. Europe was where the modern movement in art had its origin and where, for much of the first four decades of the century, the fundamental modalities of modernist expression were initiated and developed. If an art appropriate to the dynamism of American life in the twentieth century was going to be created on this side of the Atlantic, then it was clearly destined to derive its standards, if not its actual content, from this source.

The American response to the artistic initiatives of the modern movement in Europe took many forms. Some were directly creative, resulting in important changes in the way American artists thought about their work. Some were social and cultural, and led to the founding of new art institutions or to the modification of existing ones. All had the effect, sooner or later, of drastically altering the life of art in the United States. On everything from the conception of art to the collecting and criticism of it to the creation of new museums where the public might deepen its acquaintance and appreciation of a new artistic achievement, the modern movement in Europe brought to American culture an outlook that was increasingly cosmopolitan and international.

These were momentous changes, and thus not the kind of changes that could occur all at once or without significant episodes of opposition. American cultural life remained divided and pluralistic and very largely philistine in its taste. It was not to be expected that the appeals of provincialism or the comforts of "tradition" would be instantly effaced by a challenge which seemed at once so esoteric and so alien even to many well-educated minds encountering it for the first time. In a period like our own, moreover, when the resources of large cultural institutions, private foundations, government agencies, corporations, and the mainstream media, not to mention a flourishing art market, are routinely lavished on the creation, acquisition, and exhibition of modernist art, it behooves us to recall the fact that the cause of modernism in these early decades of the century belonged to an embattled coterie of artists, intellectuals, and connoisseurs who wielded little, if any, influence on public taste. But then, this whole question of the public's response to modernism in these early decades is not exclusively, or even primarily, an American issue. The history of the modern movement in Europe was not exactly devoid of spectacular episodes of opposition. There, too, modernism initially met with

bewilderment and scandal and outright rejection. Indeed, scarcely a generation after the emergence of cubism and abstract art, the modern movement in Europe met with something far more ominous than philistine distaste. First in Russia and then in Germany, where artists had been in the vanguard of the new art from its beginnings, draconian state policies were instituted for the purpose of destroying all trace of modernism and its influence on cultural life.

In this respect, as in others, the American record is an entirely honorable one. And in certain crucial matters it proved in fact to be exemplary. Less than two decades after the great Armory Show of 1913 had first introduced the American public to the modernist art of Europe on a large scale, New York could boast of a major museum resolutely devoted to the cause of modernism. And at a time when Europe was entering its long, dark night of totalitarian repression and terror, the United States suddenly found itself in the position of providing the principal haven for the modern movement's survivors in Europe. To everyone's surprise, moreover, it also found itself to be the place where modernism's artistic growth was establishing new roots and where its worldly fortunes were given a whole new lease on life. This was a development neither planned nor anticipated, but its effect was to give New York in particular and the United States in general a role in the international life of art that was wholly new.

Even then, it is worth noting, at the very moment when— owing to the collapse of liberal civilization in Europe—New York was emerging as the successor to Paris in serving as the art capital of the Western world, the United States remained remarkably immune to the spirit of cultural chauvinism. Its artists and critics—at least those most committed to the cause of modernism—were acutely conscious of what they owed to the European achievement, and were extremely diffident about making claims on their own behalf. Their severest criticisms, in fact, were reserved for what was (or was not) happening in American art and were guided by a sense of the handicaps which continued to haunt American art in its efforts to achieve an international distinction. Jackson Pollock may have been overstating the case when he declared, in 1944, "I accept the fact that the important painting of the last hundred years was done in France," and added, "American painters have generally missed the point of modern painting from beginning to end." But he was only stating a view widely held among the American artists of his generation who aspired to high achievement in the modernist line. Their outlook was nothing if not internationalist, for Europe continued to serve as the source of their inspiration.

Something of the spirit of American art in the immediate aftermath of the Second World War, especially as it illuminates this devotion to the European achievement, can be gleaned in the report which Clement Greenberg wrote for Cyril Connolly's magazine *Horizon*, published in London in 1947. In an article entitled "The Present Prospects of American Painting and Sculpture," Greenberg wrote as follows:

The American artist with any pretensions to total seriousness suffers still from his dependency upon what the School of Paris, Klee, Kandinsky and Mondrian accumulated before 1935 The three, four or five best artists in this country yearn back to Paris as it was, almost, in 1921, and live partly by time transfusions. Not that they do not reflect the present period— they would not count if they did not—but they cannot consult the present for any standard of quality and style: all excellence seems to flow still from that vivacious, unbelievable near past which lasted from 1905 until 1930 and which not even the First World War, but only Hitler, could definitely terminate.

This is hardly the language of cultural chauvinism. Even less so is Greenberg's conclusion to this article:

. . . aside from Jackson Pollock, nothing has really been accomplished as yet. The difficulty remains our failure to relate this high conception of contemporary art to our own lives, our inability to be detached about either art or life, detached and whole as people are who are at home in the world of culture. . . . The foreseeable result will be a collection of *peintres maudits*—who are already replacing the *poètes maudits* in Greenwich Village. Alas, the future of American art depends on them.

One does not have to agree with every statement in this report to appreciate the spirit in which it was written—a spirit which, in a fashion that was characteristic of American intellectuals, reserved its harshest criticism for our own cultural situation; which was thus informed by a sense of the struggle that American artists were obliged to wage on their own behalf; and which continued to look to Europe, though more and more to the European past, for its standards of quality. Among much else, it was a spirit wholly internationalist in its outlook on art, and addressed in fact to an international readership.

Yet if Greenberg's 1947 report on American art was free of any trace of chauvinist claims, it was nonetheless informed by a sense that recent political events, culminating in the terrible upheavals of the Second World War, had marked a turning point in the history of the modern movement—that one historical epoch had come to an end and another had begun. From the perspective of the 1980s, we now know that the most decisive artistic event to have occurred in the early decades of this new epoch was the emergence of the New York School. Yet even this development, though it gave to American art an aesthetic priority on the international scene it had never before enjoyed, did nothing to diminish our sense of the continuity which joined our most distinctive artistic achievements with those of Europe in a common tradition. Far from it. In the formation of the New York School in the 1940s and 1950s, which permanently altered the relation in which American art would thenceforth stand to its European counterpart, it was widely recognized that a key role was played by certain European masters of the modern movement. It

was assumed as an article of faith in American criticism that the art of neither Jackson Pollock nor Willem de Kooning nor Robert Motherwell, for example, was conceivable without the prior achievements of Picasso, Matisse, Kandinsky, Mondrian, Miró, Klee, et al. Those "time transfusions" which Greenberg had spoken of in 1947 as an essential component of the new American art had soon established themselves as elements of an entrenched tradition—an international modernist tradition—as far as the New York School was concerned. The effects of this tradition were everywhere apparent in the younger as well as the older generation. Would the art of Robert Rauschenberg have been imaginable without the precedents to be found in Kurt Schwitters, say, or that of Jasper Johns without Marcel Duchamp? Alexander Calder owed much to Mondrian, Miró, and Arp in his most ambitious work, and David Smith never tired of acknowledging his profound debt to the art of Picasso and González in his. In this respect, it was the exception rather than the rule which was noteworthy. Of the artists who made up the first generation of the New York School, only Clyfford Still seems to have owed little or nothing to European precedent. This is one of the reasons why his European admirers tend to find in his art a more authentic statement of American experience than they generally glean in the work of his contemporaries. Yet this very "freedom" from European precedent—if that is what it is—has proved to be a grave problem for Still's many American followers. Sooner or later they find that Still's wholesale repudiation of Europe, if strictly adhered to, leads them to a dead end, and they are then obliged to renew their attachment to the modernist tradition in order to remain productive artists.

All the same, by the end of the 1950s something *had* changed. We *had* entered a new epoch. The center of artistic gravity had conclusively shifted to New York, whence a new energy and influence began to make itself felt as a significant factor on the international art scene. Europe ceased to be a source of new ideas for the American artist, who now tended to look inward for the content of his art. And this growing sense of artistic strength, which was something new for the American artist, was increasingly confirmed by the interest and respect, at times amounting to an uncritical adulation, which the younger generation of artists in Europe began to lavish on the achievements of American art. About this development the attitude of the United States was, at the outset at least, one of equivocation and uncertainty. Americans had for so long looked to Europe—especially to France—for leadership in the visual arts that they hardly knew how to respond to the new situation. The very idea of an avant-garde in art was, for Americans interested in this then esoteric phenomenon, virtually inseparable from the life of art in Paris, and there was no shortage of celebrated masters still at work in France to re-enforce their habitual view of the matter. For this reason, American collectors continued to look to Paris for their major acquisitions even after the emergence of the New York School, and American museums and the American press likewise preferred the School of Paris, even in its waning days, to anything

produced in New York. Recognition came very slowly to the New York School. It was not until the late fifties and early sixties that recognition became a more or less official attitude. It was only then that museums and collectors began to compete for major acquisitions. By then there was a second generation of New York School artists to reap the benefits and win immediate rewards as well as a new generation of critics, curators, and collectors to grant them. By the early sixties there was also—for the first time—a large and enthusiastic public for this new American art. The New York art world as we know it today may stem from developments in the 1940s, but it did not achieve its most significant period of growth until twenty years later.

One factor in this process of recognition and growth was the decline (as some American critics saw it) of art in Europe. Throughout the period we are speaking of, there were always a number of European artists—Dubuffet and Giacometti in France, Henry Moore and Francis Bacon in England, and the Cobra group in Northern Europe, among others—who enjoyed high favor in America; indeed, higher favor than that enjoyed by almost any member of the New York School. There was thus nothing of a nationalistic or parochial character in the view—which more and more came to be the common view in New York—that in the creation of new art Europe had suffered something of a setback in the period immediately following upon the end of the Second World War. On the contrary, New York was more internationalist in its outlook on contemporary art in this period than it had ever been in the past. The growing pride that Americans learned to take in the new American art was due, in large part, precisely to its cosmopolitan outlook. Far from closing the door on Europe, New York remained alert—one might even say, considering some of the art that was welcomed here, excessively alert—to new developments in Europe even in the halcyon days of the New York School. As a result of this American eagerness to discover new talent in postwar Europe, more than a few minor artists on the Continent were mistaken for major ones. This naturally caused disappointment and dismay, yet American interest in European art never flagged. Far from adopting an isolationist attitude in art, New York remained ready to embrace new achievements wherever and whenever they might be discovered. One thing had changed, however. No longer would European art automatically be given preference over its American counterpart. But then, this was something that Europeans no longer did, either. For in Europe, too, New York had won recognition as the art capital of the Western world.

Its position, in this respect, was now firmly rooted in the achievements of American art, and in the vitality of our art institutions. By the 1960s, New York's new position on the international scene was reflected in the alacrity with which so many of the most gifted and ambitious European artists now began heading straight for our shores at the first opportunity. They wanted to see for themselves what American artists were doing and thinking. They also wanted to show their own work in the context of the New York art

scene, which now came more and more to be acknowledged as the place where standards of quality were likely to be determined and where, as a consequence, reputations would be made or confirmed. Over the years this change has come to be reflected in the eagerness of European museums to exhibit the latest achievements of American art, and to acquire major examples of it for their permanent collections. Just as there has always been an interest on the part of American museums to exhibit European art, and even to compete in organizing major shows devoted to it, so now there is not only a fierce competition in Europe to show the work of the younger American artists with international reputations but to be *first* in organizing their retrospective exhibitions. As a result, these American artists are given museum retrospectives at an earlier and earlier age every year—it is no longer uncommon for an American artist to be given a "major" museum exhibition in Europe before the age of thirty—and more and more European curators have come to pride themselves on having a special relationship with the American art scene; on being, in effect, the guardians and arbiters of American reputations. In this respect, as well as in others, the old relationship between the American museum world and the European art world has been reversed.

It is against this historical background that the so-called "rediscovery" of European art on this side of the Atlantic needs to be understood. Beginning somewhat slowly in the mid-1970s and then rapidly accelerating in the early 1980s, the work of certain European artists—most particularly, of course, the work of the new expressionist school in West Germany and Italy—met with a tremendous response in New York and on the American art scene generally. American critics welcomed this new development with enthusiasm, and American collectors began acquiring the work in large quantities. American museums, too, were quick to organize exhibitions of the new European art, and to compete with each other and with their European counterparts in acquiring outstanding examples of the art for their permanent collections. So important has this European "invasion" of the American art scene now become that it can truly be said to account for some of the major exhibition events on the American art calendar season after season.

If this situation can accurately be described as a "rediscovery" of Europe, it is only because European artists are once again thought to be producing new art of a quality and scope which meet the internationalist standards that New York has set for itself as well as others. For the older generation in New York, this "rediscovery" of Europe is no rediscovery at all, of course: European art has never been absent from its aesthetic consciousness. A feeling of kinship with modern European culture has remained crucial to its vision of the artistic vocation. It is for the younger generation in America—brought up, as it were, to regard the achievements of American art as central to the very idea of new art—that these recent developments may constitute an experience of "rediscovery." If this is the case—and I believe it is—then it speaks very well for the younger generation of American artists, for they too have greeted the new art of Europe with a keen sense of kinship, curiosity, and competition. What has changed, however, is that the competition is now regarded as a competition of equals. It is, in any case, upon this sense of a trans-Atlantic community of artists who are of equal interest to each other—and to us—that the 1985 Carnegie International exhibition is based.

John Ahearn

Born 1951, Binghamton, New York
Lives and works in New York

Our sculpture work has been nourished by its constant interaction with people. Our lifecasts are "tokens of our affection," made to underscore cohesion and continuity. The community portraits were created and displayed in the South Bronx. The "bust" pieces are made primarily to initiate or cement friendships; the larger figures are used for permanent sculpture murals in the area.

Pat and Selina at Play, 1983
oil on reinforced polyadam
63 x 38 x 8 in. (160 x 96.5 x 20.3 cm.)
Collection of the artist, courtesy of Brooke Alexander Gallery, New York

Thomas, 1983–84
oil on reinforced polyadam
46 x 29 x 7 in. (116.8 x 73.7 x 17.8 cm.)
Collection of Lenore and Herbert Schorr

Titi in Window, 1985
oil on reinforced polyadam
72 x 30 x 12 in. (182.9 x 76.2 x 30.5 cm.)
Collection of the artist, courtesy of Brooke Alexander Gallery, New York

Maggie and Connie, 1985
oil on reinforced polyadam
68 x 55 x 18 in. (147.3 x 139.7 x 45.7 cm.)
Collection of the artist, courtesy of Brooke Alexander Gallery, New York

Kido and Ralph, 1985
oil on fiberglass
80 x 63 x 16 in. (203.2 x 160 x 40.6 cm.)
Collection of the artist, courtesy of Brooke Alexander Gallery, New York

1985 Carnegie International Installation
John Ahearn with Rigoberto Torres
(see catalogue supplement)

Selected One-Artist Exhibitions
1985
Bronx Museum, Bronx, New York.
Institute of Contemporary Art, University of Pennsylvania, Philadelphia.
1984
Brooke Alexander, Inc., New York. Also 1983.
1982
Galerie Rudolph Zwirner, Cologne.
1979
Fashion Moda, New York.

Selected Group Exhibitions
1985
Biennale de Paris. Catalogue.
Biennial Exhibition, Whitney Museum of American Art, New York. Catalogue.
1984
The Heroic Figure, Contemporary Arts Museum, Houston (traveled to Memphis Brooks Museum of Art, Memphis; Alexandria Museum, Alexandria, Louisiana; Santa Barbara Museum of Art; Museu de Arte Moderna, Rio de Janeiro; Museo Nacional de Bellas Artes, Santiago; Museo de Arte Contemporáneo, Caracas). Catalogue by Linda Cathcart and Craig Owens.
The Human Condition: SFMMA Biennial III, San Francisco Museum of Modern Art. Catalogue with essays by Dorothy Martinson, Wolfgang Max Faust, Achille Bonita Oliva, Klaus Ottman, and Edward Kienholz.
1983
New York Now, Kestner-Gesellschaft, Hanover (traveled to Kunstverein, Munich; Musée Cantonal des Beaux-Arts, Lausanne; Kunstverein für die Rheinlande und Westfalen, Düsseldorf). Catalogue by Carl Haenlein.
New Figuration in America, Milwaukee Art Museum. Catalogue with introduction by Gerald Nordland and essays by Russell Bowman and Peter Schjeldahl.
1981
Figures: Forms and Expressions, Albright-Knox Art Gallery, Buffalo. Catalogue with essays by G. Roger Denson, Biff Henrich, Charlotta Kotik, and Susan Krane.

Westkunst—Heute: Zeitgenössiche Kunst seit 1939, Museen der Stadt Köln. Catalogue by Laszlo Glozer.
1980
Fashion Moda, The New Museum, New York.
Times Square Show, Collaborative Projects, Inc., New York.

Selected Bibliography
Theodore F. Wolff, "The Home Forum; Neighbors as Art," *Christian Science Monitor,* 13 September 1984.

Jean Baudrillard, "Astral America," *Artforum* (September 1984).

Robert Becker, "Sculptural Visions," *Interview* (June 1984).

Edit de Ak, "John Ahearn, 'We are Family' 877 Intervale Avenue, The Bronx," *Artforum* (November 1982).

Richard Goldstein, "Artbeat: Something That Loves a Wall," *The Village Voice,* 3 August 1982.

Jeanne Siegal, "The New Reliefs," *Arts Magazine* (April 1982).

Rene Ricard, "The Radiant Child," *Artforum* (December 1981).

Peter Schjeldahl, "Anxiety as a Rallying Cry," *The Village Voice,* 10 September 1981.

Kay Larson, "Sculpting Figuratively," *New York Magazine,* 16 November 1981.

Lucy R. Lippard, "Sex and Death and Shock and Schlock: A Long Review of the Times Square Show," *Artforum* (October 1980).

William Zimmer, "Fashion Moda Review," *Soho Weekly News,* 11 October 1980.

Carrie Rickey, "John Ahearn. New Museum Windows," *Artforum* (March 1980).

Walter Robinson, "John Ahearn at Fashion Moda," *Art In America* (January 1980).

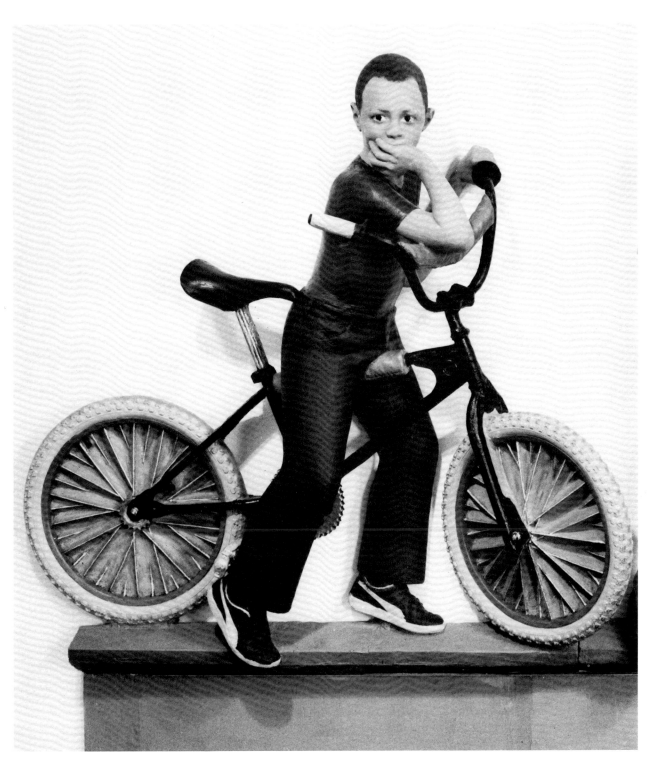

Jay with Bike, 1985
oil on fiberglass
52 x 55 x 16 in. (132.2 x 139.7 x 40.6 cm.)
Collection of the artist, courtesy of Brooke
Alexander Gallery, New York

John Ahearn

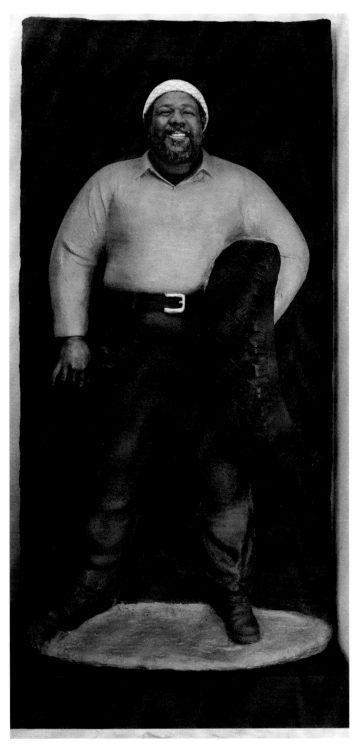

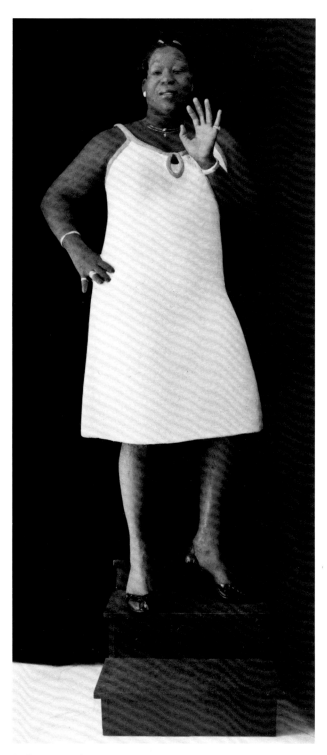

Pedro with Tire, 1984
oil on reinforced polyadam
80 x 42 x 18 in. (203.2 x 106.7 x 45.7 cm.)
Collection of Edward R. Downe, Jr.

Barbara: For Ethiopia, 1985
oil on reinforced polyadam; wood
84 x 36 x 20 in. (213.4 x 91.4 x 50.8 cm.)
Collection of Edward R. Downe, Jr.

John Baldessari

Born 1931, National City, California
Lives and works in Santa Monica

Below are the current categories in my files of movie stills which form a large part of the raw material from which I draw to do my work. I hope the categories (which are continually shifting according to my needs and interests) will provide some clues to what animates the work I do.

A
attack, animal, animal/man, above, automobiles (left), automobiles (right)

B
birds, building, below, barrier, blood, bar (man in), books, blind, brew, betray, bookending, bound, bury, banal, bridge, boat, birth, balance, bathroom

C
cage, camouflage, chaos/order, city, cooking, chairs, curves, cheering, celebrity, consumerism, curiosity, crucifixion, crowds, climbing, color, civic

D
dwarf, death, disgrace, danger, discipline, disaster, division, door

E
escape, eat, ephemeral, exteriors

F
facial (expression), fall, fake, framing, freeway, fire, foreground, falling, forest, females, form

G
good/evil, goodbye, giant, gate, grief, guns, guns (aggression), gamble, growth, groups

H
hope, horizontal, hard/soft, hands, heel (ankle), hole (cavity), houses, hiding

I
injury (impair), interiors

J
judgment, journey (path, guide)

K
knife, kiss

L
lifeless, letter, light, looking (watching), laughing

M
money, music, males (+1 female), males 2 (+1 F), male/female, message, mutilation, movement, masks (monsters), missing (area), macho

N
naked, noose, nature, nature (water), nourish, newsphotos

O
octopus, operation, oval, obstacle

P
phallic, prison, puzzle, purity, perspective, posture, paint, past, parachute, products, portrait (male), portrait (male, color), parallelograms, pairs (images)

R
roller coaster, rescue, repel, radiating (lines), race, relief, revive, rectangle (long), rectangle (wavy), reason

S
snakes, shadows, ships, smoke, sports, signal, search, secret, survive, stress, separation, safe, struggle, sad, soul, suitcase, switch, sinking, structure, seduction, sex (desire), small, shape (smear), shape (awkward), shape (black), shape (arc), shape (circle), shape (blur), shape (white)

T
technology, tables, table (settings), thinking, trapeze, time, three, trains, two, teeth, thought, triangle, triangle (truncated)

U
upside down, unconscious

V
vision, victim, vulnerable

W
walls, water, wound, watching, winning, women, women (2), women (group)

A bargain always must be struck between what is available in movie stills and the concerns I have at the moment—I don't order the stills, I must choose from the menu. Also one will read from this a rather hopeless desire to make words and images interchangeable—yet it is that futility that engrosses me. Lastly, I think one will notice the words falling into their own categories, two being those of formal concerns and content.

John Baldessari

Selected One-Artist Exhibitions

1984
Sonnabend Gallery, New York. Also 1981, 1980, 1978, 1975, 1973.

1982
Contemporary Arts Museum, Houston.

1981
The New Museum, New York (traveled to Contemporary Arts Center, Cincinnati; Contemporary Arts Museum, Houston). Catalogue with essays by Marcia Tucker and Robert Pincus-Witten and interview by Nancy Drew.

Stedelijk Van Abbemuseum, Eindhoven, and Museum Folkwang, Essen. Catalogue with introduction and interview by Rudi Fuchs.

CEPA Gallery, Buffalo.

Albright-Knox Art Gallery, Buffalo.

1978
Whitney Museum of American Art, New York.

1975
Stedelijk Museum, Amsterdam. Publication: John Baldessari, *Four Events and Reactions*.

1971
Nova Scotia College of Art and Design, Halifax.

1966
La Jolla Museum of Art, La Jolla, California. Also 1960.

1964
Southwestern College, Chula Vista, California. Also 1962.

Selected Group Exhibitions

1985
Biennale de Paris. Catalogue.

1983
Biennial Exhibition, Whitney Museum of American Art, New York. Also 1979, 1977, 1972, 1969. Catalogues.

1982
Documenta VII, Kassel. Also 1972, V. Catalogues.

Biennale of Sydney.

1981
Westkunst—Heute: Zeitgenössische Kunst seit 1939, Museen der Stadt Köln. Catalogue by Laszlo Glozer.

1978
American Narrative/Story Art: 1967–1977, Contemporary Arts Museum, Houston (traveled to University Art Museum, University of California, Berkeley).

1976
Painting and Sculpture in California: The Modern Era, San Francisco Museum of Modern Art (traveled to National Collection of Fine Arts, Smithsonian Institution, Washington, D.C.). Catalogue.

American Artists: A New Decade, Detroit Institute of the Arts (traveled to Forth Worth Art Center; Grand Rapids Art Museum). Catalogue.

1971
Art and Technology, Los Angeles County Museum of Art. Catalogue.

1970
Information, The Museum of Modern Art, New York.

1969
Konzeption-Conception, Städtisches Museum, Leverkusen, Federal Republic of Germany.

Selected Bibliography

John Baldessari, *Close Cropped Tales* (Buffalo, 1981).

Hal Foster, "John Baldessari's 'Blasted Allegories,'" *Artforum* (October 1979).

Leo Rubinfien, "Through Western Eyes," *Art in America* (September/October 1978).

Peter Frank, "John Baldessari," *Art News* (October 1977).

James Hugunin, "A Talk with Baldessari," in Lew Thomas, ed., *Photography and Language* (San Francisco, 1977).

Jeff Perrone, "John Baldessari and Daniel Buren, Matrix Art Gallery, Wadsworth Atheneum," *Artforum* (September 1977).

William Zimmer, "Newsstand Images," *Soho Weekly News,* 21 April 1977.

Michael Auping, "Recent Work by John Baldessari," *Artwork,* 23 October 1976.

John Baldessari, *Throwing a Ball Once to Get Three Melodies and Fifteen Chords* (Irvine, California, 1975).

James Collins, "Pointing, Hybrids and Romanticism: John Baldessari," *Artforum* (October 1973).

John Baldessari, *Ingres and Other Parables* (London, 1972).

Helene Winer, "Los Angeles," *Studio International* (November 1971).

Elizabeth C. Baker, "Los Angeles 1971," *Art News* (September 1971).

John Perrault, "The Action," *The Village Voice,* 26 March 1970.

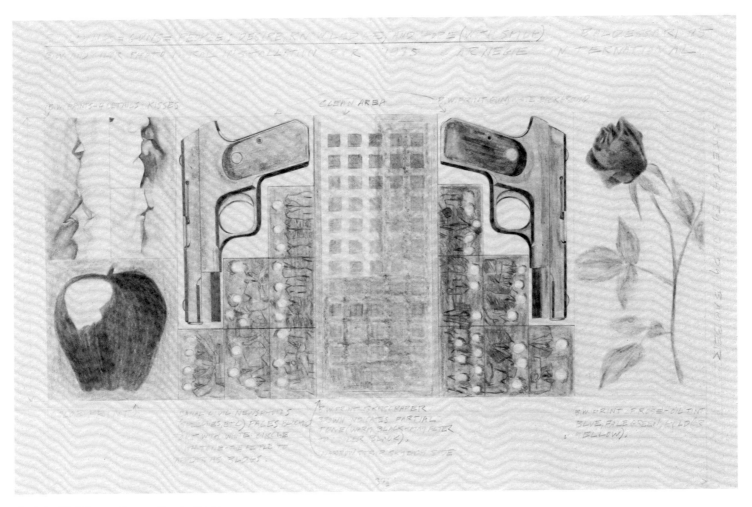

*Study for "Buildings = Guns = People: Desire,
Knowledge, and Hope (with Smog)," 1985*
graphite and colored pencil on paper by Judy Bamber
14 1/16 x 22 in. (35.7 x 55.9 cm.)
Collection of the artist

*Buildings = Guns = People: Desire, Knowledge,
and Hope (with Smog), 1985*
black and white photographs and
color photographs
192 x 450 in. (487.7 x 1143 cm.)
(see catalogue supplement)
Collection of the artist

Georg Baselitz

Born 1938, Deutschbaselitz, Germany (now German Democratic Republic)
Lives and works in Derneburg, Federal Republic of Germany

I lived in East Germany until I was eighteen. At nineteen, I was studying at the Academy in East Berlin [but] I did not learn about German Expressionism—it was not in vogue then. The discussion of Expressionism did not begin until the 70s. The label was attached to my painting even then. I thought about how this was possible since I had no connection to Expressionism, and I really only found one reason: one can say that people who deal with brushstrokes are associated with Expressionist painting from the 20s and 30s. Based on the attitude of the Expressionists, what they meant and what they did, I cannot feel a part of them. I also am not working in their tradition, since the problem of the Expressionists to illustrate, to summon up the environment, is not my problem. I am not in a position to utilize in my pictures an object from the environment. Whether I paint a cow or a deer green or blue is not an issue with me. I see pictures in a very different way, and I believe that tying [my work] to the Expressionist tradition is invalid.

Sometime or another, and I believe well back into the past, pictures originated in my head. I have at my disposal a fixed vocabulary that I am master of. This vocabulary separates me from the layman's reality, which does not at all exist for a painter. One may strive to create such references to reality; one can insist on seeing a landscape when one looks out of the window and use it for the canvas. But I find that to be a senseless endeavor, because I have realized in the meantime that the picture means something very different. When one paints a picture, one must first place the painter in the position that enables him to paint a picture. And then he must get to the point at which he does justice to his sense of composition. He must test, explore and try long enough so that he suits his own organization and paints a picture that has never been painted before. He must fill up his own being with it. When one has done that, then one is far removed from the ambition to be smartly busy with reality, to constantly correct. One actually works at inventions.

Excerpts from "Ich arbeite an Erfindungen," an interview with Georg Baselitz by Werner Krüger. Reprinted from Werner Krüger and Wolfgang Pehnt, eds., *Künstler im Gespräch* (Cologne: Artemedia Buch & Film, 1984): 12–14.

Rote Mutter mit Kind, 1985
oil on canvas
130 x 98 ¼ in. (330 x 250 cm.)
(see catalogue supplement)
Courtesy of Mary Boone/Michael Werner Gallery, New York

Selected One-Artist Exhibitions

1985
Bibliothèque Nationale, Paris. Catalogue with introduction by François Woimant and interview by Rainer Michael Mason.

1984
Galerie Michael Werner, Cologne. Catalogue. Also 1983 (catalogue), 1982 (catalogue), 1981.

Kunstmuseum, Basel, and Stedelijk Van Abbemuseum, Eindhoven (traveled to Städtisches Kunstmuseum, Bonn; Kunsthalle, Nuremberg; Kunstverein, Hanover; Badischer Kunstverein, Karlsruhe). Catalogue by Dieter Koepplin and Rudi Fuchs.

1983
Musée d'Art Contemporain, Bordeaux. Catalogue with interview by J.-L. Froment and J.-M. Poinsot.

Whitechapel Art Gallery, London (traveled to Stedelijk Museum, Amsterdam; Kunsthalle, Basel). Catalogue by Nicholas Serota and Mark Francis, eds.

1981
Kunstverein, Brunswick. Catalogue by Jürgen Schilling, ed.

1979
Stedelijk Van Abbemuseum, Eindhoven. Catalogue by Rudi Fuchs.

1976
Kunsthalle, Cologne. Catalogue by Siegfried Gohr.

1970
Kunstmuseum, Basel. Catalogue by Dieter Koepplin and Georg Baselitz.

1963
Galerie Werner and Katz, West Berlin. Catalogue by Herbert Read, Martin G. Buttig, and Edouard Roditi.

1962
Pandämonium, West Berlin. Also 1961.

Selected Group Exhibitions

1984
An International Survey of Recent Painting and Sculpture, The Museum of Modern Art, New York. Catalogue by Kynaston McShine.

Von Hier Aus, Messegelände, Düsseldorf. Catalogue by Kasper König.

1983
New Figuration—Contemporary Art from Germany, Frederick S. Wight Gallery, University of California, Los Angeles. Catalogue by Donald B. Kuspit.

Baselitz, Lüpertz, Penck, Galerie Herbert Meyer-Ellinger, Frankfurt, and Stedelijk Van Abbemuseum, Eindhoven.

Expressions: New Art from Germany, The St. Louis Art Museum (traveled to P.S. 1, Long Island City, New York; Institute of Contemporary Art, University of Pennsylvania, Philadelphia; The Contemporary Arts Center, Cincinnati; Museum of Contemporary Art, Chicago; Newport Harbor Art Museum, Newport Beach, California; Corcoran Gallery of Art, Washington, D.C.). Catalogue by Jack Cowart, Siegfried Gohr, and Donald B. Kuspit.

1982
Documenta VII, Kassel. Also 1977, *VI* (artist withdrew from exhibition). Also 1972, *V.* Catalogues.

Zeitgeist, Martin-Gropius-Bau, West Berlin. Catalogue with foreword by Christos Joachimides and Norman Rosenthal.

1981
A New Spirit in Painting, Royal Academy of Arts, London. Catalogue by Christos Joachimides and Norman Rosenthal, eds.

1980
La Biennale di Venezia, West German Pavilion.

1975
Bienal de São Paulo. Catalogue by Evelyn Weiss.

Selected Bibliography

Rudi Fuchs, in *Art of Our Time: The Saatchi Collection,* vol. 3 (New York, 1985).

Robert Pincus-Witten, "Entries: I: Baselitzmus; II: Borstal Boy Goes Mystic," *Arts Magazine* (Summer 1984).

Vivien Raynor, "The Upside Down World of Georg Baselitz," *New York Times,* 13 April 1984.

Henry Geldzahler, "Georg Baselitz," *Interview* (April 1984).

Donald B. Kuspit, "Le Moi archaïque de Georg Baselitz," *Art Press* (January 1984).

Stuart Morgan, "Georg Baselitz, Paintings 1966–1969 at Anthony d'Offay Gallery and Recent Paintings and Drawings at Waddington Gallery, London," *Artforum* (February 1983).

Siegfried Gohr, "In the Absence of Heroes: The Early Work of Georg Baselitz," *Artforum* (June 1982).

Antje van Graevenitz, "Baselitz en de bateke," *Kunstschrift* (July/August 1982).

Donald B. Kuspit, "Georg Baselitz at Fourcade," *Art in America* (February 1982).

Dorothea Dietrich-Boorsch, "The Prints of Georg Baselitz: An Introduction," *The Print Collector's Newsletter* (January/February 1982).

Donald B. Kuspit, "The Night Mind," *Artforum* (September 1982).

Siegfried Gohr, "Georg Baselitz," *Museen in Köln Bulletin* (July 1976).

Helmut Goetti, "Kullervos Füsse Der Maler Georg Baselitz," *Tendenzen* (August/September 1968).

Edouard Roditi, "Le Neo-Nazisme artistique à Berlin-Ouest," *L'Arche, Revue du FSJU* (March 1965).

Arwed D. Gorella, "Der Fall Baselitz," *Tendenzen* (December 1964).

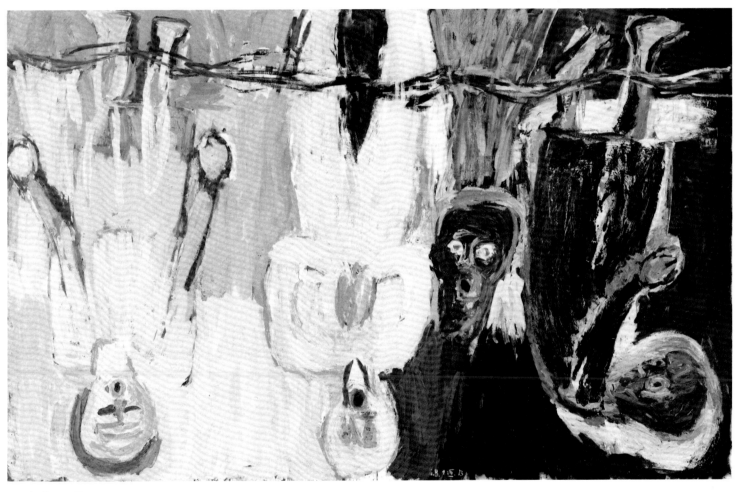

Brückechor, 1983
oil on canvas
110½ x 177 in. (280.7 x 449.6 cm.)
Collection of Emily and Jerry Spiegel

Georg Baselitz

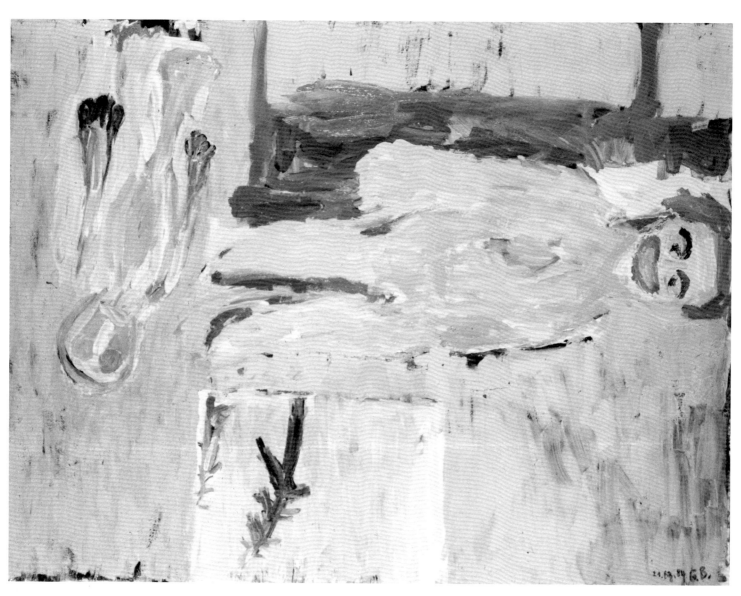

Das Liebespaar, 1984
oil on canvas
98 ½ x 130 in. (250 x 330 cm.)
Louisiana Museum, Humlebaek, Denmark

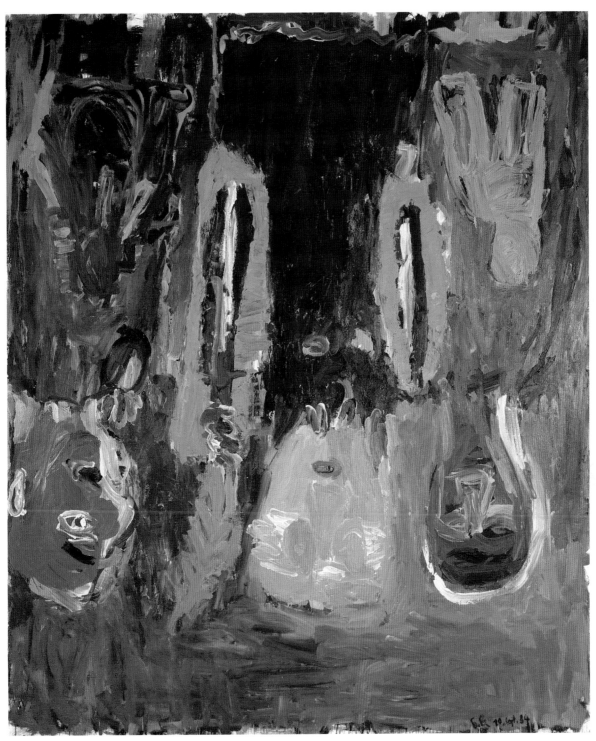

Die Verspottung, 1984
oil on canvas
120 x 100 in. (304.8 x 254 cm.)
Museum of Art, Carnegie Institute, Pittsburgh;
Gordon Bailey Washburn Memorial Fund,
Women's Committee Washburn Memorial Fund,
and Carnegie International Acquisition Fund, 1985

Dara Birnbaum

Born 1946, New York
Lives and works in New York

General Work Description: Damnation of Faust

Using the popular accessibility of TV in much the same way the 19th c. Japanese *ukiyo-e* period used the wood-block, the *Damnation of Faust* begins with the *Evocation* of the legend; a focus on Italian youths in a NYC playground. Their ritualized swinging becomes a condensed drama in both the single channel work as well as the installation (a microcosm of the playground scene). Making unique use of video's new technology, the viewer is plunged into this "rite of passage" through multiple-image picture frames of digitally generated fans and vertical pillars. Scenes unfold and snatches of meaning are revealed like a fan being splayed. Conveyed is a sense of alienation which typifies our cities' social environment and questions issues of identity: where can individual expression exist within our technocractic society? The gestures of these youths are shown to be a beginning to the act of communication. The next developed section from this series is a video-triptych, a three channel installation, with audio, that begins the development of the female character of the Faust legend, Margarete. A narrative line from "the woman" constitutes the beginning for the development of the character herself. As she reveals the tale, she begins to reveal herself. The tale is based upon the meeting of a man who is no longer there as a part of her daily experience, but is very much existent in her sense of being and longing. Using an existent tribal legend that claims the belief that a person could own "the thing," or, "its meaning," but not both, the woman tries to hold onto the meaning (illusion) of what is no longer there (the representation). The three channels are used to construct this information to the viewer in the form of syllogisms—a form of deductive reasoning consisting of a major premise, a minor premise, and a conclusion—which may or may not be true. The working title of the installation, as with the developing single channel videotape, is *will-o'-the-wisp* (a deceitful goal).

The overall form that these statements take is the three panel display itself—the triptych. This "display" of fragmented imagery is meant to alternate between décor (as with traditional Japanese textile patterns) to specific "descriptive-portraiture." The viewer is forced to challenge the statements and images presented as the wall display combines visuals and narratives into pure "aesthetics" or "gestures toward communication."

Selected One-Artist Exhibitions
1984
Galerie Graff, Montreal. Catalogue.

Institute of Contemporary Art, Boston.

Whitney Museum of American Art, New York. Catalogue.

Institute of Contemporary Arts, London. Also 1982.

Anthology Film Archives, New York. Also 1981.

1983
Musée d'Art Contemporain, Montreal. Catalogue.

1982
Hudson River Museum, Yonkers, New York.

Musée d'Art Moderne, Liège.

1981
Pacific Film Archives, University Art Museum, University of California, Berkeley.

The Museum of Modern Art, New York.

1980
The Kitchen, New York. Also 1978.

Selected Group Exhibitions
1985
Biennial Exhibition, Whitney Museum of American Art, New York. Catalogue.

1984
The Luminous Image, Stedelijk Museum, Amsterdam. Catalogue by Dorine Mignot.

Selections from the Permanent Collection, Museum of Contemporary Art, Chicago. Catalogue.

New American Video Art: A Historical Survey, 1967–1980, Whitney Museum of American Art, New York. Catalogue.

New Voices 4 : Women and the Media, New Video, Allen Memorial Art Museum, Oberlin College, Oberlin, Ohio. Catalogue.

1983
National Video Festival, American Film Institute, Los Angeles. Also 1982.

From New York: Video Blitz 82/83, Kunsthalle, Düsseldorf.

1982
Documenta VII, Kassel. Catalogue.

1981
San Francisco International Video Festival, San Francisco.

1980
Deconstruction/Reconstruction, New Museum, New York. Catalogue with essay by Shelley Rice.

Selected Bibliography

Robin Reidy, "Pop-Pop Video: Dara Birnbaum Alters Familiar Images with Advanced Technology," *American Film* (January/February 1985).

Paul Groot, "The Luminous Image," *Artforum* (January 1985).

Yvonne Stahr, "Dara Birnbaum: An Interview," *Art Papers* (March/April 1984).

Jean-Paul Fargier, "Video. Dara Birnbaum à l'American Center: Raccord de regards," *Cahiers du Cinema* (February 1984).

Charles Hagen, "Reviews: Dara Birnbaum, Anthology Film Archives Video Program at Millenium Film Workshop," *Artforum* (Summer 1984).

Robin Reidy, "Video Effects Art/Art Affects Video: Dara Birnbaum's Damnation of Faust: Evocation," *Artcom* VI, 24 (1984).

Chris Dercon, "Dara Birnbaum/Wonder Woman," *Schone Vis À Vis*, I (1984).

Craig Owens, "Phantasmagoria of the Media," *Art in America* (May 1982).

Benjamin H. D. Buchloh, "Allegorical Procedures: Appropriation and Montage in Contemporary Art," *Artforum* (September 1982).

Rosetta Brooks, "TV Transformations: An Examination of the Videotapes of NY Artist Dara Birnbaum," *ZG* LXXXI, 1 (1981).

Thomas Lawson, "Reviews," *Artforum* (October 1980).

Shelley Rice, "Reviews," *Artforum* (September 1980).

J. Hoberman, "Three Women," *The Village Voice*, 5 May 1980.

Peter Frank, "Dara Birnbaum—Artists Space," *Art News* (October 1977).

Stephanie Woodard, "Concepts in Performance, Views and Interviews: Dara Birnbaum," *Soho Weekly News*, 16 January 1977.

Damnation of Faust: will-o'-the-wisp, 1985
video installation
(see catalogue supplement)
Collection of the artist

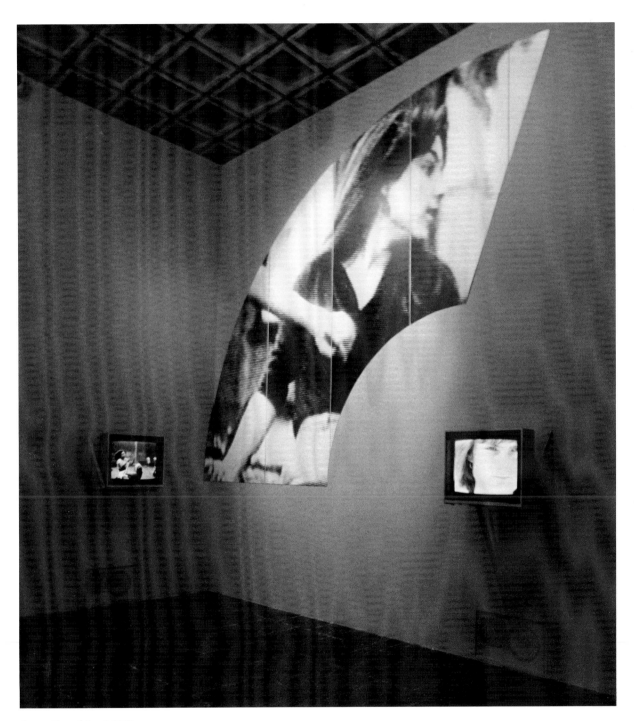

Damnation of Faust, 1985
two-channel video, color; stereo sound, photo
enlargement; colored walls and light
Installation view at Whitney Museum of American
Art, New York, 1985
(not in exhibition)

Jonathan Borofsky

Born 1942, Boston
Lives and works in Venice, California

Sounds of the World

This tape is being played from the 4 large speakers in the adjacent corners of this room. It consists of a variety of sounds that could be heard by anyone at anytime. These sounds are organized into a series of tonal passages that are edited into a larger order that is categorized (animal, machine, journal, phenomenon), and sequenced by a computer program called "Radar." The sounds are:

Owl
Tropical birds
Xylophone
Computer
Water running
Angry cat
Car horn
Ping pong
Hootowl
Calm passage:

| Seagulls |
| Orchestra tunes |

Jet
Scissors
Bird cage
School bell
Telemetry
Vanguard satellite
Precision drills
Dog
Tire Pump
Wine glass
Sharp passage:

| Buzzer |
| Baby cries |
| Skill saw |
| Hammer and nail |
| Plate glass |

Attention shoppers
Pile driver
Cathedral
Mocking bird
Electric shaver
Cats
Skid and crash
Swallows
Paper tearing
War dance
Hard passage:

| Woman screams |
| Explosion |
| Canaries |
| Bowling |

Girls screaming
Police whistle

Dive sequence
Happy bells
Bullfrog #1
Blacksmith shop
Globe smashing
Closet noise
Birds
Window breaks
Wheel of fortune
Whiplash
Alarm
Cloth tearing
Laughter
Skee-ball
Sci-fi #1
Horse whines
Mysterious passage:

| Howl |
| Sci-fi—Yoo hoo |
| Mastodon in tarpit |

Bell buoy
Soft passage:

| Synth bells |
| Music box |
| Bubbles |
| Church bells |
| 6 gongs |

Manual of arms
Pinball machine
Muslim singer
Toothbrush
War chant
Garage shop
Marching soldiers
Sawing wood
Bicycle
Attention shoppers
Elephants
Rooster
Rattlesnake
Grandfather clock
Red Sea
Sea lions
Factory whistle
Helicopter
Pencil on paper

Pigs
Machine guns
Cymbal
Sheep
Dentist drill
Tobacco auction
Cows
Fog horn
Rifle arcade
Story passage:

| Plate glass smash |
| Woman and shower |
| Door chime |

Attention shoppers
Crows
Electric typewriter
Baby
Burglar alarm
Telephone passage:

| Telephone rings |
| Telephone—busy |

J. bells
Horse gallops
Sputnik I satellite
Siren
Bullfrog #2
Dive bomber
Telephone time
Bus
Crane
Cuckoo clock
Frog at night
Cards
Cricket
Train
Steamship blast
Wolves
Can opener
Balloons
Sparrow
Drill
Quill

—Jonathan Borofsky and Ed Tomney

Selected One-Artist Exhibitions
1984
Philadelphia Museum of Art (traveled to Whitney Museum of American Art, New York; University Art Museum, University of California, Berkeley). Catalogue with essays by Mark Rosenthal and Richard Marshall.

1983
Kunstmuseum, Basel (traveled to Städtisches Kunstmuseum, Bonn; Kunstverein, Hamburg; Kunsthalle, Bielefeld; Kunstverein, Mannheim; Moderna Museet, Stockholm). Catalogue by Christian Geelhaar and Dieter Koepplin.

Paula Cooper Gallery, New York. Also 1982, 1980, 1979, 1976, 1975.

1982
Museum Boymans-van Beuningen, Rotterdam.

1981
Contemporary Arts Museum, Houston. Catalogue with essay by Linda Cathcart.

Kunsthalle, Basel, and Institute of Contemporary Arts, London. Catalogue with prefaces by Sandy Nairne and Jean-Christophe Ammann and essay by Joan Simon.

1978
University Art Museum, University of California, Berkeley. Catalogue by Mark Rosenthal.

The Museum of Modern Art, New York.

1976
Wadsworth Atheneum, Hartford. Catalogue by Mark Rosenthal.

1973
Artists Space, New York.

Selected Group Exhibitions
1984
An International Survey of Recent Painting and Sculpture, The Museum of Modern Art, New York. Catalogue by Kynaston McShine.

1983
New Art at the Tate Gallery, 1983, The Tate Gallery, London. Catalogue by Michael Compton.

Biennial Exhibition, Whitney Museum of American Art. Also 1981, 1979. Catalogues.

1982
Zeitgeist, Martin-Gropius-Bau, West Berlin. Catalogue with foreword by Christos Joachimides and Norman Rosenthal.

Documenta VII, Kassel. Catalogue.

1981
Westkunst—Heute: Zeitgenössische Kunst seit 1939, Museen der Stadt Köln. Catalogue by Laszlo Glozer.

1980
La Biennale di Venezia, United States Pavilion. Catalogue.

Sounds of the World with Chattering Man, 1985
sound and mixed media
installation by Jonathan Borofsky with Ed Tomney
(see catalogue supplement)
Collection of the artist, courtesy of Paula Cooper Gallery, New York

1976
New York—Downtown Manhattan: Soho, Akademie der Künste, West Berlin (traveled to Louisiana Museum, Humlebaek, Denmark).

1969
557,087, Seattle Art Museum (traveled to Vancouver Art Gallery as *955,000).*

No. 7, Paula Cooper Gallery, New York.

1963
Fifty-third Annual Exhibition of Associated Artists of Pittsburgh, Museum of Art, Carnegie Institute.

Selected Bibliography

Christopher Knight, "The Visible Man," *Flash Art* (March 1985).

Eric Gibson, "The Borofsky Spectacle," *The New Criterion* (February 1985).

Mark Rosenthal, in *Art of Our Time: The Saatchi Collection,* vol. 4 (London, 1984).

Katherine Howe, "I Can Never Quite Get Too Direct . . . Jon Borofsky, An Interview," *Images and Issues* (May/June 1984).

Barbara Rose, "The Maximal Art of Jonathan Borofsky," *Vogue* (April 1984).

Richard Francis, "Exhibition Reviews," *Burlington Magazine* (February 1984).

Mark Rosenthal, "The Ascendance of Subject Matter and a 1960's Sensibility," *Arts Magazine* (June 1982).

Paul Groot, "The Running Man Jon Borofsky: Op weg naar een Boeddhaachtig Figuur," *Museumsjournaal* XXVI, 1 (1981).

John Russell, "Art: Transformations of Jonathan Borofsky," *New York Times,* 24 October 1980.

Michael Klein, "Jon Borofsky's Doubt," *Arts Magazine* (November 1979).

David Bourdon, "Discerning the Shaman from the Showman," *The Village Voice,* 4 July 1977.

Morgan Thomas, "Jon Borofsky's Dream Language," *Artweek,* 23 April 1977.

Jeffrey Deitsch, "Before the Reason of Images: The New Work of Jon Borofsky," *Arts Magazine* (October 1976).

John Russell, "Jon Borofsky, Paula Cooper Gallery," *New York Times,* 15 October 1976.

Lucy R. Lippard, "Jonathan Borofsky at 2,096,974," *Artforum* (November 1974).

———, "557,087," *Artforum* (November 1969).

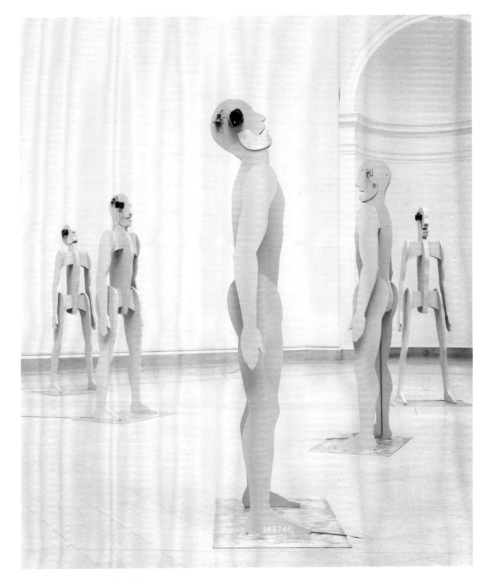

20 Chattering Men (detail), 1984
aluminum, wood, primer, bondo, electric motor
82 ½ x 23 x 13 in. (209.6 x 58.4 x 33 cm.), each
Installation view at San Francisco Museum of
Modern Art, 1984
(not in exhibition)

Scott Burton

Born 1939, Greensboro, Alabama
Lives and works in New York

My work for this exhibition is a set of six polished granite seating modules. It may be located either indoors or outside. The six parts may be arranged in any combination, including contiguous combinations, but this is a single work whose parts are meant to be kept together: the modularity is important to me. The module itself has a symmetrical profile: that is, the seat and the back of the chair look identical in the side view. This is the latest work in my series, a loose one from the last five or so years, of geometric granite furniture.

Selected One-Artist Exhibitions

1985
Max Protetch Gallery, New York. Also 1982, 1981.

1984
McIntosh-Drysdale Gallery, Houston.

1983
Contemporary Arts Center, Cincinnati, and Fort Worth Art Museum (traveled to Walker Art Center, Minneapolis; Contemporary Arts Museum, Houston). Catalogue with text by Charles F. Stuckey.

1982
Daniel Weinberg Gallery, Los Angeles. Also 1980.

1980
University Art Museum, University of California, Berkeley (performance). Brochure.

1977
Droll/Kolbert Gallery, New York.

1976
The Solomon R. Guggenheim Museum, New York (performance). Brochure by Linda Shearer.

1975
Artists Space, New York.

1972
Whitney Museum of American Art, New York (performance, repeated at American Theater Lab, New York).

1971
Finch College, New York (performance).

Selected Group Exhibitions

1984
An International Survey of Recent Painting and Sculpture, The Museum of Modern Art, New York. Catalogue by Kynaston McShine.

1983
Konstruierte Orte: 5 X D + 1 X NY, Kunsthalle, Bern.
New Art at the Tate Gallery, 1983, The Tate Gallery, London. Catalogue by Michael Compton.

1982
Documenta VII, Kassel. Also 1977, *VI* (performance). Catalogues.

1981
Developments in Recent Sculpture, Whitney Museum of American Art, New York. Catalogue by Richard Marshall.
Biennial Exhibition, Whitney Museum of American Art, New York. Also 1975. Catalogues.

1978
Young American Artists: 1978 Exxon National Exhibition, The Solomon R. Guggenheim Museum, New York. Catalogue by Linda Shearer.

1976
New York—Downtown Manhattan: Soho, Akademie der Künste, West Berlin (traveled to Louisiana Museum, Humlebaek, Denmark). Catalogue by Werner Duttmann and Lucy Lippard.

1970
Two Evenings, University of Iowa Museum of Art, Iowa City (performance).

Selected Bibliography

Phyllis Tuchman, in *Art of Our Time: The Saatchi Collection,* vol. 4 (London, 1984).

Paula Tyler, "Scott Burton: An Essay on Chairs," *Artweek,* 22 October 1983.

Donald Kuspit, "Reviews: Scott Burton, Max Protetch Gallery," *Artforum* (March 1983).

Peter Schjeldahl, "Scott Burton Chairs the Discussion," *The Village Voice,* 1 June 1982.

John Russell, "Chairs by Scott Burton and Others," *New York Times,* 21 May 1982.

John Romine, "Scott Burton: Interview," *Upstart* (May 1981).

Roberta Smith, "Scott Burton: Designs on Minimalism," *Art in America* (November/December 1978).

John Howell, "Acting/Non-Acting: Interview with Scott Burton," *Performance Art Magazine* (1978).

Robert Pincus-Witten, "Scott Burton: Conceptual Performance as Sculpture," *Arts Magazine* (September 1976).

Carter Ratcliff, "Reviews," *Artforum* (March 1976).

Edit de Ak and Walter Robinson, "An Article on Scott Burton in the Form of a Resumé," *Art-Rite* (Winter 1975).

Scott Burton, "Make a Political Statement," *Art-Rite* (Summer 1974).

John Perreault, "A Dance of Silent Victims," *The Village Voice* 27 April 1972.

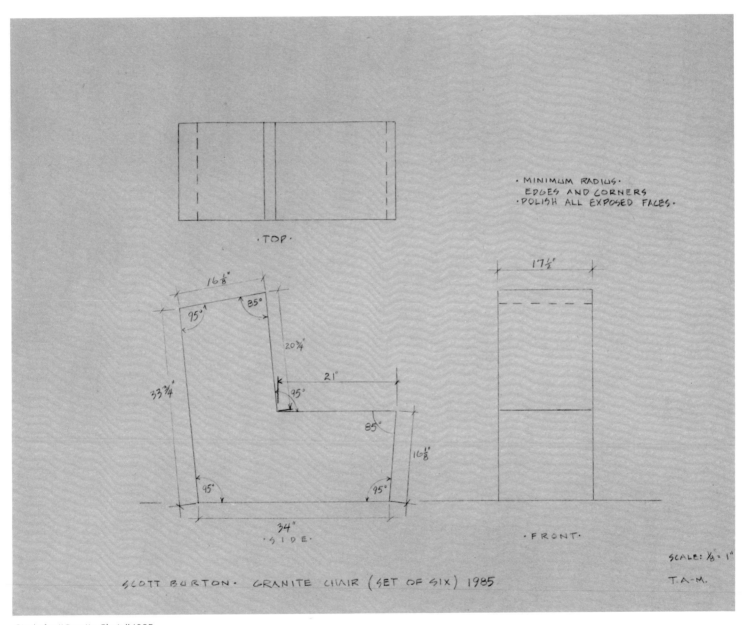

Study for "Granite Chair," 1985
blueprint
Collection of the artist, courtesy of Max Protetch
Gallery, New York

Granite Chair (Set of Six), 1985
imperial red granite
37 ½ x 17 ½ x 39 ½ in. (95.3 x 44.5 x 100.3 cm.)
(see catalogue supplement)
Collection of Mellon Bank, courtesy of Max
Protetch Gallery, New York

Francesco Clemente

Born 1952, Naples
Lives and works in Rome, Madras, and New York

In any work you do it goes like breathing, like accumulating and spending. Years ago, the accumulation for me was a flow, like a flood of drawings. Continuous, nonstop, one line going and going and going. So I was building dams, conventional frames to stop this flood of images, and the moment the images were framed, they started to flower, and to show themselves in an almost pleasant way.[1]

If you go to buy a newspaper, it's never the same thing, but it's always the same sentence. In your language it's always the same, but for your body it's not always the same. The paintings relate to the language of the body. The language of images probably relates more to all the ideas that have not the brain as a center, but the world. Paintings make propaganda for the environment against the brain.[2]

I've done innumerable works while traveling. Half of my work has been done in hotels, courtyards, terraces. . . . My best shows are the ones I've put on in airports, for customs agents at four in the morning, after an eight-hour flight.[3]

I carry inside of me the idea that it's better to be many than one, that many gods are better than just one god, many truths are better than one alone.[4]

What I'm interested in is just to travel through mythology. I fall back again and again on images which belong to some mythology. The way it goes is just not to know about any, and to have faith in the possibility of the tradition of art to give truthfulness to any image you come across.[5]

I like to imagine that style is the weight, exactly that weight which all the different fragments of what one is exert on what one is not, but nevertheless is there, and is firm.[6]

As the years go by one becomes more conscious of how one is made, but it becomes less desirable to explore one's makeup; what I mean is that the problem becomes one of knowing as little as possible, of doing, without knowing what one is doing. Naturally, the older one gets, the harder it becomes not to know.[7]

Eroticism and humor aren't held hostage by an age, whereas ideas are.[8]

The ordinary way I work is really to put myself in a condition of difficulty, as far as possible from what I know—to challenge your own gravity, to jump knowing you're to fall back again. It's a way to look at your own stupidity and machine-like way of working. The ordinary life is to be in love again and again with the same woman, with the same situation. It is a matter of melancholy, no? You could live everything just once and you keep living everything like a dozen times and don't see why. With painting it goes the other way; every time you are taken back to your own self, your own image, there is a feeling of beauty.[9]

I think, as I've said again and again, that there's a moment of grace, and that everything else is an obstacle, a repetition, a hunger.[10]

Excerpts from interviews with Francesco Clemente. Reprinted from: (1) Edit de Ak, "Francesco Clemente," *Interview* (April 1982): 68–70. (2) Whitechapel Art Gallery, London, *Francesco Clemente* (1983), exh. cat. by Mark Francis (unpublished notes). (3) Giancarlo Politi, "Francesco Clemente," *Flash Art* (April/May 1984): 12–21. (4) Giancarlo Politi. (5) Robin White, "Francesco Clemente," *View* (Oakland: Point Press, 1981). (6, 7, 8) Giancarlo Politi. (9) Whitechapel Art Gallery. (10) Giancarlo Politi. Used by permission.

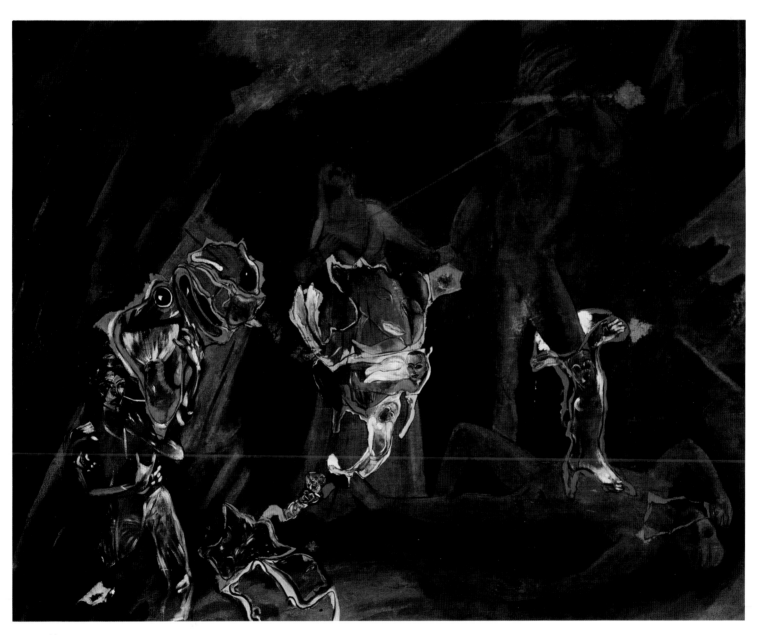

My World War III, 1983—84
oil on canvas
138 x 174 in. (350.5 x 442 cm.)
Collection of Lewis and Susan Manilow

Francesco Clemente

Selected One-Artist Exhibitions
1985
Sperone Westwater Gallery, New York. Also 1983, 1981 (traveled to Mary Boone Gallery, New York, also 1983; and Leo Castelli Gallery, New York).

1984
Nationalgalerie, West Berlin (traveled to Museum Folkwang, Essen; Stedelijk Museum, Amsterdam; Kunsthalle, Tübingen, Federal Republic of Germany).

1983
Whitechapel Art Gallery, London (traveled to Groninger Museum, Groningen; Badischen Kunstverein, Karlsruhe; Moderna Museet, Stockholm; Galerie d'Art Contemporain des Musées de Nice). Catalogue by Mark Francis, ed.

1982
Galerie Paul Maenz, Cologne. Catalogue with essay by Rainer Crone. Also 1980, 1979, 1978.

1981
University Art Museum, University of California, Berkeley.

1980
Galleria Gian Enzo Sperone, Rome. Also 1976, 1975.

1979
Galleria Gian Enzo Sperone, Turin. Catalogue. Also 1978, 1975.

Galleria Emilio Mazzoli, Modena. Catalogue by Achille Bonito Oliva. Also 1978.

1978
Art and Project, Amsterdam. Catalogue. Also 1980. Centre d'Art Contemporain, Geneva.

1974
Galleria Area, Florence.

1971
Galleria Valle Giulia, Rome.

Selected Group Exhibitions
1985
Biennale de Paris. Catalogue.

1984
An International Survey of Recent Painting and Sculpture, The Museum of Modern Art, New York. Catalogue by Kynaston McShine.

1983
New Art at the Tate Gallery, 1983, The Tate Gallery, London. Catalogue by Michael Compton.

1982
Zeitgeist, Martin-Gropius-Bau, West Berlin. Catalogue with foreword by Christos Joachimides and Norman Rosenthal.

Documenta VII, Kassel. Catalogue.

1981
Westkunst—Heute: Zeitgenössische Kunst seit 1939, Museen der Stadt Köln. Catalogue by Laszlo Glozer.

1980
7 junge Künstler aus Italien, Kunsthalle, Basel (traveled to Museum Folkwang, Essen; Stedelijk Museum, Amsterdam). Catalogue by Jean Christophe Ammann, ed.

La Biennale di Venezia.

1975
Bienal de São Paulo.

1973
Italy Two, Civic Center Museum, Philadelphia.

Selected Bibliography
Allen Ginsberg and Francesco Clemente, *The White Shroud* (Madras, 1984).

Giancarlo Politi, "Francesco Clemente," *Flash Art* (April/May 1984).

Rainer Crone, Zdenek Felix, and Lucius Grisebach, *Francesco Clemente, Pastelle 1974–1983* (Munich, 1984).

Heiner Bastian, "Samtale med Francesco Clemente," *Louisiana Revy* (June 1983).

Thomas Lawson, "Reviews: Francesco Clemente," *Artforum* (Summer 1983).

Mel Gooding, "Francesco Clemente," *Arts Review* (January 1983).

Carter Ratcliff, "On Iconography and Some Italians," *Art in America* (September 1982).

Edit de Ak, "Francesco Clemente," *Interview* (April 1982).

Danny Berger, "Francesco Clemente at The Metropolitan: An Interview," *The Print Collector's Newsletter* (March/April 1982).

Cathy Curtis, "Straddling Grace and Decadence," *Artweek,* 12 September 1981.

Edit de Ak, "A Chameleon in a State of Grace," *Artforum* (February 1981).

Francesco Clemente, *Chi pinge figura, si non puo' esser lei non la puo' porre* (Adyar, India, 1980).

Achille Bonito Oliva, *La Transavanguardia Italianna* (Milan, 1980).

Jean Christophe Ammann, Paul Groot, Pieter Heynen, and Jan Zumbrink, "Un altre art?" *Museumjournaal* (December 1980).

Robert Pincus-Witten, "Entries: If Even in Fractions," *Arts Magazine* (September 1980).

Untitled, 1984
oil on canvas
107 7/8 x 187 13/16 in. (274 x 477 cm.)
Courtesy of Thomas Ammann Fine Art, Zurich

Untitled, 1985
oil on canvas
117 x 133 in. (297.2 x 337.8 cm.)
Collection of Mr. and Mrs. Richard C. Hedreen,
courtesy of Sperone Westwater, New York

Enzo Cucchi

Born 1950, Morro d'Alba, Italy
Lives and works in Ancona

CANZONE. **One can establish profound things in the material components of the work. They say it is useless to reason with the head. Then we'll reason with the elbow (again), but only when we quicken our "rhythm" step. The sounds of things. There are many spirits in the air and many shadows on things, it is art that summons and beckons. The old lie can no longer burst into art.**

Now on earth the whole gravity of central Italy, dear friends, burns and perspires and kneads the air with closed mouth.

Excerpts from Enzo Cucchi, *Canzone* (Modena: Emilio Mazzoli Editore, 1979). Reprinted from *La ceremonia delle cose. Texts by Enzo Cucchi 1975–1985* (New York: Peter Blum Edition, forthcoming). Used by permission.

Selected One-Artist Exhibitions

1984
Mary Boone/Michael Werner Gallery and Sperone Westwater Gallery, New York. Also 1983, 1981.

1983
Stedelijk Museum, Amsterdam (traveled to Kunsthalle, Basel). Catalogue.

1982
Kunsthaus, Zurich (traveled to Groninger Museum, Groningen). Catalogue by Ursula Perucchi.

Museum Folkwang, Essen. Catalogue by Zdenek Felix.

1981
Galerie Paul Maenz, Cologne. Catalogue with statements by Diego Cortez and Enzo Cucchi.

Galeria Emilio Mazzoli, Modena. Catalogue. Also 1979 (catalogue by Achille Bonito Oliva and Enzo Cucchi).

1980
Kunsthalle, Basel (traveled to Museum Folkwang, Essen; Stedelijk Museum, Amsterdam). Catalogue.

1977
Galleria Luigi De Ambrogi, Milan.

Selected Group Exhibitions

1984
Quartetto, L'Academia Foundation, Venice. Catalogue with essays by Achille Bonito Oliva, Alanna Heiss, and Kasper König.

7000 Eichen, Kunsthalle, Tübingen, Federal Republic of Germany. Catalogue by Heiner Bastian.

1982
Zeitgeist, Martin-Gropius-Bau, West Berlin. Catalogue with forward by Christos Joachimides and Norman Rosenthal.

Avanguardia/Transavanguardia, Mura Aureliane, Rome. Catalogue by Achille Bonito Oliva.

Documenta VII, Kassel. Catalogue.

Italian Art Now: An American Perspective, The Solomon R. Guggenheim Museum, New York. Catalogue by Diane Waldman with essay by Lisa Dennison.

1981
Westkunst—Heute: Zeitgenössische Kunst seit 1939, Museen der Stadt Köln. Catalogue by Laszlo Glozer.

1980
La Biennale di Venezia.

1979
Bienal de São Paulo.

Tre o Quattro Artisti Secchi, Galleria Emilio Mazzoli, Modena. Catalogue with essays by Achille Bonito Oliva, Sandro Chia, and Enzo Cucchi.

Selected Bibliography

Grace Glueck, "Art: Apocalyptic Vision of Cucchi's Paintings," *New York Times,* 16 November 1984.

Enzo Cucchi, et al., "Guilio Cesare Roma!" *Parkett* (April 1984).

Giancarlo Politi and Helena Kontova, "Enzo Cucchi," *Flash Art* (February/March 1984).

———, "Interview with Enzo Cucchi," *Flash Art* (November 1983).

Zdenek Felix, "Bilder des Staunens: Kraft der Imagination bei Enzo Cucchi," *Kunstmagazin* XXII, 5–6 (1983).

Hjort Oystein, "Firhaendigt med historien," *Louisiana Revy* (June 1983).

Theodore F. Wolff, "A Revised View of Some Recent European Art—Thanks to Enzo Cucchi," *Christian Science Monitor,* 22 March 1983.

René Payant, "Ces formes qui ironisent, à propos de Sandro Chia et d'Enzo Cucchi," *Art Press* (March 1982).

Jean-Christophe Ammann, "Westkunst: Enzo Cucchi," *Flash Art* (Summer 1981).

Carrie Rickey, "Reviews," *Artforum* (December 1980).

Achille Bonito Oliva, *La Transavanguardia Italianna* (Milan, 1980).

William Zimmer, "Italians Iced," *Soho Weekly News,* 8 October 1980.

Thomas Lawson, "Reviews," *Flash Art* (November 1980).

Robert Pincus-Witten, "Entries: If Even in Fractions," *Arts Magazine* (September 1980).

Un quadro di fuochi preziosi, 1983
oil on canvas
117 ⅜ x 153 ½ in. (298 x 390 cm.)
Collection of Gerald S. Elliott

Enzo Cucchi

Vitebsk-Harar, 1985
oil on canvas with iron element
96 x 217 x 17 in. (243.8 x 551.2 x 43.2 cm.)
Collection of PaineWebber Group Inc.

Giorno gonfio, 1985
oil on canvas
118⅛ x 70⅞ in. (300 x 180 cm.)
(see catalogue supplement)
Courtesy of Sperone Westwater, New York

Richard Deacon

Born 1949, Bangor, Wales
Lives and works in London

In September, 1978 I went on a trip to the States; throughout the period before I left, I had been growing increasingly dissatisfied with my sculpture. When I arrived in America, I found I had no facilities available for making sculpture, and so I turned to drawing. I became interested in the notion of a non-rectilinear geometry—in my mind there were ideas of using a thin wall, a skin, an enclosure, an opening. I began to work on drawings, by starting at the centre of the paper, creating geometric figures, for example a square, diamond, rectangle or circle. I then used this figure as the basis for constructing a network of spirals, moving a series of curves around to try and clear the centre and to build up from there. I was qualifying what are quite harsh shapes by retaining the tracery of earlier possibilities—these acted like construction lines, like a map which locates the drawing on the paper. I eventually became concerned with pictorial departures, the relationship between image and reflection, form and shadow, perspectival illusions. I found at the same time, I was drawing in anticipation of making a sculpture.

Whilst making the drawings I had been reading extensively the poetry of Rilke, and the lines came to represent elements of his poetry. I was particularly interested in his transformation of objects, the way they stand for other things. Unlike symbolist poetry, where objects seem to be seen more in a two dimensional, illusory way, the objects that appear in Rilke's poetry, whilst taking on connotations, retain the quality of actuality. Working on the drawings a number of associations sprang to mind. The most obvious specific reference was to an Orpheus figure, or a singing or listening head, the aperture within the enclosure, functioning either as mouth or ear—other connotations were emblem, shield, container, vessel, eye, flower, fruit, shoes, hats, hands. I suppose there is a degree of implicit sexuality in a number of these forms. How conscious, I don't know—I certainly became interested in the concept of containers, and the inherent sexual reference.

For a while, ceramics, making pots, seemed an obvious next step, but I found them too opaque, too recognisable. What I did eventually, was to start using some thin strips of wood I had around the studio for a long time. The process of laminating became extremely interesting to me. It seems to have an affinity, however tenuous, with the process of metaphor, that I found in Rilke's poetry. It also enabled me to work with a form without making prior structural decisions, about the nature of the shape I might arrive at subsequently. It is a very low technology business—I don't have to become overtly structural.

Reprinted from Institute of Contemporary Arts, London, *Objects and Sculpture* (1981), exh. cat. Used by permission.

Selected One-Artist Exhibitions

1985
Margarete Roeder Fine Arts, New York.

Donald Young Gallery, Chicago.

The Tate Gallery, London. Brochure with essay by Richard Francis.

Le Centre International du Verre d'Aix-en-Provence.

1984
Chapter Arts Center, Cardiff. Fruitmarket Gallery, Edinburgh (traveled to Le Nouveau Musée, Lyon). Catalogue with essay by Michael Newman.

1983
Lisson Gallery, London.

Orchard Gallery, Londonderry. Catalogue by Lynne Cooke.

1981
Sheffield City Polytechnic Gallery.

1980
The Gallery, Acre Lane, London. Also 1978.

1976
Royal College of Art Galleries, London. Also 1975.

Selected Group Exhibitions

1985
Biennale de Paris. Catalogue.

The British Show (organized by The British Council; traveled to Art Gallery of Western Australia, Perth; Art Gallery of New South Wales, Sydney; Queensland Art Gallery, Brisbane; National Gallery of Victoria, Melbourne). Catalogue by Simon Wilson.

1984
Exhibition of Candidates for the First Annual Turner Prize, The Tate Gallery, London.

The British Art Show, (organized by Arts Council of Great Britain; traveled to City Museum and Art Gallery, Ikon Gallery, Birmingham; Royal Scottish Academy, Edinburgh; Mappin Art Gallery, Sheffield; Southampton Art Gallery).

Skulptur im 20 Jahrhundert, Merian Park, Basel.

An International Survey of Recent Painting and Sculpture, The Museum of Modern Art, New York. Catalogue by Kynaston McShine.

1982
Objects and Figures: New Sculpture in Britain, Fruitmarket Gallery, Edinburgh. Catalogue by Michael Newman.

Englische Plastik Heute/British Sculpture Now, Kunstmuseum, Lucerne. Catalogue with introduction by Martin Kunz and essay by Michael Newman.

1981
Objects and Sculpture, Institute of Contemporary Arts, London (traveled to Arnolfini Gallery, Bristol). Catalogue by Lewis Biggs and Sandy Nairne, eds., with interview by Iwona Blaszczyck.

1970
New Arts Lab, London (performance with Clive Walters and Ian Kirkwood).

Selected Bibliography

Lynne Cooke, in *Art of Our Time: The Saatchi Collection,* vol. 4 (London, 1984).

Richard Deacon, *Stuff Box Object* (London, 1984).

Michael Newman, "Le spectacle de la mélancolie dans la consommation de masse: signification et objectifs dans la sculpture Britannique actuelle," *Artistes 18* (1984).

Nena Dimitrijevic, "Sculpture after Evolution," *Flash Art International* (April/May 1984).

William Feaver, "Sculptural Mutations," *London Observer,* 12 February 1984.

Waldemar Januszczak, "Richard Deacon," *Manchester Guardian,* 7 February 1984.

Michael Newman, "Discourse and Desire, Recent British Sculpture," *Flash Art International* (January 1984).

Lynne Cooke, "Reconsidering the New Sculpture," *Artscribe 42* (1983).

Michael Newman, "Figuren en Objecten," *Museum Journal 2* (1983).

Lynne Cooke, "Richard Deacon," *Art Monthly* (March 1983).

Martin Kunz, "Neue Skulptur am Beispiel Englischer Künstler," *Kunst Bulletin* (June 1982).

Caryn Faure-Walker, "Interview with Richard Deacon," *Aspects* (Winter 1982).

Mark Francis, "Objects and Sculpture," *Art Monthly* (July/August 1981).

Lewis Biggs, "Objects and Sculpture," *Arnolfini Review* (May 1981).

Lynne Cooke, "Richard Deacon at The Gallery, Brixton," *Artscribe* (November 1980).

Richard Deacon, "Notes on a Piece of Sculpture," *Journal from the Royal College of Art 1* (1976).

Richard Deacon

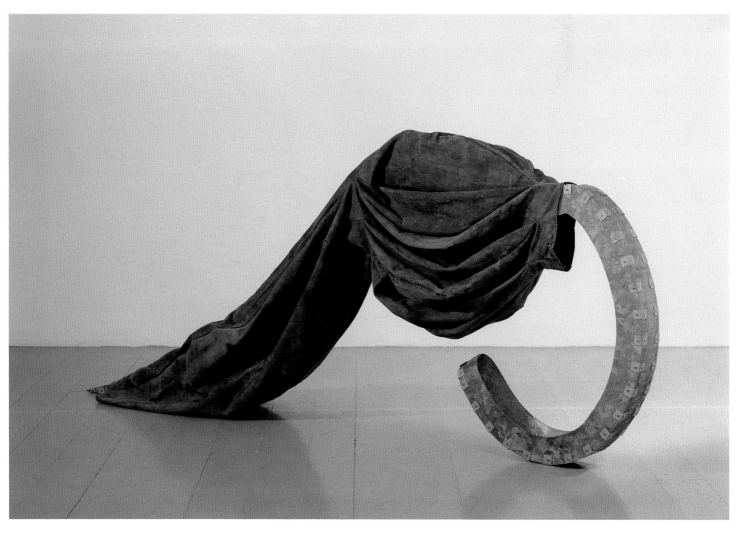

On the Face of It, 1984
galvanized steel and canvas
34 x 82 x 12 in. (86.4 x 208.3 x 30.5 cm.)
Collection of the artist

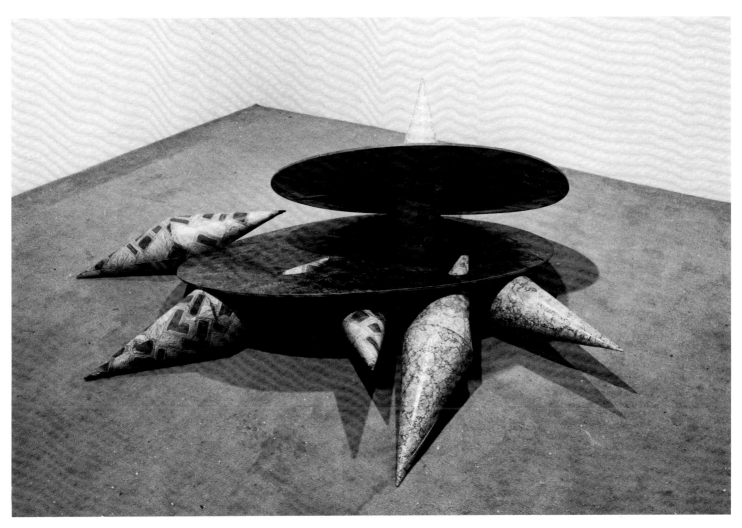

Boys and Girls, 1982
lino and plywood
36 x 72 ¹⁄₁₆ x 60 ¹⁄₁₆ in. (91.5 x 183 x 152.5 cm.)
The British Council, London

Fruit, 1985
laminated wood and galvanized steel
39 x 192 x 96 in. (99.1 x 487.7 x 243.8 cm.)
(see catalogue supplement)
Courtesy of Lisson Gallery, London and Marian
Goodman Gallery, New York

Jan Dibbets

Born 1941, Weert, The Netherlands
Lives and works in Amsterdam

Selected One-Artist Exhibitions
1983
Leo Castelli Gallery, New York. Also 1978, 1973.

1981
Galerie Konrad Fischer, Düsseldorf. Also 1977, 1974, 1973, 1971, 1968.

1980
Stedelijk Van Abbemuseum, Eindhoven (traveled to Kunsthalle, Bern; Musée d'Art Moderne de la Ville de Paris). Catalogue by Rudi Fuchs.

Galerie Yvon Lambert, Paris. Catalogue by Suzanne Page, Marcel Vos, and Carole Naggar. Also 1977, 1974, 1972, 1970.

1976
Edinburgh Scottish Arts Council Gallery. Catalogue by Barbara Reise and Marcel Vos.

1975
Art and Project, Amsterdam. Also 1973, 1972 (bulletin by Jan Dibbets), 1971 (bulletin), 1969 (bulletin).

1972
La Biennale di Venezia, Dutch Pavilion. Catalogue by Rudi Fuchs.

Stedelijk Museum, Amsterdam. Catalogue by Edy de Wilde, Rini Dippel, and Marcel Vos.

1971
Stedelijk Van Abbemuseum, Eindhoven. Catalogue by Rudi Fuchs and J. Leering.

1969
Museum Haus Lange, Krefeld. Catalogue by Paul Wember.

Selected Group Exhibitions
1983
Bienal de São Paulo.

1982
'60–'80 : Attitudes/Concepts/Images, Stedelijk Museum, Amsterdam. Catalogue.

Documenta VII, Kassel. Also 1972, V. Catalogues.

1980
Andre, Dibbets, Long, Ryman, Louisiana Museum, Humlebaek, Denmark.

1979
Biennale of Sydney.

1977
Europe in the Seventies: Aspects of Recent Art, The Art Institute of Chicago (traveled to Hirshhorn Museum and Sculpture Garden, Smithsonian Institution, Washington, D.C.; San Francisco Museum of Modern Art; Fort Worth Art Museum; Contemporary Arts Center, Cincinnati). Catalogue with essays by Jean-Christophe Ammann, David Brown, and B. H. D. Buchloh.

1974
Eight Contemporary Artists, The Museum of Modern Art, New York. Catalogue by Jennifer Licht.

1972
'Konzept'-Kunst, Kunstmuseum, Basel.

1971
Guggenheim International Exhibition 1971, The Solomon R. Guggenheim Museum, New York.

1970
Tokyo Biennale.

1967
Serielle Formationen, Universität Frankfurt.

Selected Bibliography
Marjorie Welish, "Jan Dibbets at Castelli," Art in America (November 1983).

Richard Shone, "London, Dibbets and van Elk," Burlington Magazine (April 1982).

Micky Piller, "Jan Dibbets, Van Abbemuseum, Eindhoven," Artforum (May 1980).

Hugh Adams, "Jan Dibbets and Richard Long, Arnolfini Gallery," Studio International (January 1977).

Kunstmuseum, Lucerne, Jan Dibbets: Autumn Melody, (1975), exh. cat. by Jean-Christophe Ammann.

Bruce Boice, "Jan Dibbets: The Photograph and the Photographed," Artforum (April 1973).

Marcel Vos, "Some Work of Jan Dibbets," Flash Art (January 1973).

Rudi Fuchs, "Modes of Visual Experience: New Works by Jan Dibbets," Studio International (January 1973).

Barbara Reise, "Notes[1] on Jan Dibbets's[2] Contemporary[3] Nature[4] of Realistic[5] Classicism[6] in the Dutch[7] Tradition[8]," Studio International (June 1972).

Charlotte Townsend, "Jan Dibbets in Conversation with Charlotte Townsend," Artscanada (August/September 1971).

Carel Blotcamp, "Notities over het werk van Jan Dibbets," Museumjournaal (July 1971).

"Interview with Jan Dibbets," Avalanche (Fall 1970).

Zentrum für Aktuelle Kunst, Aachen, Jan Dibbets (1970), exh. cat. by Klaus Honnef.

Jan Dibbets, Robin Redbreast's Territory/Sculpture 1969 (Cologne, 1970).

Hans Strelow, "Jan Dibbets," Studio International (July/August 1970).

Jan Dibbets, Ecologic Systems (New York, 1965).

San Casciano Ceiling (Triptych), 1982–84
color photographs, pencil, watercolor, acrylic and
wax crayon on paper mounted on wood
73 x 72 ½ in. (185.8 x 184 cm.), each panel
Collection of the artist, courtesy of Waddington
Galleries Ltd, London

Jiři Georg Dokoupil

Born 1954, Krnov, Czechoslovakia
Lives and works in Cologne, New York, and Tenerife

I am interested in art. That is, I know for certain that I will invest art with all my energy, with all my mind, with the last cell of my body.... And I believe that that is certainly more real, more vital than the talk of art as life. To live the art as art is my concern. . . .

Any type of motivation, of inner mandate—as for example "to reform the world" or "to expose dishonesty" and so on—is all the same to the pictures. They must stand on their own, in a self-contained world, which does not stand above something but next to it, next to reality. Again and again one must come to terms with this contradiction. So in opposition to all attempts to tie up art, one must insist on its independence and when its uselessness is asserted, one must emphasize the responsibility that pictures have as pictures. . . .

Seek the contradiction in the work itself. It is, I believe, really not only the perspective which changes, which presupposes a fixed point of view, but the entire person: "I slip into another role and am that then," I said once. What changes is perhaps the total attitude, the proximity, the warmth, and the coldness of the pictures. . . .

This knowledge is present, these concepts are present, these reflections are present in the back of the mind. But to begin painting expressively and figuratively three years ago, and to paint pictures of nature today, means opposing these laws, means to *play* with them, to exaggerate them, to displace them.

Even something like a religious picture presupposes the devotion to the inner inspiration: a sunset is great; to sit on a boat and to look down on the ocean is great; deeply tanned people who play on the beach are terrific. And I mean the whole thing simply the way it is. And the pictures from Spain you mentioned were an attempt to subject myself to these impressions without ulterior motive, without retractions—as for example, "You are permitted that, if no one watches you": the attempt also to approach nature completely naively, and to paint it, as if all this baggage did not exist. This is an enormous wish.

Excerpts from an interview with Jiři Georg Dokoupil by W. W. Dickhoff. Reprinted from *Wolkenkratzer Art Journal* (November/December 1983): 6, 9–10. Translated by Annegreth T. Nill. Used by permission.

Selected One-Artist Exhibitions
1985
Galerie Paul Maenz, Cologne. Also 1984, 1983, 1982 (catalogue).

1984
Museum Folkwang, Essen (traveled to Kunstmuseum, Lucerne; Groninger Museum, Groningen; Espace Lyonnais d'Art Contemporain, Lyon). Catalogue.

Groninger Museum, Groningen. Catalogue with text by Frans Haks, Wilfried W. Dickhoff, Walter Dahn, and Jiři Georg Dokoupil.

1983
Mary Boone Gallery, New York.

Produzentengalerie, Hamburg

Traveled to Galerie Paul Maenz, Cologne; Galerie Six Friederich, Munich). Catalogue.

1982
Galerie Helen van der Meij, Amsterdam.

Galerie Chantal Crousel, Paris.

Galerie 't Venster, Rotterdam.

Selected Group Exhibitions
1985
Biennale de Paris. Catalogue.

1984
Von Hier Aus, Messegelände, Düsseldorf. Catalogue by Kasper König.

ROSC, A Poetry of Vision, Guinness Hop Store, Dublin. Catalogue.

An International Survey of Recent Painting and Sculpture, The Museum of Modern Art, New York. Catalogue by Kynaston McShine.

1983
Mülheimer Freiheit Proudly Presents The Second Bombing, Fruitmarket Gallery, Edinburgh and Institute of Contemporary Arts, London. Catalogue by Wolfgang Max Faust and Jiři Georg Dokoupil.

1982
La Biennale di Venezia.

Zeitgeist, Martin-Gropius-Bau, West Berlin. Catalogue with foreword by Christos Joachimides and Norman Rosenthal.

Documenta VII, Kassel. Catalogue.

12 Künstler aus Deutschland, Kunsthalle, Basel, and Museum Boymans-van Beuningen, Rotterdam. Catalogue by Jean-Christophe Ammann.

1981
Nieuwe Duitse Kunst I—Mülheimer Freiheit, Groninger Museum, Groningen. Catalogue by Franz Haks and Wolfgang Max Faust.

1980
Auch wenn das Perlhuhn leise weint, Hahnentorburg, Cologne.

Selected Bibliography
Stephan Schmidt-Wulffen, "Georg Dokoupil—Folkwang Museum, Essen, Maenz, Cologne," *Flash Art* (January 1985).

"Jiři Georg Dokoupil—Two Letters from the Artist's Mother," *Flash Art* (January 1985).

Axel Hecht, "Axel Hecht im Gespräch mit Jiři Georg Dokoupil," *Art* (August 1984).

Jeannot L. Simmen, "Paraphrases or Key Pictures," *Flash Art* (Summer 1984).

Leo van Damme, "The Modernist Reaction: The Unilateral Misunderstanding," *Arte Factum* (February 1984).

Klaus Honnef, "Zwischenbilanz II—Neue Deutsche Malerei," *Kunstforum International* (December 1983).

Wolfgang Max Faust, "Gemeinschaftsbilder—Ein Aspekt der neuen Malerei," *Kunstforum International* (November 1983).

Wilfried W. Dickhoff, "Das letzte Abenteuer der Menschheit," *Wolkenkratzer* (November/December 1983).

Rainer Crone, "Jiři Georg Dokoupil: The Imprisoned Brain," *Artforum International* (March 1983).

Jeannot L. Simmen, "New Painting in Germany," *Flash Art* (November 1982).

Donald B. Kuspit, "Acts of Aggression: German Painting Today," *Art in America* (September 1982).

Wolfgang Max Faust and Gerd de Vries, *Hunger nach Bildern: Deutsche Malerei der Gegenwart* (Cologne, 1982).

———, "Mülheimer Freiheit," *Flash Art* (December 1981/January 1982).

Alfred Nemeczek, "Malerei '81—Die Sache mit den Wilden," *Art* (October 1981).

Peter Iden, "Die hochgemuten Nichtskönner," *Kunstwerk* XXXIV, 6 (1981).

Bildnis eines toten jungen Wissenschaftlers, 1982
dispersion on canvas
78 ¾ x 78 ¾ in. (200 x 200 cm.)
Private collection, courtesy of Galerie
Paul Maenz, Cologne

Jiři Georg Dokoupil

Die zwei Fische, 1984
synthetic resin and paint on canvas
110¼ x 78¾ in. (280 x 200 cm.)
Private collection, courtesy of Galerie
Paul Maenz, Cologne

Ohne Titel, 1982
dispersion on canvas
116⅛ x 116⅛ in. (295 x 295 cm.)
Private collection, courtesy of Galerie
Paul Maenz, Cologne

Ohne Titel (Grünspan Serie I), 1985
verdigris on burlap
47 ¼ x 57 ¹⁄₁₆ in. (120 x 145 cm.)
Private collection, courtesy of Galerie
Paul Maenz, Cologne

Jiří Georg Dokoupil

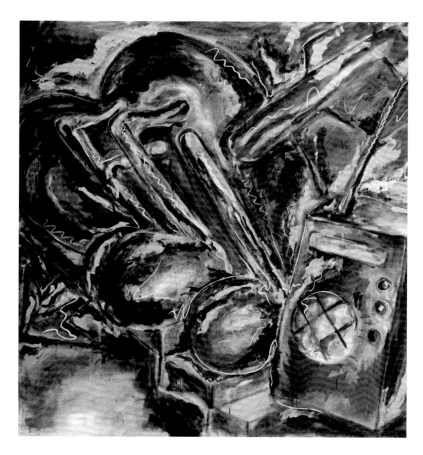

Blaue Bilder über die Liebe, II: Liebe mit
Musik, 1982
dispersion on canvas
90⁹⁄₁₆ x 90⁹⁄₁₆ in. (230 x 230 cm.)
Collection of Gerd de Vries, Cologne

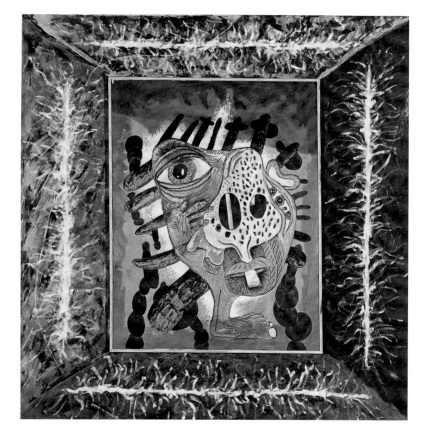

Befehle des Barock, II: Der schöne Konsul—
Da versperrte ihm der Vollmond den Blick
ins Universum, 1982
dispersion on canvas
90⁹⁄₁₆ x 90⁹⁄₁₆ in. (230 x 230 cm.)
Private collection, courtesy of Galerie
Paul Maenz, Cologne

Luciano Fabro

Born 1936, Turin
Lives and works in Milan

(When the word "art" is mentioned, the term "figurative" rings like a subterranean chord. Is that how it is with you?)

Perhaps it is so because, like conquered territory, it is no longer necessary to mention it. The writer without question is an artist; so is the poet, the musician . . . but when we say "artist" we mean one who works through the figure. If we think in the sense of "arts" on the one hand, and of something having to do with the figure on the other, we see that I am more constricted here than in other types of arts. Art is the capacity to modify natural conditions according to one's objectives. Figurative art is nature modified; its objective is to give a new shape to nature. The artist is the one who extends nature by creating another being in addition to those natural ones which exist and propagate themselves on their own accord.

(Today, the figure has once more made itself recognized. How do you track it down within your own images?)

Above all, one needs to make a distinction between figuration and representation. Figuration is the way of *conforming* to a thing itself. We link it to other things through analogy, not through similarity or resemblance; it is a thing in itself. Representation, which has returned, or which has been the fashion in these past years, is a reconstruction of images, a taking up again of figures in motion, but subject and argument remain outside the work. It is a little like photography, which represents something that, nonetheless, must exist somewhere else.

For me, representation does not stay outside. The problem must be evaluated in these terms: not in respect to what is there, but to what has come to be missing. If you think of the art now in circulation, or the art that has been in circulation, it has always managed to represent ideas—or, better, it always represented cultural objectives. Many times, in fact, we give weight and value to works that don't themselves have ideas but find them through the cultural objectives given to them, or through the people who aspire to find a meaning in them. The problem of light and technique in Impressionism, that of Futurist dynamics,

that of the Dadaist object, do not necessarily have intrinsic ideas, but rather certain objectives which serve to unmask, reveal, purify, and open up the work's horizons.

(However, once complete, they turn into the ideas of their time.)

Yes, but there can also be some non-ideas, absences of idea which have an aspect of a cultural journey, but remain apart from it. What made me think that works were being created that were just so much uncommitted space, was the very complaint that they required some internal accounting. To enter into dialogue, to give and listen to responses, was practically a duty. When in some product we insert elements which *per se* put into play—into discussion—our analogous relationship with them—as can be when I confront something—this places upon us an attitude less neutral, less speculative. The work becomes revealing, and we become revealing along with the object.

(But the work of art, as the one thing that explains a world, always proposes questions and so obligations for dialogue, even if these are not written out.)

If we make a parallel between writing and artwork, we can say that writing normally uses this strategy: it creates an ambiance and a fantasy for you; while you read you are immersed in that fantasy. With the work of art, not so. In front of a canvas, in front of a sculpture, confronted with an environment, with an ambiance, you never think of being outside your world. You are always with your feet on the ground; you are not to slip; you are to walk attentively. What happens? From your seat, from your space, from your portion of pavement you watch and judge; this is sufficient. But it could actually be that the thing you have in front of you judges you. When the thing we look at judges us, then we truly can call it "figuration," for it renders real, it puts into existence another being like us.

(It gives form to a being that finds its own life in the way you describe . . . but it doesn't replicate anything; is that it?)

Yes. It is a large distinction and everyone, with a bit of attention, can create this first experience. When we go into a museum, we pass before many works: "This is lovely; this isn't. This doesn't interest me. . . . " Then, a work rivets us. There are no saints; we can't say "oh, how beautiful"; the work looks at us and rivets us. There we have found this first aspect of figuration.

(So for you, the figure is a being that comes across as if observing you.)

Yes.

(And in what way do you approach it? With what instruments and words do you open the dialogue?)

If you proceed in the direction of a work to be judged, you will be the judge. You construct it according to a structure, according to a role, which is not necessarily that of illustration; that of idea and form also exist. But it is different when you propose to construct something that actually assumes the role of illustration. You no longer work in the direction of judging, but of continually perfecting a state of expectation.

When we give to objects a location, an order, we always make it outside us; we tend to assume the role of judge. We are the fixed element, it the mobile element—this is true—but it has a limit: at times we happen to move around. Now then, to give stability to things, to permit ourselves to move, we have to give those things an entity, a joint aspect to us—frozen, really—and create a very icy, burdened situation. That is, we have to render great autonomy, great expectation about the thing in itself. This is also called "quality." But it is at fault in implying that nothing has been expected from us, that we have been able to give nothing to it, and therefore have not been able to encounter ourselves.

Excerpts from an interview with Luciano Fabro by Francesca Pasini. Reprinted from *L'Illustrazione Italiana* 26 (September 1985), annotated by the artist. Translated by Diana Strazdes. Used by permission.

Selected One-Artist Exhibitions

1984
Galerie Paul Maenz, Cologne. Also 1978.

1983
Neue Galerie, Aachen.

Logetta Lombardesca, Ravenna. Catalogue by Jole De Sanna.

1981
Museum Folkwang, Essen, and Museum Boymans-van Beuningen, Rotterdam. Catalogue by Zdenek Felix, ed.

1980
Galleria Christian Stein, Turin. Also 1975 (catalogue).

Salvatore Ala Gallery, New York.

1977
Framart Studio, Naples. Catalogue by Luciano Fabro and A. Izzo.

1974
Galleria Notizie, Turin. Also 1971, 1969, 1968 (catalogue by M. Vertone), 1967.

Salle Patino, Geneva. Catalogue.

1973
Galleria Arte Borogna, Milan. Catalogue.

1965
Vismara Arte Contemporanea, Milan.

Selected Group Exhibitions

1985
The European Iceberg: Creativity in Germany and Italy Today, Art Gallery of Ontario, Toronto. Catalogue by Germano Celant.

1984
An International Survey of Recent Painting and Sculpture, The Museum of Modern Art, New York. Catalogue by Kynaston McShine.

1983
Werke aus der Sammlung FER, Museum Folkwang, Essen. Catalogue by Christel Sauer.

New Art at The Tate Gallery, 1983, The Tate Gallery. Catalogue by Michael Compton.

1982
Documenta VII, Kassel. Also 1972, V. Catalogues.

'60–'80: Attitudes/Concepts/Images, Stedelijk Museum, Amsterdam. Catalogue.

Avanguardia/Transavanguardia, Mura Aurelianeda, Rome. Catalogue by Achille Bonita Oliva.

1981
Identité Italienne: L'Art en Italie depuis 1959, Musée National d'Art Moderne, Centre Georges Pompidou, Paris. Catalogue by Germano Celant.

1971
New Italian Art 1953–1971, Walker Art Gallery, Liverpool.

1967
Italian Contemporary Art, Museum of Modern Art, Tokyo (traveled to Museum of Modern Art, Kyoto).

Selected Bibliography

Saskia Bos, " 'De Statua,' Stedelijk Van Abbemuseum," *Artforum* (October 1983).

Renate Puvogel, "Kunstpreis Aachen: Luciano Fabro," *Kunstwerk* (September 1983).

Paul Groot, "Luciano Fabro, Museum Boymans-van Beuningen," *Artforum* (March 1982).

Jole De Sanna, "Luciano Fabro, Una Città di 60 Giorni," *Domus* (February 1982).

Paul Winter, "Luciano Fabro, Sehnsucht," *Kunstwerk* XXXIV, 4 (1981).

Luciana Rogozinski, "Luciano Fabro, Galleria Christian Stein," *Artforum* (February 1981).

B. Risso, *Luciano Fabro* (Turin, 1980).

L. L. Ponti, "Tempo tendenze paura dell Arte: Intervista con Luciano Fabro," *Domus* (March 1980).

"Io di Luciano Fabro," *Domus* (June 1978).

Luciano Fabro, *Attaccapanni* (Turin, 1978).

L. L. Ponti, "Luciano Fabro: Attaccapanni, bronzi, colori e musiche a Napoli," *Domus* (June 1977).

Tommaso Trini, "Luciano Fabro, Galleria Borgogna," *Domus* (June 1971).

Germano Celant, *Arte Povera* (Milan, 1969).

C. Lonzi, "Intervista con Luciano Fabro—Discorsi," *Marcatré* (April 1966).

*Study for 1985 Carnegie International
Installation*, 1985
pencil on paper
(see catalogue supplement)
Courtesy of the artist

La Germania, 1984
flame-cut steel, electric lamp, lamp post,
and sandbags
112 ³⁄₁₆ x 383 ⁷⁄₈ x 69 ¹¹⁄₁₆ in. (285 x 975 x
177 cm.), overall
Installation view at Art Gallery of Ontario,
Toronto, 1985
(not in exhibition)

Eric Fischl

Born 1948, New York
Lives and works in New York

For me, painting is the process by which I return my thoughts to feelings.

A Brief History of North Africa, 1985
oil on linen
88 x 120 in. (223.5 x 304.8 cm.)
Courtesy of Mary Boone Gallery, New York

Selected One-Artist Exhibitions
1985
Mendel Art Gallery, Saskatoon, Saskatchewan (traveled to Stedelijk Van Abbemusuem, Eindhoven; Kunsthalle, Basel; Institute of Contemporary Arts, London; Art Gallery of Ontario, Toronto; Museum of Contemporary Art, Chicago; Broida Museum, New York). Catalogue with foreword by Linda Milrod and essays by Jean-Christophe Ammann, Donald B. Kuspit, and Bruce W. Ferguson.
1984
Mary Boone Gallery, New York. Catalogue with essays by Robert Rosenblum, Christopher Knight, and Mario Diancono.
1983
Galleria Mario Diancono, Rome.
1982
Sable-Castelli Gallery, Toronto. Also 1981.

University of Colorado Art Galleries, Boulder.

Edward Thorpe Gallery, New York. Also 1980, 1981.
1980
Emily H. Davis Art Gallery, University of Akron. Catalogue.
1978
Galerie B., Montreal. Also 1976.
1976
Studio, Halifax.
1975
Dalhousie Art Gallery, Halifax.

Selected Group Exhibitions
1985
Biennale de Paris. Catalogue.

Biennial Exhibition, Whitney Museum of American Art, New York. Also 1983. Catalogues.
1984
Ouverture, Castello Di Rivoli, Turin.

The Human Condition: SFMMA Biennial III, San Francisco Museum of Modern Art. Catalogue with essays by Dorothy Martinson, Wolfgang Max Faust, Achille Bonito Oliva, Klaus Ottman, and Edward Kienholz.

La Biennale di Venezia.

An International Survey of Contemporary Painting and Sculpture, The Museum of Modern Art, New York. Catalogue by Kynaston McShine.
1983
American Still Life: 1945–1983, Contemporary Arts Museum, Houston (traveled to Albright-Knox Art Gallery, Buffalo; Columbus Museum of Art; Neuberger Museum, State University of New York, Purchase; Portland Art Museum, Portland, Oregon). Catalogue.

Tendencias en Nueva York, Palacio de Velázquez, Madrid (traveled to Fundació Joan Miró, Barcelona; Musée du Luxembourg, Paris). Catalogue by Carmen Gimenez.

Back to the USA: Amerikanische Kunst der Siebziger und Achtziger, Kunstmuseum, Lucerne (traveled to Rheinisches Landesmuseum, Bonn; Württembergischer Kunstverein, Stuttgart). Catalogue by Klaus Honnef.
1978
Neun Kanadische Künstler, Kunsthalle, Basel.

Selected Bibliography
John Yau, "Eric Fischl," *Artforum* (February 1985).

Kim Levin, in *Art of Our Time: The Saatchi Collection,* vol. 4 (London, 1984).

Robert Storr, "Desperate Pleasures," *Art in America* (November 1984).

Roberta Smith, "Eric Fischl," *The Village Voice,* 30 October 1984.

Grace Glueck, "Eric Fischl," *New York Times,* 12 October 1984.

Peter Schjeldahl, "Bad Boy of Brilliance," *Vanity Fair* (May 1984).

Kevin Robbins, "Eric Fischl," *Upstart* (1984).

Lisa Liebmann, "Eric Fischl's Year of the Drowned Dog," *Artforum* (March 1984).

Donald Kuspit, "Eric Fischl's America Inside Out," *C* (Winter 1984).

Kate Linker, "Eric Fischl: Involuted Narratives," *Flash Art* (January 1984).

Carter Ratcliff, "Expressionism Today: An Artists' Symposium," *Art in America* (December 1982).

Roberta Smith, "Everyman's Land," *The Village Voice,* 26 October 1982.

Patrick Kelley, "Eric Fischl: Paintings and Drawings," *Dialogue: The Ohio Arts Journal* (September/October 1980).

Robert Pincus-Witten, "Entries: Palimpsest and Pentimenti," *Arts Magazine* (June 1980).

Hans Van Jürg Kupper, "Metaphysik des Alltälichen," *Baseler Zeitung,* 11 June 1978.

John Chandler, "Seventeen Artists: A Protean View," *Artscanada* (October/ November 1976).

Eric Fischl

Dog Days, 1983
oil on canvas
84 x 168 in. (213.4 x 426.7 cm.)
Collection of Tom and Charlotte Newby

Imitating the Dog (Mother and Daughter II), 1984
oil on canvas
96 x 84 in. (243.8 x 213.4 cm.)
Collection of Hugh Freund and Alan Flacks

Barry Flanagan

Born 1941, Prestatyn, Wales
Lives and works in London

These stone carvings were made in Pietrasanta near Lucca, Italy. The models were achieved in clay; rolled, manipulated and pressed. The local stone was chosen, rather than fine marble, as it generally conformed to the figuration of the raw clay. They are then simple likenesses, unignited by any fire to interrupt that fidelity.

Selected One-Artist Exhibitions

1985
Waddington Galleries, London. Catalogue. Also 1983, 1981 (catalogue), 1980 (catalogue by Catherine Lampert).

1983
Pace Gallery, New York. Catalogue by Michael Compton.

Musée National d'Art Moderne, Centre Georges Pompidou, Paris. Catalogue with introduction by Dominique Bozo and Bryan Swingler and essays by Catherine Lampert and Bernard Blistene.

1982
La Bienale di Venezia, British Pavilion (traveled to Museum Haus Esters, Krefeld; Whitechapel Art Gallery, London; Liliane and Michel Durand-Dessert, Paris). Catalogue by Michael Compton and Tim Hilton.

1981
Mostyn Art Gallery, Llandudno, Wales (traveled to Southampton Art Gallery; Institute of Contemporary Arts, London). Catalogue by Catherine Lampert.

1979
Art and Project, Amsterdam. Also 1977, 1975.

1977
Stedelijk Van Abbemuseum, Eindhoven (traveled to Arnolfini Gallery, Bristol; Serpentine Gallery, London). Catalogue with essay by Catherine Lampert and preface by Rudi Fuchs.

1974
The Museum of Modern Art, New York.

Museum of Modern Art, Oxford.

Rowan Gallery, London. Also 1973, 1972, 1971, 1970, 1968, 1966.

1969
Museum Haus Lange, Krefeld. Catalogue by Paul Wember.

Selected Group Exhibitions

1983
New Art at the Tate Gallery, 1983, The Tate Gallery, London. Catalogue by Michael Compton.

Ars 83 Helsinki, Ateneumin Taidemuseo, Helsinki. Catalogue.

1982
Documenta VII, Kassel. Catalogue.

British Sculpture in the 20th Century, Part 2: Symbol and Imagination 1951–1980, Whitechapel Art Gallery, London.

1980
Après le Classicisme, Musée d'Art et d'Industrie, Saint-Etienne. Catalogue by Jacques Beauffet, D. Semin, and Anne Dary-Bossut.

1978
Made by Sculptors, Stedelijk Museum, Amsterdam. Catalogue.

1975
Biennale de Paris. Also 1967. Catalogues.

1974
Within the Decade, The Solomon R. Guggenheim Museum, New York.

1973
Henry Moore to Gilbert & George—Modern British Art from the Tate Gallery, Palais des Beaux Arts, Brussels. Catalogue.

1972
The New Art, Hayward Gallery, London. Catalogue with essay by Michael Compton.

1968
British Artists: 6 painters, 6 sculptors, The Museum of Modern Art, New York. Catalogue.

Selected Bibliography

Jeanne Silverthorne, "Barry Flanagan, Pace Gallery," *Artforum* (March 1984).

Lisa Peters, "Barry Flanagan," *Arts Magazine* (January 1984).

John Glaves-Smith, "Barry Flanagan: The Role of Parody and Irony," *Art Monthly* (July/August 1982).

Catherine Lampert, "Barry Flanagan," *Artistes* (December 1979/January 1980).

Peter Fuller, "Barry Flanagan," *Arts Review* (July 1973).

John Russell, "The Pleasures of the Pioneer," *New York Times*, 15 July 1973.

Peter Fuller, "Barry Flanagan," *Connoisseur* (January 1973).

Rudi Fuchs, "More on the New Art," *Studio International* (November 1972).

Peter Schjeldahl, "And Now a 'Teddy' for the Artist?", *New York Times*, 17 October 1971.

Gene Baro, "Sculpture Made Visible," *Studio International* (October 1969).

Charles Harrison, "Barry Flanagan's Sculpture," *Studio International* (May 1968).

Anthony Fawcett, "Eye-liners. Some Leaves from Barry Flanagan's Notebook," *Art and Artists* (April 1968).

Barry Flanagan, "British Artists at the Biennale des Jeunes in Paris," *Studio International* (September 1967).

Gene Baro, "British Sculpture: The Developing Scene," *Studio International* (October 1966).

Untitled, 1984
stone
34 x 29 x 34 in. (86.4 x 73.7 x 86.4 cm.)
Collection of Mr. and Mrs. Stanley R. Gumberg

Barry Flanagan

Carving No. 1, 1983
marble
30¾ x 59½ x 28¼ in. (78 x 151.1 x 72 cm.)
Collection of the artist, courtesy of Waddington
Galleries Ltd, London

Untitled, 1984
stone
36 x 41 x 20 in. (91.4 x 104.1 x 50.8 cm.)
Collection of the artist, courtesy of Waddington
Galleries Ltd, London

Lucian Freud

Born 1922, Berlin
Lives and works in London

I get ideas for my pictures from watching the people I hope to work from naked and clothed, moving, still and asleep. It's rather like wild-life photography—by one of the animals.

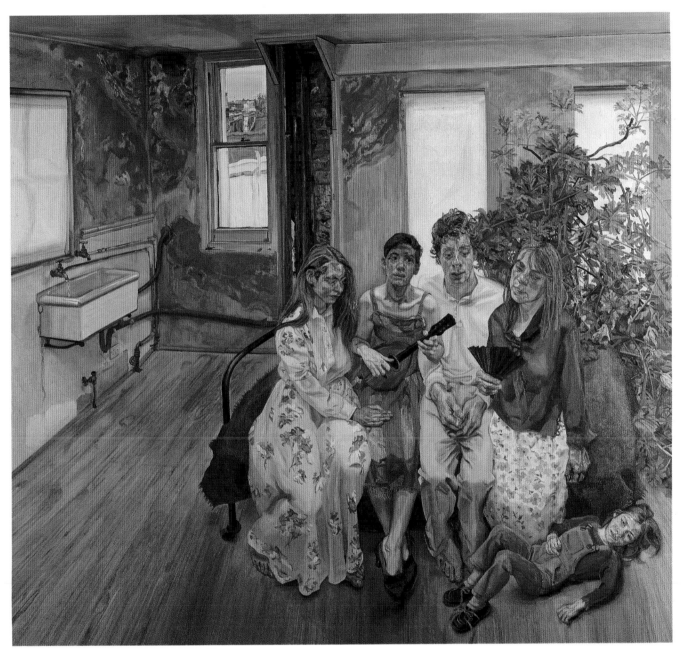

Large Interior, W.11. (after Watteau), 1981–83
oil on canvas
73 x 78 in. (185.4 x 198.1 cm.)
Collection of James Kirkman

Lucian Freud

Selected One-Artist Exhibitions
1982
Anthony d'Offay Gallery, London. Also 1978 (traveled to Davis and Long Company, New York), 1972 (traveled to Gray Art Gallery, Hartlepool).
1979
Nishimura Gallery, Tokyo.
1977
The Tate Gallery, London.
1974
Hayward Gallery (organized by Arts Council of Great Britain; traveled to Bristol City Art Gallery; Birmingham City Museum and Art Gallery; Leeds City Museum and Art Gallery). Catalogue by John Russell.
1968
Marlborough Fine Art, London. Also 1963 (catalogue), 1958.
1952
Hanover Gallery, London. Also 1950.
1947
London Gallery, London.
1944
Lefevre Gallery, London.

Selected Group Exhibitions
1985
The British Show (organized by The British Council; traveled to Art Gallery of Western Australia, Perth; Art Gallery of New South Wales, Sydney; Queensland Art Gallery, Brisbane; National Gallery of Victoria, Melbourne). Catalogue by Simon Wilson.
1982
Aspects of British Art Today, Metropolitan Art Museum, Tokyo (toured Japan). Catalogue.
1981
8 Figurative Painters, Yale Center for British Art, New Haven. Catalogue.
A New Spirit in Painting, Royal Academy of Arts, London. Catalogue by Christos Joachimides, Norman Rosenthal, and Nicholas Serota, eds.
1977
British Painting 1952–1977, Royal Academy of Arts, London. Catalogue. The Tate Gallery, London.
1975
European Painting in the Seventies, Los Angeles County Museum of Art. Catalogue.
1954
La Biennale di Venezia, British Pavilion.
1951
21 Modern British Painters, Vancouver Art Gallery.
1948
La Jeune Peinture en Grand Bretagne, Galerie René Drouin, Paris.

Selected Bibliography
Michael Peppiatt, "Lucian Freud, à l'interieur d'une oeuvre," *Connaissance des Arts* (March 1984).

————, "Lucian Freud," *Art International* (January-March 1983).

Edward B. Henning, "New Paintings by Four Artists from Britain," *Cleveland Museum Bulletin* (December 1982).

Jeffrey Weiss, "Eight Figurative Painters," *Arts Magazine* (February 1982).

Lawrence Gowing, *Lucian Freud* (London, 1982).

Edward Lucie-Smith, "Lucian Freud," *Art and Artists* (April 1978).

John Gruen, "The Relentlessly Personal Vision of Lucian Freud," *Art News* (April 1977).

John Rothenstein, *Modern English Painters,* vol. 3 (London, 1976).

Maurice Tuchman, "European Painting in the Seventies," *Art & Artists* (November 1975).

Robert Melville, "The Eve They Have Painted," *Architectural Review* (March 1974).

Peter Fuller, "In the Galleries: Lucian Freud," *Connoisseur* (April 1974).

William Feaver, "Lucian Freud," *London Sunday Times Magazine,* 3 February 1974.

John Russell, "Lucian Freud—Clairvoyeur," *Art in America* (January/February 1971).

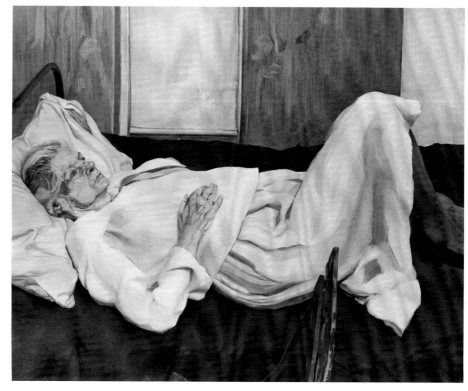

The Artist's Mother, 1983–84
oil on canvas
40½ x 50¼ in. (102.9 x 127.6 cm.)
Collection of James Kirkman

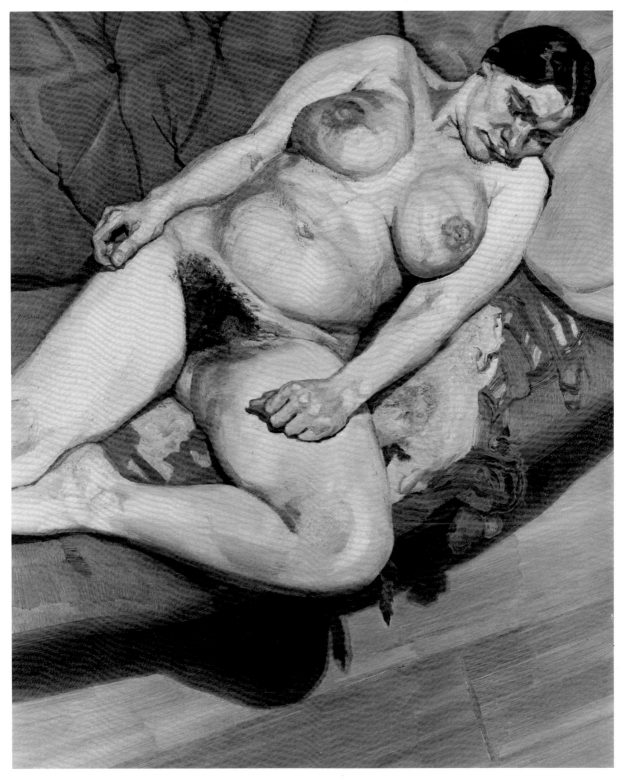

Naked Portrait II, 1980–81
oil on canvas
35½ x 29½ in. (90.2 x 74.9 cm.)
Private collection

Lucian Freud

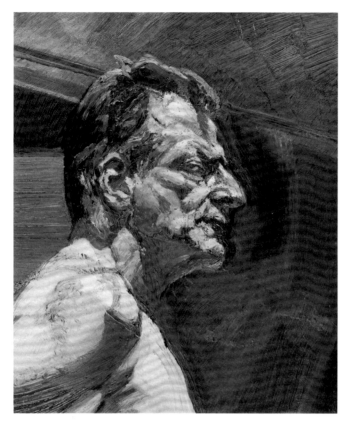

Reflection—Self Portrait, 1981–82
oil on canvas
12 x 10 in. (30.5 x 25.4 cm.)
Private collection

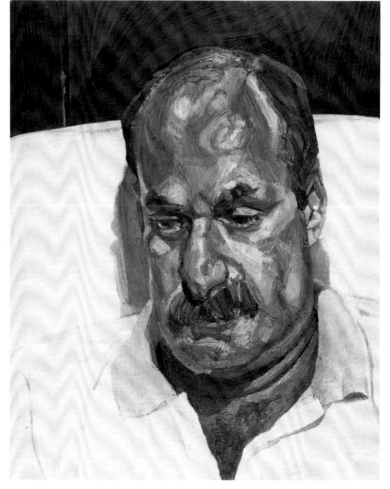

Man in a Sports Shirt, 1982–83
oil on canvas
20 x 16 in. (50.8 x 40.6 cm.)
Collection of Irving Tyndell

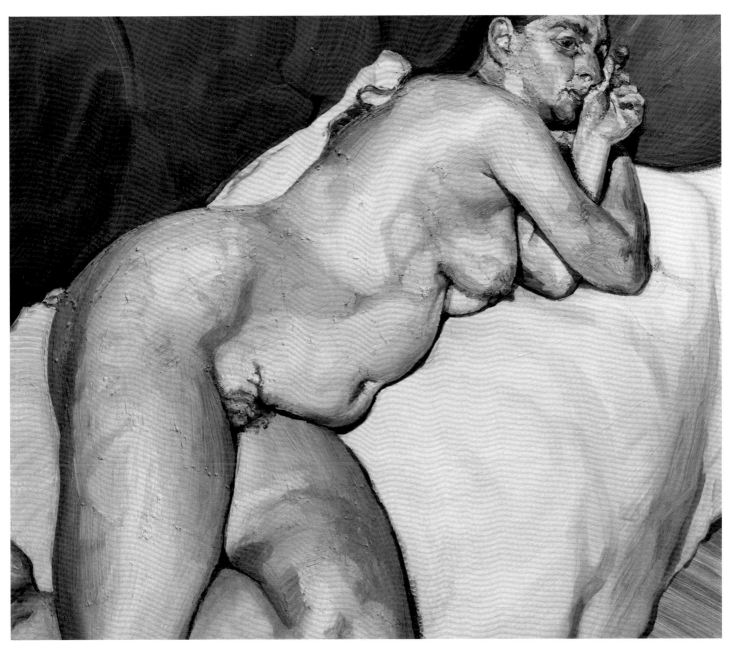

Naked Woman on Sofa, 1984—85
oil on canvas
20 x 23 ¾ in. (50.8 x 60.3 cm.)
Collection of James Kirkman

Gilbert and George

Born 1943, Dolomites, Italy Born 1942, Devon
Lives and works in London Lives and works in London

You can also say that, within the person, when we are working, we have our brain, our soul, and our sex. These are the three things that we work with. Sometimes we do a picture more for sex, sometimes more for our brain and sometimes more for our spirit, and it is always within a combination of these three that we work. The whole of civilization continues because of those three driving work forces.

They change every day. It is all based on morality. Morality is changing every single day, from new thoughts. And we believe that is art—morality and art.

There is a general belief in Western society that it is good to improve civilization. Everybody believes more or less that they are trying to do that. And if you don't do that, if you try to do the opposite, then you go to prison. That comes from Christ, from Christ's teaching. The fact that Jesus died on the cross, that is the example that made everybody build banks, commerce, education, law, monarchy, the military. Everything comes from that one example of that one dying man.

We are interested in all culture, but the basis of our civilization is that way. We cannot become Muslim, we are not interested to change our nature, we are working within a framework, a tradition. The idea of a picture is roughly Western tradition. It hardly exists in other cultures. Fine art didn't even exist until the twentieth century. Until the nineteenth century, fine art equals dead Jesus. That's all they had, they just worked for the church, more or less.

There is no division between ourselves and our production. The division that exists for normal artists doesn't exist for us. There is a different relationship. Normally you have an artist who makes some strange sculptures, then he goes to a restaurant and has dinner with his wife and some friends. That is a different idea from ours. Or you have an artist who does some very clear, very soft beautiful pictures and in the evening he is completely drunk in the pub. That is a different idea. We and our work are completely together. This house, this studio, our lives, and these pictures and our viewers—the whole thing is one big object—all based around ourselves to promote an idea and we think that is art—change the world with our intellect.

Excerpts from "Gilbert & George, Life, a great sculpture" dialogue with Adachiara Zevi. Reprinted from *AEIUO* (July 1984): 52–94. Used by permission.

Selected Exhibitions

1985
Sonnabend Gallery, New York. Also 1983, 1978, 1971.

1984
Baltimore Museum of Art (traveled to Contemporary Arts Museum, Houston; The Norton Art Gallery, West Palm Beach; Milwaukee Art Museum; The Solomon R. Guggenheim Museum, New York). Catalogue by Brenda Richardson.

Anthony d'Offay Gallery, London. Also 1982, 1980.

1982
Gewad, Ghent.

1980
Art and Project, Amsterdam, 1980. Also 1977, 1974, 1971, 1970.

Stedelijk Van Abbemuseum, Eindhoven (traveled to Kunsthalle, Düsseldorf; Kunsthalle, Bern; Musée National d'Art Moderne, Centre Georges Pompidou, Paris, with published interview by Jean-Hubert Martin; Whitechapel Art Gallery, London, with published interview by Mark Francis). Catalogue by Carter Ratcliff.

1976
Albright-Knox Art Gallery, Buffalo.

1972
Konrad Fischer Gallery, Düsseldorf. Also 1970.

Kunstmuseum, Lucerne (living sculpture presentation). Publication: Gilbert and George; *The Grand Old Duke of York.*

1971
Whitechapel Art Gallery, London (traveled to Stedelijk Museum, Amsterdam; Kunstverein, Düsseldorf, publication: Gilbert and George *The Paintings;* Kon Museum voor Schone Kunsten, Antwerp).

1969
Frank's Sandwich Bar, London. Also 1968.

Selected Group Exhibitions

1985
The British Show (organized by The British Council; traveled to Art Gallery of Western Australia, Perth; Art Gallery of New South Wales, Sydney; Queensland Art Gallery, Brisbane; Royal Exhibition Building, Melbourne, Catalogue by Simon Wilson.

1982
Zeitgeist, Martin-Gropius-Bau, West Berlin. Catalogue with foreword by Christos Joachimides and Norman Rosenthal.

Documenta VII, Kassel. Also 1977, *VI;* 1972, *V.* Catalogues.

1981
British Sculpture in the 20th Century, Whitechapel Art Gallery, London.

Westkunst—Heute: Zeitgenössische Kunst seit 1939, Museen der Stadt Köln. Catalogue by Laszlo Glozer.

1978
La Biennale di Venezia.

1977
Europe in the Seventies: Aspects of Recent Art, The Art Institute of Chicago (traveled to Hirshhorn Museum and Sculpture Garden, Smithsonian Institution,

Washington, D.C.; San Francisco Museum of Modern Art; Fort Worth Art Museum; Contemporary Arts Center, Cincinnati). Catalogue with essays by Jean-Christophe Ammann, David Brown, and B. H. D. Buchloh.

1973
From Henry Moore to Gilbert & George—Modern British Art from the Tate Gallery, Palais des Beaux Arts, Brussels. Catalogue.

1972
The New Art, Hayward Gallery, London. Catalogue with interview by Anne Seymour.

1970
Conceptual Art, Arte Povera, Land Art, Civic Gallery of Modern Art, Turin.

1969
Conception, Städtisches Museum, Leverkusen.

Selected Bibliography

John Russell, "The High Aesthetic Style of Gilbert & George," *House and Garden* (July 1985).

Douglas C. McGill, "Two Artists Who Probe the Meaning of Life," *New York Times,* 5 May 1985.

Patrick Frey, "Gilbert & George in der Fremdheit ihrer Welt," *Jahresbericht des Basler Kunstvereins, Kunsthalle Basel 1982* (February 1983).

Robert Becker, "Art: London's Living Sculpture, Gilbert & George," *Interview* (August 1983).

Roberta Smith, "Gilbert & George's Modern Faith," *The Village Voice,* 17 May 1983.

John McEwen, "Life and Times: Gilbert & George," *Art in America* (May 1982).

Alberto Moravia, "Ma che belle Statuine," *L'Espresso,* 1 January 1982.

Elisabeth Rona, "Interview: Gilbert & George," *+ − 0 Revue d'Art Contemporain* (October 1981).

Ted Castle, "Gilbert & George Arrive Beyond Alcohol and Sex," *Art Monthly* (November 1980).

Carter Ratcliff, "Down and Out with Gilbert & George," *Art in America* (May/June 1978).

Rudi Fuchs, "Gilbert & George," *Art Monthly* (April 1977).

Carter Ratcliff, "The Art and Artlessness of Gilbert & George," *Arts Magazine* (January 1976).

Carel Blotkamp, "Gilbert & George: on Cooperation, on Tradition," in *Album Amicorum J. G. van Gelder* (Nijhoff, The Netherlands, 1973).

Germano Celant, "Gilbert & George," *Domus* (March 1972).

Gilbert & George, *Side by Side* (Cologne, 1971).

———, *A Guide to the Singing Sculpture* (London, 1970).

———, *The Pencil on Paper Descriptive Works* (London, 1970).

Ger van Elk, "We Would Honestly Like to Say How Happy We Are to Be Sculptors," *Museumjournaal* (October 1969).

Drunk with God, 1983
photo-piece
191 x 438 in. (485 x 1112 cm.)
Courtesy of Anthony d'Offay Gallery, London

Howard Hodgkin

Born 1932, London
Lives and works in London and Wiltshire

Most of my pictures have had nine, ten, twelve lives. But there's a marvellous sentimental remark in Muriel Spark's new book, where she says for an artist time can always be regained, wonders never cease. And of course it's true, because of an act of imagination you can always go back. Because when a picture of mine is going wrong it's when it's losing its meaning. But one can go back to the subject. That's the one thing I can do or the one thing I would claim I can do—I mean, even to the extent of going back to some love affair of long ago, or something like that. And, because for obvious reasons it was long ago and all gone and so on, the picture might well then be almost completely dead and finished with. To turn it into a picture, one has to go back to the original feeling and then start making new bricks or rather new choices of bricks to build it up again. Somebody once said to me that I always claimed that my pictures were about feelings, whereas he thought they were always resolved in terms of the picture, in terms of pictorial language and in terms of the physical object. And he's quite right, because they are pictures and they have to be resolved in those terms. But the impetus for that resolution comes from the feeling, which is what they're about. And if I've succeeded, I've turned the original feeling, emotion, or whatever you like to call it, into an autonomous pictorial object, which I look at in exactly the same way you do. I once described finishing a painting to somebody as where— this is obviously talking of an ideal situation— the picture is somewhere hovering in mid-air between myself and the spectator so that it looks as strange or as interesting or whatever to me as it does to any other spectator.

Excerpts from "Howard Hodgkin Interviewed by David Sylvester." Reprinted from Whitechapel Art Gallery, London, *Howard Hodgkin: Forty Paintings 1973–84* (1984), exh. cat., 98–99. Used by permission.

Selected One-Artist Exhibitions

1984
Phillips Collection, Washington, D.C., and Whitechapel Art Gallery, London (traveled to *La Biennale di Venezia*, British Pavilion; Yale Center for British Art, New Haven; Kestner-Gesellschaft, Hanover). Catalogue with introduction by John McEwen and interview by David Sylvester.

M. Knoedler & Co., Inc., New York. Also 1982, 1981 (catalogue with essay by Lawrence Gowing).

1982
The Tate Gallery, London. Catalogue by Michael Compton.

1977
Museum of Modern Art, Oxford (traveled to Elizabeth House Museum, Great Yarmouth). Catalogue by Penelope Marcus.

1976
Museum of Modern Art, Oxford (traveled to Serpentine Gallery, London; Turnpike Gallery, Leigh; Laing Art Gallery, Newcastle-upon-Tyne; Aberdeen Art Gallery, Aberdeen; Graves Art Gallery, Sheffield). Catalogue by Richard Morphet.

1975
Arnolfini Gallery, Bristol. Also 1970.

1971
Kasmin Gallery, London. Also 1969.

1967
Arthur Tooth & Sons, London. Catalogue. Also 1964 (catalogue), 1962 (catalogue with introduction by Edward Lucie-Smith).

Selected Group Exhibitions

1984
An International Survey of Recent Painting and Sculpture, The Museum of Modern Art, New York. Catalogue by Kynaston McShine.

1983
Acquisition Priorities: Aspects of Postwar Painting in Europe, The Solomon R. Guggenheim Museum, New York.

1980
John Moores' Liverpool Exhibition, Walker Art Gallery, Liverpool. Catalogue.

1979
The Artist's Eye, National Gallery, London. Catalogue.

1977
British Artists of the Sixties from the Collections of the Tate Gallery, The Tate Gallery, London.

British Painting 1952–1977, Royal Academy of Arts, London. Catalogue.

1965
London: The New Scene, Walker Art Center, Minneapolis (traveled to Washington Gallery of Contemporary Art, Washington, D.C.; Institute of Contemporary Art, Boston; Seattle Art Museum; Vancouver Art Gallery; Art Gallery of Toronto; National Gallery of Canada, Ottawa). Catalogue by Martin Friedman.

1963
British Painting in the Sixties, The Tate Gallery, London, and Whitechapel Art Gallery, London. Catalogue.

1962
Two Young Figurative Painters, Institute of Contemporary Arts, London. Catalogue.

1961
The London Group, RBA Galleries, London.

Selected Bibliography

Anthony Fawcett and Jane Withers, "Howard Hodgkin at the Venice Biennale," *Studio International* CXCVII, 1005 (1984).

"Howard Hodgkin and Patrick Caulfield in Conversation," *Art Monthly* (July/August 1984).

Michael Brenson, "Art: Howard Hodgkin and Paris Legacy," *New York Times,* 27 April 1984.

John Russell, "Maximum Emotion with a Minimum of Definition," *New York Times,* 15 April 1984.

Richard Armstrong, "Howard Hodgkin," *Artforum* (March 1983).

Robert Hughes, "A Peeper into Paradise," *Time,* 29 November 1982.

Howard Hodgkin, "How to be an Artist," *Burlington Magazine* (September 1982).

Howard Hodgkin and Bruce Chatwin, *Indian Leaves* (New York, 1982).

Jesse Murray, "Reflections on Howard Hodgkin's Theater of Memory," *Arts Magazine* (June 1981).

Hilton Kramer, "Howard Hodgkin," *New York Times,* 8 May 1981.

Donald B. Kuspit, "Howard Hodgkin at Emmerich," *Art in America* (November/December 1977).

Timothy Hyman, "Howard Hodgkin," *Studio International* (May/June 1975).

"The Relevance of Matisse: A Discussion Between Andrew Forge, Howard Hodgkin and Phillip King," *Studio International* (July/August 1968).

John Russell, Bryan Robertson, and Lord Snowdon, *Private View* (London, 1965).

Howard Hodgkin, "On Figuration and the Narrative in Art," *Studio International* (September 1966).

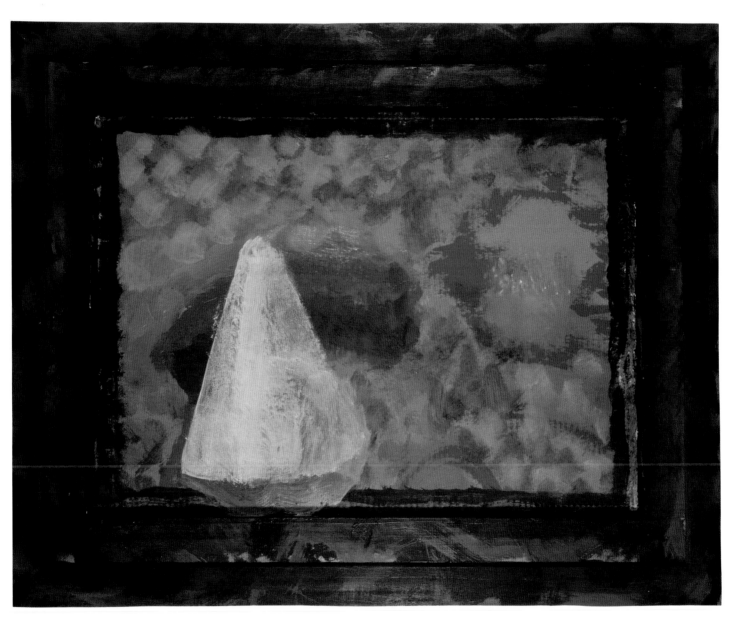

The Cylinder, the Sphere, the Cone, 1978–84
oil on board
36¼ x 46¼ in. (92.1 x 117.5 cm.)
Museum of Art, Carnegie Institute, Pittsburgh;
Gene Baro Memorial Fund and Carnegie
International Acquisition Fund, 1984

Howard Hodgkin

Goodbye to the Bay of Naples, 1980–82
oil on wood
22 x 26¼ in. (55.8 x 66.7 cm.)
Private collection, courtesy of M. Knoedler & Co.,
Inc., New York

Mr. and Mrs. James Kirkman, 1980–84
oil on canvas
40¾ x 47¾ in. (103.5 x 121.3 cm.)
Collection of Sue and David Workman

Menswear, 1980–85
oil on wood
32 ¾ x 42 ½ in. (83.2 x 107.9 cm.)
Collection of the artist, courtesy of M. Knoedler
& Co., Inc., New York

Sad Flowers, 1978–85
oil on wood
43 ½ x 55 ¼ in. (110.5 x 140.3 cm.)
Collection of the artist, courtesy of M. Knoedler
& Co., Inc., New York

Jenny Holzer

Born 1950, Gallipolis, Ohio
Lives and works in New York

The President, the enemy or a mistake can kill everyone.

Selected One-Artist Exhibitions
1984
University Gallery, University of Massachusetts, Amherst.

Kunsthalle, Basel (traveled to Le Nouveau Musée, Lyon). Catalogue with introduction by Jean-Christophe Ammann.
1983
Barbara Gladstone Gallery, New York. Also 1982.

Institute of Contemporary Arts, London.

Institute of Contemporary Art, University of Pennsylvania, Philadelphia.
1982
Artists Space, New York.
1981
Le Nouveau Musée, Lyon.

Museum für (Sub) Kultur, West Berlin.
1980
Galerie Rüdiger Schöttle, Munich.

Onze Rue Clavel, Paris.

Selected Group Exhibitions
1985
Biennale de Paris. Catalogue.

Biennial Exhibition, Whitney Museum of American Art, New York. Also 1983. Catalogues.
1984
The Human Condition: SFMMA Biennial III, San Francisco Museum of Modern Art. Catalogue with essays by Dorothy Martinson, Wolfgang Max Faust, Achille Bonito Oliva, Klaus Ottman, and Edward Kienholz.

Biennale of Sydney. Catalogue.
1983
Dahn, Daniels, Genzkin, Holzer, Longo, Visch, Stedelijk Van Abbemuseum, Eindhoven.
1982
Documenta VII, Kassel. Catalogue.
1980
Issue, Institute of Contemporary Arts, London.

Times Square Show, Collaborative Projects, Inc., New York.

The Offices, Anna Leonowens Gallery, Halifax, and 112 Workshop, New York.
1979
Pleasure/Function, David Amico Gallery, Los Angeles.

Selected Bibliography
Jenny Holzer, "Sign on a Truck," *Artforum* (November 1984).

———, *Truisms and Essays* (Halifax, 1983).

Elke Town, "Jenny Holzer," *Parachute* (Summer 1983).

Carter Ratcliff, "Jenny Holzer," *The Print Collector's Newsletter* (November/December 1982).

Dan Graham, "Signs," *Artforum* (April 1981).

Gerald Marzorati, "Monumental Confrontations," *Soho Weekly News,* 8 April 1981.

Alexander MacGregor, "Fourteen New Artists," *Artscribe* (February 1981).

Peter Schjeldahl, "Anxiety as a Rallying Cry," *The Village Voice,* 16 September 1981.

Jenny Holzer with Peter Nadin, *Eating Through Living* (New York, 1981).

———, *Eating Friends* (New York, 1981).

———, *Living* (New York, 1980).

———, *Hotel* (New York, 1980).

———, "Position Papers," *Artforum* (February 1980).

Jenny Holzer, *A Little Knowledge* (New York, 1979).

———, *Black Book* (New York, 1979).

Selections from "The Survival Series," 1983
electronic moving message unit, LED sign, red diode; edition 1/5
6½ x 121½ x 4 in. (16.5 x 308.6 x 10.2 cm.)
(see catalogue supplement)
Courtesy of the artist and Barbara Gladstone Gallery, New York

Selections from "The Survival Series," 1983
electronic moving message unit, LED sign, red diode; edition 1/4
6½ x 60¾ x 4 in. (16.5 x 154.3 x 10.2 cm.);
2 in. characters
(see catalogue supplement)
Courtesy of the artist and Barbara Gladstone Gallery, New York

Selections from "The Survival Series," 1983–84
electronic moving message unit, LED sign, yellow diode; edition 1/4
6½ x 60¾ x 4 in. (16.5 x 154.3 x 10.2 cm.)
(see catalogue supplement)
Courtesy of the artist and Barbara Gladstone Gallery, New York

Selections from "Truisms," 1983–84
electronic moving message unit, LED sign, yellow diode; edition 2/4
6½ x 60¾ x 4 in. (16.5 x 154.3 x 10.2 cm.)
(see catalogue supplement)
The Smorgon Family Collection of Contemporary American Art

Selections from "The Living Series," 1985
electronic moving message unit, LED sign, red diode; edition 1/4
6½ x 60¾ x 4 in. (16.5 x 154.3 x 10.2 cm.);
2 in. characters
(see catalogue supplement)
Courtesy of the artist and Barbara Gladstone Gallery, New York

More "Survival," 1985
electronic moving message unit, LED sign, red diode; edition 1/5
6½ x 121½ x 4 in. (16.5 x 308.6 x 10.2 cm.)
(see catalogue supplement)
Courtesy of the artist and Barbara Gladstone Gallery, New York

More "Survival," 1985
electronic moving message unit, LED sign, red diode; edition 1/5
7 x 35¾ x 4 in. (17.8 x 90.8 x 10.2 cm.)
(see catalogue supplement)
Courtesy of the artist and Barbara Gladstone Gallery, New York

More "Survival," 1985
electronic moving message unit, LED sign, red diode; edition 2/5
7 x 35¾ x 4 in. (17.8 x 90.8 x 10.2 cm.)
(see catalogue supplement)
Courtesy of the artist and Barbara Gladstone Gallery, New York

Selections from "Truisms," 1985
electronic moving message unit, LED sign, red diode; edition 1/5
6½ x 121½ x 4 in. (16.5 x 308.6 x 10.2 cm.)
(see catalogue supplement)
Courtesy of the artist and Barbara Gladstone Gallery, New York

Truisms, 1982
spectracolor board
Installation view at Times Square, New York
Courtesy of Barbara Gladstone Gallery, New York

Unex Sign #1 (Selections from "The Survival Series"), 1983
spectracolor machine with moving graphics
30½ x 113½ x 12 in. (77.5 x 288.3 x 30.5 cm.)
(see catalogue supplement)
Whitney Museum of American Art, New York;
Purchase with funds from the Louis and Bessie
Adler Foundation, Inc., Seymour M. Klein,
President, 84.3

Jörg Immendorff

Born 1945, Bleckede, Federal Republic of Germany
Lives and works in Düsseldorf

Beginning with my earliest ventures at the academy my work was affected by political activity. Initially, this involvement was more emotional. Increasingly, it became consciously concerned with academic politics: that is, directed against the kind of conformity that dominates these institutions. It was no accident that I produced the painting *Hört auf zu malen (Stop Painting)* at this time. This painting expressed my rebellion against the academic style, which existed in the guise of tachism, and produced a deadly lifelessness. A few classmates—like Sigmar Polke and me—were motivated by this political involvement to paint against and to oppose conditions at the academy.

Gradually, this political opposition moved beyond the academic sphere. At the time Günther Grass had just published in "Der Spiegel" an appeal against the Vietnam war. I became so inspired by it that I spontaneously drafted a petition on which I painted the German flag and an eagle. Beuys, Anatole, Palermo, and many others signed it, but I did not know where to send the list of signatures. I believed it was important to act on the strength of my indignation, both as an individual and an artist. I was, and am, convinced that it is impossible to separate art from politics—from those things which are happening around us. There is for me not only an aesthetic concern, but also a kind of wholesome schizophrenia: on the one hand one feels politically agitated; on the other hand one feels the urge to express oneself artistically, in the particular medium to which one is drawn.

I can say nothing about the effect of an individual work of art; to my knowledge there is no scientific method of determining how a painting will be perceived. Hence, I must for now retain the firm belief that productive, creative, artistic form is the most beautiful form of existence. Besides, my contribution is a part of the total cultural production, which my colleagues and I create together as a many-layered texture of point-counterpoint. Therein lies the only possible salvation of mankind: in a society in which everyone feels they know everything, a few people [the artists] have the courage to create a "utopia"—an ideal perspective—without knowing the effects of their interpretation. This challenge and communication is essential, and if it attracts and motivates two or three people, my job is done.

I want to emphasize first that the problem is not the "understanding" of paintings. Initially the observer responds to the pictorial signs conveyed in the painting. Then the observer reacts to the totality of the picture: composition, painting technique, and color, etc. At this point, however, I have reached the limits of explication. Were it possible to make a full description, I would no longer need to paint pictures. But the actual painting process is very important to me, although this aspect of my work continues to be neglected in discussions and reviews, which deal nearly exclusively with the content of my pictures. An ice floe is an ice floe and has symbolic value; yet it is also, and primarily, a "painted" ice floe!

I said: There is no definitive reading—my pictures are not painted lectures. Their rhetoric is different from that of the street. When, at an earlier time, I painted the raised fist and the red flag, I was representing the interests of the worker movement in what I believed to be unequivocal symbols, and these were understood. I was of the opinion that I had to proffer this picture to the viewer in a comprehensible manner. . . . Now my work is not directed toward a particular audience . . . I do not ask with respect to my work: "For whom?" but rather "What emanates from me?". . . . Today my artistic expression is built upon and nourished by real experience which conveys authentic optical information, since I am no more isolated than my neighbor. We are all related as in a great network; only in this manner can man make contact and communicate.

Excerpts from "Situation—Position; Ein Gespräch mit Jörg Immendorff über seine politische Malerei" by Jörg Huber. Reprinted from Kunsthaus, Zurich, *Jörg Immendorff* (1983), exh. cat., 36–46. Translated by Annegreth T. Nill. Used by permission.

Nachtwache, 1982
oil on canvas
110 x 130 in. (280 x 330 cm.)
Collection of Martin and Toni Sosnoff

Selected One-Artist Exhibitions
1985
Kunstverein, Brunswick.

1984
Museum of Modern Art, Oxford.

Galerie Michael Werner, Cologne. Catalogue. Also 1983 (catalogue), 1982 (catalogue), 1979 (catalogue by Siegfried Gohr and A. R. Denck), 1978 (catalogue by Johannes Gachnang, Siegfried Gohr, and Rudi Fuchs), 1977, 1975, 1974, 1973, 1972, 1971, 1969.

Kunsthalle, Hamburg.

1983
Kunsthaus, Zurich. Catalogue by Johannes Gachnang, Toni Stoos, and Harald Szeeman.

Stedelijk Van Abbemuseum, Eindhoven. Also 1981 (catalogue by Rudi Fuchs).

Kunsthalle, Düsseldorf. Also 1982 (catalogue by Jürgen Harten, Ulrich Krempel, Jörg Immendorff).

1980
Kunsthalle, Bern. Catalogue by Johannes Gachnang and Max Wechsler.

1979
Kunstmuseum, Basel. Catalogue by Dieter Koepplin.

1973
Westfälischer Kunstverein, Münster.

1965
Galerie Schmela, Düsseldorf.

1961
New Orleans-Club, Bonn.

Selected Group Exhibitions
1985
The European Iceberg: Creativity in Germany and Italy Today, Art Gallery of Ontario, Toronto. Catalogue by Germano Celant.

1984
Ouverture, Castello di Rivoli, Turin.

Von Hier Aus, Messegelände, Düsseldorf. Catalogue by Kasper König.

An International Survey of Recent Painting and Sculpture, The Museum of Modern Art, New York. Catalogue by Kynaston McShine.

1983
Expressions: New Art from Germany, The Saint Louis Art Museum (traveled to P. S. 1, Long Island City, New York; Institute of Contemporary Art, University of Pennsylvania, Philadelphia; The Contemporary Arts Center, Cincinnati; Museum of Contemporary Art, Chicago; Newport Harbor Art Museum, Newport Beach, California; Corcoran Gallery of Art, Washington, D.C.). Catalogue.

1982
Zeitgeist, Martin-Gropius-Bau, West Berlin. Catalogue with foreword by Christos Joachimides and Norman Rosenthal.

Biennale of Sydney.

1981
Westkunst—Heute: Zeitgenössische Kunst seit 1939, Museen der Stadt Köln. Catalogue by Laszlo Glozer.

1980
La Biennale di Venezia. Also 1976.

Selected Bibliography

J. Huber, "Jörg Immendorff," *Flash Art* (April/May 1984).

Donald B. Kuspit, "Jörg Immendorff," *Artforum* (January 1983).

Hans Peter Riegel, "Was Kunst soll," *Oetz* 5 (1982).

Wolfgang Max Faust and Gerd de Vries, *Hunger nach Bildern: Deutsche Malerei der Gegenwart* (Cologne, 1982).

Heiner Stachelhaus, "Jörg Immendorff. Städtische Kunsthalle Düsseldorf (26.3–9.5.1982), Galerie Strelow, Düsseldorf Oberkassel, Luegplatz 3 (bis 15.5.1983)," *Kunstwerk* (June 1982).

Gislind Nabakowski, " 'Café Deutschland'/Adlerhälfte," *Kunstforum International* 4 (1982).

Galerie Neuendorf, Hamburg, *Jörg Immendorff: Teilbau* (1981), exh. cat. by Rudi Fuchs and Johannes Gachnang.

Moderna Museet, Stockholm, *Der Hund stösst im Laufe der Woche zu mir* (1981), exh. cat. by Jörg Immendorff and Siegfried Gohr.

Jörg Immendorff and A. R. Penck, *Deutschland mal Deutschland. Ein Deutsch-Deutscher Vertrag* (Munich, 1979).

"Interview mit Jörg Immendorff," *Primitivo/Einhorn Production* (December 1979).

Siegfried Gohr and Johannes Gachnang, "Jörg Immendorffs 'Café Deutschland' " *Kunstforum International* 2 (1978).

Jörg Immendorff, *Hier und jetzt: Das tun, was zu tun ist* (Cologne, 1973).

Jörg Immendorff, et al., *Bevor man Omelette macht, muss man Eier zerschlagen* (Düsseldorf, 1970).

Jörg Immendorff, "LIDL als Gäste" and "Die ideale Akademie," in *Interfunktionen 2* (Cologne, 1969).

Chris Reinecke, "Gedanken zu Jörg Immendorffs Babies und Aktionen," *Information* 2 (1967).

beben/heben, 1983
oil on canvas
112 ³⁄₁₆ x 130 ⅛ in. (285 x 330 cm.)
Courtesy of Mary Boone/Michael Werner Gallery,
New York

Zurück Naht, 1983
oil on canvas
111 x 130 ⅛ in. (282 x 330 cm.)
Courtesy of Mary Boone/Michael Werner Gallery,
New York

Neil Jenney

Born 1945, Torrington, Connecticut
Lives and works in New York

When I first devised this group of ("Bad") paintings in 1968, I was considering the direction that our culture was inevitably moving toward. I could see that realism was going to return, and that the parameters of realism had not been defined. When you do realism you have to decide what degree of realism you are going to attempt and I decided that I did not want to be concerned about the technical factors; I wanted to develop a style that was unconcerned with position, lines, and color. I was more concerned with approaching the viewer with relationships—for instance, a crying girl and a broken vase, birds and jets, or trees and lumber. I'm not interested in a narrative; I'm interested in showing objects existing with and relating to other objects because I think that is what realism deals with—objects relating to other objects. I am interested in using imagery that is universal and transcultural—and an imagery that is profound. I wanted the objects to be stated emphatically with no psychological implications.

I am not overly concerned with making the images very abstract because I do not want to involve any confusion; but then again, I did not want to spend a lot of time refining the lines and details. I wanted to isolate objects and place them on a unified background. However, I realized that by refining the lines, I had stronger art; and then I realized that I could not avoid idealizing each painting. There is actually no distinction between abstraction and realism. All realism must resolve abstract complications because you are involved with space and balance and harmony. Realism is a higher art form because it is more precise—it not only solves all abstract concerns, but it involves precise philosophical interpretation.

I am not trying to duplicate something that I see in nature because you must always compromise—it is always going to be paint, you cannot outpaint the paint. I was not trying to disguise the fact that these are paintings. I was not trying to mimic photographs. I never wanted to avoid the realization that I was using paint; in fact, I wanted to emphasize it.

Realism is illusionism and all illusionistic painting requires frames. At first, I did not realize the crucial factor that frames can play in the illusion. The frame is the foreground and it simply enhances the illusion—it makes the illusion more functional. I designed and built the frames to suit the paintings—I realized that the frames would enchance the illusion and be a perfect place to put the title.

Neil Jenney. Reprinted from Whitney Museum of American Art, New York, *New Image Painting* (1978), exh. cat. by Richard Marshall, 38. Used by permission.

Selected One-Artist Exhibitions

1985
Carpenter and Hochman, New York.

1984
Oil and Steel Gallery, New York.

1981
University Art Museum, University of California, Berkeley (traveled to Corcoran Gallery of Art, Washington, D. C.; Contemporary Arts Museum, Houston; Kunsthalle, Basel). Catalogue by Mark Rosenthal.

1975
Wadsworth Atheneum, Hartford. Brochure.

1974
Blum/Helman Gallery, New York.

1973
98 Greene Street Loft, New York.

1970
Richard Bellamy/Noah Goldowsky Gallery, New York.
David Whitney Gallery, New York.

1968
Gallery Rudolf Zwirner, Cologne.

Selected Group Exhibitions

1984
An International Survey of Recent Painting and Sculpture, The Museum of Modern Art, New York. Catalogue by Kynaston McShine.

1983
Back to the USA: Amerikanische Kunst der Siebziger und Achtziger, Kunstmuseum, Lucerne (traveled to Rheinisches Landesmuseum, Bonn; Württembergischer Kunstverein, Stuttgart). Catalogue by Klaus Honnef.

'60–'80: Attitudes/Concepts/Images, Stedelijk Museum, Amsterdam. Catalogue.

1981
Biennial Exhibiton, Whitney Museum of American Art, New York. Also 1973, 1969. Catalogues.

1980
Biennale di Venezia.

1978
New Image Painting, Whitney Museum of American Art, New York. Catalogue by Richard Marshall.

American Painting of the 1970's, Albright-Knox Art Gallery, Buffalo (traveled to Newport Harbor Art Museum, Newport Beach, California; Oakland Museum, Oakland, California; Cincinnati Art Museum; Art Museum of South Texas, Corpus Christi; Krannert Art Museum, University of Illinois, Champaign). Catalogue by Linda Cathcart.

Bad Painting, New Museum, New York. Catalogue by Marcia Tucker.

1972
Documenta V, Kassel. Catalogue.

1970
Three Young Americans, Allen Memorial Art Museum, Oberlin College, Oberlin, Ohio.

1969
Anti-Illusion: Procedures/Materials, Whitney Museum of American Art, New York.

Selected Bibliography

Vivien Raynor, "Soho Galleries: Neil Jenney," *New York Times,* 19 April 1985.

Mark Rosenthal, in *Art of Our Time: The Saatchi Collection,* vol. 4 (London, 1984).

Paul Gardner, "Portrait of Jenney," *Art News* (December 1983).

Harry Zellweger, "Neil Jenney und Ernst Caramelle: Kunsthalle Basel," *Kunstwerk* (August 1982).

Joan Simon, "Neil Jenney: Event and Evidence," *Art in America* (Summer 1982).

Mark Rosenthal, "The Ascendance of Subject Matter and a 1960's Sensibility," *Arts Magazine* (June 1982).

Hilton Kramer, "Neil Jenney: Elegance with a Political Twist," *New York Times,* 17 May 1981.

Cathy Curtis, "Neil Jenney: A Sensibility of Stylistic Synthesis," *Artweek,* 16 May 1981.

Jean-Christophe Ammann, "Neil Jenney: Birds and Jets," *Domus* (December 1980).

Mark Rosenthal, "From Primary Structures to Primary Imagery," *Arts Magazine* (October 1978).

Art Museum of South Texas, Corpus Christi, *Eight Artists* (1974), exh. cat. by David Whitney.

Robert Pincus-Witten, "New York: Neil Jenney," *Artforum* (January 1971).

Athena Spear, "Reflections on the Work of Charles Close, Ron Cooper, Neil Jenney and Other Contemporary Art," *Oberlin College Allen Memorial Art Museum Bulletin* (Spring 1970).

Klaus Honnef, "Ausstellungen: Neil Jenney," *Kunstwerk* (December 1968–January 1969).

Outside, 1984
oil on wood
40¾ x 36¾ in. (103.5 x 93.3 cm.)
Collection of Mr. and Mrs. Robert K. Hoffman

Neil Jenney

The Bruce Hardie Memorial, 1978–82
oil on wood
74 x 84 in. (188 x 213.4 cm.)
Collection of Mr. and Mrs. Lewis E. Nerman,
courtesy of The Nelson-Atkins Museum of Art,
Kansas City

Acid Story, 1983–84
oil on wood
34½ x 140 x 5 in. (87.6 x 355.6 x 12.7 cm.)
Collection of the artist

Bill Jensen

Born 1945, Minneapolis
Lives and works in New York

Oil Paint

Born of the need to paint living tissue. It is a witch doctor who has cured the ills of society for centuries.

Submerged in the murk of modern life, immersed in the murk of oil, the great mark-maker breathes forth clarity. A clarity of light and human compassion. A clarity of poignant concentration and compression. The murky clarity transcended into living tissue.

Selected One-Artist Exhibitions
1984
Washburn Gallery, New York. Also 1982, 1981, 1980.
1975
Fischbach Gallery, New York. Also 1973.
1974
The Gallery of July and August, Woodstock, New York.

Selected Group Exhibitions
1984
An International Survey of Recent Painting and Sculpture, The Museum of Modern Art, New York. Catalogue by Kynaston McShine.

Five Painters in New York, Whitney Museum of American Art, New York. Catalogue by Richard Armstrong and Richard Marshall.

1983
Tendencias en Nueva York, Palacio de Velázquez, Madrid (traveled to Fundació Joan Miró, Barcelona; Musée du Luxembourg, Paris). Catalogue by Carmen Gimenez.

1981
Biennial Exhibition, Whitney Museum of American Art, New York. Catalogue.

1979
American Painting: The Eighties, A Critical Interpretation, Grey Art Gallery and Study Center, New York University, New York (traveled to Contemporary Arts Museum, Houston; The American Center, Paris). Catalogue by Barbara Rose.

1977
A Painting Show, P. S. 1, Long Island City, New York.

1976
Approaching Painting, Hallwalls, Buffalo.

1974
Fischbach Gallery. Also 1972.

Vick Gallery, Philadelphia.

Brooklyn Museum. Also 1971.

Selected Bibliography

Hilton Kramer, in *Art of Our Time: The Saatchi Collection,* vol. 4 (London, 1984).

Ann Lauterbach, "Poets and Art," *Artforum* (November 1984).

Kenneth Baker, "Bill Jensen at Washburn," *Art in America* (October 1984).

Donald Kuspit, "Bill Jensen," *Artforum* (February 1983).

Hayden Herrera, "Memory of Closeness," *Art in America* (December 1982).

Addison Parks, "Bill Jensen and the Sound and Light Beneath the Lid," *Arts Magazine* (November 1981).

Hilton Kramer, "Art: Bill Jensen Works Shown," *New York Times,* 13 November 1981.

John Perreault, "Ryder on the Storm," *Soho Weekly News,* 11 November 1981.

Kay Larson, "Art," *New York Magazine,* 30 November 1981.

Klaus Kertess, "Painting Metaphorically: The Recent Work of Gary Stephan, Stephen Mueller and Bill Jensen," *Artforum* (October 1981).

Hilton Kramer, "Art: Bill Jensen Evokes Tradition, Individuality," *New York Times,* 21 March 1980.

Roberta Smith, "Bill Jensen's Abstractions," *Art in America* (November 1980).

———, "Reviews," *Artforum* (June 1973).

Gerrit Henry, "Reviews and Previews," *Art News* (May 1973).

James Mellow, "Bill Jensen, Fischbach Gallery," *New York Times,* 29 March 1973.

Thomas Hess, "The Return of Heavy Paint," *New York Magazine,* 18–25 December 1972.

Vanquished, 1982–83
oil on canvas
36 x 25 in. (91.4 x 63.5 cm.)
Collection of Mr. and Mrs. James H. Rich

Bill Jensen

Hunger, 1984—85
oil on linen
16 x 20 in. (40.6 x 50.8 cm.)
Saatchi Collection, London

Kepler, 1984—85
oil on linen
20 x 36 in. (50.8 x 91.4 cm.)
Courtesy of Washburn Gallery, New York

The Lamb, 1977–83–84
oil on canvas
28 x 24 in. (71.1 x 61 cm.)
Saatchi Collection, London

Studio, 1984–85
oil on linen
29 x 24 in. (73.6 x 61 cm.)
Private collection, courtesy of Washburn Gallery,
New York

Ellsworth Kelly

Born 1923, Newburgh, New York
Lives and works in Spencertown, New York

I have wanted to free shape from its ground, and then to work the shape so that it has a definite relationship to the space around it; so that it has a clarity and a measure within itself of its parts (angles, curves, edges, amount of mass); and so that, with color and tonality, the shape finds its own space and always demands its freedom and separateness.

Selected One-Artist Exhibitions

1985
Blum Helman Gallery, New York. Also 1984, 1982, 1981 (catalogue), 1979, 1977, 1975.

1984
Leo Castelli Gallery, New York. Also 1981, 1980, 1977, 1975, 1973.

1982
Whitney Museum of American Art, New York (traveled to St. Louis Art Museum). Catalogue by Patterson Sims.

1979
The Metropolitan Museum of Art, New York. Catalogue with introduction by Elizabeth C. Baker.

Stedelijk Museum, Amsterdam (traveled to Hayward Gallery, London; Musée National d'Art Moderne, Paris; Staatliche Kunsthalle, Baden-Baden). Catalogue by Barbara Rose and Antje von Graevenitz.

1973
The Museum of Modern Art, New York (traveled to Pasadena Art Center; Walker Art Center, Minneapolis; Detroit Institute of Arts). Catalogue by E. C. Goossen.

1971
Sidney Janis Gallery, New York. Also 1968 (catalogue), 1967, 1965.

1963
Betty Parsons Gallery, New York. Also 1961, 1959, 1958, 1957, 1956.

Gallery of Modern Art, Washington, D. C. (traveled to Institute of Contemporary Art, Boston). Catalogue with foreword by Adelyn D. Breeskin and interview by Henry Geldzahler.

1951
Galerie Arnaud, Paris.

Selected Group Exhibitions

1984
La Grande Parade: Highlights in Painting After 1940, Stedelijk Museum, Amsterdam. Catalogue with essay by Edy de Wilde.

1982
'60–'80: Attitudes/Concepts/Images, Stedelijk Museum, Amsterdam. Catalogue.

1973
Biennial Exhibition, Whitney Museum of American Art, New York. Catalogue. Also *Annual Exhibition,* 1968, 1967, 1966, 1965, 1963, 1961, 1960, 1959.

1969
New York Painting and Sculpture: 1940–1970, The Metropolitan Museum of Art, New York. Catalogue.

1968
Documenta IV, Kassel. Catalogue with essays by Arnold Bode, Max Imdahl, and Jean Leering. Also 1964, *III* (catalogue with essays by Werner Haftmann and Arnold Bode).

1967
The 1967 Pittsburgh International Exhibition of Contemporary Painting and Sculpture, Museum of Art, Carnegie Institute. Also 1964, 1961, 1958.

American Sculpture of the Sixties, Los Angeles County Museum of Art. Catalogue with introduction by Maurice Tuchman and essay by James Monte.

Post-Painterly Abstraction, Los Angeles County Museum of Art. Catalogue with foreword by James Elliot and essay by Clement Greenberg.

Painting and Sculpture of a Decade, 54/64, The Tate Gallery, London.

1959
Sixteen Americans, The Museum of Modern Art, New York.

1951
Réalités Nouvelles 1951, Numéro 5, Salon des Réalités Nouvelles, Paris. Catalogue. Also 1950.

1949
Boris Mirski Art Gallery, Boston. Also 1948.

Selected Bibliography

Vivien Raynor, "Ellsworth Kelly Keeps His Edge," *Art News* (March 1983).

Carter Ratcliff, "Kelly's Spectrum of Experience," *Art in America* (Summer 1981).

Joseph Masheck, "Ellsworth Kelly at the Modern," *Artforum* (November 1973).

Harold Rosenberg, "The Art World: Dogma and Talent," *The New Yorker,* 15 October 1973.

Hilton Kramer, "Kelly: Extremely Individual and Extremely Traditional," *New York Times,* 23 September 1973.

John Coplans, *Ellsworth Kelly* (New York, 1973).

Diane Waldman, *Ellsworth Kelly Drawings, Collages, Prints* (Greenwich, Connecticut, 1971).

John Elderfield, "Color and Area: New Paintings by Ellsworth Kelly," *Artforum* (November 1971).

Robert Pincus-Witten, "Systemic Painting," *Artforum* (November 1966).

Dore Ashton, "Kelly's Unique Spatial Experiences," *Studio International* (July 1965).

Henry Geldzahler, "Interview with Ellsworth Kelly," *Art International* (February 1964).

Michael Fried, "New York Letter: Ellsworth Kelly at Betty Parsons Gallery," *Art International* (January 1964).

William Rubin, "Ellsworth Kelly: The Big Form," *Art News* (November 1963).

Lawrence Alloway, "Easel Painting at the Guggenheim," *Art International* (December 1961).

Parker Tyler, "Ellsworth Kelly," *Art News* (October 1957).

Michel Seuphor, "Paris: French Critic Reacts," *Arts Magazine* (March 1953).

Blue Curve, 1985
oil on canvas
108 ½ x 111 ½ in. (275.6 x 283.2 cm.)
Private collection, courtesy of Blum Helman
Gallery, New York

Ellsworth Kelly

Untitled, 1983
weathering steel
75 ½ x 174 x 164 in. (191.8 x 442 x 416.6 cm.)
Private collection, courtesy of Leo Castelli Gallery,
New York and Blum Helman Gallery, New York

Diagonal with Curve XVI, 1984
mahogany
127 x 52 x 2 ¼ in. (322.6 x 132.1 x 5.7 cm.)
Private collection, courtesy of Blum Helman
Gallery, New York

Anselm Kiefer

Born 1945, Donaueschingen, Federal Republic of
Germany
Lives and works in Hornbach, Odenwald, Federal
Republic of Germany

I am not primarily concerned with the persons
who are portrayed; rather, it is the history of
the reactions to their work. . . . When I cite
Richard Wagner, then I do not mean the com-
poser of this or that opera. For me, it is more
important that Wagner changed, if you will,
from a revolutionary into a reactionary. I also
mean the phenomenon—Wagner. The way in
which he was used in the Third Reich and the
problems in connection with this. Why, in fact,
was it possible to use him then and to offer him
to the people in such a primitive way? You must
assume that a part of what they made of him
was present in his work. In the person Wagner,
extreme possibilities are unified; also the phe-
nomenon of [the] use and misuse [of these
possibilities]. . . .

"Scorched earth" is a technical term used by
the army. Troops in retreat burn the area they
are leaving behind so that the enemy will not be
able to produce on this land anymore. When
applied to painting, this doesn't mean that I
want to illustrate a regular military operation,
but that I wish to portray the present-day prob-
lems in the art of painting. If you wish, you can
view it as the new beginning which each paint-
ing must make again, every time. Each artwork
destroys the one that precedes it. The earlier
artworks still exist, but no longer for the artist.
They live on in the museum and take on a dif-
ferent character. The fact that painting—or to
put it more generally, art—has, in this age, be-
come a difficult and especially a theoretical
involvement, is also apparent in another detail
from this painting [*Painting of Scorched Earth*,
1974]: the lines around the palette. What does
this palette mean set in this landscape?

The palette represents the art of painting; ev-
erything else which can be seen in the paint-
ing—for example, the landscape—is, as the
beauty of nature, annihilated by the palette.
You could put it this way: the palette wants to
abolish the beauty of nature. It is all very com-
plicated, because it actually does not become
annihilated at all. It has to do with the problem
of art in general. The way of imitating or of
disregarding it.

Excerpts from "Drie vertegenwoordigers van een
nieuwe Duitse schilderkunst," an interview with
Anselm Kiefer by Jörg Zutter. Reprinted from *Muse-
umjournaal* (April 1978): 59–61. Translated by Carol
V. Bloom. Used by permission.

Selected One-Artist Exhibitions
1985
Marian Goodman Gallery, New York. Catalogue. Also
1982, 1981.

1984
Städtische Kunsthalle, Düsseldorf (traveled to Musée
d'Art Moderne de la Ville de Paris). Catalogue by Rudi
Fuchs, Suzanne Pagé, and Jürgen Harten.

Galerie Paul Maenz, Cologne. Also 1982 (catalogue),
1981.

Musée d'Art Contemporain, Bordeaux. Catalogue by
René Denizot.

1981
Museum Folkwang, Essen, and Whitechapel Art
Gallery, London. Catalogue by Zdenek Felix and
Nicholas Serota.

1980
La Biennale di Venezia, West German Pavilion.
Catalogue by Klaus Gallwitz and Rudi Fuchs.

1979
Stedelijk Van Abbemuseum, Eindhoven. Catalogue by
Rudi Fuchs.

1978
Kunsthalle, Bern. Catalogue by Johannes Gachnang
and Marianne Schmidt-Miesher, eds.

1977
Kunstverein, Bonn. Catalogue by Dorothea von
Stetten, Evelyn Weiss, and Anselm Kiefer.

Galerie Michael Werner, Cologne. Also 1976, 1975,
1974, 1973.

1969
Galerie am Kaiserplatz, Karlsruhe.

Selected Group Exhibitions
1985
Biennale de Paris. Also 1977. Catalogues.

1984
La Grande Parade: Highlights in Painting After 1940,
Stedelijk Museum, Amsterdam. Catalogue with essay
by Edy de Wilde.

*An International Survey of Recent Painting and
Sculpture*, The Museum of Modern Art, New York.
Catalogue by Kynaston McShine.

Von Hier Aus, Messegelände, Düsseldorf. Catalogue
by Kasper König.

1983
Expressions: New Art from Germany, Saint Louis Art
Museum (traveled to P. S. 1, Long Island City, New
York; Institute of Contemporary Art, University of
Pennsylvania, Philadelphia; The Contemporary Arts
Center, Cincinnati; Museum of Contemporary Art,
Chicago; Newport Harbor Art Museum, Newport
Beach, California; Corcoran Gallery of Art,
Washington, D.C.). Catalogue by Jack Cowart,
Siegfried Gohr, and Donald B. Kuspit.

1982
Zeitgeist, Martin-Gropius-Bau, West Berlin. Catalogue
with foreword by Christos Joachimides and Norman
Rosenthal.

Documenta VII, Kassel. Also 1977, *VI*. Catalogues.

1981
Westkunst—Heute: Zeitgenössische Kunst seit 1939,
Museen der Stadt Köln. Catalogue by Laszlo Glozer.

A New Spirit in Painting, Royal Academy of Art,
London. Catalogue by Christos Joachimides and
Norman Rosenthal, eds.

1976
Beuys und seine Schüler, Kunstverein, Frankfurt.

1973
14 x 14, Staatliche Kunsthalle, Baden-Baden.
Catalogue by Klaus Gallwitz.

Selected Bibliography
John Russell, "Anselm Kiefer's Paintings Are Inimitably
His Own," *New York Times*, 21 April 1985.

Peter Schjeldahl, in *Art of Our Time: The Saatchi
Collection*, vol. 3 (London, 1984).

Lizbeth Marano, "Anselm Kiefer: Culture as Hero,"
Portfolio (May/June 1983).

Anne Seymour, *Anselm Kiefer: Watercolors,
1970–1982* (London, 1983).

Sanford Schwartz, "Anselm Kiefer, Joseph Beuys and
the Ghosts of the Fatherland," *The New Criterion*
(March 1983).

Carter Ratcliff, "Anselm Kiefer, Mary Boone Gallery,
New York," *Flash Art* (January 1983).

Saskia Bos, "Anselm Kiefer, Helen Van der Meij Gallery,
Amsterdam," *Artforum* (January 1983).

Anselm Kiefer, "Gilgamesch und Enkidu im
Zedernwald," *Artforum* (June 1981).

Rudi Fuchs, "Kiefer Schildert," *Museumjournaal* XXV,
5 (1980).

Johannes Gachnang, "Anselm Kiefer," *Kunst-
Nachrichten* XVI, 3 (1979).

Hans-Joachim Müller, "Anselm Kiefer, Kunsthalle,
Bern," *Kunstwerk* (December 1978).

Anselm Kiefer, *Die Donauquelle*, Michael Werner, ed.
(Cologne, 1978).

Evelyn Weiss, "Anselm Kiefer," *Kunstforum
International* XX (1977).

Anselm Kiefer, *Selbstbiographie* (Bonn, 1977).

Theo Kneubühler, "Die Kunst, das 'Ungleiche' und die
Kritik," *Kunst-Bulletin* 10 (1976).

Anselm Kiefer, "Besetzungen 1969," *Interfunktion* 12
(1969).

Midgard, 1980—85
oil and emulsion on canvas
142 x 237 ¾ in. (360 x 604 cm.)
Collection of the artist

Anselm Kiefer

Dem unbekannten Maler, 1983
oil, shellac, emulsion, woodcut, latex, and straw
on canvas
110 x 110 in. (280 x 280 cm.)
Museum of Art, Carnegie Institute, Pittsburgh;
Richard M. Scaife Fund and The A. W. Mellon
Acquisition Fund, 1983

Das Buch, 1979–85
lead, oil, and emulsion on canvas
130 x 218 ½ in. (330 x 555 cm.)
Collection of the artist

Per Kirkeby

Born 1938, Copenhagen
Lives and works in Copenhagen; Laes, Denmark; and
Karlsruhe

Caption

Painting is laying layer upon layer. Without exception it is fundamental to all painted pictures even if they look as if they were done in one movement. The movement has always crossed its own track somewhere. It is easy to understand that a picture is layer upon layer when it comes to Picabia's puzzle pictures or my own material works, but it is difficult with the "synchronous." By the "synchronous" I mean all those pictures where all the layers aim at the same picture, where the underpainting and following layers—glazed or not—fall on top of each other. The "unsynchronous" are the ones where each new layer is a new picture. It is like geological strata with cracks and discordances. But each new layer, however furious, is always infected and coloured by the underlying one. Even when it is slates where the previous layer is completely removed physically, wiped off.

Thus, it is with all pictures; there are many layers, and with good reason an analysis nearly always deals only with the last. The last layer in a superficial sense. But how then can one talk of what one cannot see, the overpainted or wiped-off layers, how to go about for example, photographs that are like slates with layers which no longer exist. The answer is that they exist nevertheless, taken up into the visible layer by a rubbing-off, but the problem, on the whole, is how one deals with the visible layer. The angle-sure, viewpoint-seeking and in the worst sense "analytic" intercourse with the picture. This method does not call up the invisible layers. The invocatory tone of intercourse is the "synthetic," which does not seek results immediately but treats the picture sensually and then allows the apparently most unreasonable associations to grow. In this way invisible layers in oneself are invoked, and this is the only kind of invisible layer in the picture which allows itself to be invoked. This is "unscientific" and apparently uncontrollable and subjective. But the subjective is to a large extent the common; the invisible, subterranean layers are fertile soil for the great common pictures.

Reprinted from Per Kirkeby, *Selected Essays from Bravura* (Eindhoven: Stedelijk Van Abbemuseum, 1982). Translated by Peter Shield. First published in Danish (Copenhagen: Borgen, 1981). Used by permission.

Selected One-Artist Exhibitions

1984
Galerie Michael Werner, Cologne. Catalogue. Also 1983 (catalogue), 1982 (catalogue), 1980 (catalogue with essays by Rudi Fuchs, Johannes Gachnang, and Per Kirkeby), 1978, 1974.

Strasbourg Museum. Catalogue.

1983
Galerie Ascan Crone, Hamburg. Also 1982 (catalogue). DAAD Galerie, Berlin. Catalogue by Johannes Gachnang.

1982
Stedelijk Van Abbemuseum, Eindhoven. Catalogue by Rudi Fuchs, Johannes Gachnang, and Per Kirkeby.

1981
Museum Ordrupgaardsamlingen, Copenhagen. Catalogue by Rudi Fuchs and Hanne Finsen.

1979
Kunsthalle, Bern. Catalogue by Johannes Gachnang and Theo Kneubuhler.

1978
Kunstraum, Munich. Catalogue by Hermann Kern and Per Kirkeby.

1977
Museum Folkwang, Essen. Catalogue with essays by Zdenek Felix and Troels Anderson.

1964
Hoved-Bibliotek, Copenhagen.

Selected Group Exhibitions

1984
An International Survey of Recent Painting and Sculpture, The Museum of Modern Art, New York. Catalogue by Kynaston McShine.

Von Hier Aus, Messegelände, Düsseldorf. Catalogue by Kasper König.

Uit het Noorden: Edvard Munch, Asger Jorn, Per Kirkeby. Stedelijk Van Abbemuseum, Eindhoven. Catalogue by Rudi Fuchs, Johannes Gachnang, and Per Kirkeby.

1982
Zeitgeist, Martin-Gropius-Bau, West Berlin. Catalogue with foreword by Christos Joachimides and Norman Rosenthal.

Biennale of Sydney. Catalogue.

Sleeping Beauty—Art Now, Scandinavia Today, The Solomon R. Guggenheim Museum, New York (traveled to Port of History Museum at Penn's Landing, Philadelphia; Los Angeles Municipal Art Gallery). Catalogue with essays by Pontus Hulten and Oystein Hjort.

Documenta VII, Kassel. Catalogue.

1981
A New Spirit in Painting, Royal Academy of Arts, London. Catalogue by Christos Joachimides, Norman Rosenthal, and Nicholas Serota, eds.

1980
La Biennale di Venezia. Also 1976.

1966
Nordisk Ungdomsbienale, Louisiana Museum, Humlebaek, Denmark.

1962
Den eksperimenterende Kunstskole, Galerie Admiralgade 20, Copenhagen.

Selected Bibliography

Kunstraum, Munich, *Per Kirkeby, Übermalungen 1964–1984* (1984), exh. cat. by Luis Horn and Per Kirkeby.

Galerie Springer, Berlin, *Per Kirkeby: Bilder aus der Berliner Zeit 1982* (1983), exh. cat.

Richard Shone, "London Exhibitions," *Burlington Magazine* (February 1983).

Alexander Dückers, *Erste Konzentration* (Munich, 1982).

Skulpturen und Objekte von Malern des 20. Jahrhunderts (Cologne, 1982).

Per Kirkeby, *Selected Essays from Bravura* (Eindhoven, 1982).

"Zeitgeist," *Kunstforum* (December 1982).

Johannes Gachnang, "New German Painting," *Flash Art* (February/March 1982).

Siegfried Gohr, "The Situation and the Artist," *Flash Art* (February/March 1982).

"Betrifft: Backsteinskulpturen," *Bauen und Wohnen* (December 1981).

Johannes Gachnang, "Vom Gesicherten zum Wesentlichen-Spaziergänge: Gedanken zur Kunst in Dänemark," *Bauen und Wohnen* (November 1981).

Ingrid Rein, "Ausstellung: 39. Biennale/Arte visive '80," *Pantheon* (October/December 1980).

John Hunov, *Per Kirkeby: Ouevre Katalog, 1958–1977* (Copenhagen, 1979).

Jürgen Morschel, "Kunstraum München: Ausstellung," *Kunstwerk* (August 1978).

Allan de Waal, Troels Anderson, and Per Hovdenakk, *Per Kirkeby: Norge Sverige Danmark 1975/76* (Copenhagen, 1975).

Erdbeben, 1983
oil on canvas
78 ¾ x 154 ⁵⁄₁₆ in. (200 x 392 cm.)
Courtesy of Mary Boone/Michael Werner
Gallery, New York

Per Kirkeby

Fenster Kreuz, 1985
oil on canvas
78 ¾ x 59 1/16 in. (200 x 150 cm.)
Collection of Mr. and Mrs. Milton Fine

Kristall Baum, 1985
oil on canvas
78¾ x 59¹⁄₁₆ in. (200 x 150 cm.)
Courtesy of Mary Boone/Michael Werner
Gallery, New York

Flugten Til Aegypten, 1985
oil on canvas
78¾ x 59¹⁄₁₆ in. (200 x 150 cm.)
Courtesy of Mary Boone/Michael Werner
Gallery, New York

Jannis Kounellis

Born 1936, Pireaus, Greece
Lives and works in Rome

On that sultry day in July 1932, a tortoise near the lake was explaining to a blackbird a collage of Schwitters: "Can you tell me which is more gothically vertical, a train ticket or Cologne cathedral?"

Before Schwitters came the Cubists, Schwitters lived in Hanover, the Cubists in Paris.

Paris . . . old friend!

The German traveller of that era can understand what the Spanish exiles gave to Paris (a stab in the belly for any one who speaks ill of exiles!). Schwitters lived in a fortress like Bosch; Brecht wrote "Bilbao"; the Expressionists' landscapes are African; Brecht dreams with melancholy of the lost German colonies in Africa; with the Expressionists, Africa is a reaction to Fauve paintings; and Schwitters continues to live inside the castle. The atmosphere of the Expressionists is of landscape; whereas the atmosphere of Schwitters is urban, dramatically objective and critical.

The blackbird, perched on a pine branch, said to the tortoise: "At the time of war, I remember that I was near the port. At that hour, the shops were closed, the pavements were deserted, and the sea was calm. At a certain moment, I saw a sailor and a woman. The woman said to the sailor, as they passed by me: "War, War!" They walked on and disappeared round the corner.

All of a sudden, the old eagle entered the scene, and said to the tortoise: "I knew Van Eyck, I saw the birth of Rubens, Rembrandt, de la Tour, Fragonard, Watteau, David, Delacroix, Manet, Renoir, Lautrec, Degas, Klimt, Boccioni, Burri, Fontana; now let me tell you about a work of mine which has not yet been carried out: what has always pleased me is the return of Ulysses to Ithaca and to Penelope. Some people say that the richness of the workmanship is a fault. It's obvious that those who uphold such a view have never seen the branches of Anatolia in Anatolia. Behind Buren's work lies Descartes, the funerary inscriptions from Alexandria have in their centuries-old veins the brilliance of the branches of Anatolia. In my head, I have thousands of voyages. When I return, I want to draw a black square on azure paper."

The tortoise, the blackbird, and the eagle are in fact a fountain in the Jewish quarter of Rome.

The Nike (Victory) who unlaces her sandal on the balustrades of the temple of Athena had a black band over her eyes. She was sitting next to me, that dramatic evening, in a Turkish café in Berlin. A handsome Polish poet was telling her about a mountain in spring, a stream, a plane tree, a rose, a little train, a border guard, the southern borders of the country. Unexpectedly the glass door of the café was opened violently. A man entered, wearing a raincoat and hat. The scene became yellow like Van Gogh's picture with crows. He looked closely at the customers' faces, went up to his friend the poet, pulled a knife out of his pocket and cut the poet's throat.

"HE-E-E-LP!"

A daisy floating in a puddle had cod-petals and a tomato heart.

A man was wearing a Japanese nightingale on his head, above the nightingale spiked on a pin a little elephant, above the elephant, decorated with parrot feathers, a dwarf ballerina.

A woman passing by: the complexion of her face was like a flower, her glasses stone, the black scarf she wore on her head revealed metal hair.

A student's blue hand held a lit paraffin lamp.

Into the severed leg of an old tramp they had incorporated the wheel of a train.

The glass sea like the desert had an oasis like a lake with palm trees and cacti.

The sky, pure as ever, has, since then, a hole in the direction of Ursa Minor.

On the left side of the picture, lit by a candle, sits Mario, painted in ochre and earth colours. On the shady background, in front of the corner, there is a Neapolitan bat dressed as Napoleon.

I remember that, six months ago, during a trip from Turin to Arles to visit Van Gogh's house, he told me that after leaving prison he suffered from nightmares and obsessions. Sensitivity, he told me, is an exile; it is enough to see Beuys's work in present-day Germany to understand this.

We share with the Mannerists the same prison island, in another period. But where, in reality, is our ship heading? Did Gauguin's ever arrive in Tahiti? Or that island in the Brittany of Delacroix's period. How many certainties did Giotto live?

The certainty of Giotto, the certainty of Cézanne.

The other, different, dramatically different is still Van Gogh.

Rimbaud's star, like the moon, is reflected in all the lakes of Europe.

We're arriving at Arles—at this time of year the Mistral blows, the corn will be high, Van Gogh's small two-storeyed house will be yellow; at this hour the café near the house will be open.

"How desperate this train and these speeches! Now we need a bottle of red wine and two women, one blue and one purple."

(Apollinaire! Apollinaire!)

Excerpt reprinted from Stedelijk Van Abbemuseum, Eindhoven, *Jannis Kounellis* (1981), exh. cat., 81–85. Used by permission.

Untitled, 1976
brick smokestack with traces of smoke on walls
and ceiling
173 ¼ x 34 ⅝ x 34 ⅝ in. (440 x 88 x 88 cm.)
Installation view at Salvatore Ala Gallery, Milan

1985 Carnegie International Installation
(see catalogue supplement)

Jannis Kounellis

Selected One-Artist Exhibitions

1985
Städtische Galerie im Lenbachhaus, Munich.

1984
Frederick S. Wight Art Gallery, University of California, Los Angeles.

Sonnabend Gallery, New York. Also 1983, 1980, 1974, 1973, 1972.

1983
Contemporary Museum, Rimini. Catalogue by Germano Celant.

1982
Staatliche Kunsthalle, Baden-Baden.

1981
Stedelijk Van Abbemuseum, Eindhoven (traveled to La Caixa, Madrid; Whitechapel Art Gallery, London). Catalogue.

1979
Museum Folkwang, Essen. Catalogue.

1978
Städtisches Museum, Mönchengladbach. Catalogue.

Galleria la Tartaruga, Rome. Also 1964, 1960.

1977
Boymans-van Beuningen Museum, Rotterdam.

Selected Group Exhibitions

1984
Overture, Castello di Rivoli, Turin.

1983
New Art at the Tate Gallery, 1983, The Tate Gallery, London. Catalogue by Michael Compton.

1982
Documenta VII, Kassel. Also 1977, *VI;* 1972, *V.* Catalogues.

Zeitgeist, Martin-Gropius-Bau, West Berlin. Catalogue with foreword by Christos Joachimides and Norman Rosenthal.

1981
Westkunst—Heute: Zeitgenössische Kunst seit 1939, Museen der Stadt Köln. Catalogue by Laszlo Glozer.

A New Spirit in Painting, Royal Academy of Art, London. Catalogue by Christos Joachimides, Norman Rosenthal, and Nicholas Serota, eds.

1980
La Biennale di Venezia. Also 1978, 1974.

1969
When Attitudes Become Form, Kunsthalle, Bern (traveled to Museum Haus Lange, Krefeld; Institute of Contemporary Arts, London).

1963
Schrift en Beeld, Stedelijk Museum, Amsterdam.

1961
XII Premio Lissone, Lissone, Italy.

Selected Bibliography

L. L. Ponti, "Domusinterviews: Jannis Kounellis," *Domus* (May 1984).

Germano Celant, "Collision and the Cry: Jannis Kounellis," *Artforum* (October 1983).

Marlis Grüterich, "Museum Folkwang Ausstellung: Jannis Kounellis," *Pantheon* (January 1980).

Robin White, "Interview at Crown Point Press," in *View,* vol. 2 (Oakland, California, 1979).

Marlis Grüterich, "Jannis Kounellis in Mönchengladbach," *Pantheon* (October/November/December 1978).

Germano Celant, "Jannis Kounellis," *Studio International* (January/February 1976).

Achille Bonita Oliva, *Europe-America: The Different Avant-gardes* (Milan, 1976).

Willoughby Sharp, "Structure and Sensibility: An Interview with Jannis Kounellis," *Avalanche* (Summer 1972).

G. E. Simonetti, "Jannis Kounellis," *Flash Art* (May/June 1972).

Jannis Kounellis, "Non per il teatro ma con il teatro," Siparo *(April 1969).*

————, "Pensieri e osservazioni (a cura di G. B.)," *Marcatré* (July/September 1968).

Germano Celant, "Arte Povera. Appunti per una Guerriglia," *Flash Art* (November/December 1967).

Mario Diancono, "Jannis Kounellis," *Bit* (March 1967).

Carlo Lonzi and Jannis Kounellis, "Interview," *Marcatré* (December 1966).

Sol LeWitt

Born 1928, Hartford, Connecticut
Lives and works in Spoleto, Italy

*Study for "A wall is divided vertically into four
parts...,"* 1985
graphite and construction paper on board
by Jo Watanabe
10 7/8 x 17 1/2 in. (27.6 x 44.5 cm.)
Courtesy of the artist

*A wall is divided vertically into four parts. All one-,
two-, and three-, and four-part combinations of
four colors,* 1985
India ink wash and colored ink wash
29 1/2 x 72 ft. (9 x 22 m.)
(see catalogue supplement)
Installation at Museum of Art, Carnegie Institute,
October 1985, by David Higgenbotham, Anthony
Sansotta, and Jo Watanabe
Courtesy of the artist

Sol LeWitt

Selected One-Artist Exhibitions
1984
Stedelijk Museum, Amsterdam; Stedelijk Van
Abbemuseum, Eindhoven; Wadsworth Atheneum,
Hartford. Catalogue by Susanna Singer, ed.

1981
Wadsworth Atheneum, Hartford.

1978
The Museum of Modern Art, New York (traveled to
Museum of Contemporary Art, Montreal; Krannert
Art Museum, University of Illinois, Champaign;
Museum of Contemporary Art, Chicago; La Jolla
Museum of Contemporary Art, La Jolla, California).
Catalogue by Alice Legg, ed., with essays by Lucy R.
Lippard, Bernice Rose, and Robert Rosenblum.

1977
Museum of Modern Art, Oxford.

1974
New York Cultural Center, New York (traveled to
Vancouver Art Gallery; Art Gallery of Ontario,
Toronto; Everson Museum of Art, Syracuse, New York;
High Museum of Art, Atlanta; San Francisco Museum
of Art; Mint Museum of Art, Charlotte; Tyler Museum
of Art, Tyler, Texas; Arkansas Arts Center, Little Rock;
Illinois State University, Normal; Winnipeg Art Gallery;
Johnson Museum of Art, Cornell University, Ithaca,
New York).

Stedelijk Museum, Amsterdam.

Rijksmuseum Kröller-Müller, Otterlo, The
Netherlands.

1970
Gemeentemuseum, The Hague. Catalogue by John N.
Chandler, Enno Develing, Dan Graham, et al.

Dwan Gallery, New York. Also 1968, 1966.

1965
Daniels Gallery, New York.

Selected Group Exhibitions
1984
La Grande Parade: Highlights in Painting After 1940,
Stedelijk Museum, Amsterdam. Catalogue with essay
by Edy de Wilde.

1982
Documenta VII, Kassel. Also 1977, *VI*; 1972, *V*; 1968,
IV. Catalogues.

1981
Westkunst—Heute: Zeitgenössische Kunst seit 1939,
Museen der Stadt Köln. Catalogue by Laszlo Glozer.

1979
Biennial Exhibition, Whitney Museum of American
Art, New York. Also 1967. Catalogues.

1976
Drawing Now, The Museum of Modern Art, New York
(traveled to Kunsthaus, Zurich; Staatliche Kunsthalle,
Baden-Baden; Albertina Museum, Vienna; Sonja
Henie-Niels Onstad Foundation, Oslo; Tel Aviv
Museum). Catalogue by Bernice Rose.

1975
Functions of Drawing, Rijksmuseum Kröller-Müller,
Otterlo, The Netherlands.

1968
The Art of the Real, The Museum of Modern Art, New
York (traveled to Grand Palais, Paris; Kunsthaus,
Zurich; The Tate Gallery, London). Catalogue by E. C.
Goossen.

1967
American Sculpture of the Sixties, Los Angeles County
Museum of Art (traveled to Philadelphia Museum of
Art). Catalogue by Maurice Tuchman, ed.

1966
Primary Structures, Jewish Museum, New York.
Catalogue with introduction by Kynaston McShine.

1964
Kaymar Gallery, New York.

Selected Bibliography
Peter Schjeldahl, in *Art of Our Time: The Saatchi
Collection*, vol. 4 (London, 1984).

Richard Armstrong, "Sol LeWitt," *Artforum* (March
1983).

John Carlin, "Sol LeWitt Wall Drawings: 1968–1981,"
Art Journal (Spring 1982).

Sol LeWitt, project for "Portfolio," *Artforum* (October
1981).

Joseph Mashek, "Hard-Core Painting," *Artforum*
(April 1978).

Thomas Hess, "Sol LeWitt and the Blizzard of Cubes,"
New York Magazine, 27 February 1978.

Michael Harvey, *Notes on the Wall Drawings of Sol
LeWitt* (Geneva, 1978).

Donald B. Kuspit, "Sol LeWitt: The Look of Thought,"
Art in America (September/October 1975).

Lawrence Alloway, "Sol LeWitt: Modules, Walls,
Books," *Artforum* (April 1975).

Roberta Smith, "Sol LeWitt," *Artforum* (January
1975).

Thomas Hess, "Sol LeWitt," *New York Magazine*, 18
November 1974.

Paul Bianchini, ed., *Sol LeWitt, Work from 1962 to
1974* (Lausanne, 1974).

Robert Pincus-Witten, "Sol LeWitt: Word Object,"
Artforum (February 1973).

Jeanne Siegel, "Sol LeWitt: 46 Variations Using Three
Different Kinds of Cubes," *Arts Magazine* (February
1968).

Robert Smithson, "Entropy and the New
Monuments," *Artforum* (June 1966).

Mel Bochner, "Primary Structures," *Arts Magazine*
(May 1966).

Robert Longo

Born 1953, Brooklyn
Lives and works in New York

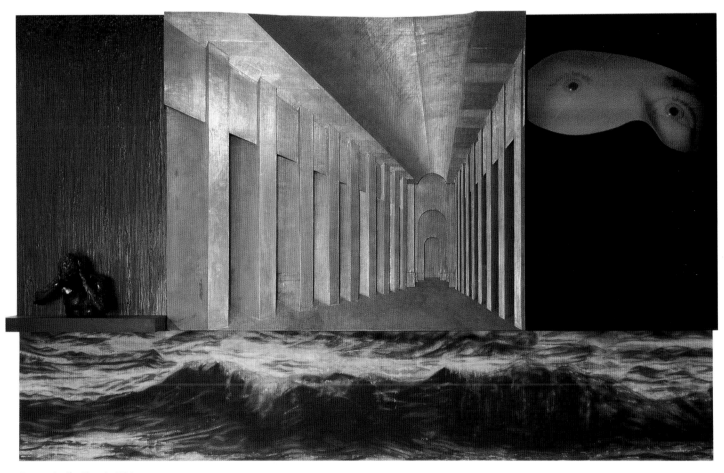

Tongue to the Heart, 1984
acrylic and oil on wood, cast plaster, hammered
lead on wood, durotran, and acrylic on canvas
136 x 216 x 25 in. (345.4 x 548.6 x 63.5 cm.)
Saatchi Collection, London

Tongue to the Heart

Screens of images in the weight of pictures.

The coordinates of meaning, to a network of unknowns.

Memory as an opera set in a wall of sound.

Falling apart in a world of special effects, the pressure to paint.

A glance from a corner entrance, hesitant to enter into a room where decisions made could make us all live in lead rooms.

In the eyes of a pilot flying at such speed that he can see god.

The waves rumbling in with the base notes of thunder.

Imagine kissing someone so deeply, you are caressing their heart.

Wanting as an object.

Still

Telescoping meaning, jerking me into time, in the arrangement of DNA, in the structure of a sentence, a clue to a crime.

Here's my heart.

In a view from a pillow.

Liftoff and drop.

Reflections trapped in a dead force.

The space of love lost in the wing span of a condor.

Joy Division. From nature undone.

Still pictures, still bodies.

Still life, still waiting.

Still as an object.

Selected One-Artist Exhibitions

1985
University of Iowa Museum of Art, Iowa City. Catalogue by Robert Hobbs.
The Brooklyn Museum.

1984
Larry Gagosian Gallery, Los Angeles. Also 1981.
Metro Pictures, New York. Also 1983, 1981.
Akron Art Museum. Catalogue by Hal Foster.

1983
Galerie Schellmann and Kluser, Munich.
Leo Castelli Gallery, New York.

1982
Texas Gallery, Houston.
The Kitchen, New York. Also 1979, 1977.

1976
Hallwalls, Buffalo.

Selected Group Exhibitions

1984
The Heroic Figure, Contemporary Arts Museum, Houston (traveled to Memphis Brooks Museum of Art, Memphis; Alexandria Museum, Alexandria, Louisiana; Santa Barbara Museum of Art; Museu de Arte Moderna, Rio de Janeiro; Museo Nacional de Bellas Artes, Santiago; Museo de Arte Contemporáneo, Caracas). Catalogue with essays by Linda Cathcart and Craig Owens.

An International Survey of Recent Painting and Sculpture, The Museum of Modern Art, New York. Catalogue by Kynaston McShine.

1983
Dahn, Daniels, Genzken, Holzer, Longo, Visch, Stedelijk Van Abbemuseum, Eindhoven. Catalogue by Rudi Fuchs.

New Art at the Tate Gallery, 1983, The Tate Gallery, London. Catalogue by Michael Compton.

Biennial Exhibition, Whitney Museum of American Art, New York. Catalogue.

1982
Documenta VII, Kassel. Catalogue.

1981
Westkunst—Heute: Zeitgenössische Kunst seit 1939, Museen der Stadt Köln. Catalogue by Laszlo Glozer.

1980
Extensions: Jennifer Bartlett, Lynda Benglis, Robert Longo, Judy Pfaff, Contemporary Arts Museum, Houston. Catalogue by Linda Cathcart.

1976
Convergence and Dispersal, S. E. M. Festival, Albright-Knox Art Gallery, Buffalo.

1975
Working on Paper, Hallwalls, Buffalo.

Selected Bibliography

Carter Ratcliff, *Robert Longo* (New York, 1985).

Grace Glueck, "The Very Timely Art of Robert Longo," *New York Times,* 10 March 1985.

Maurice Berger, "The Dynamics of Power: An Interview with Robert Longo," *Arts Magazine* (January 1985).

Mark Rosenthal, in *Art of Our Time: The Saatchi Collection,* vol. 4 (London, 1984).

Hunter Drohojowska, "The 'Spectacles' of Robert Longo," *Los Angeles Weekly,* 9 November 1984.

The Tate Gallery, London, *Robert Longo Talking About the Sword of the Pig* (1984), exh. cat. by Richard Francis.

Peter Schjeldahl, "Vanity Fair Notes: Robert Longo," *Vanity Fair* (May 1983).

Carter Ratcliff, "Robert Longo," *Interview Magazine* (April 1983).

Robert Pincus-Witten, "Defenestrations: Robert Longo and Russ Bleckner," *Arts Magazine* (November 1982).

Barry Blinderman, "Robert Longo's 'Men in the Cities': Quotes and Commentary," *Arts Magazine* (March 1981).

William Zimmer, "Robert Longo: Metro Pictures," *Soho Weekly News,* 21 January 1981.

Jeanne Siegel, "Lois Lane and Robert Longo: Interpretation of Image," *Arts Magazine* (November 1980).

Craig Owens, "The Allegorical Impulse: Toward a Theory of Postmodernism, Parts I and II," *October* (Spring 1980).

Brooke Alexander, Inc., New York, *Illustration and Allegory* (1980), exh. cat. by Carter Ratcliff.

Howard Fox, "Desire for Pathos: The Art of Robert Longo," *Sun and Moon* (Fall 1979).

Artists Space, New York, *Pictures* (1977), exh. cat. by Douglas Crimp.

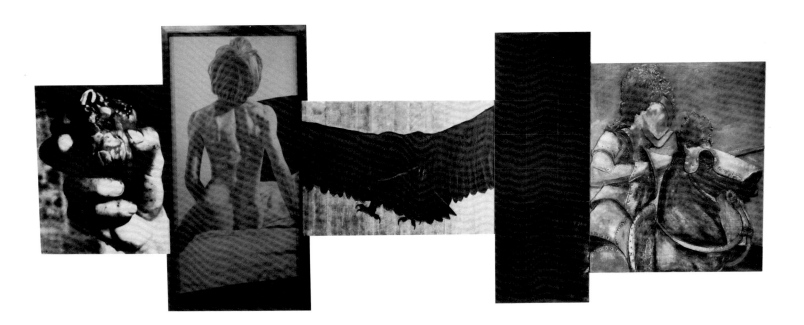

Still, 1984
acrylic and silkscreen on wood; charcoal and
graphite on dyed paper; oil and copper leaf
on carved oak; granite and metal; oil on
hammered lead
96 x 288 in. (243.8 x 731.5 cm.), overall
The Edward R. Broida Trust, Los Angeles

Markus Lüpertz

Born 1941, Reichenberg, Bohemia (now Liberec, Czechoslovakia)
Lives and works in West Berlin, Karlsruhe, and Milan

I believe that I, or my generation, have absolutely nothing in common with Expressionism. It is true that Expressionism was the last German painting style to gain wide recognition before the beginning of the Third Reich. But Expressionist themes had to do with weltschmerz, presentiments of war, fears of existence. I belong to a generation which doesn't know these feelings. I do not have fears of existence, I do not fear a nuclear war, I do not fear death. All this is alien to me, because I subscribe to an ideology of art which claims the eternal, the ingenious, the elitist, the deliberately self-conscious, everything which is above the common. The generation after mine, however, has all these fears, and that is where the circle closes itself again. My generation finds its definition, inspiration, and motivation in art. That attitude may not be very popular nowadays and may contribute to misunderstanding or a total misconception. People make it too easy for themselves when they equate violent gestures and a harsh application of paint with Expressionism. They only look at the surface and its structure, but never beyond that. I'll never understand either why Expressionism in painting has never been studied to the same extent as Expressionism in literature—especially astonishing, as the protagonists are dead and now are historical figures. But as far as this "Neo-Expressionism" is concerned, perhaps because Expressionism came from Germany, they classify the first art which comes from Germany again as Expressionism. . . .

To repeat something so that you can't tell it apart from the original, that is an adventure. That is an attack on painting. I have never disdained painting, I have never stopped painting, instead I have always attacked it, sometimes by exaggeration. Repetition of a gestural painting is also a very specific type of discipline. It is testing of my abilities. . . .

The repetitions were my answer to the principle of variation. Variations are a classical principle. Today I tend to work more with variations. At that time it was more a testing of the spirit of the time to find an answer to "Multiple Art." I always open myself to new influences, but I always try to find a position which is mine. . . .

Now there are many paintings again. Then, paintings themselves constituted an exaggeration. I made extremely large paintings. Perhaps these types of provocation are no longer necessary. I have shifted them to other aspects. Now I change the picture surface, the color. There are always ways of seeing which one can interrupt. There are provocations which still seem possible today, as, for example, a very specific quality of painting. . . .

Excerpts from "A Conversation with Markus Lüpertz" by Dorothea Dietrich. Reprinted from *The Print Collector's Newsletter* (March/April 1983): 9–12. Used by permission.

Selected One-Artist Exhibitions

1984
Waddington Galleries, London. Catalogue. Also 1983, 1981 (catalogue by Tony Godfrey).

Galerie Michael Werner, Cologne. Catalogue by Wieland Schmied. Also 1983 (catalogue by Wieland Schmied), 1982 (catalogue by Jiri Svestka), 1981, 1979, 1978 (catalogue), 1977, 1976 (catalogue), 1975, 1974.

1983
Kestner Gesellschaft, Hanover. Catalogue by Carl Haenlein, ed.

Stedelijk Van Abbemuseum, Eindhoven. Catalogue by Rudi Fuchs, Johannes Gachnang, and Siegfried Gohr.

1979
Whitechapel Art Gallery, London. Catalogue by Nicholas Serota and Siegfried Gohr.

Josef-Haubrich-Kunsthalle, Cologne. Catalogue by Siegfried Gohr.

1977
Kunsthalle, Hamburg. Catalogue by Werner Hofmann and Siegmar Holsten.

Kunsthalle, Bern. Catalogue by Theo Kneubühler, Johannes Gachnang, and Marianne Schmidt.

1973
Staatliche Kunsthalle, Baden-Baden. Catalogue by Klaus Gallwitz and George Tabori.

1969
Galerie Hake, Cologne. Also 1968.

1966
Galerie Grossgörschen 35, Berlin. Also 1964.

Selected Group Exhibitions

1984
An International Survey of Recent Painting and Sculpture, The Museum of Modern Art, New York. Catalogue by Kynaston McShine.

1983
New Art at the Tate Gallery, 1983, The Tate Gallery, London. Catalogue by Michael Compton.

Expressions, New Art from Germany, The Saint Louis Art Museum (traveled to P. S. 1, Long Island City, New York; Institute of Contemporary Art, University of Pennsylvania, Philadelphia; The Contemporary Arts Center, Cincinnati; Museum of Contemporary Art, Chicago; Newport Harbor Art Museum, Newport Beach, California; Corcoran Gallery of Art, Washington, D.C.). Catalogue by Jack Cowart, Siegfried Gohr, and Donald B. Kuspit.

De Statua, Stedelijk Van Abbemuseum, Eindhoven. Catalogue.

1982
Zeitgeist, Martin-Gropius-Bau, West Berlin. Catalogue with foreword by Christos Joachimides and Norman Rosenthal.

Documenta VII, Kassel. Also 1977, *VI* (artist withdrew from exhibition). Catalogues.

1981
A New Spirit in Painting, Royal Academy of Arts, London. Catalogue by Christos Joachimides and Norman Rosenthal, eds.

1979
Werke aus der Sammlung Crex, InK, Zurich (traveled to Louisiana Museum, Humlebaek, Denmark; Stedelijk Van Abbemuseum, Eindhoven; Städtische Galerie im Lenbachhaus, Munich). Catalogue with essay by Christel Sauer.

1978
13° East—Eleven Artists Working in Berlin, Whitechapel Art Gallery, London. Catalogue.

1969
14 mal 14: Eskalation, Staatliche Kunsthalle, Baden-Baden. Catalogue by Klaus Gallwitz.

Selected Bibliography

Peter Winter, "Markus Lüpertz Bilder 1970–1983," *Kunstwerk* (November 1983).

Antje von Graevenitz, "Eindhoven, Stedelijk Van Abbemuseum, Markus Lüpertz," *Pantheon* (April/May/June 1983).

A. Dagbert, "Markus Lüpertz," *Art Press* 62 (1982).

Ross Skoggard, "Markus Lüpertz at Marian Goodman," *Art in America* (February 1982).

Wolfgang Max Faust and Gerd de Vries, *Hunger nach Bildern: Deutsche Malerei der Gegenwart* (Cologne, 1982).

Robert J. Harding, "M. Lüpertz Interview," *Art World* VI, 4 (1980/81).

Marlis Grüterich, "Markus Lüpertz, Gemälde und Handzeichnungen 1964 bis 1979. Josef Haubrich Kunsthalle Köln," *Pantheon* (April/May/June 1980).

Hanno Reuther, "Markus Lüpertz. Kunsthalle Köln," *Kunstwerk* XXXIII, 2 (1980).

Siegfried Gohr, "Markus Lüpertz, le jeu de l'ironie," *Art Press* (September 1980).

Marlis Grüterich, "Markus Lüpertz. Kunsthalle Köln, bis 13. Januar 1980," *Kunstforum International* XXXVI, 6 (1979).

Jörg Zutter, "Drie vertegenwoordigers van een nieuwe Duitse schilderkunst. Opmerkingen bij het werk van Georg Baselitz, Markus Lüpertz en Anselm Kiefer," *Museumsjournaal* XXIII, 2 (1978).

Theo Kneubühler, "Malerei als Wirklichkeit—Baselitz, Kiefer, Lüpertz, Penck," *Kunst-Bulletin des Schweizerischen Kunstvereins* XI, 2 (1978).

Peter Winter, "Markus Lüpertz. Hamburger Kunsthalle," *Kunstwerk* (June 1983).

Walter Ehrmann, "Markus Lüpertz, Bemerkungen zum Problem Identität bei Markus Lüpertz," *Kunstforum International* XX, 2 (1977).

Markus Lüpertz, "Dithyramben, die die Welt verändern," *Magazin Kunst* XIII, 50 (1973).

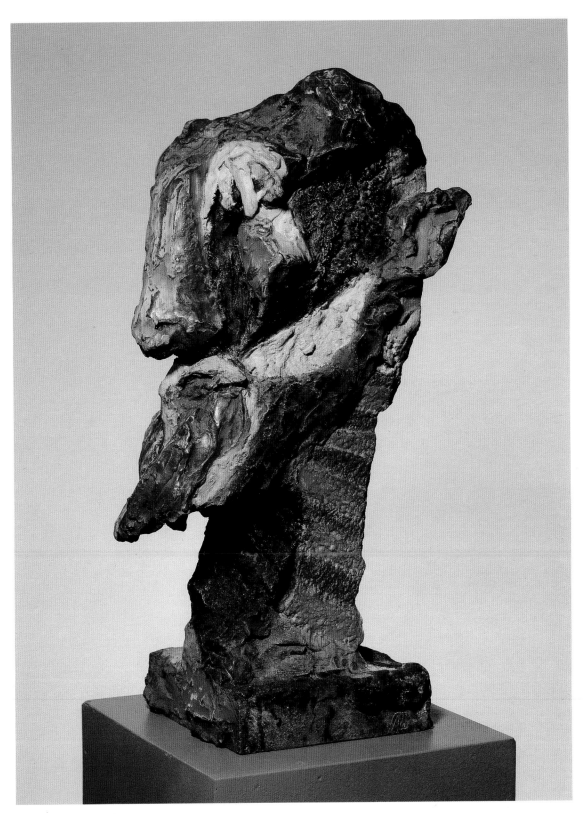

Die Bürger von Florenz: B.C., 1983
painted bronze
23 ⅝ x 13 ⅞ x 9 1/16 in. (60 x 35 x 23 cm.)
Courtesy of Mary Boone/Michael Werner
Gallery, New York

Markus Lüpertz

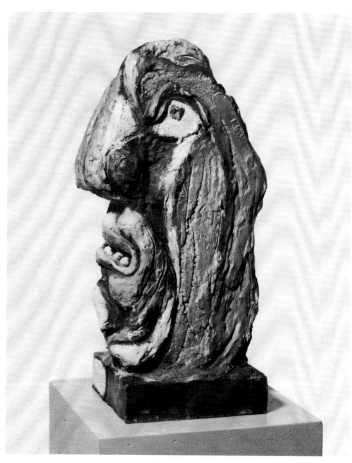

Die Bürger von Florenz: Il Principe, 1983
painted bronze
19 ¼ x 8 ⅛ x 9 ½ in. (49 x 19.5 x 24 cm.)
Courtesy of Mary Boone/Michael Werner
Gallery, New York

Die Bürger von Florenz: Der Medici, 1983
painted bronze
21 ¼ x 12 ½ x 11 in. (54 x 32 x 38 cm.)
Courtesy of Mary Boone/Michael Werner
Gallery, New York

Die Bürger von Florenz: Der Mohr, 1983
painted bronze
17 ⅞ x 8 ⅛ x 12 ½ in. (45 x 19.5 x 32 cm.)
Courtesy of Mary Boone/Michael Werner Gallery,
New York

Die Bürger von Florenz: Tourist, 1983
painted bronze
12 ½ x 12 ½ x 8 ⅝ in. (32 x 32 x 22 cm.)
Courtesy of Mary Boone/Michael Werner
Gallery, New York

Markus Lüpertz

Die Bürger von Florenz: S, 1983
painted bronze
19 ¼ x 11 ½ x 11 ½ in. (49 x 29 x 29 cm.)
Courtesy of Mary Boone/Michael Werner Gallery,
New York

The Black Phoenix, 1983
painted bronze
17 ⁵⁄₁₆ x 8 ¹¹⁄₁₆ x 7 ½ in. (44 x 22 x 19 cm.)
Courtesy of Mary Boone/Michael Werner
Gallery, New York

Robert Mangold

Born 1937, North Tonawanda, New York
Lives and works in New York

Two Color Frame Painting, 1984
acrylic and pencil on canvas
99 x 72 in. (252 x 183 cm.)
Stedelijk Museum, Amsterdam

Selected One-Artist Exhibitions

1984

Akron Art Museum (traveled to Albright-Knox Art Gallery, Buffalo; Contemporary Arts Museum, Houston; La Jolla Museum of Contemporary Art, La Jolla, California; University Art Museum, University of California, Berkeley; Neuberger Museum, State University of New York, Purchase). Catalogue by Marcianne Herr and Susanna Singer, eds., with essays by Mark Stevens and I. Michael Danoff.

Institute of Contemporary Art, Boston. Pamphlet by Elisabeth Sussman.

1982

Stedelijk Museum, Amsterdam. Publication: Alexander van Grevenstein and Susanna Singer, *Robert Mangold—Paintings 1964–1982.*

1980

Kunsthalle, Bielefeld. Catalogue.

1977

Kunsthalle, Basel. Catalogue.
Museum Haus Lange, Krefeld.

1974

La Jolla Museum of Contemporary Art, La Jolla, California. Catalogue with introduction by Naomi Spector.

1973

Fischbach Gallery, New York. Also 1971, 1970, 1969, 1967, 1965.

1971

The Solomon R. Guggenheim Museum, New York. Catalogue by Diane Waldman.

Selected Group Exhibitions

1985

Biennial Exhibition, Whitney Museum of American Art, New York. Also 1983, 1979. Catalogues.

1984

La Grande Parade: Highlights in Painting After 1940, Stedelijk Museum, Amsterdam. Catalogue with essay by Edy de Wilde.

La Rime et la Raison: Les Collections Menil, Grand Palais, Paris. Catalogue.

1983

Minimalism to Expressionism: Painting and Sculpture Since 1965 from the Permanent Collection, Whitney Museum of American Art, New York.

Concepts in Construction: 1910–1980 (organized by Independent Curators Incorporated; traveled to Tyler Museum of Art, Tyler, Texas; Norton Gallery and School of Art, West Palm Beach; Bass Museum of Art, Miami Beach; Cincinnati Art Museum; Alberta College of Art Gallery, Calgary; Norman Mackenzie Art Gallery, University of Regina; Anchorage Historical and Fine Arts Museum, Anchorage; Long Beach Museum of Art, Long Beach, California; Palm Springs Desert Museum, Palm Springs, California; Neuberger Museum, State University of New York, Purchase).

1982

Documenta VII, Kassel. Also 1977, *VI;* 1972, *V.* Catalogues.

1979

Selections/Permanent Collection, Los Angeles Museum of Contemporary Art.

1978

American Painting of the 1970's, Albright-Knox Art Gallery, Buffalo (traveled to Newport Harbor Art Museum, Newport Beach, California; The Oakland Museum, Oakland, California; Cincinnati Art Museum; Art Museum of South Texas, Corpus Christi; Krannert Art Museum, University of Illinois, Champaign). Catalogue by Linda Cathcart.

1966

Systemic Painting, The Solomon R. Guggenheim Museum, New York. Catalogue by Lawrence Alloway with statement by Robert Mangold.

Selected Bibliography

Robert Berlind, "Robert Mangold: Nuanced Deviance," *Art in America* (May 1985).

Peter Schjeldahl, in *Art of Our Time: The Saatchi Collection,* vol. 1 (London, 1984).

Robert Mangold, cover and centerfold, *Artforum* (Summer 1982).

John Russell, "Robert Mangold," *New York Times,* 19 March 1982.

John Weber Gallery, New York, *Robert Mangold Painting for Three Walls* (1980), exh. cat. with essay by Naomi Spector.

Mark Stevens, "Beautiful Deceptions," *Newsweek,* 24 March 1980.

Robin White, "Interview with Robert Mangold," *View,* vol. I (Oakland, California, 1978).

Joseph Mashek, "A Humanist Geometry," *Artforum* (March 1974).

Rosalind Kraus, "Robert Mangold: An Interview," *Artforum* (March 1974).

Harris Rosenstein, "To Be Continued," *Art News* (October 1970).

Mel Bochner, "A Compilation for Robert Mangold," *Art International* (April 1968).

Lucy R. Lippard, "The Silent Art," *Art in America* (January/February 1967).

———, "Robert Mangold and the Implications of Monochrome," *Art and Literature* 9 (1966).

Four Color Frame Painting No. 6, 1984
acrylic and pencil on canvas
99 x 72 in. (252 x 183 cm.)
Collection of Gerald S. Elliott

Robert Mangold

Four Color Frame Painting No. 9, 1984
acrylic and pencil on canvas
115 x 77 ½ in. (292.1 x 196.8 cm.)
Collection of Paul and Camille Oliver-Hoffman

Four Color Frame Painting No. 10, 1985
acrylic and pencil on canvas
110 x 80 in. (279.4 x 203.2 cm.)
Private collection

Brice Marden

Born 1938, Bronxville, New York
Lives and works in New York

Green (Earth), 1983—84
oil on canvas
84 x 109 in. (213.4 x 276.9 cm.)
Private collection, courtesy of The Pace Gallery,
New York

Write about the edge as the place where we go from one to another, or stay still.

How going from one to another can move in rhythms.

Taking some thing through, one to another.

The edge: the balancing point

Standing on the edge, staring straight into space, watching the spaces on the periphery, trying to encompass the whole.

What is the name of that place, the infini-tesimal hinge between.

Wanting to show the whole of it.

Excerpt reprinted from Whitechapel Art Gallery, London, *Brice Marden: Paintings, Drawings and Prints* (1981), exh. cat.

Selected One-Artist Exhibitions

1985
Daniel Weinberg Gallery, Los Angeles.

1984
Pace Gallery, New York. Also 1982, 1980, 1978 (catalogue by Jean Claude Lebanszlejn).

1981
Whitechapel Art Gallery, London. Catalogue with essays by Roberta Smith and Stephen Bann.

1980
Galerie Konrad Fischer, Düsseldorf. Also 1975, 1973, 1972, 1971.

1979
Kunstraum, Munich (traveled to Institut für Moderne Kunst, Nuremberg). Catalogue by Klaus Kertess and Hermann Kern.

1975
The Solomon R. Guggenheim Museum, New York. Catalogue by Linda Shearer.

1974
Bykert Gallery, New York. Also 1973, 1972, 1970, 1969, 1968, 1966.

Contemporary Arts Museum, Houston (traveled to Loretta-Hilton Gallery, St. Louis; Bykert Gallery, New York; Fort Worth Art Museum; Minneapolis Institute of Arts). Catalogue with introduction by Dore Ashton.

1973
Galerie Yvon Lambert, Paris. Also 1969.

1963
Wilcox Gallery, Swarthmore College, Swarthmore, Pennsylvania.

Selected Group Exhibitions

1981
A New Spirit in Painting, Royal Academy of Arts, London. Catalogue by Christos Joachimides, Norman Rosenthal, and Nicholas Serota, eds.

1977
Biennial Exhibition, Whitney Museum of American Art, New York. Also 1973. Catalogues.

1976
Drawing Now, The Museum of Modern Art, New York (traveled to Kunsthalle, Zurich; Staatliche Kunsthalle, Baden-Baden; Albertina Museum, Vienna; Sonja Henie-Niels Onstad Foundation, Oslo; Tel Aviv Museum). Catalogue by Bernice Rose.

1975
Brice Marden, David Novros, Mark Rothko, Institute for the Arts, Rice University, Houston. Catalogue by Sheldon Nodelman.

Fundamentele Schilderkunst/Fundamental Painting, Stedelijk Museum, Amsterdam. Catalogue by Rini Dippel.

1974
Eight Contemporary Artists, The Museum of Modern Art, New York. Catalogue by Jennifer Licht.

1972
Documenta V, Kassel. Catalogue.

1971
The Structure of Color, Whitney Museum of American Art, New York. Catalogue by Marcia Tucker.

1970
1969 Annual Exhibition: Contemporary American Painting, Whitney Museum of American Art, New York. Catalogue with foreword by John I. H. Baur.

1968
Rejective Art (organized by The American Federation of the Arts; traveled to University of Omaha; Museum of Fine Arts, Houston; School of Architecture, Clemson University, Clemson, South Carolina).

1960
The Second Competitive Drawing Exhibition, Lyman Allyn Museum, New London, Connecticut.

Selected Bibliography

Robert Storr, "Brice Marden: Double Vision," *Art in America* (March 1985).

Maurice Poirer, "Color-Coded Mysteries," *Art News* (January 1985).

Peter Schjeldahl, in *Art of Our Time: The Saatchi Collection,* vol. 1 (London, 1984).

Robin White, "Brice Marden Interview," *View* III, 2 (1980).

Edit de Ak, et al., "Conversation with Brice Marden," *Art Rite* (Spring 1975).

Brice Marden, "Three Deliberate Grays for Jasper Johns," *Art Now: New York* (March 1971).

Carl Andre, "New in New York: Line Work," *Arts Magazine* (May 1967).

Stephen Bann, "Adriatics à propos of Brice Marden," *Twentieth Century* Studies 15/16 (1976).

Carter Ratcliff, "Abstract Painting, Specific Spaces: Novros and Marden in Houston," *Art in America* (September/October 1975).

Mel Ramsden, "Jeremy Gilbert Rolfe's as Silly as You Can Get Brice Marden's Painting," *The Fox* (April 1975).

Brice Marden, *Suicide Notes* (Lausanne, 1974).

Jeremy Gilbert-Rolfe, "Brice Marden's Paintings," *Artforum* (October 1974).

Roberta Smith, "Brice Marden's Paintings," *Arts Magazine* (May/June 1973).

Robert Pincus-Witten, "Ryman, Marden, Manzoni: Theory, Sensibility, Mediation," *Artforum* (June 1972).

John Ashbery, "Gray Eminence," *Art News* (March 1972).

Lucy R. Lippard, "The Silent Art," *Art in America* (January/February 1967).

Elements III, 1983–84
oil on canvas
84 x 36 in. (213.4 x 91.4 cm.)
Collection of Douglas S. Cramer

Brice Marden

Number One, 1983–84
oil on canvas
84 x 109 in. (213.4 x 276.9 cm.)
Whitney Museum of American Art, New York;
Purchase with funds from the Julia B. Engel
Purchase Fund

Elements IV, 1983–84
oil on canvas
84 x 72 ½ in. (213.4 x 184.2 cm.)
Collection of Linda and Harry Macklowe

Malcolm Morley

Born 1931, London
Lives and works in New York

I think that oil painting is to painters like the theatre is to actors and that acrylic is like the movies for actors. So that there's a certain fear about oil painting and its association . . . I didn't realize I was actually doing turpentine paintings. It was really turpentine which I've more or less eliminated, I don't use much liquid. I use it in a very pasty way, so I'm trying to not change the nature of the materials, but rather work with the nature of the material. It's a continuous invention going on in terms of looking at something very exactly and you can't really, as somebody mentioned, copy anything because you're having to translate it into another medium altogether. From watercolour to oil paint.

I pick up these tonal shifts in the watercolour that give the illusion of transparency in the painting, but the surface actually is quite opaque. It's just some kind of tonal fidelity that gives that illusion in some of the paintings.

The way I like to use the paint is pasty and opaque, so that it doesn't spread out a long way and it allows me to build a sort of a pasty surface without stretching the paint too far, because it deoxidises within a few minutes. It starts actually to develop a skin in a half an hour. In an hour you'd get a skin on the paint. So this way of painting guarantees the freshness of the paint, which is another plus. I started finding lots of benefits that I hadn't originally . . . the necessity of dividing the whole up into parts was to be able to perceive it in manageable bits. But then I began to find out that there were other kinds of advantages in all of this. One is to do with the actual chemical structure of oil paint. That it's really technically very good to paint like this, because it's all wet and wet. There's no painting wet paint on top of semi-drying paint. I didn't decide to make painting that way in order to guarantee the longevity of the surface. It just happened to be a by-product of that.

One of the things about the brush stroking in these early pictures is when I first painted them I suppose they were the first original superrealist. It is the term I used, as against photorealist, a term that was invented by an art critic's wife who was rather a mediocre painter. When the other guys came up afterwards with their air brushes and the critics start to say, "you know, those Morley paintings are not very real at all, they're quite brush strokey and you should see these other pictures which are really real, you know, sort of air brush not made by human hand." It never was my intention to make that kind of painting. My intention was to make a painting, a brush stroke painting.

Well, what is abstract, you know, for me all painting is abstract. The idea of whether there was a figure or not is a figure of speech. I mean, it's linguistic, plastic linguistic. It's like a language. You might think of it being able to decipher these marks. It suggests the idea that it is a language, that it does have a structure and that you might learn the language and make something out of that. It's a sort of pseudolanguage. It's the first digital sort of effect, rather than analogue painter which is the abstract expressionism overallness. It's beginning to break down into its individual parts and also it refers to music and in a way, the way I make paintings is very much like music. In a sense that every mark is made in the immediate moment without regard to the past or the future. They all exist autonomously in and of themselves, so this in a way is like the bars, you know like a music structure that you'd see.

Excerpts from an interview with Malcolm Morley by Mike Mortimer for BBC Television, 1985.

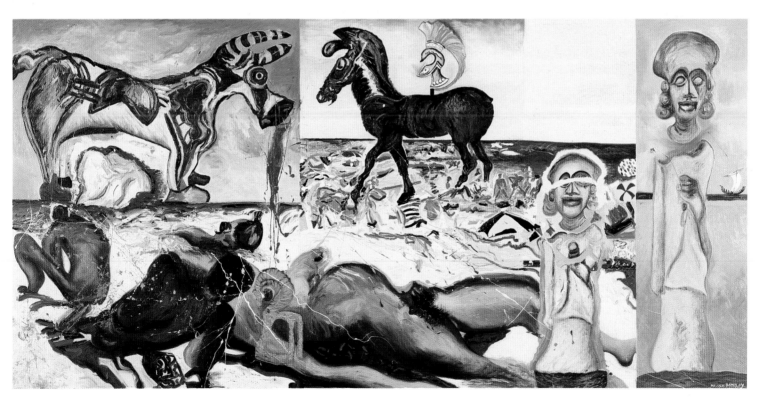

Farewell to Crete, 1984
oil on canvas
80 x 164 in. (203.2 x 416.6 cm.)
Saatchi Collection, London

Selected One-Artist Exhibitions

1985
Fabian Carlsson Gallery, London.

1984
Xavier Fourcade, Inc., New York. Catalogue. Also 1982, 1981.

1983
Whitechapel Art Gallery, London (traveled to Kunsthalle, Basel; Museum Boymans-van Beuningen, Rotterdam; Corcoran Gallery of Art, Washington, D.C.; Museum of Contemporary Art, Chicago; The Brooklyn Museum). Catalogue with text by Michael Compton.

1981
Akron Art Museum.

1980
Wadsworth Atheneum, Hartford, Connecticut. Catalogue.

1979
Nancy Hoffman Gallery, New York.

1977
Galerie Jollenbeck, Cologne.

1976
The Clocktower, Institute for Art and Urban Resources, New York. Catalogue.

1974
Stefanotty Gallery, New York. Also 1973.

1973
Galerie Gerald Piltzer, Paris.

1969
Kornblee Gallery, New York. Also 1967, 1964, 1957.

Selected Group Exhibitions

1984
Exhibition of Candidates for the First Annual Turner Prize, The Tate Gallery, London.

An International Survey of Recent Painting and Sculpture, The Museum of Modern Art, New York. Catalogue by Kynaston McShine.

1983
New Art at the Tate Gallery, 1983, The Tate Gallery, London. Catalogue by Michael Compton.

American Still Life: 1945–1983, Contemporary Arts Museum, Houston (traveled to Albright-Knox Art Gallery, Buffalo; Columbus Museum of Art; Neuberger Museum, State University of New York, Purchase; Portland Art Museum, Portland, Oregon). Catalogue.

1982
Zeitgeist, Martin-Gropius-Bau, West Berlin. Catalogue with foreword by Christos Joachimides and Norman Rosenthal.

1981
A New Spirit in Painting, Royal Academy of Arts, London. Catalogue by Christos Joachimides, Norman Rosenthal, and Nicholas Serota, eds.

1977
Documenta VI, Kassel. Also 1972, V. Catalogues.

British Painting 1952–1977, Royal Academy of Arts, London.

1970
22 Realists, Whitney Museum of American Art, New York.

1967
Bienal de São Paulo.

1966
The Photographic Image, The Solomon R. Guggenheim Museum, New York.

Selected Bibliography

John Yau, "Malcolm Morley," *Flash Art* (April/May 1985).

Matthew Collings, "The Happy Return: Malcolm Morley," *Artscribe* (January/February 1985).

Anthony Haden-Guest, "Art's New Wonder Boy," *London Telegraph Sunday Magazine,* 29 July 1984.

Hilton Kramer, in *Art of Our Time: The Saatchi Collection,* vol. 3 (London, 1984).

Roberta Smith, "Eros is Eros is Eros," *The Village Voice,* 27 March 1984.

Robert Hughes, "Haunting Collisions of Imagery," *Time,* 5 March 1984.

William Zimmer, "Malcolm Morley's Circuitous Route to Expressionism," *New York Times,* 12 February 1984.

Adrian Lewis, "Morley and Modernism," *Art Monthly* (October 1983).

Hilton Kramer, "The Malcolm Morley Retrospective," *The New Criterion* (September 1983).

Paul Richard, "Less Isn't Morley: At Corcoran, Paintings of Rage and Precision," *Washington Post,* 10 September 1983.

Klaus Kertess, "Malcolm Morley: Talking About Seeing," *Artforum* (Summer 1980).

Les Levine, "Dialogue: Malcolm Morley," *Cover* (Spring/Summer 1980).

Valentin Tatransky, "Morley's New Paintings," *Art International* (October 1979).

Kim Levin, "Malcolm Morley, Post Style Illusionism," *Arts Magazine* (February 1973).

Lawrence Alloway, "Malcolm Morley," *Unmuzzled Ox* IV, 2 (1976).

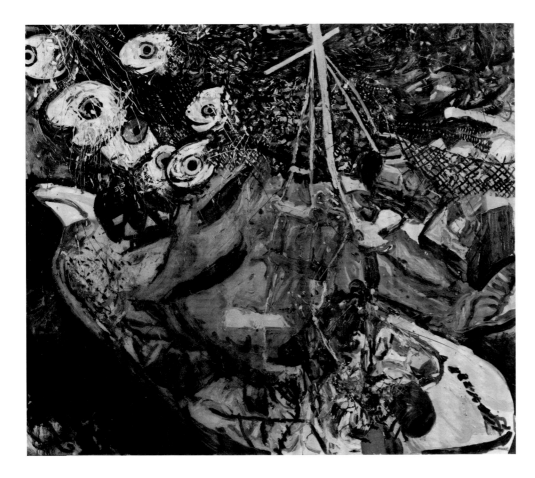

Day Fishing in Heraklion, 1983
oil on canvas
80 x 90 in. (203.2 x 228.6 cm.)
Private collection, courtesy of Xavier Fourcade,
Inc., New York

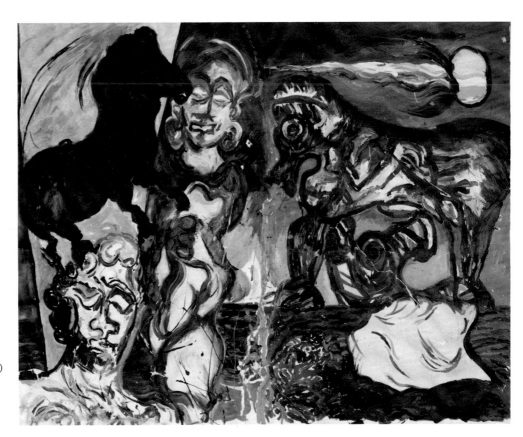

Albatross, 1985
oil on canvas
72 x 90 in. (182.9 x 228.6 cm.)
Collection of Gerald S. Elliott

Malcolm Morley

The Sky Above, The Mud Below, 1984
oil on canvas
85 x 60 in. (215.9 x 152.4 cm.)
Collection of Mr. and Mrs. Gilbert H. Kinney

Bruce Nauman

Born 1941, Fort Wayne, Indiana
Lives and works in Pecos, New Mexico

Study for "Having Fun/Good Life/Symptoms,"
1984
acrylic, pencil, and collage on paper
68½ x 131 in. (174 x 332.8 cm.)
Courtesy of Sperone Westwater, New York

Having Fun/Good Life/Symptoms, 1985
neon
68½ x 131 x 16 in. (174 x 332.8 x 40.6 cm.)
(see catalogue supplement)
Museum of Art, Carnegie Institute, Pittsburgh;
Museum purchase: gift of the Partners of Reed
Smith Shaw & McClay and Carnegie International
Acquisition Fund, 1985

Bruce Nauman

Selected One-Artist Exhibitions
1984
Sperone Westwater Gallery, New York. Also 1982.

Leo Castelli Gallery, New York. Also 1982, 1980, 1978, 1976, 1975, 1973, 1971, 1969, 1968.

1983
Museum Haus Esters, Krefeld.

Gallery Konrad Fischer, Düsseldorf. Also 1980, 1978, 1975, 1974, 1971, 1970, 1968.

1982
Baltimore Museum of Art. Catalogue by Brenda Richardson.

1981
Rijksmuseum Kröller-Müller, Otterlo, The Netherlands (traveled to Staatliche Kunsthalle, Baden-Baden). Catalogue with essays by Katharina Schmidt, Ellen Joosten, and Siegmar Holsten.

1978
InK, Zurich.

1975
Albright-Knox Art Gallery, Buffalo.

1972
Los Angeles County Museum of Art (traveled to Whitney Museum of American Art, New York; Kunsthalle, Bern; Städtische Kunsthalle, Düsseldorf; Stedelijk Van Abbemuseum, Eindhoven; Palazzo Reale, Milan; Contemporary Arts Museum, Houston; San Francisco Museum of Modern Art). Catalogue by Jane Livingston and Marcia Tucker.

1970
Nicholas Wilder Gallery, Los Angeles. Also 1969, 1966.

Selected Group Exhibitions
1985
Biennial Exhibition, Whitney Museum of American Art, New York. Catalogue.

1982
Documenta VII, Kassel. Also 1968, *IV. Catalogues.*

'60–'80: Attitudes/Concepts/Images, Stedelijk Museum, Amsterdam. Catalogue.

1981
Art in Los Angeles—Seventeen Artists in the Sixties, Los Angeles County Museum of Art.

1980
La Biennale di Venezia.

1975
Drawing Now, The Museum of Modern Art, New York (traveled to Kunsthaus, Zurich; Staatliche Kunsthalle, Baden-Baden; Albertina Museum, Vienna; Sonia Henie-Niels Onstad Foundation, Oslo; Tel Aviv Museum). Catalogue by Bernice Rose.

1974
Idea and Image in Recent Art, The Art Institute of Chicago.

1971
Guggenheim International Exhibition 1971, The Solomon R. Guggenheim Museum, New York.

1970
Information, The Museum of Modern Art, New York. Catalogue with essay by Kynaston McShine.

1967
American Sculpture of the Sixties, Los Angeles County Museum of Art. Catalogue with introduction by Maurice Tuchman and essay by James Monte.

Selected Bibliography
Peter Schjeldahl, in *Art of Our Time: The Saatchi Collection,* vol. 1 (London, 1985).

Annelie Pohlen, "Reviews: Bruce Nauman, Galerie Fischer, Museum Haus Esters," *Artforum* (May 1984).

Richard Armstrong, "Reviews: John Duff, Robert Mangold, Bruce Nauman," *Artforum* (September 1983).

Jan Butterfield, "Bruce Nauman: The Center of Yourself," *Arts Magazine* (February 1975).

Barbara Caitor, "Über den Subjektivismus bei Bruce Nauman," *Kunstwerk* (November 1973).

Peter Plagens, "Roughly Ordered Thoughts on the Occasion of the Bruce Nauman Retrospective in Los Angeles," *Artforum* (March 1973).

Carter Ratcliff, "Adversary Spaces," *Artforum* (October 1972).

Robert Pincus-Witten, "Bruce Nauman: Another Kind of Reasoning," *Artforum* (February 1972).

Marcia Tucker, "PheNAUMANology," *Artforum* (December 1970).

Germano Celant, "Bruce Nauman," *Casabella* (February 1970).

Scott Burton, "Time on Their Hands," *Art News* (Summer 1969).

Robert Pincus-Witten, "New York: Bruce Nauman," *Artforum* (April 1968).

John Perreault, "Bruce Nauman," *Art News* (March 1968).

Fidel Danieli, "The Art of Bruce Nauman," *Artforum* (December 1967).

Knute Stiles, "William Geis and Bruce Nauman," *Artforum* (December 1966).

David Antin, "Another Category: 'Eccentric Abstraction,'" *Artforum* (November 1966).

Sigmar Polke

Born 1941, Oels, Germany (now German Democratic
Republic)
Lives and works in Hamburg and Cologne

Paganini, 1982
dispersion on canvas
78 ¾ x 177 in. (200 x 450 cm.)
Saatchi Collection, London

Sigmar Polke

Selected One-Artist Exhibitions
1985
Mary Boone Gallery, New York (also 1984) and Michael Werner (also 1983, 1974). Catalogue with essay by Peter Schjeldahl.

1984
Marian Goodman Gallery, New York.

Kunsthaus, Zurich. Catalogue by Siegfried Gohr, Dietrich Helms, Barbara Reise, Reiner Speck, and Harald Szeemann.

1983
Museum Boymans-van Beuningen, Rotterdam, and Städisches Kunstmuseum, Bonn. Catalogue with essays by Dierk Stemmler, Hagen Lieber-Knecht, and Sigmar Polke.

1978
InK, Zurich. Catalogue by Christel Sauer.

1976
Kunsthalle, Düsseldorf; Stedelijk Van Abbemuseum, Eindhoven; Kunsthalle, Tübingen. Catalogue.

1975
Kunsthalle, Kiel. Catalogue by Jens Christian Jensen, Eberhard Freitag, and Karl Vogel.

1973
Westfälischer Kunstverein, Münster. Catalogue by Jean-Christophe Ammann.

1969
Galerie René Block, Berlin. Also 1968, 1966 (catalogues).

1968
Kunstmuseum, Lucerne.

Selected Group Exhibitions
1984
Von Hier Aus, Messegelände, Düsseldorf. Catalogue by Kasper König.

1983
New Art at the Tate, The Tate Gallery, London. Catalogue by Michael Compton.

Zeitgeist, Martin-Gropius-Bau, West Berlin. Catalogue with foreword by Christos Joachimides and Norman Rosenthal.

1982
Documenta VII, Kassel. Also 1977, *VI*; 1972, *V.* Catalogues.

1981
A New Spirit in Painting, Royal Academy of Arts, London. Catalogue by Christos Joachimides and Norman Rosenthal, eds.

Westkunst—Heute: Zeitgenössische Kunst seit 1939, Museen der Stadt Köln. Catalogue by Laszlo Glozer.

1975
Bienal de São Paulo. Catalogue with interview by Kathrin Steffen.

1972
Amsterdam-Paris-Düsseldorf, The Solomon R. Guggenheim Museum, New York. Catalogue.

1969
Konzeption-Conception, Städtisches Museum, Leverkusen. Catalogue.

1967
Artypo, Stedelijk Van Abbemuseum, Eindhoven. Catalogue.

1963
Demonstration für den kapitalistischen Realismus, Möbelhaus Berges, Düsseldorf.

Selected Bibliography
Rudi Fuchs, in *Art of Our Times: The Saatchi Collection,* vol. 3 (London, 1984).

Jeanne Silverthorne, "Sigmar Polke," *Artforum* (October 1984).

Patrick Frey, "Sigmar Polke," *Flash Art* (Summer 1984).

Paul and Heynen Groot, "Wat Bezielt Sigmar Polke: Een Poging tot Analyse van een geliefd Kunstenaar," *Museumjournaal* (May 1983).

Wolfgang Max Faust and Gerd de Vries, *Hunger nach Bildern: Deutsche Malerei der Gegenwart* (Cologne, 1982).

Benjamin Buchloh, "Parody and Appropriation in Francis Picabia, Pop and Sigmar Polke," *Artforum* (March 1982).

Donald B. Kuspit, "The Night Mind," *Artforum* (September 1982).

Brice Curriger, "Das Lachen von Sigmar Polke ist nicht zu töten," *Kunstnachrichten* (September 1977).

Dierk Stemmler, "Sigmar Polke," *Kunstforum* X (1974).

Georg Jappe, "Young Artists in Germany," *Studio International* (February 1972).

———, "Sigmar Polke," *Frankfurter Allgemeine Zeitung,* 24 December 1970.

Jean-Christophe Ammann, "Raum—Zeit—Wachstum in der aktuellen Kunst," *Kunstjahrbuch* 1 (1970).

Heinz Ohff, *Pop und die Folgen* (Düsseldorf, 1968).

———, "Poetry in Contemporary German Art," *Studio International* (December 1964).

Hochsitz II, 1984—85
silver, silver oxide, and synthetic resin on canvas
119 13/16 x 88 11/16 in. (304 x 225.3 cm.)
Museum of Art, Carnegie Institute, Pittsburgh;
William R. Scott, Jr., Fund, 1985
(Photographed under four different lighting
conditions)

Sigmar Polke

Yggdrasil, 1984
silver, silver oxide, silver nitrate, and natural resin
on canvas
119 x 88 ½ in. (302.3 x 224.8 cm.)
Saatchi Collection, London

Bufo-Tenin, 1984
silver, silver bromide, and natural resin on canvas
117 x 88 in. (297.2 x 223.5 cm.)
The Rivendell Collection

Gerhard Richter

Born 1932, Dresden
Lives and works in Cologne

Every time we describe an event, add up a column of figures or take a photograph of a tree, we create a model; without models we would know nothing about reality and would be like animals.

Abstract paintings are fictitious models because they visualize a reality which we can neither see nor describe but which we may nevertheless conclude to exist. We attach negative names to this reality: the un-known, the un-graspable, the in-finite, and for thousands of years we have depicted it in terms of substitute images like heaven and hell, gods and devils. With abstract painting we created a better means of approaching what can be neither seen nor understood because abstract painting illustrates with the greatest clarity, that is to say with all the means at the disposal of art, "nothing." Accustomed to recognizing real things in paintings we refuse, justifiably, to consider color alone (in all its variation) as what the painting reveals, and instead allow ourselves to see the unseeable, that which has never before been seen and indeed is not visible. This is not an artful game, it is a necessity; and since everything unknown frightens us and fills us with hope at the same time, we take these images as a possible explanation of the inexplicable or at least as a way of dealing with it. Of course even representative paintings have this transcendental aspect; since every object, being part of a world whose last and first causes are finally unfathomable, embodies that world, the image of such an object in a painting evokes the general mystery all the more compellingly the less "function" the representation has. This is the source of the continually increasing fascination, for example, that so many old and beautiful portraits exert upon us. Thus paintings are all the better, the more beautiful, intelligent, crazy and extreme, the more clearly perceptible and the less decipherable metaphors they are for this incomprehensible reality.

Art is the highest form of hope.

Gerhard Richter. Reprint from D + V Paul Dierichs GmbH & Co KG, Kassel, *Documenta 7* (1982), exh. cat., I, 443. Used by permission.

Selected One-Artist Exhibitions
1983
Galerie Konrad Fischer, Düsseldorf. Also 1977, 1975, 1972, 1970.

1982
Kunsthalle, Bielefeld (traveled to Kunstverein, Mannheim). Catalogue by Rudi Fuchs and Heribert Heere.

1978
Stedelijk Van Abbemuseum, Eindhoven (traveled to Whitechapel Art Gallery, London). Catalogue by B. H. D. Buchloh and Rudi Fuchs.

1974
Galerie René Block, West Berlin. Also 1969, 1966, 1965, 1964 (catalogue by Manfred de la Motte).

Galerie Heiner Friedrich, Munich. Also 1972, 1971, 1970, 1967, 1966, 1964.

Städtisches Museum, Mönchengladbach. Catalogue by Johannes Cladders.

1972
La Biennale di Venezia, West German Pavilion. Catalogue by Dieter Honisch.

Kunstmuseum, Lucerne. Catalogue by Jean-Christophe Ammann.

1971
Kunstverein, Düsseldorf. Catalogue by Dietrich Helms.

1969
Galerie Gegenverkehr, Aachen. Catalogue by Klaus Honnef.

Selected Group Exhibitions
1985
The European Iceberg: Creativity in Germany and Italy Today, The Art Gallery of Ontario, Toronto. Catalogue by Germano Celant.

Biennale de Paris. Also 1967. Catalogues.

1984
Von Hier Aus, Messegelände, Düsseldorf. Catalogue by Kasper König.

An International Survey of Recent Painting and Sculpture, The Museum of Modern Art, New York. Catalogue by Kynaston McShine.

1982
Documenta VII, Kassel. Also 1972, V. Catalogues.

'60–'80: Attitudes/Concepts/Images, Stedelijk Museum, Amsterdam. Catalogue.

1981
A New Spirit in Painting, Royal Academy of Arts, London. Catalogue by Christos Joachimides, Norman Rosenthal, and Nicholas Serota, eds.

1975
Fundamental Painting, Stedelijk Museum, Amsterdam. Catalogue.

1969
Nine Young Artists, The Solomon R. Guggenheim Museum, New York.

1963
Demonstration für den kapitalistischen Realismus, Möbelhaus Berges, Düsseldorf.

Selected Bibliography

William Zimmer, "Richter Scaled," *Soho Weekly News,* 20 February 1980.

Jeff Spalding, "Gerhard Richter at Anna Leonowens Gallery," *Artmagazine* (June 1978).

Willi Bongard, "Gerhard Richter," *Art Aktuell* (June 1978).

I. Michael Danoff, "Gerhard Richter: Multiple Styles," *Arts Magazine* (June 1978).

Gerhard Richter, *128 Details from a Picture* (Halifax, 1978).

James Collins, "Gerhard Richter, Onnasch Gallery," *Artforum* (January 1974).

Jean-Christophe Ammann, "Gerhard Richter," *Art International* (September 1973).

Klaus Honnef, "Richter's New Realism," *Art and Artists* (September 1973).

Irmeline Leeber, "Gerhard Richter ou la réalité de l'image" *Chroniques de l'Art Vivant* (February 1973).

Heiner Stachelhaus, "Doubts in the Face of Reality: The Paintings of Gerhard Richter," *Studio International* (September 1972).

Edward Fry, "Gerhard Richter, German Illusionist," *Art in America* (November/December 1969).

Gerhard Richter, "Artists on their Art," *Art International* (March 1968).

Abstract Painting (555), 1984
oil on canvas
98 7/16 x 98 7/16 in. (250 x 250 cm.)
Collection of Mobay Chemical Corporation

Gerhard Richter

Janus (529), 1983
oil on canvas
118 ⅛ x 98 ⁷⁄₁₆ in. (300 x 250 cm.)
Courtesy of Ponova Gallery, Toronto

Buschdorf (572-5), 1985
oil on canvas
39 ⅜ x 55 ⅛ in. (100 x 140 cm.)
Courtesy of Konrad Fischer, Düsseldorf

Netz (573-2), 1985
oil on canvas
78¾ x 118⅛ in. (200 x 300 cm.)
Collection of Martin Sklar, courtesy of Marian
Goodman Gallery, New York and Sperone
Westwater, New York

Scheune (550-1), 1984
oil on canvas
38½ x 39½ in. (97.8 x 100 cm.)
Collection of Arthur and Carol Goldberg, courtesy
of Marian Goodman Gallery, New York and
Sperone Westwater, New York

Susan Rothenberg

Born 1945, Buffalo, New York
Lives and works in New York

The way the horse image appeared in my paintings was not an intellectual procedure. Most of my work is not run through a rational part of my brain. It comes from a place in me that I don't choose to examine. I just let it come. I don't have any special affection for horses. A terrific cypress will do it for me too. But I knew that the horse is a powerful, recognizable thing, and that it would take care of my need for an image. For years I didn't give much thought to why I was using a horse. I thought about wholes and parts, figures and space.

Then I did the human heads and hands. I started with 9-inch studies—mesmerizing at that size, and I suppose I connected to it because that's what I work with, a head and a hand, and I thought, why not paint it. Then I blew them up to 10 by 10 feet and they became very confrontational.

After the year of doing those enormous heads and hands, I felt I had finished with that problem. There were no variations that I was interested in exploring, and I thought I'd move to oil paints. When I taught myself oil painting, I was living on a creek in Long Island and there were boats parked out front. There were swans in the water. I started painting boats to learn how to use oils after a dozen years of acrylic.

What I think the work was starting to talk about is growing, taking journeys. The boat became a symbol to me—about the freedom I was feeling. Sailboats are beautiful—they're light and they depend on wind. They suggest qualities of light and atmospheric conditions. They started to lead me down a different avenue of painting. There is some kind of space now. Shadow and movement. Depth and resonance. At first I was horrified. "Christ—what is this, Neo-Impressionism?" But if I have to put black behind the swan so it will sit right there and look right, I do it. There need not be so strict an image and ground. Instead I had a figure and a sense of location.

In *Ten Men*, I pared the idea of a group down so much that all that was left was a figure and a shadow. That figure has the quality of a Giacometti man in a big place. This has been remarked on. I can remember a time when I would have gotten ruffled at the thought of being compared to Giacometti, because I thought he was old-fashioned and stylized, but certainly I now have enough sense of the problem and respect for a great artist to appreciate that if you are going to mess with the human body you're likely to run into him.

My paintings are still really visceral. It comes back to trying to invent new forms to stand in

for the body since I don't want to make a realist painting. I wanted to get that body down in paint, free it from its anatomical confines. I'm very aware of my body in space—shoulders, frontal positions. I have a body language that is difficult to explain. A lot of my work is about body orientation, both in the making of the work and in the sensing of space, comparing it to my own physical orientation.

I'm also teasing myself with some other problems. If I could paint a painting about New York City, how would I do it? If I wanted to paint a landscape, would I choose a panorama or a blade of grass? I'd like to do portraits. The paintings wouldn't be realistic. I'd probably do something weird. I'll need to make the human figure more specific, rather than addressing myself to the body orientation and gut-felt thing, which has been the raft on which I've floated for a long time.

Excerpts from "Expressionism Today: An Artists' Symposium," interview with Susan Rothenberg by Hayden Herrera. Reprinted from *Art in America* (December 1982): 58–75, 139, 141. Used by permission.

Ten Men, 1982
oil on canvas
61 x 197 in. (155 x 500.4 cm.)
Museum of Art, Carnegie Institute, Pittsburgh;
Museum purchase: gift of Mr. and Mrs. Anthony
J. A. Bryan and The A. W. Mellon Acquisition
Endowment Fund, 1983

Mist from the Chest, 1983
oil on canvas
78 x 89 in. (198.1 x 226.1 cm.)
Milwaukee Art Museum, gift of Friends of Art

Susan Rothenberg

Selected One-Artist Exhibitions
1985
Willard Gallery, New York. Also 1983, 1981, 1979, 1977, 1976.

1984
Barbara Krakow Gallery, Boston.

1983
Los Angeles County Museum of Art (traveled to San Francisco Museum of Art; Museum of Art, Carnegie Institute; Institute of Contemporary Art, Boston; Aspen Center for the Visual Arts, Aspen, Colorado; The Tate Gallery, London). Catalogue by Maurice Tuchman.

1982
Stedelijk Museum, Amsterdam. Catalogue by Alexander van Grevenstein.

1981
Akron Art Museum.

1980
James Mayor Gallery, London (traveled to Galerie Rudolf Zwirner, Cologne).

1978
Greenburg Gallery, St. Louis.

Walker Art Center, Minneapolis.

University Art Museum, University of California, Berkeley. Brochure by Mark Rosenthal.

1975
112 Greene Street Gallery, New York.

Selected Group Exhibitions
1985
Biennial Exhibition, Whitney Museum of American Art, New York. Also 1983, 1979. Catalogues.

1984
An International Survey of Recent Painting and Sculpture, The Museum of Modern Art, New York. Catalogue by Kynaston McShine.

1983
Back to the USA: Amerikanische Kunst der Siebziger und Achtziger, Kunstmuseum, Lucerne (traveled to Rheinisches Landesmuseum, Bonn; Württembergischer Kunstverein, Stuttgart). Catalogue by Klaus Honnef.

1982
Zeitgeist, Martin-Gropius-Bau, West Berlin. Catalogue with foreword by Christos Joachimides and Norman Rosenthal.

1980
La Biennale di Venezia, United States Pavilion. Catalogue.

1979
American Painting: The Eighties, A Critical Interpretation, Grey Art Gallery and Study Center, New York University, New York (traveled to Contemporary Arts Museum, Houston; The American Center, Paris). Catalogue with essay by Barbara Rose.

1978
New Image Painting, Whitney Museum of American Art, New York. Catalogue by Richard Marshall.

1977
New Acquisitions, The Museum of Modern Art, New York.

1976
New Work/New York, Fine Arts Gallery, California State University, Los Angeles.

1974
New Talent, A. M. Sachs Gallery, New York.

Selected Bibliography

Hayden Herrara, "In a Class by Herself," *Connoisseur* (April 1984).

Lisbet Nilson, "Susan Rothenberg: 'Every Brushstroke is a Surprise,'" *Art News* (February 1984).

Mark Rosenthal, in *Art of Our Time: The Saatchi Collection,* vol. 4 (London, 1984).

Peter Schjeldahl, "Putting Painting Back on Its Feet," *Vanity Fair* (August 1983).

John Russell, "Art: 9-Painting Show That's Best of Season," *New York Times,* 28 January 1983.

Hayden Herrara, "Expressionism Today: An Artists' Symposium," *Art in America* (December 1982).

Barbara Rose, "Robert Moskowitz, Susan Rothenberg, and Julian Schnabel," *Flash Art* (February/March 1982).

I. Michael Danoff, "Susan Rothenberg," *Akron Art Museum Newsletter* (November 1981).

Hal Foster, "Susan Rothenberg, Willard Gallery," *Artforum* (Summer 1981).

Peter Schjeldahl, "Bravery in Action," *The Village Voice,* 29 April 1981.

Andrea Hill, "Susan Rothenberg at Mayor," *Artscribe* (April 1980).

Peter Schjeldahl, "Susan Rothenberg, Willard Gallery," *Artforum* (Summer 1979).

Mark Rosenthal, "From Primary Structures to Primary Imagery," *Arts Magazine* (October 1978).

Hilton Kramer, "Art: New Finds at the Modern," *New York Times,* 17 June 1977.

Hayden Herrara, "Susan Rothenberg at Willard Gallery," *Art in America* (September 1976).

Hilton Kramer, "Art," *New York Times,* 24 April 1976.

Hayden Herrara, "Reviews," *Art News* (September 1974).

Bucket of Water, 1983–84
oil on canvas
84 x 127 in. (213.4 x 322.6 cm.)
Private collection, courtesy of Willard Gallery,
New York

Holding the Floor, 1985
oil on canvas
87 x 147 in. (221 x 373.4 cm.)
(see catalogue supplement)
Private collection, courtesy of Willard Gallery,
New York

Robert Ryman

Born 1930, Nashville
Lives and works in New York

It is accepted that a painter does need a knowledge of painting of the past, in order to be able to focus correctly on the problems of painting. Yet, it is this very knowledge that can hinder the possibilities for discovery, that keeps our minds cluttered with past procedures, making our vision static and bound to the known.

A painter is only limited by his degree of perception. Painting is only limited by the known.

Robert Ryman. Reprinted from D + V Paul Dierichs GmbH & Co KG, Kassel, *Documenta 7* (1982), exh. cat., I, 68. Used by permission.

Selected One-Artist Exhibitions
1985
Rhona Hoffman Gallery, Chicago.
1984
Galerie Maeght Lelong, Paris. Catalogue with preface by Jean Frémon.
1981
Musée National d'Art Moderne, Centre Georges Pompidou, Paris. Catalogue by Yves-Alain Bois and Christel Sauer.
Sidney Janis Gallery, New York. Also 1979 (catalogue).
1980
Konrad Fischer Gallery, Düsseldorf. Also 1973, 1968, 1969.
1977
Whitechapel Art Gallery, London. Catalogue with introduction by Naomi Spector.
1975
Kunsthalle, Basel. Catalogue with introduction by Carlo Huber.
1974
Westfälischer Kunstverein, Münster. Catalogue with introduction by Klaus Honnef.
Stedelijk Museum, Amsterdam. Catalogue with introduction by Naomi Spector.
1972
The Solomon R. Guggenheim Museum, New York. Catalogue with introduction by Diane Waldman.
1967
Paul Bianchini Gallery, New York.

Selected Group Exhibitions
1984
La Grand Parade: Highlights in Painting After 1940, Stedelijk Museum, Amsterdam. Catalogue with essay by Edy de Wilde.
Overture, Castello di Rivoli, Turin.
1982
Documenta VII, Kassel. Catalogue. Also 1977, *VI;* 1972, *V.* Catalogues.
1981
Westkunst—Heute: Zeitgenössische Kunst seit 1939, Museen der Stadt Köln. Catalogue by Laszlo Glozer.
A New Spirit in Painting, Royal Academy of Arts, London. Catalogue by Christos Joachimides, Norman Rosenthal, and Nicholas Serota, eds.
1980
La Biennale di Venezia. Catalogue. Also 1976.
1978
American Painting of the 1970's, Albright-Knox Art Gallery, Buffalo (traveled to Newport Harbor Art Museum, Newport Beach, California; The Oakland Museum, Oakland, California; Cincinnati Art Museum; Art Museum of South Texas, Corpus Christi; Krannert Art Museum, University of Illinois, Champaign). Catalogue by Linda Cathcart.
1977
Biennial Exhibition, Whitney Museum of American Art, New York. Catalogue.
1975
Fundamental Painting, Stedelijk Museum, Amsterdam. Catalogue.
1966
Systemic Painting, The Solomon R. Guggenheim Museum. Catalogue by Lawrence Alloway.
1964
Eleven Artists, Kaymar Gallery, New York.

Selected Bibliography
Peter Schjeldahl, in *Art of Our Time: The Saatchi Collection,* vol. 1 (London, 1984).

Carter Ratcliff, "Mostly Monochrome," *Art in America* (April 1981).

Donald B. Kuspit, "Ryman, Golub: Two Painters/Two Positions," *Art in America* (July/August 1979).

Naomi Spector, et al., *Macula 3/4 : Dossier Ryman* (Paris, 1978).

Robert Pincus-Witten, "Entries: The White Rectangle: Robert Ryman and Benni Efrat," *Arts Magazine* (April 1977).

Jeremy Gilbert-Rolfe, "Appreciating Ryman," *Arts Magazine* (December 1975).

Marian Verstraeten, "Robert Ryman, Le Geste," $+ - 0$ *Revue d'Art Contemporain* (November 1974).

Barbara M. Reise, "Robert Ryman: Unfinished II (Procedures)," *Studio International* (March 1974).

———, "Robert Ryman: Unfinished I (Materials)," *Studio International* (February 1974).

John Russell, "Robert Ryman," *New York Times,* 12 October 1973.

Robert Pincus-Witten, "Ryman, Marden, Manzoni: Theory, Sensibility, Mediation," *Artforum* (June 1972).

Phyllis Tuchman, "An Interview with Robert Ryman," *Artforum* (May 1971).

Peter Schjeldahl, "The Ice Palace That Robert Ryman Built," *New York Times,* 7 February 1971.

Hilton Kramer, "Reviews," *New York Times,* 22 May 1969.

Barbara Rose, "ABC Art," *Art in America* (October/November 1965).

Issue, 1985
oil on aluminum
55⅞ x 55⅞ in. (142 x 142 cm.)
Museum of Art, Carnegie Institute, Pittsburgh;
Edith H. Fisher Fund, 1985

Robert Ryman

Charter, 1985
oil on aluminum
82 x 31 x 2 ½ in. (208.3 x 78.8 x 6.4 cm.)
Collection of Gerald S. Elliott

Appointment, 1985
oil on aluminum
51¾ x 47¾ in. (131.4 x 121.3 cm.)
Collection of Mr. and Mrs. J. Todd Simonds

Century, 1985
oil on canvas
49 x 45 in. (124.5 x 114.3 cm.)
Collection of Mrs. Faith Golding

David Salle

Born 1952, Norman, Oklahoma
Lives and works in New York

The pictures may give an illusion of being pan-cultural, but in fact I think they are quite culture-specific in terms of most of the images and most of the material. I've used Japanese calligraphy in my painting—I've gone totally Oriental—but that's just Orientalism as it appears in the West in 1982. It is the way things appear in reproduction, the way things appear through various forms of presentation, that's what is interesting to me. The original source is never really very interesting to me. What I've recently refused to do is to identify all the different sources; the point is all the images come from somewhere, sometimes they come directly from things I've drawn or observed, some of them are drawn from life, and some of them are invented images—so-called imaginary images, which is a hilarious term in so far as what it discriminates against. It's not the case that they come from anywhere; to focus on *where* they come from is I think to make at this point a distortion about what it is they are all doing together. Basically, I am attracted to images which are either self-effacing or self-conscious or both. The way I used to experience

it was: images which seem to understand us. . . .

The images are about empathy. A lot of people are horrified to hear that. Because the images sometimes have a public source they consider them to be *a priori* debased or banal. I wish people could stop using that word. Probably one of the reasons why some people have difficulty with my work is because of that assumption which doesn't exist for me. It may exist for other images I don't use but it seems for a lot of people to exist for *any* image that doesn't spring full blown from the so called imagination or an image which is somehow derived from what might be called close observation. But I'm not using images from either of those sources. I'm using images that exist on some level already. The distinctions I make are between some images that exist already and other images that exist already. Historically that is not so different from what artists have done for a long time. . . .

People see [my work] as cool or detached or distanced. Which is not a contradiction—I'm not saying it couldn't be both, or couldn't be

somewhere in between the two, or couldn't be about those things being the flip side of the same coin. But in my mind it is about the process by which something transforms itself from a point of empathy to a point of detachment and vice versa. It's that kind of reciprocity in one's emotional life which I am interested in. I'm not interested in making a statement about alienation, or any of that nonsense. What is interesting about that is that empathy by nature is very humble and very *humbling* and yet the depiction and presentation of it is somewhat arrogant. That is another polarity between which the work seems to run back and forth. I don't think it is something one would be even momentarily puzzled by in poetry. Yet in painting it is seen as something very unpainterly, almost unmanly. The reaction to it is very revealing in itself.

Excerpts from "An Interview with David Salle" by John Roberts. Reprinted from *Art Monthly* (March 1983): 3–7. Used by permission.

Miner, 1985
acrylic, oil, wood and metal tables on fabric
and canvas
96 x 162 ¼ in. (243.8 x 412.1 cm.)
Collection of Philip Johnson

Shower of Courage, 1985
acrylic, wood chairs, and fabric on canvas
98 x 148 ½ in. (248.9 x 377.2 cm.)
Collection of Lewis and Susan Manilow

David Salle

One-Artist Exhibitions
1985
Mary Boone Gallery, New York. Catalogue. Also 1983, 1982, 1981.
1984
Galerie Bruno Bischofberger, Zurich. Also 1982, 1980.
Leo Castelli Gallery, New York. Also 1982.
1983
Addison Gallery of American Art, Phillips Academy, Andover, Massachusetts.
Museum Boymans-van Beuningen, Rotterdam. Catalogue by W. A. L. Beeren and Carter Ratcliff.
1980
Fondation de Appel, Amsterdam. Also 1977.
1979
Gagosian/Nosei-Weber Gallery, New York.
Anna Leonowens Gallery, Halifax.
1978
Fondation Corps de Garde, Groningen. Also 1976.
1975
Claire S. Copley Gallery, Los Angeles.
Project, Inc., Cambridge, Massachusetts.

Selected Group Exhibitions
1985
Biennial Exhibition, Whitney Museum of American Art, New York. Also 1983. Catalogues.
1984
An International Survey of Contemporary Painting and Sculpture, The Museum of Modern Art, New York. Catalogue by Kynaston McShine.
1983
Bienal de São Paulo.
1982
Zeitgeist, Martin-Gropius-Bau, West Berlin. Catalogue with foreword by Christos Joachimides and Norman Rosenthal.
Documenta VII, Kassel. Catalogue.
La Biennale di Venezia.
1981
Body Language: Figurative Aspects of Recent Art, Hayden Gallery, Massachusetts Institute of Technology, Cambridge. Catalogue by Roberta Smith (traveled to Fort Worth Art Museum; University of South Florida Art Gallery, Tampa; Contemporary Arts Center, Cincinnati).
Westkunst—Heute: Zeitgenössische Kunst seit 1939, Museen der Stadt Köln. Catalogue by Laszlo Glozer.

1980
L'Amérique aux Indépendants, Grand Palais, Paris.
1977
Hallwalls, Buffalo, New York.
1975
Southland Video Anthology, Long Beach Museum of Art, Long Beach, California (traveled to Portland Center for the Visual Arts, Portland, Oregon; The Kitchen, New York).
1974
Conceptual Performance, California State College, Los Angeles.

Selected Bibliography
Mark Rosenthal, in *Art of Our Time: The Saatchi Collection,* vol. 4 (London, 1984).

Peter Schjeldahl, "The Real Salle," *Art in America* (September 1984).

Sanford Schwartz, "David Salle: The Art World," *The New Yorker,* 30 April 1984.

John Walker, "David Salle's Exemplary Perversity," *Tension Magazine* (July/August 1983).

John Roberts, "An Interview with David Salle," *Art Monthly* (March 1983).

Carter Ratcliff, "Expressionism Today: An Artists' Symposium," *Art in America* (December 1982).

Hilton Kramer, "Signs of Passion: The New Expressionism," *The New Criterion* (November 1982).

Robert Pincus-Witten, "David Salle: Holiday Glassware," *Arts Magazine* (April 1982).

Peter Schjeldahl, "David Salle Interview," *Journal* (September/October 1981).

David Salle, "Post-Modernism," *Real Life* (Summer 1981).

Carter Ratcliff, "Westkunst: David Salle," *Flash Art* (Summer 1981).

Thomas Lawson, "David Salle at Mary Boone," *Artforum* (May 1981).

David Salle, "Images That Understand Us: A Conversation with David Salle and James Welling," *Journal* (June/July 1980).

Walter Robinson, "David Salle at Gagosian/Nosei-Weber," *Art in America* (March 1980).

Thomas Lawson, "David Salle," *Flash Art* (January/February 1970).

Intact Feeling, 1984
acrylic and oil on canvas; wood
120 x 84 in. (304.8 x 213.4 cm.)
Collection of Michael Werner, courtesy
of Mary Boone Gallery, New York

Julian Schnabel

Born 1951, New York
Lives and works in New York

I'm not distorting things in my paintings. I'm selecting things that have already been distorted in life, and painting them pretty true to their contour. It's not interpretive. My brushstrokes are not emotional. It's the way they configure together that becomes emotional. Some paintings are brushy and I don't think they're emotional at all.

Also, maybe the work isn't designed to illustrate how I do or don't feel about something. My painting is more about what I think the world is like than what I think I'm like. I'm aiming at an emotional state, a state that people can literally walk into and let themselves be engulfed by. Some people might think my paintings are ugly. I think the feeling that you get from them is a feeling of beauty. They're very morose, also—like Beethoven. There's something heartbroken about Beethoven. In my last show the paintings were all parts of one state of consciousness. It had a chapellike feeling. I wanted to have a feeling of God in it. Now I don't know if there's a God up there or anywhere. I'm talking about everything that's outside of you and everything that's inside of you. Maybe I make paintings larger than I am so that I can step into them and they can massage me into a state of unspeakableness.

The paintings in my last show are the view from the bridge, the bridge between life and death. I think about death all the time. The painting called *Rest* is about after a bullfight. During the bullfight there's one moment just before the end when the bull has been stuck by the picador and is breathing heavily. There's blood coming out of his back. Everybody is waiting. There is the glare of the sun and this adrenaline quality to the event, a compression of time.

My work, like all art, is formal as well as subjective. The way color functions is part of the subject. Color colors the meaning. I don't always choose a color beforehand. As you work on a painting, a color may have nothing to do with anything except that you like green next to violet or gray next to cadmium red. Some of my paintings are very thin; some of the velvet paintings are gossamer. Some are very heavy. It's like screaming sometimes and whispering other times.

The thing that interests me about primitive art is its directness and primariness, something carved out of wood with an incredible economy. Also, I'm interested in it in a sociological way. I think my paintings do something besides hang on the wall in back of people's couches. All my paintings have a function, so they're real things in the way that primitive objects might have been real, usable or magical things to the Indians in Mexico. My paintings allude to some kind of power. But they're really not primitive at all. They're pretty sophisticated. They are solar-powered energy generators. They seem to be alive in some way.

The thing that is most important is the direct connection between the artist and the work, and the viewer and the work. My presumption is that if the viewer becomes conscious of these realizations about life and death in my paintings, the world might be a better place. It's as fundamental as that.

Excerpts from "Expressionism Today: An Artists' Symposium," interview with Julian Schnabel by Hayden Herrera. Reprinted from *Art in America* (December 1982): 58–75, 139, 141. Used by permission.

Selected One-Artist Exhibitions

1985
Galerie Bruno Bischofberger, Zurich. Also 1984, 1983, 1982, 1980.

1984
The Pace Gallery, New York. Catalogue by Gert Schiff.

1982
The Tate Gallery, London. Catalogue by Richard Francis.

University Art Museum, University of California, Berkeley.

Los Angeles County Museum of Art.

Stedelijk Museum, Amsterdam. Catalogue by René Ricard and Alexander van Grevenstein.

Mary Boone Gallery, New York. Also 1979.

1981
Anthony d'Offay Gallery, London. Mary Boone Gallery and Leo Castelli Galleries, New York.

1978
Galerie December, Düsseldorf.

1976
Contemporary Arts Museum, Houston.

Selected Group Exhibitions

1985
Biennale de Paris. Catalogue.

1984
An International Survey of Recent Painting and Sculpture, The Museum of Modern Art, New York. Catalogue by Kynaston McShine.

1982
La Biennale di Venezia (traveled to Anthony d'Offay Gallery, London, Gallerie Bruno Bischofberger, Zurich).

'60–'80: Attitude/Concepts/Images, Stedelijk Museum, Amsterdam. Catalogue.

1981
Westkunst—Heute: Zeitgenössische Kunst seit 1939, Museen der Stadt Köln. Catalogue by Laszlo Glozer.

Biennial Exhibition, Whitney Museum of American Art, New York. Catalogue.

A New Spirit in Painting, Royal Academy of Art, London. Catalogue by Christos Joachimides, Norman Rosenthal, and Nicholas Serota, eds.

1980
La Biennale di Venezia, United States Pavilion. Catalogue.

1979
Visionary Images, Renaissance Society, University of Chicago. Catalogue by Carter Ratcliff.

1974
W. I. S. P. Exhibition, Whitney Museum of American Art, New York.

1971
Hidden Houston, University of Saint Thomas, Houston.

Selected Bibliography

Donald B. Kuspit, "The Rhetoric of Rawness: Its Effects on Meaning in Julian Schnabel's Paintings," *Arts Magazine* (March 1985).

Hilton Kramer, in *Art of Our Time: The Saatchi Collection,* vol. 3 (London, 1984).

Arthur Danto, "Julian Schnabel," *The Nation,* 8 December 1984.

Robert Pincus-Witten, "Julian Schnabel: Blind Faith," *Arts Magazine* (February 1982).

Carter Ratcliff, "Samtale med Julian Schnabel," *Louisiana Revy,* 2 January 1982.

Christos Joachimides, "Ein neuer Geist in der Malerei," *Kunstforum* (May 1981).

Ivan Nagel, "Von Schrecken und Aufruhr: Julian Schnabels Gemälde in New Yorker Gallerien," *Frankfurter Allgemeine Zeitung,* 16 May 1981.

Mark Stephens, "Bull in the China Shop," *Newsweek,* 11 May 1981.

Peter Plagens, "The Academy of the Bad," *Art in America* (November 1981).

Peter Schjeldahl, "Bravery in Action," *The Village Voice,* 29 April 1981.

John Perrault, "Is Julian Schnabel That Good?", *Soho Weekly News,* 22 April 1981.

Hilton Kramer, "Art: Two Painters Explore New Wave," *New York Times,* 17 April 1981.

Carter Ratcliff, "Art to Art: Julian Schnabel," *Interview Magazine* (October 1980).

Rene Ricard, "Julian Schnabel's Plate Painting at Mary Boone," *Art in America* (November 1979).

William Zimmer, "Julian Schnabel: New Painting," *Soho Weekly News,* 22 February 1979.

Edit de Ak, "Julian Schnabel," *Art Rite Magazine* (May 1975).

Sun of Justice, 1985
oil, plates, bondo, and vine garland on wood
113 ½ x 228 in. (288.3 x 579 cm.)
Collection of Douglas S. Cramer

Julian Schnabel

King of the Wood, 1984
oil and bondo with plates and spruce roots
on wood
120 x 234 in. (304.8 x 594.4 cm.)
Courtesy of The Pace Gallery, New York

The Walk Home, 1984—85
oil, plates, copper, bronze, fiberglass, and bondo
on wood
112 x 232 in. (284.5 x 589.3 cm.)
Collection of Aron and Phyllis Katz, courtesy of
The Pace Gallery, New York

Richard Serra

Born 1939, San Francisco
Lives and works in New York

Art-meaning is the meaning of art, not the meaning of meaning. (Ad Reinhardt, 1962–63)

The contextual issues of site-specific work remain problematic. Site-specificity is not a value in itself. Works which are built within the contextual frame of governmental, corporate, educational and religious institutions run the risk of being read as tokens of those institutions. One way of avoiding ideological co-optation is to choose leftover sites which cannot be the object of ideological misinterpretation. However, there is no neutral site. Every context has its frame and its ideological overtones. It's a matter of degree. But there are sites where it is obvious that art work is being subordinated to/ accommodated to/ adapted to/ subservient to/ required to/ useful to/. . . . That's not to say that art is not ideological. Art is always ideological, whether it carries an overt political message or whether it is art for art's sake, based on an attitude of indifference. Art always, either explicitly or implicitly, manifests a value judgment about the larger sociological context of which it is part. Art supports or neglects, embraces or rejects class interests. Tatlin's *Monument for the Third International* is not more ideological than a black painting by Ad Reinhardt. Ideological expression does not limit itself to affirmation of power or political bias.

My large scale pieces in public spaces are often referred to as being monumental and oppressive, yet, if you look at these pieces, are you asked to give any credence to the notion of the monument? Neither in form nor content do they relate to the history of monuments. They do not memorialize any person, place or event. They relate solely as sculpture. I am not interested in the idealization of the perennial monuments of art history, emptied of their historical function and meaning, being served up by architects and artists who need to legitimatize their aesthetic production by glorifying past historical achievements. The "appropriate historical solution" is nothing other than kitsch eclecticism. So much for the bronze figure on the pedestal and the ionic column. The return to historical images, icons and symbols is based on an illusory notion, the nostalgic longing for the good old days when times were better and art more meaningful. Nostalgia assumes full meaning today when the real is nothing other than a second hand representation of the past. Styles, subject matter, historical icons, authenticity are all up for grabs. I might add that one of the glaring problems of Post Modernism is that imagination itself has been reduced to a commodity. XEROX history.

The biggest break in the history of sculpture in the twentieth century was to remove the pedestal. The historical concept of placing sculpture on a pedestal was to establish a separation from the behavioral space of the viewer. "Pedestalized" sculpture invariably transfers the effect of power by subjugating the viewer to the idealized, memorialized or eulogized theme. As soon as art is forced or persuaded to serve alien values it ceases to serve its own needs. To deprive art of its uselessness is to make other than art.

I am interested in sculpture which is non-utilitarian, non-functional. Any use is a misuse. There is a trend now to demean abstract art as not being socially relevant. I have never felt and I don't feel now that art needs any justification outside of itself. One can only be suspicious of those artists and architects "who gotta serve somebody" (Bob Dylan's Jesus Christ capitalist theology). I know that there is no audience for sculpture; as is the case with poetry and experimental film. There is, however, a big audience for products which give people what they want and supposedly need, and which do not attempt to give them more than they understand. Marketing is based on this premise. Warhol is a master of art as commercial enterprise. No one demands that sculpture or poetry resist manipulation from the outside. On the contrary, the more one betrays one's language to commercial interests the greater the possibility that those in authority will reward one's efforts.

I think that if a work is substantial, in terms of its context, then it does not embellish, decorate or point to a specific building, nor does it add to a syntax that already exists. In my work I analyze the site and determine to redefine it in terms of sculpture not in terms of the existing physiognomy. I have no need to augment existing contextual languages. I have always found that that leads to application. I'm not interested in affirmation.

Selected One-Artist Exhibitions

1984
Leo Castelli Gallery, New York. Also 1982, 1979, 1973, 1970.

1983
Blum/Helman, New York. Also 1981, 1976.

Musée National d'Art Moderne, Paris.

1981
Mönchehaus, Museum für moderne Kunst, Goslar, Federal Republic of Germany.

1980
Hudson River Museum, Yonkers, New York. Catalogue.

1979
University Art Museum, University of California, Berkeley. Catalogue with essay by Michael Auping.

Staatliche Kunsthalle, Baden-Baden. Catalogue with essay by Hans-Albert Peters.

1977
Stedelijk Museum, Amsterdam (traveled to Kunsthalle, Tübingen; Staatliche Kunsthalle, Baden-Baden). Catalogue with essay by Rini Dippel and interview by Lizzie Borden.

1975
Portland Center for the Visual Arts, Portland, Oregon.

1970
Pasadena Art Museum. Catalogue.

1966
Galleria La Salita, Rome.

Selected Group Exhibitions

1984
ROSC, A Poetry of Vision, Guinness Hop Store, Dublin. Catalogue.

1982
'60–'80: Attitudes/Concepts/Images, Stedelijk Museum, Amsterdam. Catalogue.

Documenta VII, Kassel. Also 1977, *VI*; 1972, *V*. Catalogues.

1980
La Biennale di Venezia.

Mel Bochner/Richard Serra, Hayden Gallery, Massachusetts Institute of Technology, Cambridge. Catalogue.

1979
Biennial Exhibition, Whitney Museum of American Art, New York. Also 1977, 1973, 1970, 1968. Catalogues.

Carnegie, 1985
weathering steel
38 ft. 10 in. (11.8 m.)
(see catalogue supplement)
Museum of Art, Carnegie Institute, Pittsburgh;
Museum purchase: gift of Mrs. William R. Roesch in memory of her husband, 1985

1975
The Condition of Sculpture, Hayward Gallery, London.

1969
Kunst der Sechziger Jahre, Wallraf Richartz Museum, Cologne. Verborgene Strukturen, Museum Folkwang, Essen.

1966
From Arp to Artschwager I, Richard Bellamy/Noah Goldowsky Gallery, New York.

Selected Bibliography

Peter Schjeldahl, in *Art of Our Time: The Saatchi Collection,* vol. 1 (London, 1984).

Harriet Senie, "The Right Stuff," *Art News* (March 1984).

Douglas Crimp, "Richard Serra's Urban Sculpture: An Interview," *Arts Magazine* (November 1980).

Donald B. Kuspit, "Richard Serra, Utopian Constructivist," *Arts Magazine* (November 1980).

Robert Pincus-Witten, "Entries: Oedipus Reconciled," *Arts Magazine* (November 1980).

Regina Cornwell, "Three by Serra," *Artforum* (December 1979).

Annette Michaelson, Richard Serra, and Clara Weyergraf, "The Films of Richard Serra: An Interview," *October* (Fall 1979).

Antje von Graevenitz, "Stedelijk Museum, Amsterdam: Ausstellung," *Pantheon* (April 1978).

Liza Béar, "Skulptur als Platz: ein Gespräch mit Richard Serra," *Kunstwerk* (February 1978).

Robert Pincus-Witten, "Richard Serra: Slow Information," in *Postminimalism* (New York, 1977).

Liza Béar, "Richard Serra: Sight Point '71–75/ Delineator '74–76," *Art in America* (May/June 1976).

Robert Pincus-Witten, "Richard Serra, Group Show, Lo Giudice Gallery, New York City," *Artforum* (January 1972). Reply by Serra in "Letters," *Artforum* (March 1972).

Los Angeles County Museum of Art, *A Report on the Art and Technology Program of the Los Angeles County Museum of Art, 1967–71* (1971), essays by Richard Serra and Gail R. Scott.

Corinne Robins, "The Circle in Orbit," *Art in America* (November/December 1968).

Model for "Carnegie," 1984
steel
49 ¾ in. (126.4 cm.)
Courtesy of the artist

Cindy Sherman

Born 1954, Glen Ridge, New Jersey
Lives and works in New York

Selected One-Artist Exhibitions

1984
Akron Art Museum (traveled to Institute of
Contemporary Art, Philadelphia; Museum of Art,
Carnegie Institute; Des Moines Art Center; Baltimore
Museum of Art; Broida Museum, New York).

Laforet Museum, Tokyo. Catalogue.

Seibu Gallery of Contemporary Art, Tokyo. Catalogue.

1983
Metro Pictures, New York. Also 1982, 1981, 1980.

1982
Stedelijk Museum, Amsterdam (traveled to Gewad,
Ghent; Watershed Gallery, Bristol; John Hansard
Gallery, University of Southampton; Palais
Stutterheim, Erlangen, Federal Republic of Germany;
Haus am Waldsee, West Berlin; Centre d'Art
Contemporain, Geneva; Sonja Henie-Niels Onstadt
Foundation, Copenhagen; Louisiana Museum,
Humlebaek, Denmark). Catalogue by Els Barents.

1980
Contemporary Arts Museum, Houston. Catalogue by
Linda Cathcart.

1979
Hallwalls, Buffalo. Also 1977, 1976.

1977
Visual Studies Workshop, Rochester.

Selected Group Exhibitions

1985
Biennial Exhibition, Whitney Museum of American
Art, New York. Also 1983. Catalogues.

1984
The Heroic Figure, Contemporary Arts Museum,
Houston (traveled to Memphis Brooks Museum of Art,
Memphis; Alexandria Museum, Alexandria, Louisiana;
Santa Barbara Museum of Art; Museu de Arte
Moderna, Rio de Janeiro; Museo Nacional de Bellas
Artes, Santiago; Museo de Arte Contemporáneo,
Caracas). Catalogue with essays by Linda Cathcart and
Craig Owens.

1982
Documenta VII, Kassel. Catalogue.

Eight Artists: The Anxious Edge, Walker Art Center,
Minneapolis. Catalogue by Lisa Lyons.

La Biennale di Venezia.

The Image Scavengers: Photography, Institute of
Contemporary Art, University of Pennsylvania,
Philadelphia. Catalogue by Paula Marincola and
Douglas Crimp.

1981
Body Language: Figurative Aspects of Recent Art,
Hayden Gallery, Massachusetts Institute of
Technology, Cambridge. Catalogue by Roberta Smith.

Young Americans, Allen Memorial Art Museum,
Oberlin College, Oberlin, Ohio. Catalogue by Douglas
Crimp.

1978
Four Artists, Artists Space, New York. Catalogue.

1975
Hallwalls, Buffalo.

The 35th Western New York Exhibition, Albright-Knox
Art Gallery, Buffalo.

Selected Bibliography

Mark Rosenthal, essay in *Art of Our Time: The Saatchi
Collection,* vol. 4 (London, 1984).

Peter Schjeldahl and I. Michael Danoff, *Cindy Sherman*
(New York, 1984).

Andreas Kallfelz, "Cindy Sherman: Ich mache keine
Selbsportraits," *Wolkenkratzer Art Journal*
(September/October 1984).

Musée d'Art et d'Industrie Saint-Etienne, France,
Cindy Sherman (1983), exh. cat. by Christian Caujolle.

Art Gallery, Fine Arts Center, State University of New
York at Stony Brook, *Cindy Sherman* (1983), exh. cat.
by Thom Thompson.

Klaus Honnef, "Cindy Sherman," *Kunstforum* (April
1983).

Galerie Déjà Vu, Dijon, *Cindy Sherman* (1982), exh.
cat.

Christopher Knight, "Photographer with an Eye on
Herself," *Los Angeles Herald Examiner,* 10 October
1982.

John Howell and Shelley Rice, "Cindy Sherman's
Seductive Surfaces," *Alive Magazine* (September/
October 1982).

Peter Schjeldahl, "Shermanettes," *Art in America*
(March 1982).

"Cindy Sherman Untitled Film Stills," *Paris Review* 82
(1981).

Andy Grundberg, "Cindy Sherman: A Playful and
Political Post Modernist," *New York Times,* 22
November 1981.

"Cindy Sherman: Recent Pictures," *Sun and Moon*
(Fall 1979).

Albright-Knox Art Gallery, Buffalo, *In Western New
York* (1979), exh. cat. by Linda Cathcart.

No. 143, 1985
color photograph
48 x 48 in. (121.9 x 121.9 cm.)
Courtesy of Metro Pictures, New York

Cindy Sherman

No. 147, 1985
color photograph
48 x 72 in. (121.9 x 182.9 cm.)
Courtesy of Metro Pictures, New York

No. 145, 1985
color photograph
72 x 48 in. (182.9 x 121.9 cm.)
Courtesy of Metro Pictures, New York

No. 146, 1985
color photograph
72 x 48 in. (182.9 x 121.9 cm.)
Courtesy of Metro Pictures, New York

Frank Stella

Born 1936, Malden, Massachusetts
Lives and works in New York

Selected One-Artist Exhibitions

1985
M. Knoedler & Co., Inc., New York. Also 1981, 1979, 1975, 1973, 1969, 1967, 1960.

1983
Fogg Art Museum, Harvard University, Cambridge, Massachusetts.

Jewish Museum, New York. Catalogue by Caroline Cohen.

1982
Addison Gallery of American Art, Phillips Academy, Andover, Massachusetts. Catalogue with introduction and interview by Christopher C. Cook.

Leo Castelli Gallery, New York. Also 1979, 1975, 1973, 1969, 1967, 1966, 1964, 1962, 1960.

American Federation of the Arts and the University of Michigan Museum of Art, Ann Arbor (traveled to Whitney Museum of American Art, New York; Huntsville Museum of Art, Huntsville, Alabama; Sarah Campbell Blaffer Gallery, Houston; Brunnier Gallery, Iowa State University, Ames; Cleveland Museum of Art; Mary and Leigh Block Gallery, Northwestern University, Evanston; Pennsylvania Academy of Fine Arts, Philadelphia; Memorial Art Gallery, University of Rochester; Laguna Gloria Art Museum, Austin; Brooks Memorial Art Gallery, Memphis; Beaumont Art Museum, Beaumont, Texas; Nelson-Atkins Museum, Kansas City; Columbus Museum of Art; Los Angeles County Museum of Art). Catalogue by Richard Axsom.

1978
Fort Worth Art Museum (traveled to Newport Harbor Art Museum, Newport Beach, California; Montreal Museum of Fine Arts; Vancouver Art Gallery; Corcoran Gallery of Art, Washington, D.C.; Mississippi Art Museum, Jackson; Denver Art Museum; Minneapolis Institute of Arts; Des Moines Art Center). Catalogue by Philip Leider.

1977
Kunsthalle, Bielefeld, and Kunsthalle, Tübingen. Catalogue.

1976
Baltimore Museum of Art. Catalogue by Brenda Richardson.

Kunsthalle, Basel. Catalogue by Franz Meyer.

1970
The Museum of Modern Art, New York (traveled to Hayward Gallery, London; Stedelijk Museum, Amsterdam; Pasadena Art Museum; Art Gallery of Ontario). Catalogues by John McLean (for Hayward Gallery) and William Rubin.

1969
Rose Art Museum, Brandeis University, Waltham, Massachusetts. Catalogue by William Seitz.

1966
Pasadena Art Museum (traveled to Seattle Art Museum).Catalogue with essay by Michael Fried.

Selected Group Exhibitions

1984
La Grande Parade: Highlights in Painting After 1940, Stedelijk Museum, Amsterdam. Catalogue with essay by Edy de Wilde.

BLAM!: The Explosion of Pop, Minimalism and Performance 1958–1964, Whitney Museum of American Art, New York. Catalogue by Barbara Haskell.

1978
American Painting of the 1970's, Albright-Knox Art Gallery, Buffalo (traveled to Newport Harbor Art Museum, Newport Beach, California; The Oakland Museum, Oakland, California; Cincinnati Art Museum; Art Museum of South Texas, Corpus Christi; Krannert Art Museum, University of Illinois, Champaign). Catalogue by Linda Cathcart.

1971
Pittsburgh International, Museum of Art, Carnegie Institute. Also 1967.

1969
New York Painting and Sculpture: 1940–1970, The Metropolitan Museum of Art, New York.

Annual Exhibition, Whitney Museum of American Art, New York. Also 1967, 1965, 1964. Catalogues.

1968
Documenta IV, Kassel. Catalogue.

1965
Bienal de São Paolo. Catalogue with introduction by Walter Hops.

Three American Painters: Kenneth Noland, Jules Olitski, Frank Stella, Fogg Art Museum, Harvard University, Cambridge, Massachusetts. Catalogue by Michael Fried.

1964
La Biennale di Venezia. Catalogue with essay by Alan K. Solomon.

1959
Sixteen Americans, The Museum of Modern Art, New York. Catalogue with essay by Carl Andre.

Selected Bibliography

John Russell, "The Power of Frank Stella," *New York Times,* 1 February 1985.

Robert Rosenblum, in *Art of Our Time: The Saatchi Collection,* vol. 2 (London, 1984).

Roni Feinstein, "Stella's Diamonds: Frank Stella's New Work," *Arts Magazine* (January 1983).

Hilton Kramer, "Frank Stella's Brash and Lyric Flight," *Portfolio* (April/May 1979).

Bud Hopkins, "Frank Stella's New Work, a Personal Note," *Artforum* (December 1976).

Noel Frackman, "Frank Stella's Abstract-Expressionist Aerie: A Reading of Stella's New Paintings," *Arts Magazine* (December 1976).

Rosalind Krauss, "Stella's New Work and the Problem of Series," *Artforum* (December 1971).

Robert Rosenblum, *Frank Stella* (Baltimore, 1971).

Philip Leider, "Literalism and Abstraction: Frank Stella's Retrospective at the Modern," *Artforum* (April 1970). Reply by William S. Rubin in "Letters," *Artforum* (June 1970).

Hilton Kramer, "Frank Stella: 'What You See Is What You See,'" *New York Times,* 10 December 1967.

Bruce Glaser, "Questions to Stella and Judd," *Art News* (September 1966).

Robert Creeley, "Frank Stella: A Way to Go," *Lugano Review* (Summer 1965).

Robert Rosenblum, "Frank Stella: Five Years of Variations of an 'Irreducible' Theme," *Artforum* (March 1965).

The Jewish Museum, New York, *Toward a New Abstraction* (1963), exh. cat. with essay by Michael Fried.

William Rubin, "Younger American Painter," *Art International* (January 1960).

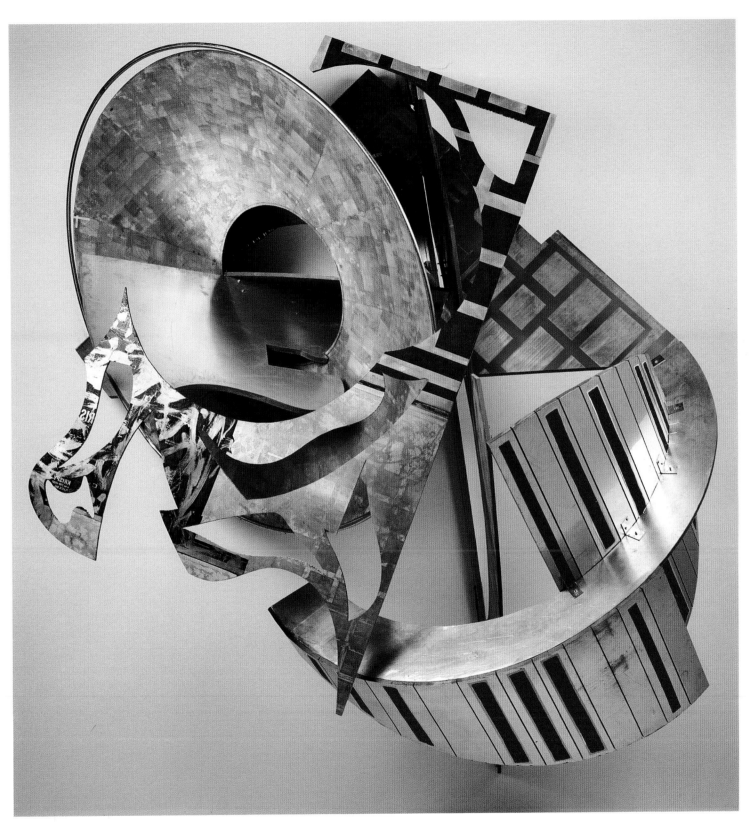

St. Michael's Counterguard, 1984
mixed media on aluminum and fiberglass
honeycomb
156 x 135 x 108 in. (396.2 x 342.9 x 274.3 cm.)
Los Angeles County Museum of Art, gift of
Anna Bing Arnold

Frank Stella

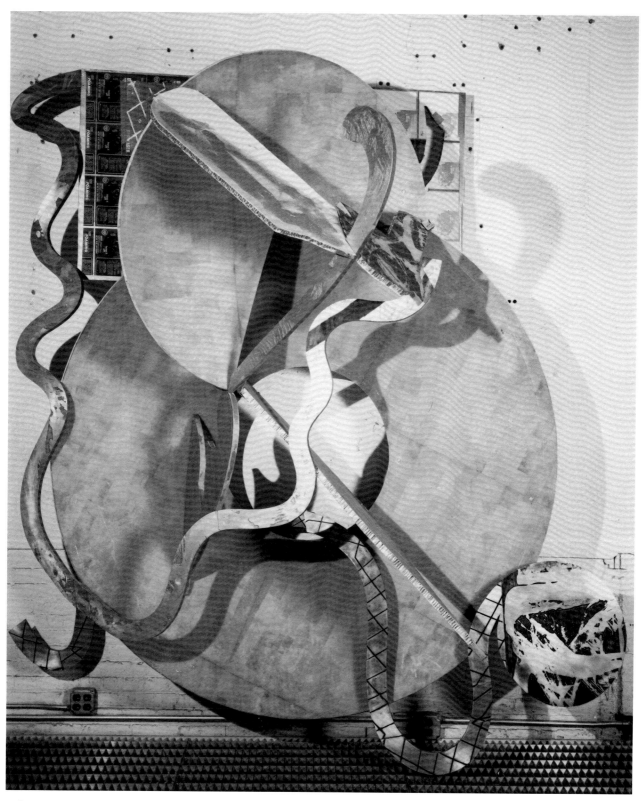

Valletta, 1983
mixed media on magnesium and honeycombed
aluminum
107 x 101 x 52 in. (271.8 x 256.5 x 132.1 cm.)
Collection of Mr. and Mrs. Graham Gund

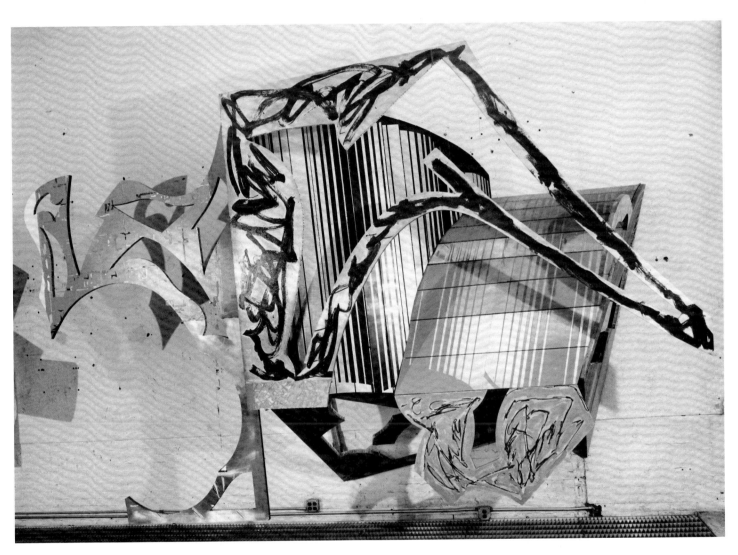

Xagna, 1984–85
mixed media on magnesium and honeycombed
aluminum
115 ½ x 185 ⅝ x 60 ¼ in. (293.4 x 471.5 x 153 cm.)
Courtesy of M. Knoedler & Co., Inc., New York

Bill Woodrow

Born 1948, Henley, England
Lives and works in London

(Could you tell me something about how you work things over and how you select the parts)?

After making the earlier pieces of things embedded in concrete (these pieces I still think are very important—sort of the base of all the other things), I discarded the concrete and the embedding and started cutting into the actual object, and just displacing sections of it and combining the bits that I had cut out of the original object. For instance, in the piece with the television, I simply smashed the screen and then laid the broken glass in front of the television on the floor in the shape of a screen. It was a very simple piece but I think rather effective. I did several other things like that. Eventually I picked up some frames which I wanted to use in some way. I ended up by cutting the bicycle frames in certain ways so that I could bend them out into a straight line. I made a couple of pieces with these. For the next work I was thinking I'd like to remake the bicycle out of another material. I had some spin-dryers in the studio which I had picked up somewhere. Eventually I decided I would try and make the bicycle out of the spin-dryer. I mean it was in a sense quite a quick decision. Suddenly it seemed that that was the right thing to do. So I used the surface of the spin-dryer and cut it just with a pair of hand-cutters in such a way that I had a form which I could bend into the shape of a bicycle frame.

That was the very first time I used the surface of one object to make another one. The two were left connected, which I was excited about because of the combination of the two things. It was quite bizarre to start with, the bicycle and the spin-dryer. Not before, but as I was doing it, I realized that there were lots of other connotations which seemed to be very important. That's the process as it developed and I guess it became more sophisticated in someways when I used two or three objects combined. . . .

In some works the relationship between the thing I make and the actual object is very direct, is very obvious. I can think of one example where this is easy to see. It is the piece called *Twin-Tub with Beaver.* The washing machine that I had found was covered with a plastic imitation wood. I had had this in the studio for quite some time and every time I looked at it I thought, "What can I do with that?" It came slowly over a couple of months and then suddenly one day I had the idea of making a beaver because of the connection with the wood. The idea of a beaver made out of plastic wood, and all the ecological connotations of that, I realized only *after* making it. Many of my other works became discoveries while I was making them. . . .

To start with I see the original object and then the total sculpture which I made from it. I don't see them as individual pieces that have to be read separately. In this way I think that within the whole work there are many relationships which arise in the process of making a work between the original and the created object, and those having social and environmental connotations. All of those things I view as being interwoven. I am not particularly interested in separating them out because for me what is really important is the visual total—how they actually look—because that's the sculpture, that's your first contact with them, *that* has to be right. . . .

There's always a sense of wanting to find something, revealing something even with the long aspirator, I knew what it was before I embedded it and poured the concrete over it and totally covered it. But it was still very much an exciting discovery to cut it back and reveal it again, and to reveal it as a different thing to when I found it. So in that sense I think the cutting thing always is revealing something—the innards of the machine which show the technology in a very open, sordid sort of way because it doesn't have its covering, its make-up on. The surface usually serves to cover up something which you shouldn't see—how the thing works—it's a cosmetic layer.

Excerpts from an interview with William Woodrow by Catherine Ferbos. Reprinted from Kunsthalle Bern, *Leçons des Choses* (1982), exh. cat. by Jean-Hubert Martin. Used by permission.

Selected One-Artist Exhibitions
1985
Kunsthalle, Basel. Catalogue with essays by Jean-Christophe Ammann.

1984
Musée de Toulon, France.

1983
Barbara Gladstone Gallery, New York.

Museum of Modern Art, Oxford. Catalogue with essay by David Elliott.

Lisson Gallery, London. Also 1982.

Museum van Hedendaagse Kunst, Ghent.

1982
Galerie 't Venster, Rotterdam.

1980
The Gallery, 52 Acre Lane, London.

1979
Künstlerhaus, Hamburg.

1972
Whitechapel Art Gallery, London.

Selected Group Exhibitions
1984
An International Survey of Recent Painting and Sculpture, The Museum of Modern Art, New York. Catalogue by Kynaston McShine.

1983
Bienal de São Paolo. Catalogue by Lewis Biggs.

The Sculpture Show, Hayward/Serpentine Gallery, London. Catalogue.

A Pierre et Marie (Phases 1-3, 5), Rue d'Ulm, Paris.

Figures and Objects, John Hansard Gallery, Southampton. Catalogue by Michael Newman.

1982
Tema Celeste, Museo Civico d'Arte Contemporanea, Gibellina, Italy. Catalogue by Demetrio Paparoni.

Objects and Figures: New Sculpture in Britain, Fruitmarket Gallery, Edinburgh. Catalogue by Michael Newman.

Englische Plastik Heute/British Sculpture Now, Kunstmuseum, Lucerne. Catalogue with essay by Michael Newman and introduction by Martin Kunz.

Leçons des Choses, Kunsthalle, Bern (traveled to Musées d'Art et d'Histoire, Chambéry, France; Maison de la Culture, Chalon-sur-Sane). Catalogue with interview by Catherine Ferbos.

1981
British Sculpture in the 20th Century, Whitechapel Art Gallery, London.

Objects and Sculpture, Institute of Contemporary Arts, London, and Arnolfini Gallery, Bristol. Catalogue by Lewis Biggs and Sandy Nairne, eds., with interview by Iwona Blaszczyck.

Selected Bibliography
Mark Francis, "Bill Woodrow: Material Truths," *Artforum* (January 1984).

Michael Newman, "Discourse and Desire: Recent British Sculpture," *Flash Art* (January 1984).

Lynne Cooke, "Reviews: Bill Woodrow at Barbara Gladstone," *Art in America* (November 1983).

Alain Cueff, "Bill Woodrow: La conduite du matériau," *Artistes* (June 1983).

Marco Livingston, "Reviews: Bill Woodrow at the Lisson Gallery," *Artscribe* (June 1983).

William Feaver, "Salvage into Sculpture," *London Observer,* 24 April 1983.

John Roberts, "Urban Renewal, New British Sculpture," *Parachute* (March 1983).

Michael Newman, "New Sculpture in Britain," *Art in America* (September 1982).

Martin Junz, "Neue Skulptur am Beispiel englischer Künstler," *Kunst-Bulletin* (June 1982).

John Roberts, "Car Doors and Indians," *ZG* (April 1982).

Caroline Collier, "Reviews: London, Bill Woodrow, Lisson Gallery," *Flash Art* (February/March 1982).

Michael Newman, "Bill Woodrow," *Art Monthly* (February 1982).

Waldemar Januszczak, "Bill Woodrow," *London Guardian,* 14 January 1982.

Thomas Lawson, "Reviews: Edinburgh, Bill Woodrow, New 57 Gallery," *Artforum* (December 1981).

William Feaver, "An Air of Light Relief," *London Observer,* 28 June 1981.

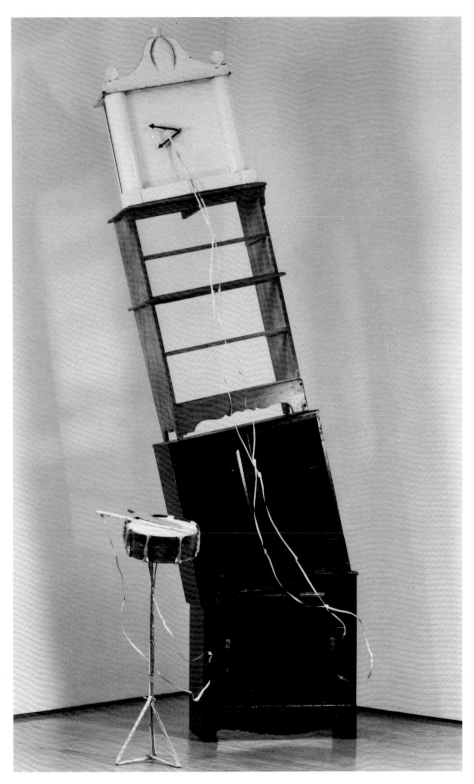

Time and Place for Nothing, 1985
three wooden dressers and file cabinet drawers
with spray enamel
128 x 49 x 51½ in. (325.1 x 124.5 x 130.8 cm.)
Courtesy of Barbara Gladstone Gallery, New York
(not in exhibition)

1985 Carnegie International Installation
mixed material found in Pittsburgh
(see catalogue supplement)
Collection of the artist, courtesy of Lisson Gallery,
London and Barbara Gladstone Gallery, New York

Acknowledgments

Judy Adam
Brooke Alexander
Jean-Christophe Ammann
Julian Andrews
June Batten Arey
Thomas N. Armstrong III
James D. Barron
Douglas Baxter
Nancy Beattie
Richard Bellamy
Monique Beudert
Ann S. Blasier
Irving Blum
Mary Boone
Peter Boris
Saskia Bos
Russell Bowman
Alan Bowness
Donald Brill
Bazon Brock
Dixon R. Brown
Mary Florence Brown
Susan Brundage
Benjamin H. D. Buchloh
Sarah Buie
Charlotte Bungeroth
David Carrier
Leo Castelli
Linda L. Cathcart
Germano Celant
Vicky A. Clark
Hallie Weissman Cohn
Michael Compton
Rita P. Coney
Michael Conforti
Paula Cooper
Jack Cowart
Peter J. Curry
Patricia A. Curtis
Judy Davenport

Maureen E. Dawley
E. L. L. de Wilde
Robert J. Dodds III
Anne d'Offay
Anthony d'Offay
Robert S. Dorsett
Michel Durand-Dessert
John Elderfield
James Elliot
Julia M. Ernst
Singleton R. Euwer
Nancy Fales
Nina Felshin
Konrad Fischer
Hal Foster
Xavier Fourcade
Martin Friedman
Charles B. Froom
Rudi H. Fuchs
Johannes Gachnang
Floyd Ganassi
Frank Garrity
Barbara Gladstone
Michael Glass
Arnold Glimcher
Marge Goldwater
Helen J. Goodman
Marian Goodman
Julie Graham
Thomas C. Graham
James Gregory
Detlef Grethenkort
Heather K. Hall
Jane Haskell
Daryl Harnisch
James W. Hawk, Jr.
Philip Heidinger
H. J. Heinz II
H. John Heinz III
Joseph Helman

David M. Hillenbrand
Rhona Hoffman
Antonio Homen
Henry T. Hopkins
Vivian Horan
W. R. Jackson
Knud Jensen
Miani Johnson
William D. Judson
Cathy Kaiser
Wallace F. Katz
Lauren A. Kintner
James Kirkman
Walter J. Kissel
Franklin Kissner
Kasper König
Richard Koshalek
Hilton Kramer
Donald B. Kuspit
William Lafe
Jane Richards Lane
Ernest Lefebvre
William Lieberman
Nicholas Logsdail
Genevieve A. Long
Barbara Luderowski
Paul Maenz
Kate Maloy
Donald Marron
Richard Marshall
Jean Hubert Martin
Susan Larsen Martin
Mark B. McCormick
Priscilla McCready
Thomas McEvilley
Paul Mellon
Thomas M. Messer
Bernita Mills
Lisa F. Miriello
Peter B. Mulloney

John Hallmark Neff
Annegreth T. Nill
Gordon Novak
Nancy Noyes
Michael Olijnyk
Achille Bonito Oliva
Andrew Oliver, Jr.
Reiner Opoku
Barbara L. Phillips
Frank J. Pietrusinski
Mary C. Poppenberg
Earl A. Powell III
Max Protetch
Alden Read
William A. Real
Cheryl Regan
Janelle Reiring
Christine Reusch
Elisabeth L. Roark
David M. Roderick
Jane H. Roesch
Anne Rorimer
Nancy Rosen
Mark Rosenthal
Fernande E. Ross
Margit Rowell
Lawrence Rubin
Marilyn Miller Russell
David Ryan
Amy Baker Sandback
Richard M. Scaife
Aurel Scheibler
Peter Schjeldahl
Adolph W. Schmidt
Ann Schroeder
Fairfax Seay
Nicholas Serota
Richard Siegesmund
Joan Simon
Lea Hillman Simonds

Patterson Sims
Susanna Singer
Ingrid Sischy
Lynn L. Sloneker
Anne Parsons Smith
Alice R. Snyder
W. P. Snyder III
Raymond Sokolowski
Ileana Sonnabend
Beverly Specht
Gianenzo Sperone
James A. Speyer
Diana J. Strazdes
Janet Sumner
Jurgen Tesch
Marcia L. Thompson
Ellen Tobin
Maurice Tuchman
Marcia Tucker
Helen van der Meij
Hester van Royen
John M. Vensak
Arno Vriends
Eleanor Vuilleumier
Diane Waldman
Brian Wallis
James M. Walton
Joan Washburn
Helene Weiner
Gisela Weis
Konrad M. Weis
Michael Werner
Angela Westwater
Bobby Whitaker
Robert C. Wilburn
Marc F. Wilson
Sue Wyble

Carnegie Institute

Trustees and Staff

Supplement

This supplement is published to provide a record of the installations made for the 1985 Carnegie International and to reproduce those works for which photographs were not available when the catalogue went to press.

John Ahearn

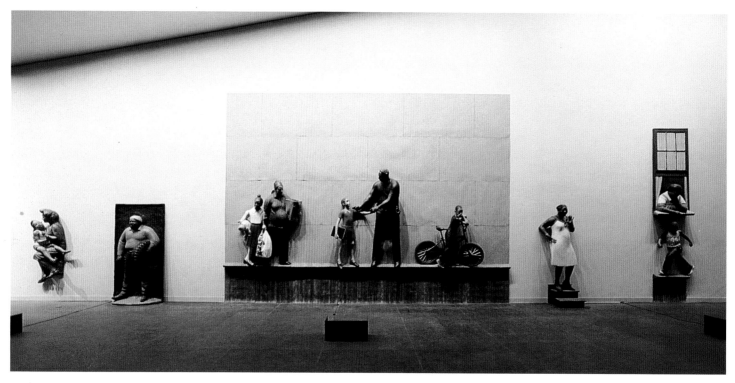

1985 Carnegie International installation by John Ahearn and Rigoberto Torres, left to right:

Pat and Selina at Play, 1983
oil on reinforced polyadam
63 x 38 x 8 in. (160 x 96.5 x 20.3 cm.)
Collection of the artist, courtesy of Brooke Alexander Gallery, New York

Pedro with Tire, 1984
oil on reinforced polyadam
80 x 42 x 18 in. (203.2 x 106.7 x 45.7 cm.)
Collection of Edward R. Downe, Jr.

Maggie and Connie, 1985
oil on reinforced polyadam
68 x 55 x 18 in. (147.3 x 139.7 x 45.7 cm.)
Collection of the artist, courtesy of Brooke Alexander Gallery, New York

Kido and Ralph, 1985
oil on fiberglass
80 x 63 x 16 in. (203.2 x 160 x 40.6 cm.)
Collection of the artist, courtesy of Brooke Alexander Gallery, New York

Jay with Bike, 1985
oil on fiberglass
52 x 55 x 16 in. (132.2 x 139.7 x 40.6 cm.)
Collection of the artist, courtesy of Brooke Alexander Gallery, New York

Barbara: For Ethiopia, 1985
oil on reinforced polyadam; wood
84 x 36 x 20 in. (213.4 x 91.4 x 50.8 cm.)
Collection of Edward R. Downe, Jr.

Titi in Window, 1985
oil on reinforced polyadam
72 x 30 x 12 in. (182.9 x 76.2 x 30.5 cm.)
Collection of the artist, courtesy of Brooke Alexander Gallery, New York

Thomas, 1983–84
oil on reinforced polyadam
46 x 29 x 7 in. (116.8 x 73.7 x 17.8 cm.)
Collection of Lenore and Herbert Schorr

(see pp. 88–90)

John Baldessari

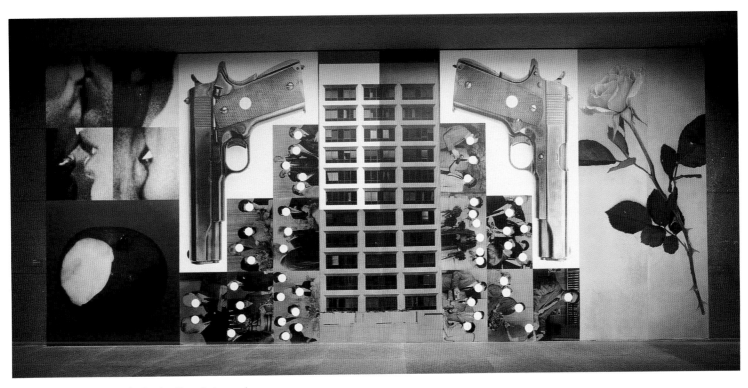

*Buildings = Guns = People: Desire, Knowledge, and
Hope (with Smog)*, 1985
black and white photographs and color photographs
192 x 450 in. (487.7 x 1143 cm.)
Collection of the artist

(see pp. 91–93)

Georg Baselitz

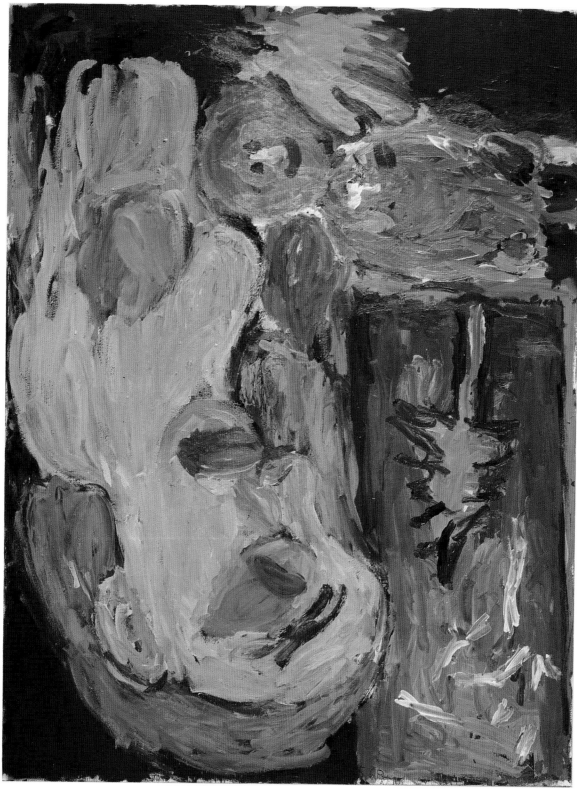

Rote Mutter mit Kind, 1985
oil on canvas
130 x 98¼ in. (330 x 250 cm.)
Courtesy of Mary Boone/Michael Werner Gallery,
New York

(see pp. 94–97)

Dara Birnbaum

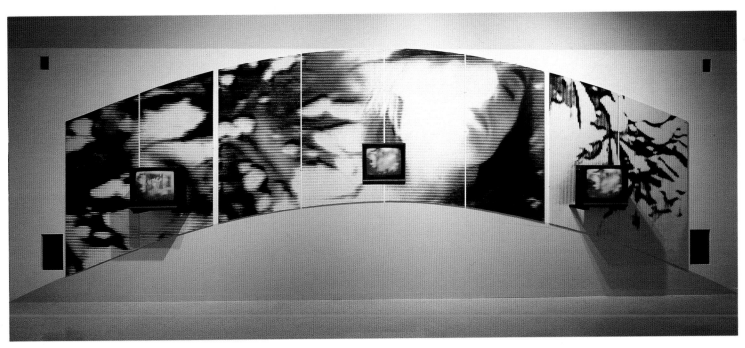

1985 Carnegie International installation:

Damnation of Faust: will-o'-the-wisp, 1985
video installation: black and white photo panels;
three monitors; ¾ in. video tape, color, 4 minutes;
sound, 8 minutes
144 x 438 in. (365.7 x 1112.5 cm.)
Collection of the artist

(see pp. 98—99)

Jonathan Borofsky

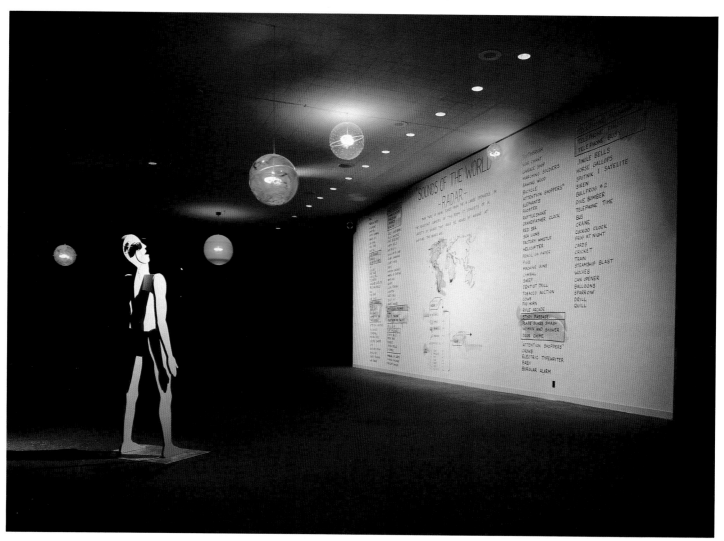

1985 Carnegie International installation by Jonathan Borofsky and Ed Tomney:

Sounds of the World with Chattering Man, 1985
sound installation: 4 speakers, tape deck, amplifier; 60 minutes
drawing installation: felt tip pen and acrylic wash on painted wallboard
192 x 510 in. (487.7 x 1295.4 cm.)
Chattering Man: aluminum, wood, primer, bondo, electric motor, speaker, and tape deck
82 ½ x 23 x 13 in. (209.6 x 58.4 x 33 cm.)

Five Globes:
1) ink on plexiglass, fluorescent light, electric motor
 36 in. (91.4 cm.), dia.
2) plexiglass with molecule holes, fluorescent light
 24 in. (61 cm.), dia.
3) ink on plexiglass, fluorescent light
 24 in. (61 cm.), dia.
4) ink on plexiglass, fluorescent light
 18 in. (45.7 cm.), dia.
5) ink on plexiglass, fluorescent light
 14 in. (35.6 cm.), dia.
Courtesy of Paula Cooper Gallery, New York

(see pp. 100–101)

Scott Burton

Granite Chairs (Set of Six), 1985
imperial red granite
36 ¾ x 106 x 38 in. (93.3 x 269.2 x 100.3 cm.)
Collection of Mellon Bank, courtesy of Max Protetch
Gallery, New York

(see pp. 102–103)

Enzo Cucchi

Giorno gonfio, 1985
oil on canvas on wood
118⅛ x 70⅞ in. (300 x 180 cm.)
Courtesy of Sperone Westwater, New York

(see pp. 108—110)

Richard Deacon

Fruit, 1985
laminated wood and galvanized steel
39 3/8 x 175 1/2 x 86 5/8 in. (100 x 445.7 x 220 cm.)
Courtesy of Lisson Gallery, London and Marian
Goodman Gallery, New York

(see pp. 111–113)

Luciano Fabro

1985 Carnegie International installation:

La Dialettica, 1985
Carrara marble, wood, and brass
91 x 193 x 30¾ in. (231.1 x 490.2 x 77.8 cm.)
Collection of the artist

(see pp. 121–123)

Jenny Holzer

1985 Carnegie International installation, left to right:
(All works courtesy of the artist and Barbara
Gladstone Gallery, New York, except where noted)

Unex Sign #1 (selections from "The Survival Series"),
1983
spectracolor machine with moving graphics
30½ x 113½ x 12 in. (77.5 x 288.3 x 30.5 cm.)
Whitney Museum of American Art, New York;
Purchase, with funds from the Louis and Bessie Adler
Foundation, Inc., Seymour M. Klein, President, 84.3

More "Survival," 1985
electronic moving message unit, LED sign, red diode;
edition 1/5
7 x 35¾ x 4 in. (17.8 x 90.8 x 10.2 cm.)

Selections from "The Living Series," 1985
electronic moving message unit, LED sign, red diode;
edition 1/4
6½ x 60¾ x 4 in. (16.5 x 154.3 x 10.2 cm.)

Selections from "The Survival Series," 1983
electronic moving message unit, LED sign, red diode;
edition 1/4
6½ x 60¾ x 4 in. (16.5 x 154.3 x 10.2 cm.); 2 in.
characters

Selections from "The Survival Series," 1983–84
electronic moving message unit, LED sign, yellow
diode; edition 1/4
6½ x 60¾ x 4 in. (16.5 x 154.3 x 10.2 cm.)

Selections from "Truisms," 1985
electronic moving message unit, LED sign, red diode;
edition 1/5
6½ x 121½ x 4 in. (16.5 x 308.6 x 10.2 cm.)

More "Survival," 1985
electronic moving message unit, LED sign, red diode;
edition 1/5
6½ x 121½ x 4 in. (16.5 x 308.6 x 10.2 cm.)

Selection from "Truisms," 1983–84
electronic moving message unit, LED sign, yellow
diode; edition 2/4
6½ x 60¾ x 4 in. (16.5 x 154.3 x 10.2 cm.)
The Smorgon Family Collection of Contemporary
American Art

Selections from "The Survival Series," 1983
electronic moving message unit, LED sign, red diode;
edition 1/5
6½ x 121½ x 4 in. (16.5 x 308.6 x 10.2 cm.)

More "Survival," 1985
electronic moving message unit, LED sign, red diode;
edition 2/5
7 x 35¾ x 4 in. (17.8 x 90.8 x 10.2 cm.)

(see pp. 142–143)

247

Jannis Kounellis

1985 Carnegie International installation:

Untitled, 1978
brick, mortar, and soot
156 x 37 ¾ x 37 ¾ in. (396 x 82 x 82 cm.)
Crex Collection, Schaffhausen

Untitled, 1985
burlap, steel, and paint
191 x 166 x 15 in. (485 x 422 x 38 cm.)
Courtesy of Sonnabend Gallery, New York

(see pp. 168–170)

Sol LeWitt

A wall is divided vertically into four parts. All one-, two-, and three-, and four-part combinations of four colors, 1985
colored ink wash
29½ x 72 ft. (9 x 22 m.)
Courtesy of the artist

(see pp. 171–172)

Bruce Nauman

Having Fun/Good Life/Symptoms, 1985
neon
69 x 131¼ in. (175.3 x 333.4 cm.)
Museum of Art, Carnegie Institute, Pittsburgh;
Museum purchase: gift of the Partners of Reed Smith
Shaw & McClay and Carnegie International
Acquisition Fund, 1985

(see pp. 193–194)

Susan Rothenberg

Holding the Floor, 1985
oil on canvas
87 ⅛ x 147 in. (221 x 373.4 cm.)
Private collection, courtesy of Willard Gallery,
New York

(see pp. 204–207)

Richard Serra

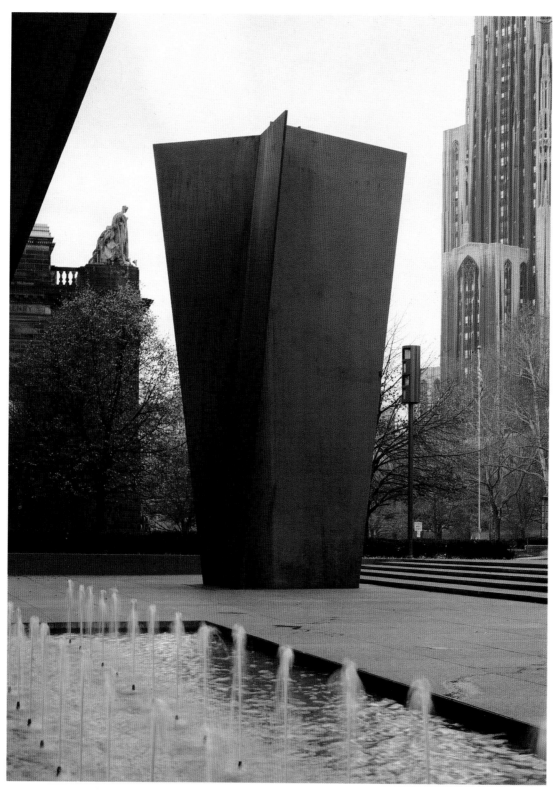

Carnegie, 1985
weathering steel
38 ft. 10 in. x 19 ft. x 21 ft. 3 in. (11.8 x 5.8 x 6.5 m.)
Museum of Art, Carnegie Institute, Pittsburgh;
Museum purchase: gift of Mrs. William R. Roesch in
memory of her husband, 1985

(see pp. 220–221)

Bill Woodrow

Promised Land, 1985
steel office cabinets, car hoods, enamel paint, and
men's jackets
181 7⁄16 x 155 x 207 in. (460.8 x 393.7 x 525.8 cm.)
Collection of the artist, courtesy of Lisson Gallery,
London and Barbara Gladstone Gallery, New York

(see pp. 230–231)

1985 Carnegie Prize

The 1985 Carnegie Prize was awarded to Anselm Kiefer for *Midgard* (see p. 161) and Richard Serra for *Carnegie* (see p. 252).

The jury of award for the 1985 Carnegie Prize was The Honorable H. John Heinz III and The Honorable Adolph W. Schmidt (co-chairmen) and Linda L. Cathcart, Rudi H. Fuchs, Kasper König, Hilton Kramer, Nicholas Serota, and Maurice Tuchman.

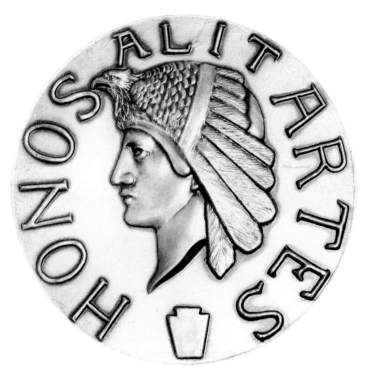

Obverse and reverse of the 1985 Carnegie Prize medal, struck from the 1896 medal.

Errata

Page 105
Corrected image of Francesco Clemente, *My World War III* appears below:

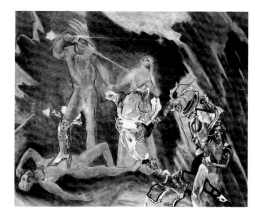

The media for the following paintings should read as follows:

Page 109
Un quadro di fuochi preziosi: oil on canvas with neon light

Page 120
Befehle des Barock, II: dispersion and plaster on canvas and velvet

Page 140
Mr. and Mrs. James Kirkman: oil on board

Page 163
Das Buch: lead, oil, and emulsion on photographic paper and canvas

Page 195
Paganini: dispersion on printed fabric

Page 211
Century: oil on aluminum

Page 218
King of the Wood: oil, bondo, bronze, and plates on wood

Photo Credits

The Museum of Art, Carnegie Institute wishes to thank the lenders for supplying photographs; additional acknowledgment is due for the following:

page 89, Ivan Dalla Tana; 90, Noel Rowe Photography; 93, David Aschkenas; 95, Zindman/Fremont; 97, Tom Barr; 101, Benjamin Blackwell, San Francisco Museum of Modern Art; 103, David Aschkenas; 105 and 107, Dorothy Zeidman; 109, Richard Geoffrey, Photo Lab Ltd.; 112, Lisson Gallery; 113, Gordon Bishop; 115, Piet Ysabie; 123 (top), David Aschkenas; 123 (bottom), Art Gallery of Ontario, Toronto; 124, 126, and 127, Zindman/Fremont; 131-135, Prudence Cuming Associates, Ltd.; 140, Ken Cohen; 141, Anthony d'Offay Gallery; 143 (bottom), Lisa Kahane; 149, Wharton Photography; 151, Eric Pollitzer; 153-155, Steve Sloman; 158, Jack Shear; 162, Tom Barr; 171, Kevin Brunelle; 175, Larry Gagosian Gallery; 183, Paula Cooper Gallery; 184, Geoffrey Clements; 185-188, The Pace Gallery; 191 and 192, Ivan Dalla Tana; 193, Dorothy Zeidman; 199, Prudence Cuming Associates, Ltd.; 201 and 204, Tom Barr; 207, Roy Elkind; 209 and 211 (top), Allan Finkelman; 210 and 211 (bottom), Rhona Hoffman Gallery; 212, 213, and 215, Zindman/Fremont; 217, The Pace Gallery; 219, Phillips/Schwab; 221, Tom Barr; 228 and 229, Ken Cohen; 231, Barbara Gladstone Gallery; 238-253 and 255, Tom Barr.

Designed by Michael Glass Design, Inc. Chicago, Illinois
Typeset by AnzoGraphics Typographers, Chicago, Illinois
Printed by Eastern Press, New Haven, Connecticut